PASSIONATE DETACHMENTS

PASSIONATE DETACHMENTS

An Introduction to Feminist Film Theory

SUE THORNHAM

Principal Lecturer in Media and Cultural Studies,
University of Sunderland

A member of the Hodder Headline Group
LONDON • NEW YORK • SYDNEY • AUCKLAND

First published in Great Britain 1997 by
Arnold, a member of the Hodder Headline Group
338 Euston Road, London NW1 3BH
175 Fifth Avenue, New York, NY 10010

Distributed exclusively in the USA by
St Martin's Press Inc.,
175 Fifth Avenue,
New York, NY 10010

British Library Cataloguing in Publication Data
A catalogue record for this book is available from the British Library

Library of Congress Cataloging-in-Publication Data
Thornham, Sue.
 Passionate detachments: an introduction to feminist film theory
 p. cm.
 Includes bibliographical references and index.
 1. Woman in motion pictures. 2. Feminism and motion pictures.
 3. Feminist film criticism. I. Title.
 PN1995.9.W6T44 1997
 791.43'082—dc21 97-2480
 CIP

ISBN 0 340 65225 X (Pb)
ISBN 0 340 65226 8 (Hb)

Typeset in 10/12 pt Sabon by
Phoenix Photosetting, Lordswood, Chatham, Kent
Printed and bound in Great Britain by
J. W. Arrowsmith Ltd, Bristol

Contents

Acknowledgements

I should like to thank all those graduate and undergraduate students at the University of Sunderland who have helped me clarify my thinking during the course of writing this book, especially Janice Cheddie, Mel Gibson, Jill Marshall, Angela Werndly and Trish Winter. I should also like to thank my colleagues, and particularly John Storey, for shouldering additional administrative burdens in order that I might have time to write, and the School of Arts, Design and Communications, University of Sunderland, for giving me research leave. Thanks must also go to Lesley Riddle, of Arnold, who insisted that I take the leave, when guilt about dereliction of my administrative duties (!) prompted me to forego it. Finally, I should especially like to thank Mike, for his tolerance, and Dan, Helen and Beth Thornham for being pretty good at listening, and at tackling their share of the household chores.

Introduction:
Passionate detachments

The first blow against the monolithic accumulation of traditional film conventions ... is to free the look of the camera into its materiality in time and space and the look of the audience into dialectics and passionate detachment. (Mulvey 1989a: 26)

When, in 1973, Laura Mulvey sought a phrase to describe the stance which she felt should be adopted by the feminist engaged in a critical reading of cinema – whether as film critic, as film-maker, or as audience member – the expression she chose was 'passionate detachment'. In 1991, the same phrase was adopted by the postmodernist feminist philosopher, Donna Haraway, to describe her own ideal of the 'critical vision' required of theorists engaged in what she calls 'the politics of visual culture'. 'Passionate detachment', she writes, should characterize the feminist critic, who must counter the claims to 'unlimited disembodied vision' of the dominant culture with her own 'situated knowledge' as a woman.[1] Between these two writings lies a complex history of debate, as feminist film theory has engaged both with theoretical currents from outside its own political borders – from structuralism and psychoanalysis in the 1970s to post-colonial theory, queer theory and postmodernism in the 1990s – and with its own internally generated conflicts. Because a vital part of feminism's project has been to 'transform women from an object of knowledge into a subject capable of appropriating knowledge' (Delmar 1986: 25), and because *seeing* is so crucial to knowledge in Western culture, these debates have been central within feminist theory. 'The struggle', argues feminist philosopher, Rosi Braidotti, 'is ... over imaging and naming. It is about whose representations will prevail' (1994: 72).

This book, then, seeks to chart that history. At the heart of its debates is the difficult triangular relationship between three central figures. First, there is the figure of 'Woman' as image or cinematic representation. Second, there

is the figure of the real-life woman, who is always in fact *women* – a whole array of female subjects positioned differently within history and culture. Finally, there is the figure of the feminist theorist who – in however complex or theoretical a way – *speaks as* a woman. This relationship – always tense, always a struggle over power and precedence – has been manifest in different ways. It was central to arguments about how to find a voice and an appropriate language for feminist film theory and a feminist film practice – one which would not simply replicate existing ways of seeing but which would nevertheless be empowering, and accessible, to its readers. It was also central to debates about the relationship between the 'female spectator', that spectral feminine figure who is the spectator which the film text *imagines* for itself, and to which its address is made, and the real-life woman in the audience – female, certainly, but perhaps different from her neighbour in every other way. And it underlies debates about methodology: whether textual analysis or ethnographic research should be the preferred method of study, and whether either can ever produce more than theoretical abstractions which exclude more than they explain.

It is a history, however, which is shadowed by two other histories which are not charted here: the activist history of the post-1970 women's movement, and the history of feminist film-*making*, the 'utopian other' (Mulvey 1989e: 77) of feminist film theory. In the early 1970s these histories seemed inextricable. Laura Mulvey, for example, describes how it was the women's movement, with its insistence that women's 'exclusion from the *public* voice and the language of culture and politics' was a *political* issue, and one which must therefore be confronted, which made it possible for her to begin to be able to write (1989b: viii). Like other activists, she took part in demonstrations against the 1970 Miss World competition, and then collaborated in writing an article, 'The Spectacle is Vulnerable' – part personal account, part theoretical – about the experience. And when, in 1972, the first issue of a (short-lived) American journal called *Women and Film* was published, its editors were in no doubt about their position as feminist *activists*. 'The women in this magazine', they wrote, 'as part of the women's movement, are aware of the political, psychological, social and economic oppression of women. The struggle begins on all fronts and we are taking up the struggle with women's image in film and women's roles in the film industry – the ways in which we are exploited and the ways to transform the derogatory and immoral attitudes the ruling class and their male lackys [*sic*] have towards women and other oppressed peoples' (1972: 5). Women, the editors go on, are oppressed within the film *industry* (they are 'receptionists, secretaries, odd job girls, prop girls' etc.); they are oppressed by being packaged as images (sex objects, victims or vampires); and they are oppressed within film *theory*, by critics who celebrate male *auteurs* like Sirk or Hitchcock as 'superstars', as if 'filmmaking were a one-man show' (1972: 6). The analysis begs a good many questions (what is the precise relationship, for example, between these different types of oppression? Does one

cause the others, or are they all products of something else – perhaps 'patriarchal ideology'?). But its optimism and sense of the interrelationship of cultural theory and social activism are invigorating.

In a similar way, the following chronology provided by the editors of *Re-Vision* (1984) gives some idea of the interrelationship of feminist film theory and criticism and feminist film-*making* in the early 1970s:

1971 Release of *Growing Up Female, Janie's Janie, Three Lives* and *The Woman's Film* – first generation of feminist documentaries.

1972 First New York International Festival of Women's Films and the Women's Event at Edinburgh Film Festival. First issue of *Women and Film* magazine; special issues on women and film in *Take One, Film Library Quarterly* and *The Velvet Light Trap*; filmography of women directors in *Film Comment*.

1973 Toronto Women and Film Festival. Washington Women's Film Festival, season of women's cinema at National Film Theatre in London and Buffalo women's film conference. Marjorie Rosen's *Popcorn Venus* (first book on women in film) and *Notes on Women's Cinema*, edited by Claire Johnston for British Film Institute (first anthology of feminist film theory).

1974 Chicago Films by Women Festival. First issue of *Jump Cut* (quarterly on contemporary film emphasizing feminist perspective); two books on images of women in film: Molly Haskell's *From Reverence to Rape* and Joan Mellen's *Women and their Sexuality in the New Film*.

(Doane, Mellencamp and Williams 1984: 3)

To this chronology we might add the information that, for example, the 1971 documentary, *Three Lives*, was produced by Kate Millett, whose theoretical-polemical work *Sexual Politics* had been published in 1970, and that Laura Mulvey's own films, *Penthesilea, Queen of the Amazons* (1974), and *Riddle of the Sphinx* (1977, both co-directed with Peter Wollen), were concerned to explore the same theoretical preoccupations as her written work.

By the 1990s, however, this interrelationship had been lost. Writing in 1989, Laura Mulvey argues that by the late 1980s, feminist film theory had 'lost touch with feminist filmmaking, that which had hitherto acted as its utopian other' (1989e: 77), and Janet Bergstrom and Mary Ann Doane trace a similar history of growing academic institutionalization and loss of interconnection in feminist film theory. 'A younger generation', they write, 'has already written dissertations based on a large body of pre-existing literature written by feminist film scholars. There is a feeling among many ... that feminist film and media theory has been cut off from its original sense of bold

innovation and political purpose' (1989: 16). The sense of a shared community and a close, *transparent*[2] relationship between the feminist theorist/critic, the feminist film-maker, and an audience of women united by a common positioning and political consciousness, is now perhaps evident only in the work of some black feminist writers. For Jacqueline Bobo, for example, writing in 1995, it is still true that as 'cultural producers, as critics, and as audience members, black women constitute a dynamic entity, each component of which has an impact on the others at key junctures' (1995: 60). It is the task of the black feminist critic, as member of this 'interpretive community', to 'give voice' to the shared readings of its members (1995: 51).

The move of feminist (and non-feminist women) film-makers 'into the mainstream' of narrative film production has added to this divorce. Michelle Citron, whose work in the 1970s formed an important part of independent feminist film-making, sees herself, by the late 1980s, as part of this move. She is ambivalent about its consequences. In the 1970s, she writes, she felt that she 'wanted to make films that articulated women's experiences and saw the need for a new film language with which to do so', but in retrospect she suspects this motivation: 'I realize there was another, deeper reason – my attraction to the avant-garde was one manifestation of an almost relentless intellectual upward mobility. ... I was determined to rise above my working-class family by proving I was an intellectual' (1988: 48). The films which were made in the 1970s were, she feels, 'theoretically interesting and politically sound, but flat. They offer intellectual pleasure but rarely emotional pleasure' (1988: 51). The move into the mainstream, she writes, has its dangers: through it, one trades control for power. But power means 'the opportunity to reach a larger audience, the potential of using mainstream culture to critique or subvert it, the freedom to define and test one's own personal boundaries as film-maker' (1988: 57). Above all, it means the move from didacticism into the 'contradictions, paradoxes, uncertainties' of mainstream narrative film (1988: 62). If we look at the recent films of Sally Potter, who with *Orlando* (1993) has made a similar move, or Jane Campion (*The Piano* 1993), it would be difficult to maintain that these films do *not* manifest a preoccupation with concerns central to feminist theory: the relationship of women to language, and to public and private histories; sexual difference and its relationship to other forms of difference; the limits and possibilities of desire; the relationship between women – in particular between mothers and daughters. At the same time, they engage fully – if subversively – with the conventions of popular film: in this case, with costume melodrama and the 'woman's film'. Perhaps, indeed, as Bergstrom and Doane tentatively suggest, this divorce, whilst bringing losses, is also a sign of success. Even 'institutionalization' is not wholly to be deplored:

we all inhabit institutions of one sort or another (the family, the press, legal, educational, governmental institutions) and persistently work

within, on the border and outside of these institutions. Relations among power, access to discourse, institutionalization and resistance are complex and difficult and require extended analysis – in particular, a feminist analysis. It would be bitterly ironic if feminists were to succumb to a pop-psychology concept of women's 'fear of success' just now, when one at least glimpses the possibility of real change. (1989: 16)

Nevertheless, these developments mean that the two histories of women's activism and feminist film-making, with which feminist film theory was intertwined in the 1970s, remain as shadow narratives in this book.

Chapter One, then, traces the theoretical forerunners and contemporaries of the first work on feminism and film to appear in the 1970s. It sets this work in the context of what Laura Mulvey has called the 'wider explosive meeting between feminism and patriarchal culture' which characterized 'second wave' feminism (1979: 179). Mulvey identifies three main arguments in this analysis of women's place in culture. The first is the claim that women have, in fact, produced more in mainstream culture than has ever been recognised'. The second, which in many ways runs counter to the first, is the insistence on women's *absence* from cultural production, in inverse proportion to the exploitation of female *images* in the subject matter of art and popular culture. Finally, she argues, there was a revival of interest in 'minor arts and crafts', where women *have* produced cultural artefacts, in however marginalized and undervalued a way. It is the second of these arguments, the exposure of the sexist content of cinematic narrative and the construction of images of women that simply express male fantasies that characterized the American feminist writing on film of the early 1970s which is explored in this chapter. Since, however, such writing draws on, in both its strengths and weaknesses, the more general theoretical accounts of patriarchal culture which appeared at this time, the chapter provides an outline, too, of these accounts.

Chapter Two examines a different body of work which appeared in the early 1970s, that identified with British feminist film theory. Such work moves away from a view of patriarchal ideology as 'false values' and 'images' which can be simply overthrown, to one which sees it as, in Claire Johnston's words, 'an effect of the form of the film text itself' (1975: 122) and hence inextricably bound into the meanings and pleasures which film offers. This move arose from an engagement with contemporary developments in European film and cultural theory, particularly that emerging in the late 1960s in France. Three elements of this theory can be distinguished. The first two, a structuralist and semiotic approach to textual analysis, and a view of ideology as produced in and through the operations of the film text, led to a focus on the film as *text*, rather than on its relationship to contemporary social developments or its production of images or stereotypes of women. The third, which drew on contemporary

developments within psychoanalytic theory, focused on the *spectator–screen relationship* and the processes of film viewing. It is these approaches, and the theoretical movements on which they drew, which are examined in this chapter.

Chapter Three pursues the question provoked, but not directly addressed, by much of the work on film spectatorship produced in the early 1970s: the question, 'But what about the *female* spectator?' This question, and B. Ruby Rich's rather more textually based reformulation of it as, 'What is there in a film with which a *woman* identifies?', produced a shift in analytic focus in feminist film theory and criticism, away from the study of mainstream male-centred narratives which presume a male, or a masculine, spectator, and towards a focus on those Hollywood genres specifically addressed to women. As Bergstrom and Doane argue, 'Since the linguistic/semiotic/psychoanalytic paradigm encouraged a text based analysis, women's genres ... were central to initiating the analysis of the female spectator' (1989: 7–8). The shift, then, was to an analysis of melodrama and the 'woman's film'. Chapter Three explores the range of answers produced by feminist theory and criticism of the 1980s to the question so forcefully asked by Rich in 1978.

The 'cine-psychoanalysis' (Gledhill 1988: 65) on which much of this work relied, however, seemed finally to produce an impasse within feminist film theory. Despite its explanatory power, the influential work of theorists like Laura Mulvey and Mary Ann Doane seemed to leave little space for resistance by female spectators to the power of patriarchal structures. To explain the power and pleasures of film both Mulvey and Doane argued that it draws on the fundamental mechanisms by which our (sexed) identities are produced. But if this explains the ideological *power* of film representations, it seems to leave us little scope for *changing* the situation. After all, if film works by appealing to mechanisms which are both central to the construction of our (sexed) identities and *unconscious*, how can we hope to produce *different* representations? Criticizing this explanatory framework, Christine Gledhill sums up the impasse it produced:

> While these arguments have attracted feminists for their power to explain the alternate misogyny and idealization of cinema's female representations, they offer largely negative accounts of female spectatorship, suggesting colonized, alienated or masochistic positions of identification. (1988: 66)

In response, there seemed to be two possible directions for feminist film theory to take. One was to return to psychoanalyic theory in order to wrest from it a more flexible concept of cinematic spectatorship and processes of identification. The alternative was to look elsewhere for theoretical ground from which to argue the possibility and/or reality of women's resistance to patriarchal power. Both directions were pursued; discussion of them forms the material of Chapters Four and Five.

Chapter Four, then, considers the impact of British Cultural Studies on feminist work on film. Like feminist film theory, cultural studies embraced the theories of ideology and subjectivity emerging in the 1960s and 1970s. The textual focus of cultural studies, however, ranged more widely than film, embracing a range of materials drawn from popular culture and the mass media. In addition, its concern was to produce a model of the text–reader relationship which would account for the *whole* of the communicative process – for audience readings as well as media production processes and textual structures. Using theories drawn from the work of the Italian Marxist, Antonio Gramsci, it argued that cultural texts – films, television programmes, popular fiction, for example – are the sites of *struggles* over meaning. The dominant cultural order – those in power – will always seek to impose their 'classifications of the social and cultural and political world' through cultural texts (Stuart Hall 1980c: 134), but these meanings will always, to some extent, remain open to contestation.The meanings of texts cannot be fixed. And audiences, too, will be engaged in the struggle over meaning. As part of the same social formation as the text's producers, they will have access to broadly the same 'maps of meaning', but because their *position* in this social formation may be different – as working class, as members of an ethnic minority group, as women – the meanings 'preferred' by the text may be negotiated or even opposed by them. This concept of 'negotiation' was taken up in a number of different ways by feminist writers. Some, like Christine Gledhill, employed it in textual analysis, to argue that the film spectator is never so fixed by the structures of the film as theorists of the 1970s had suggested. Others turned their attention to studies of the actual readings made by audiences, to argue that, whatever the meanings revealed by textual analysis, women can and do 'negotiate' to produce their own meanings and pleasures from popular texts.

Chapter Five explores the use by feminist film theory of 'fantasy theory'. Central to this is a 1964 essay, 'Fantasy and the Origins of Sexuality' by psychoanalytic theorists Jean Laplanche and Jean-Bertrand Pontalis. Fantasy, in Laplanche and Pontalis' account, has a number of characteristics which are suggestive for a reworking of psychoanalytic film theory. The most important is that the processes of identification in fantasy, rather than being fixed according to our gender, seem rather to be shifting, unconfined by boundaries of biological sex, cultural gender or sexual preference. If, then, fantasy can be seen to offer shifting and multiple positions for the fantasizing subject, then so, too, might the 'dream factory' of cinema. If fantasy is 'not the object of desire, but its setting', so that in it we do not occupy any fixed position but are instead 'caught up ... in the sequence of images' (1986: 26), then the processes of cinematic identification might work in much the same way. Chapter Five explores the uses – and the limitations – for feminist film theory of these theories, with their seductive suggestions of the possibility of escape from our sexed identities through the pleasures of film.

Chapters Six and Seven deal with two further challenges to the feminist
film theory developed in the 1970s and early 1980s, that arising from les-
bian theory, and that emerging from black and post-colonial feminist
theory. Both challenge the claims of white, heterosexual feminist film
theorists to speak *for women*. Both point out the marginalization and exclu-
sion of other voices which this claim entails. But both also engage with the
terms of that theory, exploring the extent to which theoretical frameworks
which have operated to exclude may be reworked to provide a more inclu-
sive account – and the extent to which they must be simply discarded. Thus
lesbian writers question whether what is needed is a theorising of a *specific*
lesbian desire and its relationship to representation, fantasy and cinema – a
set of processes radically *other* than those used to theorise the relationship
of heterosexual women to cinema and representation. Or whether it is
rather a more *general* rethinking of the issues of female desire, identification
and fantasy which is needed, one which would not relegate lesbian desire to
the realms of the immature or the merely imitative, but one which would
not constitute it as radically other. The first risks leaving the structures of
heterosexuality (and perhaps heterosexism) untouched. The second, how-
ever, risks denying the *difference* of lesbianism.

Black feminist writers have been deeply suspicious of the analytic frame-
works offered by white feminist film theory. Writing in 1992, for example,
bell hooks states:

> Feminist film theory rooted in an ahistorical psychoanalytic frame-
> work that privileges sexual difference actively suppresses recognition
> of race, reenacting and mirroring the erasure of black womanhood
> that occurs in films, silencing any discussion of racial difference – of
> racialized sexual difference. Despite feminist critical interventions
> aimed at deconstructing the category 'woman' which highlight the sig-
> nificance of race, many feminist film critics continue to structure their
> discourse as though it speaks about 'women' when in actuality it
> speaks only about white women. (hooks 1992: 123)

Chapter Seven, then, explores responses to the problem of this theoretical
invisibility. Such responses include the focus of some black feminist writers
upon *rendering visible*, by reclaiming a tradition of black women's theory
and cultural production which is seen as founded on a distinctive black –
often specifically black American – experience. They also, however, include
the work of post-colonial feminist theorists which places as central the ques-
tion of the fragmented, or hybrid, subject-identities which arise from the
experience of colonial and post-colonial power. Such theorists argue that in
these circumstances it becomes impossible to look to a concept of 'authen-
tic' experience on which to ground a politics of resistance, for one can never
be *outside* the discourse which maps that experience. Our very denuncia-
tions of oppression are spoken within the terms of that oppression. Thus
theorist and film-maker, Trinh T. Minh-ha, for example, argues that 'differ-

ence' must be understood not only as differences *between* outsider and insider – two entities. It must also include a 'critical difference from myself' (Minh-ha 1989b: 89).

Arguments about fragmentation and difference lead to the material of the final chapter, Chapter Eight, which discusses the problems for the whole enterprise of feminist film theory posed by feminist engagements with postmodernism. Such problems can include a fragmenting of the *object* of film theory. After all, I may now watch a film in the cinema or I may watch (or re-watch) it on video; I may watch it on large-screen TV. I may watch it in all three contexts in a concentrated fashion; alternatively, I may accord it only what Lawrence Grossberg calls 'TV's delegated look and distracted glance' (1987: 34). I may segment it, replay it, interrupt it with other segments from different media or overlay it with other media texts. In such shifting contexts, can it be maintained that the film *as text* remains the same? Problems can also include a loss of confidence in the project as a whole. If sexual difference is only *one* term of difference, and one which is not necessarily *fundamentally* constitutive of our identities, can it, in justice, be privileged? Or does privileging it become, in Christine Di Stefano's words (1990: 65–6), 'just another ... totalizing fiction which should be deconstructed and opposed'?

'Passionate detachments', then, seems an appropriate designation for this history or patterning of 'story lines' (Mulvey 1989b: vii). It captures the complex positioning of a body of theory which seeks to liberate through explanation and yet which is always *passionately* engaged. It captures the sense of connection in conflict which characterizes the relationship between different strands of feminist film and cultural theory. And it captures the passionate intent with which some strands seek to *disengage* from arguments they find totalizing or monolithic. It may, in some views, capture the present state of feminist film theory as a whole. I prefer, however, to see in the line of connection which can be drawn through the term a persistence of engagement in a 'politics of vision' which, given the centrality of what Rosi Braidotti calls the 'visual metaphor' to 'everything our culture has constructed in the ways of knowledge' (1994: 70), must be crucial to any feminist politics.

|1|

Forerunners and beginnings

> The first idea that is likely to occur in the course of any historical think-
> ing about feminism is that feminism is a *social* force. The emergence of
> feminist ideas and feminist politics depends on the understanding that,
> in all societies which divide the sexes into different cultural, economic
> or political spheres, women are less valued than men. Feminism also
> depends on the premise that women can consciously and collectively
> change their social place. (Humm 1992: 1)

> Once an oppressed group becomes aware of its cultural as well as
> political oppression, and identifies oppressive myths and stereotypes –
> and in the case of women, female images that simply express male fan-
> tasies – it becomes the concern of that group to expose the oppression
> of such images and replace their falsity, lies and escapist illusions with
> reality and the truth. (Gledhill 1978: 462)

Written in 1978, Christine Gledhill's critical examination of developments
in feminist film criticism spans its first ten years, the years which saw the
emergence, in America and Europe, of 'second wave' feminism. This term,
now a common description of the post-1968 women's movement,[1] is itself a
product of those years. It was coined by the feminist activists of the late
1960s and early 1970s to insist upon the continuities of feminist struggle.
When, a few years earlier, in 1963, Betty Friedan had published *The
Feminine Mystique*, she could describe feminism only in terms of the past,
as 'dead history' which, for women born after 1920, 'ended as a vital move-
ment in America with the winning of that final right: the vote' (Friedan
1965: 88). By 1970, however, radical feminist Shulamith Firestone was
insisting that the 'pioneer Western feminist movement' of the nineteenth
and early twentieth centuries must be seen as 'only the first onslaught' of
'the most important revolution in history' (Firestone 1979: 23), Kate Millett
could herald the emergence of 'a second wave of the sexual revolution'
(Millett 1977: 363), and Germaine Greer could begin *The Female Eunuch*

(Greer 1971: 11) by pronouncing it to be 'part of the second feminist wave'. A feminist history was being claimed, or re-claimed, and with it an identification of feminism as *theoretical* position with the women's movement as *political practice*.

Politics and theory are, then, interdependent. Moreover, feminist theorists from Mary Wollstonecraft (1759–97) onwards have identified as a primary source of women's oppression the cultural construction of femininity which renders women 'insignificant objects of desire' and opposes the category 'woman' to the category 'human' (Wollstonecraft in Todd 1989: 85-7). 'From its beginnings', writes Annette Kuhn, 'feminism has regarded ideas, language and images as crucial in shaping women's (and men's) lives' (Kuhn 1985: 2). The beginnings of 'second wave' feminism, therefore, were marked not only by new political groupings and campaigns, such as those organized around abortion legislation and the demand for equal pay, but also by the publication of ambitious theoretical works such as Kate Millett's *Sexual Politics* and Shulamith Firestone's *The Dialectic of Sex* (both 1970) which emphasized the political significance of culture. They were also marked by political actions organized around cultural representations, such as the 1968 demonstration against the Miss America contest and a similar demonstration in London in 1970[2] against the Miss World competition. Feminism has, then, taken as an object of both analysis and intervention the construction of images, meanings and representations. It has also been concerned with the struggle to find a voice through which such knowledge might be expressed. For the development of an autonomous female subject, capable of speaking in her own voice within a culture which has persistently reduced her to the status of object, is also part of feminism's project. As Rosalind Delmar writes:

> It has been part of the project of feminism in general to transform women from an object of knowledge into a subject capable of appropriating knowledge, to effect a passage from the state of subjection to subjecthood. (1986: 25)

The beginnings of feminist film theory, then, form part of what Laura Mulvey has called the 'wider explosive meeting between feminism and patriarchal culture' which characterized 'second wave' feminism (Mulvey 1979: 179). Mulvey identifies three main arguments in this analysis of women's place in culture. The first is the 'recurring hope that women have, in fact, produced more in mainstream culture than has ever been recognised'. Dale Spender's work in excavating 'lost' British women writers[3] can be cited as an example of this argument. The second, and in many ways running counter to the first, is the insistence on women's *absence* from cultural production, in inverse proportion to the exploitation of female *images* in the subject matter of art and popular culture. Finally, there was a revival of interest in 'minor arts and crafts', where women *have* produced cultural artefacts, in however marginalized and undervalued a way. As Christine Gledhill makes clear, it

is the second of these arguments, the exposure of the sexist content of cine-
matic narrative and the construction of 'female images that simply express
male fantasies' that characterized feminist writing on film of the early 1970s.
Since, however, such writing draws on, in both its strengths and weaknesses,
the more general theoretical accounts of patriarchal culture which appeared
at this time, it is to these texts and their antecedents that I will turn first.

Simone de Beauvoir, *The Second Sex* (1949)

It is de Beauvoir's account of the cultural construction of woman as '*Other*'
which laid the foundations (though sometimes unacknowledged) of the
theoretical work which appeared in the 1970s:

> One is not born, but rather becomes, a woman. No biological, psy-
> chological, or economic fate determines the figure that the human
> female presents in society; it is civilization as a whole that produces
> this creature, intermediate between male and eunuch, which is
> described as feminine. Only the intervention of someone else can
> establish an individual as an *Other*. (de Beauvoir 1988: 295)

Here is the inspiration for the title of Germaine Greer's *The Female Eunuch*
(1970). Here, too, can be found the analytical framework which grounds
works as politically disparate as Betty Friedan's *The Feminine Mystique*
(1963), whose liberal feminist argument claims that the 'drastic reshaping of
the cultural image of femininity' which, Friedan agrees, is necessary, can be
achieved through 'liberal education, as it is given at the best of colleges and
universities' (Friedan 1965: 318–20), and radical feminist Shulamith
Firestone's *The Dialectic of Sex* (1970), which insists that nothing short of a
feminist revolution will produce the necessary cultural changes.

De Beauvoir's arguments are underpinned by the existentialist philoso-
phy identified with Jean-Paul Sartre. For Sartre, human freedom is attained
in moving from the inert or fixed state of 'immanence' ('Being-in-Itself')
towards the ideal of 'transcendence' ('Being-for-Itself') through action, or
projects in the world.[4] Simone de Beauvoir reframes this distinction between
types of human existence in terms of gender. For man, woman represents
the 'immanence' that can confirm his 'transcendence', the Other that can
confirm his identity as Self. 'The category of the *Other*', writes de Beauvoir,
'is as primordial as consciousness itself' (1988: 16), since the Self can only
be defined in opposition to something which is not-self. Man, however, has
assigned to himself the category of Self, and constructed woman as Other:

> She is defined and differentiated with reference to man and not he with
> reference to her; she is the incidental, the inessential as opposed to the essen-
> tial. He is the Subject, he is the Absolute – she is the Other. (1988: 16)

For this reason, the cultural category 'woman' has no fixed content, for it represents a projection of male fantasies and fears. It is elaborated, then, in myths of unattainable and ideal beauty and self-sacrifice (the myth of the 'Eternal Feminine'). But this 'myth of woman set up as the infinite Other entails also its opposite':

> Because she is a false Infinite, an Ideal without truth, she stands exposed as finiteness and mediocrity and, on the same ground, as falsehood. (1988: 218)

Her 'mystery', having been entirely constructed by man, is 'revealed' as deception, her idealized beauty to be concealing 'a trap of inert matter':

> The womb, that warm, peaceful, and safe retreat, becomes a pulp of humours, a carnivorous plant, a dark, contractile gulf, where dwells a serpent that insatiably swallows up the strength of the male. (1988: 223)

De Beauvoir's description here powerfully foreshadows the landscapes and aliens of those much later science fiction films which were to become the subject of feminist theory and analysis.[5]

Culture – 'religions, traditions, language, tales, songs, movies' (1988: 290) – is the carrier of society's myths; through it our material existences are viewed, and lived. But, though '[r]epresentation of the world, like the world itself, is the work of men; they describe it from their own point of view, which they confuse with absolute truth' (1988: 175), women, too, see themselves through these representations. Indeed, if woman is not to contest her positioning as incidental, inessential Other, object rather than subject, it is vital for man that she *make herself* object, or Other:

> in order that all reciprocity may appear quite impossible, it is necessary for the Other to be for itself an other, for its very subjectivity to be affected by its otherness. (1988: 288)

A 'true woman' is required to accept herself as Other for man. What power she possesses is achieved through passivity and abjection: 'she takes delight in a masochism that promises supreme conquests' (1988: 319).

In her analysis of how woman *became* the Other, de Beauvoir considers the explanations of biologists, psychoanalysts (Freudian), and Marxists. Since psychoanalysis was to become so important in feminist theory, I shall briefly consider the second of these. Psychoanalysis, for de Beauvoir, fails adequately to explain 'why woman is the *Other*'. Its explanation involves a psychic determinism which reduces to a matter of unconscious drives what is in fact socially and culturally produced. Woman is not Other because, as Freud suggests, she lacks a penis. The power of the penis is a purely symbolic power: 'the phallus assumes such worth as it does because it symbolizes a dominance that is exercised in other domains', culturally and socially (1988: 80). In societies organized differently, alternative symbols of power

might be found. Psychoanalysis has mistaken a historically specific observation for a universal truth. In so doing, it has also denied the possibility of change. If woman's 'feminine destiny' is the product of her unconscious drives, then she is a prisoner of that destiny. If on the other hand, 'woman is defined as a human being in quest of values in a world of values, a world of which it is indispensable to know the economic and social structure' (1988: 83), then choice, however difficult, is possible. The way forward, for de Beauvoir, is for women to 'continue their ascent' to 'complete economic and social equality' (1988: 738). This achieved, 'inner transformation' will follow, and men and women will confront each other as equals.

If de Beauvoir's analytical framework was to ground later analyses, the problems in her position were also to haunt later feminist theory. The first of these problems is that her concept of woman as culturally constructed Other leaves no clear site for women's resistance to such a construction. At times de Beauvoir suggests the presence of such a resistance, unheard but not unarticulated, for example when she writes that '[t]o say that woman is a mystery is to say, not that she is silent, but that her language is not understood' (1988: 286). Usually, however, women are seen as complicit in their cultural oppression; they have 'no religion or poetry of their own: they still dream through the dreams of men' (1988: 174). But if culture does not constitute a site of women's resistance, neither, despite the fact that she sees cultural myths as persistently inscribed upon the female body, does the body itself. Woman's body is also seen as complicit in her subjection: 'she herself submits to it as to some rigmarole from outside; her body does not seem to her to be a clear expression of herself; within it she feels herself a stranger' (1988: 286). Equally, no appeal to women's experience is possible, since 'in human society nothing is natural and ... woman, like much else, is a product elaborated by civilization' (1988: 734). Indeed, de Beauvoir's model of 'transcendence', the ideal state of committed action, or 'Being-for-Itself', seems almost by definition male. Certainly, it is the masculine model which women are urged to adopt, their identity *as women* which they are urged to transcend: 'if she is given opportunity, woman is as rational, as efficient, as a man; it is in abstract thought, in planned action, that she rises most easily above her sex' (1988: 539).

A second problem lies in the differing status which de Beauvoir assigns to men's and women's cultural productions. In a move that was to be repeated by Kate Millett in *Sexual Politics* (1970), de Beauvoir turns to a detailed account of specific male authors to confirm her analysis of 'the feminine myth' as it has been constructed within cultural representation. Yet, despite her refusal to see women's experience as a site of resistance to male myths, when she considers women's writing, de Beauvoir denies it the distance from its object which she gives to male writing. Women have written 'sincere and engaging feminine autobiographies'; they 'take inventory without trying to discover meanings'; they 'make remarkable reporters' (1988: 719). Denied the liberty which could produce 'transcendence', however, they

cannot produce art, or philosophy. Women's writing becomes *evidence*, whilst that of men is *representation*. This problem, too, was to recur in feminist writing about film in the 1970s.

Finally, but connected to both of these, there is the problem of de Beauvoir's own speaking voice. Unlike Virginia Woolf, who in *A Room of One's Own* (1929) in effect *performed* the division in consciousness she experienced in attempting to speak *as a woman*, writing in a series of juxtaposed voices and identities, de Beauvoir's voice slips in and out of identification with women. She, too, offers *evidence* of women's oppression, but in claiming also 'transcendence', in her effort to 'reveal the whole of reality and not merely her personal self', she refuses to speak *as a woman* and instead occupies a position which, by her own definitions, is masculine: 'it is for those alone who are in command to justify the universe by changing it, by thinking about it, by revealing it; they alone can recognize themselves in it and endeavour to make their mark upon it' (1988: 722–3).

'Second wave' theorists

De Beauvoir's identification of the construction of female 'Otherness' as a key to the oppression of women was taken up with varying degrees of theoretical clarity by 'second wave' feminist theorists. Betty Friedan's (1963) account[6] of the need for a 'drastic reshaping of the cultural image of femininity that will permit women to reach maturity, identity, completeness of self, without conflict with sexual fulfilment' (Friedan 1965: 318), owes much to de Beauvoir's work. But in Friedan's account, de Beauvoir's ideal of 'transcendence' loses its philosophical complexity, and is instead identified with the highest point in the 'hierarchy of human needs' identified by psychologist A. H. Maslow.[7] That point is a matter, simply, of normal psychological health. The 'fundamental human drive' is not, as psychoanalysis claimed, 'the urge for pleasure or the satisfaction of biological needs', but, according to Maslow, 'the need to grow and to realize one's full potential' (Friedan 1965: 272). 'Self-actualization' is the goal of humanity. With this reformulation, the argument moves from the sphere of culture to that of nature. Cultural constructions such as the 'feminine mystique' may temporarily thwart such growth for women, but only in 'a strange breath-holding interval before the larva breaks out of the shell into maturity' (1965: 330). Moreover, the struggle for women's equality can be easily aligned with a mainstream political agenda, that of American liberalism. Since American society already espouses the goal of individual fulfilment, all that is needed for the release of women's potential is their admission into full participation in that society. The solution is a national programme of education for women which will lead to fulfilling 'work' – though not

necessarily, Friedan adds, to paid jobs. Since 'self-actualizing people', having realized their true identities, are 'so certain of their maleness or femaleness that they [do] not mind taking on some of the cultural aspects of the opposite sex role' (Maslow in Friedan 1965: 281), the ensuing changes will be liberating for both sexes. No great social upheaval will be necessary – not, at least, in America.

This determined optimism leads to some extraordinary theoretical contortions – at one point Friedan, having compared the housewife to the inmate of a concentration camp, concludes that in such camps 'not the S.S. but the prisoners themselves became their own worst enemy' (1965: 265). However, unlike de Beauvoir's, Friedan's account of oppressive 'ideas, language and images' (Kuhn 1985: 2) offers a detailed analysis of elements of contemporary *popular* culture, from which a far less sanguine picture emerges. What is distinctive, too, about her account is that she writes quite consciously *as a woman*[8] and therefore as caught in the contradictions which she describes.

Friedan's tracing of the post-war construction of 'the feminine mystique' in the shifting 'image of American woman' to be found in women's magazines, cinema stars and advertising images, suggests a more complex process at work than her conclusions allow. Against the background of the real sociological changes in American women's lives, she traces the shifts in the female image, arguing that the madonna/whore split which has always characterized men's representations of women has been redefined in contemporary culture as the split between 'the feminine woman, whose goodness includes the desires of the flesh, and the career woman, whose evil includes every desire of the separate self' (1965: 40). It is a shift which can be traced through the narrative structures and heroine figures of popular fiction for women, but which is also to be found in the non-fiction content of women's magazines. Here, a more complex relationship between representation and 'the real' is suggested, for here:

> [t]he line between mystique and reality dissolves; real women embody the split in the image. In the spectacular Christmas 1956 issue of *Life*, devoted in full to the 'new' American woman, we see, not as women's magazine villain, but as documentary fact, the typical 'career woman – that fatal error that feminism propagated' – seeking 'help' from a psychiatrist. She is bright, well-educated, ambitious, attractive; she makes about the same money as her husband; but she is pictured here as 'frustrated', so 'masculinized' by her career that her castrated, impotent, passive husband is indifferent to her sexually. (1965: 51-2)

This analysis startlingly prefigures Susan Faludi's account of the anti-feminist *Backlash* of the 1980s (Faludi 1991), but Friedan has no theoretical framework adequate to her description. In particular, she has no concept of *ideology* which might account for the power of the discourses and representations she describes, in the construction of women's material existences.

Such a concept is certainly *not* lacking in Kate Millett's *Sexual Politics* (1970), though it might be argued that her account of ideology sees it as so monolithic that its explanatory power is no more adequate to its material than is Friedan's liberal feminism.[9] Millett argues that patriarchy, which she defines as 'the institution whereby that half of the populace which is female is controlled by that half which is male', is a *political* institution, and sex a 'status category with political implications' (Millett 1977: 24–5). Moreover, patriarchy, she argues, is the *primary* form of human oppression, without whose elimination other forms of oppression, racial, political or economic, will continue to function. Patriarchal domination is maintained principally, though not exclusively, through *ideological* control:

> government is upheld by power supported either through consent or imposed through violence. Conditioning to an ideology amounts to the former. Sexual politics obtains consent through the 'socialization' of both sexes to basic patriarchal polities with regard to temperament, role, and status. (1977: 26)

Evident throughout history, and 'legitimized' by the 'science' of psycho-analysis, especially during the 'counterrevolution' (1930–60) which fol-lowed the 'first phase' of the feminist sexual revolution (1830–1930), patriarchal ideology has been all-pervasive:

> one is forced to conclude that sexual politics, while connected to eco-nomics and other tangibles of social organization, is, like racism, or certain aspects of caste, primarily an ideology, a way of life, with influ-ence over every other psychological and emotional facet of existence. It has created, therefore, a psychic structure, deeply embedded in our past, capable of intensification or attenuation, but one which, as yet, no people have succeeded in eliminating. (1977: 168)

We can trace its cultural expressions through from primitive myth to the development of religion and ethics and into the contemporary myths of sci-ence. The result of such socialization is that women internalize the ideology of femininity, accepting their inferior status, but, in instances of failure, patriarchy can also, like other 'total ideologies', call on force. Institutionalized force, from legal penalties for women's adultery to the lack of abortion rights, is paralleled by sexual violence, both in material form, as in rape, and as embodied in cultural forms, for example pornography and contemporary fiction.

As one form of evidence for the 'merciless, total, and seemingly irrefutable control' (1977: 233) which patriarchal ideology has exercised over its 'victims', Millett, following the example of de Beauvoir, cites the work of male novelists. Her reading of the work of D. H. Lawrence, Henry Miller and Norman Mailer refuses the position of respectful literary criti-cism. Instead, she interrogates their descriptions of sexual relations and practice for their *ideological* and *political* implications, and insists that their

writing be seen within its social and cultural context, in relation to ideolog-
ical positions found in other contemporary discourses and practices. In this
process, she inaugurates a mode of feminist analysis which was to produce
a distinctive body of feminist critical writing about literature, film, and pop-
ular culture. She also gives a distinctive, and distinctively *angry*, voice to
such criticism. Her rhetorical style, writes Dale Spender, is itself 'an act of
insurrection against male rule'.[10] Unlike de Beauvoir and Friedan, Millett
does not cite women's complicity as a factor in their continued oppression.
For her, patriarchal ideology is a matter of false representations politically
deployed against women, who are its victims. Women's apparent complic-
ity can be explained by their status as 'a dependency class' who 'like all per-
sons in their situation (slaves are a classic example here) ... identify their
own survival with the prosperity of those who feed them. The hope of seek-
ing liberating radical solutions of their own seems too remote for the major-
ity to dare contemplate and remains so until consciousness on the subject is
raised' (1977: 38).

Despite (or because of) its vast scope and apparent certainty, there are
clear problems with Millett's theoretical framework. Her concept of patri-
archal ideology as a conscious conspiracy operated by men against women
does not allow for internal contradictions or historical differences. Nor does
it offer an explanation of the kinds of unconscious complicities and internal
divisions which both de Beauvoir and Friedan identify as characteristic of
women's experience. Her assumption, too, that literature is a conscious ren-
dering of its author's ideological position, so that author, protagonist and
point of view can be unproblematically identified, makes it impossible for
her to admit to textual ambiguities and contradictions. Nor can it permit an
adequate discussion of texts authored by women. As a product of the 'first
phase' of the sexual revolution, and a book 'too subversive to be popular'
(1977: 140), Charlotte Brontë's *Villette* (1853) can be discussed, but only in
terms of the conflict between its 'revolutionary sensibility' and the 'bogs of
sentimentality which period feeling mandates [Charlotte Brontë] sink in'
(1977: 146–7) . Elsewhere, Millett endorses John Stuart Mill's judgment
that 'most of what women produced when they began to write was but
sycophancy to male attitude and ego' (1977: 139). Indeed, how could it be
otherwise, if patriarchal ideology is as all-embracing as Millett suggests, and
literature merely its 'reflection'.[11] Despite its own apparent rhetorical confi-
dence, therefore, the voices of women are curiously absent from this book.
Reduced to the status of victim, by a concept of ideoloy that admits of no
contradictions, and no spaces for resistance, women appear as silent, or as
speaking in a diluted version of the voice of the oppressor. Unlike in de
Beauvoir's work, they do not even offer *evidence* of their own plight.

The conclusion of *Sexual Politics* is at once Utopian and depressing.
Without a concept of ideology which includes its operation at the level of
the unconscious, Millett foresees no barriers to the complete overthrow of
patriarchal power. At the same time, however, she can cite few examples of

women's resistance in the past or present which might inspire such opti-
mism. It is not clear on what ground her own resistant voice is established.
At the level of cultural production, she offers no ground for resistance or
agency. Literature is a reflection of its author's ideological position. Popular
culture is assimilated, as it is in de Beauvoir's account, into a global and
transhistorical description of patriarchal myths and religions. In her account
of these developments, Millett borrows heavily from her predecessor. But
here again we have culture viewed as a product shaped by ideas produced
elsewhere, yet – in an unresolved (but partially acknowledged) contradic-
tion – as also *productive* of woman's 'Otherness':

> As both the primitive and civilized worlds are male worlds, the ideas
> which shaped culture in regard to the female were also of male design.
> The image of women as we know it is an image created by men and
> fashioned to suit their needs. These needs spring from a fear of the
> 'otherness' of woman. Yet this notion itself presupposes that patri-
> archy has already been established and the male has already set him-
> self as the human norm, the subject and referent to which the female is
> 'other' or alien. Whatever its origin ... (1977: 46–7)

Shulamith Firestone's *The Dialectic of Sex*, also published in 1970, is an
equally uncompromising view of patriarchal history. Women's oppression,
she writes, is not a 'superficial inequality' that can be solved by 'merely a
few reforms, or perhaps by the full integration of women into the labour
force' (Firestone 1979: 11). It is 'the oldest, most rigid class/caste system in
existence, ... a system consolidated over thousands of years, lending the
archetypal male and female roles an undeserved legitimacy and seeming per-
manence' (1979: 23). Pre-dating oppression based on race or economic
class, it is founded on 'the natural reproductive difference between the
sexes' which 'led to the first division of labour' and the construction of a
class/caste system based on biological differences (1979: 17). Women's lib-
eration, therefore, following the Marxist model which Firestone employs,
requires 'the revolt of the underclass (women) and the seizure of control of
reproduction: not only the full restoration to women of ownership of their
own bodies, but also their (temporary) seizure of control of human fertility
– the new population biology as well as all the social institutions of child-
bearing and child-rearing' (1979: 19). Firestone's Utopian vision of the
future envisages a world in which, women having been freed by technology
from 'the tyranny of reproduction' (1979: 221), cultural differences based
on sex will disappear.

Firestone's is a far more radical vision than that of her contemporary,
Kate Millett, but, interestingly, it is a vision which also includes a more
complex view of women's relation to cultural representation and produc-
tion. Drawing directly on de Beauvoir, she argues that '[t]he tool for repre-
senting, for objectifying one's experience in order to deal with it, culture, is
so saturated with male bias that women almost never have a chance to see

themselves culturally through their own eyes' (1979: 149). Her definition of culture, however, is one which includes popular culture, as both representation and lived experience, and, although she urges a complete cultural revolution, she also argues that both spaces for women's resistance and a separate sphere of women's culture have existed and continue to exist in the margins and interstices of dominant patriarchal culture. Women may have been 'denied the use of the cultural mirror' (1979: 157), but women's writing is no more limited than that of men. It merely describes a *different* reality to that of men, one not recognized, and therefore not seen as '"serious", relevant, and important' by the controllers and critics of the Cultural Establishment, men (1979: 151).

Women, then, have always found spaces for resistance, in lived experience as well as in their own cultural productions:

> Over the centuries strategies have been devised, tested, and passed on from mother to daughter in secret tête-à-têtes, passed round at 'kaffeeklatsches' ('I never understand what it is women spend so much time talking about!'), or, in recent times, via the telephone. These are not trivial gossip sessions at all (as women prefer men to believe), but desperate strategies for survival. (1979: 131)

This identification of what has later been termed 'feminine discourse'[12] as a source of women's resistance to patriarchy also allows Firestone to consider women's popular culture as a positive development. The creation of 'a female audience' has produced romantic fiction, soap opera, women's magazines and popular films aimed at women, all 'crude beginnings', but nevertheless referencing a 'female reality' (1979: 157–8). Not only is Firestone's concept of culture wider than that of de Beauvoir or Millett, but her vision of the future also anticipates later accounts of the 'postmodern' breakdown of cultural categories and hierarchies. This development she sees as liberating. Film, she writes, with its hybrid identity as both aesthetic and technological medium, offers to break down 'the very division between the artificial and the real, between culture and life itself', and hence to threaten the category of '"pure" high art'; and similar progressive potential, as yet unfulfilled, exists in 'the breakdown of traditional categories of media (mixed media), and of the distinctions between art and reality (happenings, environments)' (1979: 177–8). Perhaps because of her broader definition, Firestone can view the cultural as less thoroughly saturated with patriarchal ideology than does Millett (she rarely uses the term 'ideology', preferring 'myths', 'Image' or 'cultural processes'), attributing to women the possibility of agency, however circumscribed, in their activities as audiences, as producers of everyday discourses, and as cultural producers and critics.

All of these theorists, and other representatives of the feminist 'second wave' such as Germaine Greer (*The Female Eunuch* 1970) and Eva Figes (*Patriarchal Attitudes* 1970), have in common a view of culture as *political*,

as, in Annette Kuhn's words, producing 'images, meanings, representations' which 'define[] and confine[] women' (1985: 3). They also share an approach which combines an attempt to situate cultural representations in their wider social and economic context with a broad historical and cultural sweep which emphasizes, sometimes at the expense of a flattening out of historical and cultural differences, the all-pervasiveness of patriarchal structures. And they wrestle with the same issues. What relation, for instance, do representations of women ('images of women') have to women's lived experience? Why are *women* identified so consistently with a limited range of defining images? Is femininity constructed in specific ways through such representations? What do these representations have to do with sexuality? With power? With knowledge?[13] What is the relationship between specific images and their social context? What historical changes can be observed and what continuities perceived? What way out of such defining and confining representations might be envisaged, and how might it be brought about? Finally, and implicit in all these questions, are two key issues. What is the relationship of feminist theory to feminist practice, both political (in the form of activist politics) and cultural? And what is the relationship of feminism to *women*? In what sense does the feminist theorist speak *for* women, or *as a woman,* if she also speaks, critically, *about* women?[14]

'Second wave' feminism and film

Chronicling the emergence of the feminist 're-vision' of film studies in the 1970s, Mary Ann Doane, Patricia Mellencamp and Linda Williams write that

> several broad outlines emerge: the initial feminist documentaries and women's film festivals which were an integral part of the activism and consciousness-raising of the woman's movement; beginning scholarship on the 'image of woman' in male-authored cinema (paralleled in literary and art history studies by similar 'image of woman' investigations of stereotyping); the discovery of a previously lost history of women filmmakers, writers, editors, animators and documentarians; the introduction of new critical theories and methodologies of semiology and psychoanalysis by British feminists; and finally, the rise of feminist film criticism as an academic field that has already begun to produce a generation of film scholars. (Doane, Mellencamp and Williams 1984: 4)

The year 1971 saw the release of the first generation of feminist documentaries, which included Kate Millett's *Three Lives.* The following year saw the launch of the first journal of feminist film criticism, *Women and Film,* and the organization of the first two women's film festivals, in New York

and Edinburgh. As Laura Mulvey writes, '[t]hese events were a response in film terms to the early attention paid by the Women's Movement to the politics of representation' (Mulvey 1979: 180). I shall discuss 'the introduction of new critical theories and methodologies' in the next chapter of this book. Here, I want to examine two examples of what Doane, Mellencamp and Williams call '"images of women" investigations', Marjorie Rosen's *Popcorn Venus* (1973) and Molly Haskell's *From Reverence to Rape* (1974).

'[T]he Cinema Woman is a Popcorn Venus, a delectable but insubstantial hybrid of cultural distortions', writes Rosen (1973: 10). Her history of 'the flickering image of the ideal woman'[15] in American cinema draws explicitly on de Beauvoir's account of the 'myth of the eternal feminine', and Friedan's *The Feminine Mystique*. In its sweep through the history of twentieth-century America, its concern to set a cultural history within the context of changing material and social conditions, and its political stance, it also echoes Millett's *Sexual Politics*. Beginning in 1900, Rosen explores the changing image of woman in the Hollywood films of each decade, against the background of the profound changes in women's social role and economic conditions which were taking place. It is through the myths constructed within 'religions, traditions, language, tales, songs, movies', wrote de Beauvoir, that patriarchal society imposes its authority on women (1988: 290). From the emergence from 'Victorianism' of the 1900s to the 'permissiveness' of the 1960s, Hollywood cinema is seen by Rosen as an industry consciously devoted to the construction of such myths, moulding its female stars and constructing its cinematic narratives in a response to the changing social and economic position of real women, a response which had always as its primary concern the maintenance of male dominance. Describing cinema's emergence as a major industry at the end of the First World War, she sets the scene for the dramatic struggle to come:

> Power to films – new and sure and vital.
> Power to women – floundering but slowly awakening.
> ... How would this new medium, in the hands of fearful, exploitative and money-hungry men, manipulate the image of emerging womankind? Could it preserve, against the tide of feminine opinion, man's cherished eternal girl-child? (1974: 33)

In answer, the post-war surge in the activities of the Women's Movement is seen to produce a shift in film representations of women, rendering them both more sexual and more independent. Always, however, 'the industry held a warped mirror up to life' (1974: 81), reflecting male fears of women's changing position in its representation of women as 'sex objects' and its construction of the 'vamp', 'mother of the *femmes fatales*, the Mysterious Women, the Impenetrable Bitches of later screen generations' (1974: 61). The pattern was to be constantly repeated. In the 1920s, Hollywood's 'glossy ladies, living in the celluloid shadows of a changing society, were at

once enhanced by male fantasy and repressed by male prejudices' (1974: 97). Films of the 1930s provided a 'belated distortion of the truth of woman's social role', 'in extravagant misrepresentations' which disguised the real 'backlash against female accomplishments' (1974: 140–1). In the 1940s:

> The genre of the female victim occurred simultaneously with that of the Evil Woman. It may be no coincidence that the plethora of these films coincided with female acquisition of economic and social power in life. In fact, such movies may even have been in part a consequence, signifying that women were finally a threat to the status quo. (1974: 238)

For the 1950s, when '[s]ocial and economic pressures sent [women] scurrying back to the homes', Hollywood produced both 'Everywife' and the 'obsessive mammary madness' of figures such as Marilyn Monroe, a 'Fantasy Woman' who was 'an exploitative and grotesque parody of woman's body as isolated from her mind, emotions, soul, and all other functions that would make her truly human and desirable' (1974: 281–5). Finally, faced with the social changes of the 1960s and 1970s, Hollywood responded with 'sermon[s] against woman's self-determination' such as *Joanna* (1968), the equation of female sexuality with psychopathy, as in Polanski's *Repulsion* (1965) and Eastwood's *Play Misty for Me* (1972), and the cinematic 'auto-eroticism' of *Butch Cassidy and the Sundance Kid* (1970) or *Easy Rider* (1969) (1974: 339, 358, 362).

Popcorn Venus offers no explicit theoretical framework but makes a number of theoretical assumptions. One is that representations *reflect* a social and economic world whose events are the *real* site of conflict and change. Representations are also, however, a source of social control. An industry devoted to producing images in the service of a patriarchal society will produce *misrepresentations*, distorted images which embody both male fantasies ('celluloid aphrodisiacs – talking, walking, and comforting a patriarchal society') and male fears. Movies, then, form part of 'the politics of fantasy', their images and narratives an 'opiate for the masses' which has constantly 'attempted to squash feminine self-determination whose seeds [are] rooted in the reality of events' (1974: 154, 104). The assumptions echo Millett's concept of ideology as conscious conspiracy and Rosen sees the film, as Millett sees the novel, as a reflection of its author's (here the film director's) ideological position.

Films, then, reflect social reality, but these mirror images, warped by patriarchal ideology, vary in their relationship to that reality. They may be more or less accurate: now driven to greater accuracy by the pressures of an emerging feminism; now acting as a delayed reflection of an era just past; now offering fantasy compensations for male fears of a loss of sexual and economic control, or grotesque distortions of the threatening independent woman. Filmic representations can also, however, exert a powerful influ-

ence on the lives of real women. Sometimes this influence is conceptualized as operating according to a crude 'effects' model. A 1933 study of '252 delinquent teen-age girls, all of whom admitted they had played truant from school to attend movies', 'reveals' that films 'harmed women in unexpected ways', teaching girls, through their fantasies of 'glamorous or seductive situations', to 'barter their sex for money' (1974: 105–6). More often, however, it is seen as ideological: 'As long as movies exist, so does the danger that we will surrender ourselves unquestionably to their instant makeovers and portable ideals' (1974: 387).

In this process the central figure is the female star. It was not the 'moral outcome of the movie' which so impressed those delinquent girls; it was the 'alluring heroine, the vivacity with which she approached life, and the lavish clothes, furs and jewels she wore'. We too 'anoint the actresses embodying our fantasies as deities, our Popcorn Venuses' (1974: 106, 388). The star herself is seen to live out these contradictions. Identified with her roles, she is both a figure of male fantasy and a real woman forced to live out these fantasies and the contradictions they produce within her life, often in her relationships with the male directors of whose fantasies she is the literal embodiment. Here is Rosen's description of the Garbo of the forties, an account which echoes Friedan's descriptions of the workings of the 'feminine mystique'. Garbo's 'elasticity', she writes,

> explicitly reflects the historical crux of the woman's role just as it explains our attraction to Mysterious Females. After all, how cleverly the trappings of mystery and illusion cloak a vacuum, the embryo of a personality that has never developed – or been allowed to. And how expiating of man to elevate mystery if he is the force which has prevented (in fact, even abhorred) the embryo's development. (1974: 173)

In the end, then, films, 'unconsciously or consciously' both 'define and reflect us' (1974: 388), but Rosen has no theoretical framework which might account for this double operation. She can only call for the construction of more 'truthful' representations of women, their choices and dilemmas.

Popcorn Venus draws implicitly on a model of ideology and social change which, like Kate Millett's, is based on a loosely Marxist conception in which ideology reflects and misrepresents the real social and economic conditions of people's lives. Hollywood cinema can offer only an ideological reflection of the greedy patriarchal industry of which it is the product; the few women directors who have worked in Hollywood have been 'token' women, imprisoned by its structure. In Europe, where the industry has been less rigidly controlled, a few women have been able to make feminist films. Rosen's implicit framework leaves her unable to conceive of complexities *within* popular culture, or to examine the film as a text which might be more than the reflection of its director's fears and fantasies as embodied in the figures of its stars and the narratives which reward or punish them. Her survey

methodology identifies star with role and film with narrative content. Nevertheless, her insistence on placing film within the social context of its production and reception produces an account of the relationship between text and context which can often be suggestive of a complexity which remains untheorised. Her conception of the star, who is at once an image, produced through representation, and a woman who lives out, subverts or contests that image, is one instance. Her detailed accounts of the relationship between social change and cultural representation can produce others. This relationship is found to be complex and shifting; women are social agents who, in their role as audience, may 'surrender' to cinema's patriarchal images and values, but may also resist or even – 'however tentatively – set the vogue in popular culture, silently commanding the media to reflect their interests and life-styles' (1974: 283). Implicitly, and uncomfortably, since it is still seen as 'reflecting' social changes produced elsewhere, cinematic representation becomes here the site of struggle.

Rosen's *Popcorn Venus* and Molly Haskell's *From Reverence to Rape*, written one year later, are often discussed together. Both trace a chronology of cinematic roles for women and relate this to contemporary changes in women's social role and position, and both have been seen as employing a 'sociological or quasi-sociological' methodology (see Macdonald 1995: 15; Kuhn 1982: 75). As Annette Kuhn argues, they also share a frame of reference 'defined by a ... usually implicit assumption concerning the relationship between cinematic representation and the "real world": that a film, in recording or reflecting the world in a direct or mediated fashion, is in some sense a vehicle for transmitting meanings which originate outside of itself'. Despite their similarities, however, Haskell's is a far more complex – if uneven and often contradictory – view of cinema and its relationship to its context and audience, and her relation to the 'sexual revolution' of 'second wave' feminism is more ambivalent.

Haskell begins *From Reverence to Rape* with a quotation from Virginia Woolf's *A Room of One's Own* ('Women have served all these centuries as looking glasses possessing the magic and delicious power of reflecting the figure of man at twice its natural size') and in terms which echo de Beauvoir. 'The big lie perpetrated on Western society is the idea of women's inferiority', she writes, a lie which has been perpetrated in 'bad faith'[16] and 'sanctioned by law and custom'. The 'movie business', as the 'propaganda arm of the American Dream machine', is 'an industry dedicated for the most part to reinforcing the lie' (Haskell 1987: 1–2). Nevertheless, she insists, films cannot be reduced to their conscious content and overt ideological stance. Like dreams, they contain also 'unconscious elements, often elaborately disguised, [which come] to trouble our sleep and stick pins in our technicolored balloons' (1987: 2). Their female images may be 'the projection of male values', 'the vehicle of male fantasies' and 'the scapegoat of men's fears' (1987: 39), as Rosen also argues, but for Haskell this is no conscious conspiracy. Such images are instead the product of an 'unconscious drive working to

keep women in their place, a taboo that has arisen out of a fear, or awe, of woman's greater survival and sexual powers' (1987: 14–5). As such, they are also subject to unacknowledged contradictions and repressions. This suggestive but only partially theorised psychoanalytic approach is accompanied by a view of the film's meaning as the product not only of the conscious and unconscious obsessions of its director (the *auteur*) but also of other competing and subversive voices. These 'obtrusions of a woman's point of view' (1987: 34) come largely from the film's female stars, women who may be required to live out the fantasies of their male directors but who may equally act as counter-*auteurs* of their films.

To some extent, then, Haskell's book follows the same pattern as Rosen's. It charts the shifts in women's film roles through the decades of the twentieth century as they 'reflected, perpetuated, and in some respects offered innovations on the roles of women in society' (1987: 12). During this period woman has been 'Idealized as the "feminine principle incarnate"', 'worshipped as "mother"', 'venerated as "earth goddess"', both 'celebrated and feared as separate-but-equal', and finally, in the backlash against feminism, excised altogether in the 1960s' 'buddy-film' or rendered subject to the violence of such 'apocalyptic allegories of male virility' as Peckinpah's *Straw Dogs* (1972). The trajectory is straightforward, if depressing:

> The closer women come to claiming their rights and achieving independence in real life, the more loudly and stridently films tell us it's a man's world (1987: 363).

Nevertheless, in what she sees as the conflict between a view of film as 'sociological artifact' and its treatment as 'artistic creation', Haskell places herself firmly in the latter camp and is critical of what she regards as the 'totalitarian stridency' of a feminist criticism which would see 'all film history [as] grist in the mills of outraged feminism' (1987: 38–9; 30). If we compare Haskell's reading of the 1937 King Vidor film, *Stella Dallas*, with Rosen's description of the same film, we can see the difference in their positions. Rosen's account concentrates on the film's narrative content and central character. The film, she writes, is a 'ludicrous allegor[y] of sacrifice, tears and female humiliation', the product of the antifeminism of the Depression years. Its central character is a 'grotesque hyperbole of mother love, [who] has sabotaged her own identity, stifled her fears and dreams, and assuaged her emptiness through a comically vigorous motherhood, which would in the end leave her alone' (1974: 184). Haskell's reading, however, opens up a distance between the film's ideological project and its meaning, a distance embodied in the contradictions offered by its star, Barbara Stanwyck. The *excess* of Stanwyck's performance brings a double, and contradictory, identity to the central character, who becomes Stella/Stanwyck. In resistance to the film's self-sacrificial plot,

Stanwyck brings us to admire something that is both herself and the
character; she gives us a Stella that exceeds in stupidity and beauty and
daring the temperate limitations of her literary model and all the gen-
eralizations about the second sex. (1987: 6)[17]

Haskell's admission of the concept of an unconscious (however imper-
fectly theorised) in her understanding of the operation of film also compli-
cates her readings of both films and audience responses to them. In this she
anticipates later arguments by feminist theorists[18] about the ambivalent, and
uncomfortable, role of fantasy in the construction of cinematic meaning and
pleasure. In seeing film simply as male fantasy, she writes, the feminist critic
ignores the fact that women's own 'rearguard fantasies of rape, sadism, sub-
mission, liberation and anonymous sex are as important a key to our eman-
cipation, our self-understanding, as our more advanced and admirable
efforts at self-definition' (1987: 32). In the 1987 edition of the book, she
goes further, arguing that, in 'leaning so heavily on the unilateral notion of
male oppression' and 'insisting on the thesis of victimization', feminists have
deprived women of 'a secret pleasure in the dark side of sex, those delicious
(and politically "incorrect") fantasies of domination and submission which
it was the function of sexual liberation to allow us to express' (1987:
381–2).

It is in her chapter on 'The Woman's Film' of the 1930s and 1940s that
the complexity of Haskell's view of popular film is most fully realized. Here
she departs from the chronological approach she employs in the major part
of the book, in favour of a categorization of the genre in terms of its domi-
nant themes. These are 'sacrifice' (often maternal), 'affliction' (the heroine is
struck down by illness), 'choice' (between suitors), and 'competition' (with
another woman for a man) (1987: 163–4). Pervading all categories, indeed
virtually synonymous with the woman's film, is the theme of sacrifice.
Haskell's reading of the genre is a complex one. On the one hand, these
films are ideologically complicit and politically conservative:

> At the lowest level, as soap opera, the 'woman's film' fills a masturba-
> tory need, it is soft-core emotional porn for the frustrated housewife.
> The weepies are founded on a mock-Aristotelian and politically con-
> servative aesthetic whereby women spectators are moved, not by pity
> and fear but by self-pity and tears, to accept, rather than reject, their
> lot. (1987: 154–5)

On the other hand, in this critically despised genre ('the final image is of
wet, wasted afternoons'), 'the woman – *a* woman – is at the centre of the
universe'. She may die at its close, but she dominates its narrative. And if she
'hogs this universe unrelentingly, it is perhaps her compensation for all the
male-dominated universes from which she has been excluded: the gangster
film, the Western, the war film, the *policier*, the rodeo film, the adventure
film'. The woman's film is, moreover, no more maudlin and self-pitying

than these filmic celebrations of masculinity, and it speaks of, and to, 'an unholy amount of real misery' in the lives of its female audience (1987: 155–6). Indeed, its tailoring *for* a female audience means that it must express not only women's 'avowed obligations' but also their 'unconscious resistance', the repressed anger and guilt which is the corollary of the insistence that women find fulfilment in 'institutions – marriage, motherhood – that by translating the word "woman" into "wife" and "mother", end her independent identity' (1987: 159–60).

If the woman's film is both complicit with and resistant to ideologies of femininity, so too is the female star. Drawing on de Beauvoir,[19] Haskell argues that 'the actress merely extends the role-playing dimension of woman, emphasizing what she already is'. But if one reason for this role-playing is woman's 'need to have her value confirmed by affection and attention' (1987: 243), Haskell adds another: the opening up of a critical distance between actress and role. The self-parody of Marilyn Monroe, for example, can 'form a subtle, skin-fitting camouflage by which not the slave but the master ... is slyly ridiculed' (1987: 105). It is a 'strategy that is played out on a tightrope', since too much ironic distance will result in a charge of 'masculinisation' and the actress will be 'dismissed as a woman', and too little means submission. But it is a strategy which, through its parody of sexual roles, can provide a space for resistance to male-imposed definitions of femininity.

Haskell, then, rejects the kind of feminist analysis which sees film merely as a 'rich field for the mining of female stereotypes' (1987: 30), arguing that it must be examined in all its complexities *as* film, and for all our complexities of response. Though many of her points – the need to look at film's unconscious and excessive elements, the ambivalent nature of fantasy, the identification of the female star with a masquerade of femininity, the presence in film of competing voices – would be taken up by later feminist theorists, however, her lack of an adequate theoretical framework means that she herself can interpret her own arguments for complexity only as *non-feminist* writing. She writes, she feels, as a divided subject, split between the 'film critic', the 'feminist' and the 'romantic', and she is 'a film critic first and a feminist second' (1987: 38). She also occupies an ambivalent position in relation to 'second wave' feminism. She sees around her no evidence of a feminist revolution, only of an 'earthquake, an upheaval whose end is nowhere in sight' (1987: xvii). The 1970s are seen as a 'painful transitional period' in which men 'haven't yet adjusted to a new definition of masculinity' (1987: 24), but her way forward often seems a nostalgic look back. In the past, she writes, echoing Betty Friedan's view that fulfilled people are certain of their gender roles, 'sexual confidence enabled stars to reverse roles, exchange sexes, and come back to center, a center that was easily found, being the repository of sexual norms that no longer have authority' (1987: 268). In the present the 'real risks' still lie in the challenge of heterosexual love, 'a love that relishes separateness, grows stronger with resis-

tance, and, in the maturity of admitting dependence, acknowledges its own mortality' (1987: 25). Although her final pages include an exhortation to woman to 'reinvent herself' and 'go beyond herself to the world at large, to an interest in its history which she at last will have a hand in shaping' (1987: 368), the book ends with a lament for the lost 'camaraderie' and 'mutual support among women' of the past: for 'where, in the movies and out, are their modern equivalents?' (1987: 371)

Conclusion: the 'search for a theory'[20]

[P]olitics and knowledge are interdependent. In the ordinary way, the link between them will often go unnoticed or be taken for granted: where feminism is concerned, however, this is impossible, precisely because knowledge has had to be self-consciously produced alongside political activity. (Annette Kuhn 1985: 1–2)

As Molly Haskell points out, however (1987: 30), whilst feminists have grounds for anger at cinema's reduction of the image of woman to a limited range of female stereotypes, the mining of film history for such stereotypes does not produce the kind of knowledge that can explain either how film works *as film* to produce these representations, or how real women, whether audiences or film critics, read them. Typically, Haskell suggests, but does not elaborate, one of the crucial sources of cinema's power in the construction of these images. The film image, she writes, unites fantasy with 'documentary authenticity' (1987: 12), possessing a visceral immediacy which gives it an illusion of reality quite unlike the metaphorical character of the literary 'image'. This ability of film to *naturalize* what are in fact the constructions of patriarchal ideology or male fantasy, through the figure of the female star who literally embodies them, is one of which Haskell is acutely aware but which she cannot adequately explain. The theoretical assumptions on which she draws, based on 'second wave' American feminism's equation of representation with reflection, simply cannot account for them. Nor can they account for either complexities within the popular film text or the position of the *woman* film-maker, situated as she must be both within and, to some extent, alienated from the dominant patriarchal culture.

If, as Simone de Beauvoir suggests, the very concept 'woman' is a patriarchal construction, without substance and ungrounded in the realities of women's lives; if that concept has as one of its fundamental characteristics that of *image,* the ideal object which exists passively *to be looked at* and thereby possessed; then feminist theory must produce knowledge which is more than simply a history of such images. It must investigate the processes through which images or representations are constructed, and the ways in

which they relate to both the conscious and unconscious construction of our identities as men and women. Feminist film theory must, as Doane, Mellencamp and Williams argue (1984: 6), turn from the analysis of '"images of" to the axis of vision itself – to the modes of organizing vision and hearing which result in the production of that "image"'. Such a move will necessitate the appropriation and transformation of theories and methodologies being developed elsewhere. It will also have implications for a feminist film *practice*, which will need to do more than simply offer positive images of women, and instead find ways of *reorganizing* vision and hearing if it is to do more than simply reproduce the conventions of a patriarchally organized industry. Such an approach was developed in Britain in the early 1970s.

|2|

Structures of fascination: ideology, representation and the unconscious

Reviewing Rosen's *Popcorn Venus* and Haskell's *From Reverence to Rape* in 1975,[1] Claire Johnston is dismissive of both. They reflect, she writes,

> a particular stage in the feminist intervention in film criticism which has by now been superseded . . . It is therefore particularly important that, whatever their journalistic merits, they should not be inscribed into curricula dealing with women's studies. Feminist film criticism has developed considerably from this simplistic ideological history of the cinema. (Johnston 1975: 122)

She adds that in Britain, feminist film criticism 'has taken a very different direction: here emphasis has been placed on the primacy of the film text itself, relating very directly to current developments in film theory as such' (1975: 122). The assertion reads oddly: British feminist film criticism is both contemporary with and has superseded the American approach. Whilst Johnston's claim is clearly polemical, however, it is not without justification. Her edited collection, *Notes on Women's Cinema* (1973) was published in the same year as *Popcorn Venus*, and by 1976 the first issue of a 'journal of feminism and film theory', *Camera Obscura,* was launched in the USA. Acknowledging its debt to the work done in Britain by Johnston, Pam Cook and Laura Mulvey, the *Camera Obscura* editorial collective stated that its perspective was based on the recognition that 'film is a specific cultural product', and gave as its aim that of examining 'the way in which bourgeois and patriarchal ideology is inscribed in film. This involves a process of investigation and theoretical reflection on the mechanisms by which meaning is produced in film' (1976: 3). It is a very different introduction from that which in 1972 had launched *Women and Film*,[2] the journal out of which *Camera Obscura* had grown. There, the editors had seen themselves as 'taking up the struggle with women's image in film and women's roles in the film industry', freeing women from 'stereotypes and false values' in order to 'take charge over our minds, bodies, and image' (1972: 5). This

move from a view of patriarchal ideology as 'false values' and 'images' which can be overthrown, to one which sees it as, in Johnston's words, 'an effect of the form of the film text itself' (1975: 122) signals, as she indicates, an engagement with contemporary developments in film and cultural theory, particularly as it had been developing since the late 1960s in France. Three elements of this theory might be distinguished here. The first two, a structuralist and semiotic approach to textual analysis, and a view of ideology as produced in and through the operations of the film text, lead to a focus on the film as *text*, rather than on its relationship to contemporary social developments or its production of images or stereotypes of women. The third, a model of the process through which meaning is produced which involves the active participation of the spectator, leads to a focus on the *spectator–screen relationship*, and draws on contemporary developments within psychoanalytic theory. Whilst in practice these approaches are often interdependent, they were nevertheless given different degrees of emphasis within the work of British feminist film theorists of the 1970s, and for the purposes of this analysis I shall separate them here.

Semiotics

As Molly Haskell recognized (1987: 12), it was film's apparent ability to reproduce reality which led to film criticism's equation of its representations with more or less truthful *reflections* of a world, or meanings, originating elsewhere. Cinema was perceived, then, in Stephen Heath's words, 'as *natural*, ... unfolding, as it were, outside any concrete process of the production of meaning' (1973: 103–4). Though it communicates meanings, film appears, unlike written or spoken language, to be 'uncoded'. In the 1960s, however, semiotics, the application of Saussurian structural linguistics to a more general study of how signs operate in society, had begun to investigate the codes, or textual systems, through which film could, in fact, be seen to be constructed. Writing in 1971, Christian Metz (1976: 583) concluded that film, unlike written or spoken language, lacks an underlying language-system or structure from which meanings are generated. Moreover, the signs of which film is composed have a relationship to reality of analogy, or resemblance, unlike the arbitrary relationship which characterizes the linguistic sign (there is no necessary relationship between 'c-a-t' and the animal which this word designates). Nevertheless, like the written text, film is composed of textual segments (linked series of shots which form units of meaning), and it is structured by codes. Some of these codes Metz designates as socio-cultural: codes of dress or facial expression, for example, will extend beyond the film into the wider socio-cultural context which has produced it. Others, like the use of long shot or close-up, or of different editing tech-

niques, are specific to cinema. It is out of the combination of these codes, or textual systems, that meaning is produced, both within the individual segment and in the film as a whole. For this reason, Stephen Heath writes in 1973 that the 'point of development for a cinesemiotics today ... now seems to be established as the examination of the *multiplicity* of *codes* at work in the cinetext both in their diversity and in their combination' (1973: 107–8). Heath's analysis of Orson Welles' *Touch of Evil* in 1975 (Heath 1975a; 1975b), and Raymond Bellour's analysis of a number of Hitchcock's films (Bellour 1972; 1977; 1979) are examples of such examinations.

Ideology

If the film is properly to be seen as a highly coded set of signifying systems, how are we to view the impression of realism, of a mirroring of reality, which it produces? The answer, argues Stephen Heath, lies in its 'relation to the representation of "reality" a particular society proposes and assumes' (1973: 110). Heath is drawing here on the redefinition of the concept of ideology produced by Louis Althusser in the 1960s. Ideology, argues Althusser, comprises that 'complex formation of *montages* of notions–representations–images on the one hand, and of *montages* of modes of behaviour and conduct–attitudes–gestures on the other. The whole functions as practical norms which govern the attitude and the concrete stance of men with regard to the real objects and real problems of their social and individual existence, and of their history' (quoted in Heath 1973: 110). It is film's conformity to the ways in which we understand reality, rather than to reality itself, which constitutes its 'realism', and those ways of understanding are the product of ideology. To this we must add the fact that film's operation as an analogical rather than an arbitrary textual system, in its use of the moving photographic image, makes it a particularly effective carrier of ideology. Ideology seeks always to efface the signs of its own operation and present its meanings as 'natural' or self-evident. Film effectively 'naturalises' ideology through the operation of its 'signs which do not look like signs' (Barthes 1977: 116).

Roland Barthes' application of the principles of semiotic analysis to popular cultural texts and practices, in order to uncover their ideological operations (Barthes 1973), provides one model of the kind of politically motivated semiotic analysis which Heath advocates. Such texts and practices, argues Barthes, function as cultural signs, and hence as carriers of ideology or, in Barthes' terminology, 'myth'. Myth invades the sign, giving it meaning in excess of what it, at a primary level, denotes. Barthes' most famous example is that of a photograph of a black soldier saluting the French flag, which appeared on a 1955 cover of the magazine, *Paris Match*.

The meaning of this photograph is quite specific, yet it also carries added signification, 'that France is a great Empire, that all her sons, without any colour discrimination, faithfully serve under her flag, and that there is no better answer to the detractors of an alleged colonialism than the zeal shown by this Negro in serving his so-called oppressors' (1973: 116). The very specificity of the photograph serves to render invisible its ideological content.

A model of ideological analysis as applied to cinema was provided by the editors of the French film journal, *Cahiers du Cinema*, in the work they produced after 1968.[3] In an editorial of October 1969, Jean-Louis Comolli and Jean Narboni, following Althusser, argue that film, 'as a result of being a material product of the system, ... is also an ideological product of the system'. Thus, '*every film is political,* inasmuch as it is determined by the ideology which produces it' (1976: 24), so that when cinema appears to be reproducing reality, what 'the camera in fact registers is the vague, unformulated, untheorized, unthought-out world of the dominant ideology'. Comolli and Narboni go on to offer a typology of films in terms of their precise relationship to this ideology, arguing that to be truly radical, it is not enough for a film to offer radical content; it must also act self-consciously to disrupt the spectator's illusion of watching a depiction of reality. They divide films into seven categories. 'The first and largest category', they write, 'comprises those films which are imbued through and through with the dominant ideology in pure and unadulterated form, and give no indication that their makers were even aware of the fact' (1976: 25). Other categories are constructed along the twin axes of content/form; radical/non-radical, and take in both commercial and avant-garde, fiction and documentary films. The category which was taken up most widely within textual criticism was Comolli and Narboni's fifth category:

> Five: films which seem at first sight to belong firmly within the ideology and to be completely under its sway, but which turn out to be so only in an ambiguous manner. ... The films we are talking about throw up obstacles in the way of the ideology, causing it to swerve and get off course. The cinematic framework lets us see it, but also shows it up and denounces it. ... An internal criticism is taking place which cracks the film apart at the seams. If one reads the film obliquely, looking for symptoms; if one looks beyond its apparent formal coherence, one can see that it is riddled with cracks: it is splitting under an internal tension which is simply not there in an ideologically innocuous film. (1976: 27)

These films, then, 'criticize themselves' through the gaps and disjunctures which can be observed between their ideological project and the specific textual operations of the film. It becomes the critic's task to point to these gaps and dislocations, reading the film for its 'symptoms', its 'constituent lacks' and 'structuring absences', for what it has to exclude and repress in order to

maintain its surface of ideological coherence. The *Cahiers* editors' 1970 reading of John Ford's *Young Mr. Lincoln* (1939) provides an example of this methodology. Breaking the film down into segments, they analyse each one in terms of what it must repress, displace or exclude in order to pursue the film's project of elevating the figure of Abraham Lincoln to the status of myth, outside history, outside politics and beyond the erotic. The first scene of the film, for example, in which the young Lincoln makes his first electoral speech, represses not only Lincoln's personal origins but also any specific political content. Lincoln's politics are therefore presented as somehow *above* politics, and identified instead with morality itself. Textual analysis thus becomes a 're-writing' of the text, one which exposes its 'double repression – politics and eroticism' (1976: 497).

It can be seen from this account that the analytic technique proposed by the *Cahiers* editors, in its emphasis on 'symptoms', 'repressions', 'displacements' and 'structuring absences', draws on the terminology and methods of psychoanalysis as well as on semiotic and ideological analysis. What is suggested here, as Annette Kuhn argues, is that 'ideological operations in films are seen ... as in some sense unconscious, or repressed, within texts' (1982: 86). I shall return to film theory's use of psychoanalysis later in this chapter. Here, however, I want to suggest one problem that is thrown up in the *Cahiers* editors' analysis of *Young Mr. Lincoln* as belonging to the category of films whose 'internal tensions' threaten their ideological coherence, a problem which was to recur in feminist appropriations of the *Cahiers* approach. Whilst the reading of *Young Mr. Lincoln* is effective in its analysis of the operations of ideology, it is less clear how *this* film might be seen to differ from other Hollywood films which fall into Comolli and Narboni's largest category, those films which are thoroughly imbued with the dominant ideology. Indeed, if the operations of ideology can be seen to function in some sense as the unconscious of the text, it would seem that this must be true of *every* film, for it will be in the nature of ideology itself to leave the traces of its repressions and excisions. If this is the case, then the distinction between internally self-critical and other mainstream texts collapses. This will have two consequences. First, a wider range of texts is opened up for this kind of ideological analysis. Second, it becomes the act of reading/criticism, rather than the text itself, which 'cracks the film apart' to reveal the workings of ideology. This, in turn, must lead to a shift in focus away from the film as text, and toward the text–reader relationship.

Claire Johnston and Pam Cook

It is in the work of Claire Johnston during the 1970s that the *Cahiers* approach to film analysis can most clearly be seen to be appropriated for

feminism. Johnston adopts Althusser's definition of ideology as 'a system of representations: "images, myths, ideas or concepts"', a 'profoundly unconscious' system which 'represent[s] itself as at once transparent, "natural" and universal to the viewer' (1988: 38), but employs it in the analysis of *patriarchal* ideology. 'Within a sexist ideology and a male-dominated cinema', she writes, 'woman is presented as what she represents for man'. Despite the 'enormous emphasis placed on woman as spectacle in the cinema', therefore, 'woman as woman is largely absent' (1973b: 26). Instead, the image of woman operates in film as a *sign*, but one which refers not to the 'reality' of women's lives, but to the desires and fantasies of men. Drawing on Barthes' concept of 'myth', she argues that 'myth transmits and transforms the ideology of sexism and renders it invisible' (1973b: 25), emptying the sign 'woman' of meaning and replacing it with 'the collective fantasy of phallocentrism'. It is thus pointless to compare, as Marjorie Rosen and Molly Haskell did, cinematic stereotypes of women with the reality of women's lives. Instead, what must be examined is the functioning of the sign 'woman' within the specific film text:

> woman is essentially a message which is being communicated in patriarchal culture, and it is in her inscription through stereotyping and myth as a sign which is being exchanged that she operates, finally, in the dominant cultural forms. In art, therefore, and hence in the film text, the representation of woman is not primarily a sociological theme or problem, as is often thought, but a sign which is being communicated. (1975: 124)

In her analysis of Raoul Walsh's *The Revolt of Mamie Stover* (1956), written with Pam Cook, Johnston examines the operation of this process in a film which, despite the presence of a strong central female protagonist, nevertheless constructs her 'as a signifier in a circuit of exchange where the values of exchange have been fixed by/in a patriarchal culture' (1988: 26). *The Revolt of Mamie Stover* is 'the story of a bar-room hostess's attempts to buck the system and acquire wealth and social status within patriarchy' (1988: 26). Yet her rebellion is undercut by both the film's narrative structure, which punishes Mamie for the threat which she poses, and its persistent representation of her as erotic object, through 'the myths of woman as pin-up, vamp, "Mississippi Cinderella"'. In order 'to become the subject of desire, she is compelled to be the object of desire, and the images she "chooses" remain locked within the myths of representation governed by patriarchy' (1988: 30–31). Mamie is, moreover, never allowed to be the subject of her own discourse. The writer-hero, Jimmy, stands in for the absent male spectator in 'constantly trying to write Jane Russell/Mamie's story for her' (1988: 32). Nevertheless, the figure of Jane Russell/Mamie remains a source of anxiety within the text, threatening the film's narrative and ideological coherence. 'Woman' is thus 'the locus of a dilemma for the patriarchal human order, ... a locus of contradictions' (1988: 35). Following Comolli and

Narboni, then, *The Revolt of Mamie Stover* is seen as a text which is 'splitting under an internal tension', but this tension is generated – in a way half-suggested by, but going far beyond, the *Cahiers* editors' mention of the text's repression of 'the erotic' – by the figure of woman.

Johnston and Cook return to the issue of the internally self-critical Hollywood film in their 1975 analyses of the films of Dorothy Arzner. Arzner was one of the very few women who worked as a director in the Hollywood of the 1920s, 1930s and 1940s and produced a substantial body of work. In Johnston's analysis, Comolli and Narboni's category of the internally self-critical text is once again used to describe Arzner's work, but this time the category is termed the '"progressive" classic Hollywood film', since Arzner is seen to employ 'strategies of dislocation, subversion and contradiction' in order to undermine the dominant patriarchal ideology (1988: 38, 44). 'In general', writes Johnston, 'the woman in Arzner's films determines her own identity through transgression and desire in a search for an independent existence beyond and outside the discourse of the male' (1988: 39). In the internal conflict which is generated in the films between the dominant discourse of Hollywood within which Arzner must operate and the 'discourse of the woman', it is the latter, 'or rather her attempt to locate it and make it heard, [which] gives the system of the text its structural coherence, while at the same time rendering the dominant discourse of the male fragmented and incoherent' (1988: 39). The dominant discourse is thus broken up, subverted and 're-written' from within, with the very stereotypes of women which Hollywood has produced now operating critically, held up for examination within the film rather than being naturalized by the film's narrative. The endings of the films see the transgressing woman fail to 'impose her desire upon' the dominant discourse; nevertheless, her voice cannot be erased, and in its continued presence as *excess* over the film's narrative ending, we see the 'insistence of the woman's discourse [as] a triumph over non-existence' (1988: 44). Arzner's work, then, whilst it cannot radically change dominant patriarchal structures, nevertheless 'open[s] up an area of contradiction in the text' and so contributes 'to the development of a feminist counter-cinema' (1988: 44–45).

Pam Cook's 1975 article on Arzner makes similar claims for the internally self-critical quality of Arzner's films, though on slightly different grounds. Films, argues Cook, must be approached as 'texts (complex products demanding an active reading in terms of the contradictions at work in them), which are produced within a system of representation which tries to fix the spectator in a specific closed relationship to the film' (1988: 46). Arzner's 'ironic method' plays on Hollywood's stereotypes of women through staged 'performance' scenes, creating an ironic distance between the viewer and the stereotype and 'between image and narrative' (1988: 56). The 'transparency' of the myth is destroyed, and our focus as viewers shifted to our own voyeuristic relationship to film. Cook's analysis makes of Arzner's films a rather more overtly interventionist body of work, and of the

conventional Hollywood film a more 'closed' textual system than does
Johnston's. Both, however, regard Arzner's work in 'making visible' the
contradictions in the film text generated by the figure of woman as a model
for the intervention into patriarchal ideology of both the feminist critic and
the feminist film-maker.

Johnston's concept of a 'feminist counter-cinema' extends her discussion
to include the problems for a feminist film *practice*, but it also raises wider
questions about the nature and limits of any feminist intervention into cul-
tural practice. Like Comolli and Narboni, Johnston argues that a radical
cinema must disrupt at the level of cinematic practice and not merely in its
content, rejecting as inadequate the *cinéma-vérité* films produced by women
in the early 1970s. These films, of which Kate Millett's *Three Lives* (1971)
is an example, 'largely depict images of women talking to camera about
their experiences'. As a radical strategy they are inadequate since 'it is not
enough to discuss the oppression of women within the text of the film; the
language of the cinema/the depiction of reality must also be interrogated, so
that a break between ideology and text is effected' (1973b: 29). Johnston
also insists, however, on the importance of *fantasy* in women's cinema: 'In
order to counter our objectification in the cinema, our collective fantasies
must be released: women's cinema must embody the working through of
desire: such an objective demands the use of the mainstream entertainment
film' (1973b: 31). This is a strategy which, perhaps surprisingly, privileges
as disruptive texts mainstream films such as Dorothy Arzner's, rather than
more overtly political avant-garde feminist films. And it leaves unanswered
questions as to the precise nature and status of our 'collective fantasies' as
women in a patriarchal culture, questions which would be taken up later by
feminist theorists. But it arises at least in part from Johnston's perception of
the difficulties posed for a feminist politics by the theoretical and analytical
approach she has adopted. If cinematic textual systems, like linguistic struc-
tures, operate to construct woman as sign in a patriarchal discourse,
repressing women's own discourse and rendering absent 'woman as
woman', then from what position can the feminist film-maker or critic
speak? Arzner's films, writes Johnston, 'pose the problem for all of us: is it
possible to sweep aside the existing forms of discourse in order to found a
new language?' (1988: 44). Her answer is equivocal. We should, she writes,
'seek to operate at all levels: within the male-dominated cinema and outside
it'. Only when we have interrogated and demystified the workings of ideol-
ogy will 'a genuinely revolutionary conception of counter-cinema for the
women's struggle ... come' (1973b: 31).

Johnston's work of the early 1970s represents a hugely ambitious
attempt to appropriate for feminism the theories and methodologies of ide-
ological and semiotic theory and analysis. Along with the work of Laura
Mulvey, it set the terms for feminist film theory for the next twenty years.
Reviewing this body of work in 1979, Janet Bergstrom listed the key ele-
ments of Johnston's contribution as:

an insistence on a theoretical rather than a sociological approach to feminist filmmaking and criticism, a recognition of the importance of feminist criticism and theory *for* feminist filmmaking, an emphasis on the importance of an understanding of how the representation of women operates in classical narrative film, ... the connections made between language, discourse and the working through of the woman's desire, the introduction of topics within feminist theory such as woman-as-sign, the relationship between woman, representation and fetishism, the rejection of the idealistic notion that a political film had to reject pleasure ... (1979a: 25)

Inevitably, though, Johnston's work raises more issues than it can resolve. Two of these are suggested by Johnston herself in her review of the work of Rosen and Haskell. The first concerns the exclusively *textual* focus of her own mode of analysis, which abstracts the film from its context of both production and reception: 'there is a real danger that the textual analysis we are engaged in ... may lead to a kind of ahistorical voluntarism, in which the particular historical conjuncture in which the film functions is rendered irrelevant' (1975: 124). The second, and related, issue concerns the relationship of this kind of analysis to feminism as a *political* movement. 'In this country', reflects Johnston, 'we have a situation in which film theory and film practice have little or no meeting point in the Women's Movement and where subjective response and personal expression (e.g. in the feminist search for "identity") are validated in our politics' (1975: 124). It is a point forcefully put by Rosalind Delmar:

> To deconstruct the subject 'woman', to question whether 'woman' is a coherent identity, is also to imply the question of whether 'woman' is a coherent political identity, and therefore whether women can unite politically, culturally, and socially as 'women' for other than very specific reasons. It raises questions about the feminist project at a very fundamental level. (1986: 28)

Johnston's first concern, that textual analysis abstracts the film from its historical and political context, is a problem in all semiotic and ideological analysis, whether feminist or not, but it is raised in a particularly acute form by feminist analysis. Johnston and Cook's examinations of the 'internally self-critical' film text locate the site of the textual rupturing as always already *within* the text, not in the operation which the (historically and politically positioned) critic/reader performs on it. Yet in seeing films by both the patriarchal Raoul Walsh and the proto-feminist Dorothy Arzner as falling into this category, their analyses raise, and constantly evade, the question of how far this rupturing is conscious on the part of the film-maker, and how far it is the result simply of the internal (and unconscious) contradictions which the sign 'woman' poses for a patriarchal ideology. This in turn raises further questions. If the rupturing is unconscious, how can women hope to escape this positioning as the repressed of patriarchal

ideology, and how does this textual 'feminine' relate to the real, historically and socially positioned women who watch the film? If, on the other hand, it is conscious, as the analysis of Arzner's films seems to suggest, from where does this 'woman's discourse' arise and how is it inserted into the textual systems of the film? How do we *know* that it is conscious, and what happens when, as Janet Bergstrom recounts (1979a: 29), the feminist critic presents her reading to a feminist audience, who simply disagree with her account of how they have read the film? All of this raises questions about the precise relationship of the reader to the text, about the relationship of the feminist critic to the woman spectator, and, finally, about the relationship of women to the textual structures, linguistic and filmic, which consistently position us as object or sign.

Psychoanalysis

Criticizing Johnston's thesis that textual 'rupturing' is located within the 'progressive' film text itself rather than in the act of reading, Janet Bergstrom concludes in 1979 that it is an application of psychoanalytic theory to the text–spectator relationship which provides the best way out of the difficulties which such a thesis presents. Through such an application one 'can specify the parameters of audience reaction/placement more convincingly, even if not an exact meaning at an exact moment' (1979a: 30). Clearly, it is to some extent artificial to separate the influence of psychoanalytic theory from that of semiotic and ideological analysis when discussing feminist film theory of the 1970s. Both Johnston and Cook, for example, employ psychoanalytic concepts in their analyses and Johnston's 1975 essay on Jacques Tourneur's *Anne of the Indies*[4] takes an explicitly psychoanalytic approach to the text. Nevertheless, as Bergstrom indicates, the application of psychoanalytic theory *to the act of reading* signals an important shift in feminist film theory, and in order to account for that, I shall deal separately with psychoanalysis here.

Writing in 1975, film theorist Christian Metz describes the shift in his own perspective from 'classical semiology, i.e. of the linguistic inspiration' which was the 'main guide in my earliest filmic investigations', to the psychoanalytic perspective which he will now employ. The question to be posed is: 'What contribution can Freudian psychoanalysis make to the study of the cinematic signifier?' (1975: 28). Both bodies of theory, he explains, are concerned with 'the symbolic', but whereas semiotics (or semiology) is concerned with the text, psychoanalysis considers the question, in Annette Kuhn's words, of 'how cinematic meanings are constituted for viewing subjects: how, that is, in the moment of reading, spectators are caught up in, formed by, and at the same time construct, meanings' (1982: 44). Metz adds

that he no longer believes that '*a* textual system' can be abstracted from the film text; instead, it is the processes of reading, the 'psychoanalytic implications of the *cinematic*' (1975: 35, 41) which interest him. Jean-Louis Baudry, writing in 1976, signals a similar shift:

> the key to the impression of reality [which the cinema gives] has been sought in the structuring of image and movement, in complete ignorance of the fact that the impression of reality is dependent first of all on a subject-effect and that it might be necessary to examine the position of the subject facing the image in order to determine the need for cinema-effect. (1976: 118–9)

It is not in the determinate structures of the text, then, that meaning is to be sought, but in the ways in which the cinematic 'apparatus' addresses, and constructs, the human subject who is its spectator. In order to understand this shift in perspective we must go back to the theories, first, of Freud, and second, of Jacques Lacan.

Clearly, an adequate discussion of a body of theory of the scope and complexity of Freudian psychoanalysis is impossible here. Such accounts are in any case available elsewhere.[5] Here, therefore, I merely want to indicate some of the key elements which were taken up by film theorists. The first is the Oedipus complex, through which, according to Freud, the (male) child leaves the mutually identifying relationship with the mother and acquires a gendered identity within culture. Elizabeth Grosz describes this process:

> The father regulates the child's demands and its access to the mother by prohibiting (sexual) access to her. The boy perceives his father as a potential castrator, an (unbeatable) rival for the mother's affections and attentions. He construes the father's (or mother's) prohibitions as castration threats, and these eventually lead him to renounce his desire of the mother because of his fear of the organ's loss, i.e., because of the father's authority and power as 'possessor' of the phallus. ... In exchange for sacrificing his relation to the mother, whom he now recognizes as 'castrated', the boy identifies with the authority invested in the father. He internalizes the symbolic father's authority to form the superego, by means of which he 'shatters' his oedipal attachment by repressing his desire. This founds the unconscious through the act of primal repression. (1990: 68)

Thus the move from the pleasurable, symbiotic, and sexually undifferentiated relationship with the mother into a mature (and fixed) sexual identity is also the entry into (patriarchal) culture and the moment in which the unconscious and its repressed desires are formed. This moment is also one which privileges the *visual*. The boy, writes Freud, begins by believing that all human beings possess a penis; it is the sight of the woman's difference which precipitates the Oedipus complex:

The observation which finally breaks down his unbelief [in the threat of castration] is the sight of the female genitals. Sooner or later the child, who is so proud of his possession of a penis, has a view of the genital region of a little girl and cannot help being convinced of the absence of a penis in a creature who is so like himself. With this, the loss of his own penis becomes imaginable, and the threat of castration takes its deferred effect. (1977a: 318)

In the post-Oedipal human (male) subject, the axis of vision retains its erotic charge, in two apparently contradictory activities. The first is scopophilia, erotic pleasure in looking, which arises from the preoccupation with sexual difference and a desire to 'complete the sexual object by revealing its hidden parts' (Freud 1977b: 69). In its character as *active* drive, this desire has links with another possible perversion[6] of the sexual drive: sadism. Both are 'masculine' and both have 'feminine' (passive) counterparts: exhibitionism and masochism (Freud 1977a: 70). The second activity arises from the boy's initial reaction to the girl's perceived sexual difference:

when a little boy first catches sight of a girl's genital region, he begins by showing irresolution and lack of interest; he sees nothing or disavows what he has seen, he softens it down or looks about for expedients for bringing it in line with his expectations. It is not until later, when some threat of castration has obtained a hold on him, that the observation becomes important to him.[7] (Freud 1977c: 336)

This process of disavowal, the retention of the belief in the woman's phallus despite the knowledge of its absence, is what gives rise to fetishism:

It is not true that, after the child has made his observation of the woman, he has preserved unaltered his belief that women have a phallus. He has retained that belief, but he has also given it up. . . . Yes, in his mind the woman *has* got a penis, in spite of everything; but this penis is no longer the same as it was before. Something else has taken its place, has been appointed its substitute, as it were, and now inherits the interest which was formerly directed to its predecessor. (Freud 1977d: 353)

The second key element in Freudian theory which I wish to highlight is Freud's account of dreams. In Freud's model of the human psyche, those impulses which in the post-Oedipal subject are repressed, nevertheless strive constantly for access to consciousness. In sleep, when impulses are by definition denied access to active expression, the psychic sensor can afford to relax. Unconscious wishes can therefore achieve limited expression, by attaching themselves to perceptual images (memories) in hallucinatory fashion. Thus the dream is a disguised (hallucinatory) fulfilment of a repressed wish. The disguise is the result of the 'dream-work', which, in Madan Sarup's words, 'transforms the "latent" content of the dream, the forbidden

dream-thoughts, into the "manifest" dream-stories – what the dreamer remembers' (1992: 6). This 'dream-work' has four aspects. The first is condensation, in which two or more ideas are compressed, to become a composite image which carries a number of repressed desires. The second is displacement. Here the unconscious wish is disguised by being displaced on to a figure or image with which it is associated in some way, but which does not itself attract repression. The third aspect of the dream-work is what Freud calls 'considerations of representability in the peculiar psychical material of which dreams make use – for the most part, that is, representability in visual images' (1976: 458). Dreams, that is, must rely on visual material to express logical or causal relations and abstract thoughts, and must therefore transform the desires which they express into visual form. Finally, there is 'secondary revision'. In this process, the dream is reorganized so as to become a relatively coherent and comprehensible narrative; when we recount our dreams, we are engaged in this process, smoothing out gaps and contradictions to produce a consistent narrative.

It can be seen from the above account how readily psychoanalytic theory lends itself to the analysis of film. Indeed, it is tempting when describing Freud's account of 'dream-work' to resort to the analogy of film construction.[8] Before turning to its adoption in film theory, however, I want to look briefly at the work of Jacques Lacan. Again, I shall consider just two aspects. The first is Lacan's account of the 'mirror stage'. Here is Madan Sarup's description:

> The mirror phase is supposed to occur (usually between the age of six months and eighteen months) when the child has not fully mastered its own body. The mirror phase is a period at which, despite its imperfect control over its own bodily activities, the child is first able to imagine itself as a coherent and self-governing entity. What happens is this: the child finds itself in front of a mirror. It stops, laughs at its reflection, and turns around towards whoever is holding it. It looks at its mother or its father, and then looks again at itself. For this necessary stage to occur, the child must have been separated from its mother's body (weaned) and must be able to turn around and see someone else *as* someone else. That is, it must be able to sense its discrete separation from an Other, and must begin to assume the burden of an identity which is separate, discrete. (1992: 64)

There are several points which are important to note about this process. The first is that this first recognition of itself as a discrete individual, the foundation of the ego and the basis on which the child will later be able to say 'I', is in fact a *misrecognition*. The mirror-image with which the child identifies is more co-ordinated, more unified and in control, than is the child itself. Nevertheless, it is this imaginary wholeness which the child internalises as an 'ideal ego'. The second point to note is the importance of the visual image in this acquisition of a sense of identity. The mirror phase is, in

Sarup's words, 'a moment of self-delusion, of captivation by an illusory image' (1992: 83). Image, identity and identification are interdependent. We assume our identities through a process of (mis)identification. The phase of development which the mirror stage inaugurates is termed by Lacan the Imaginary. Third, it is important to recognize that this moment of self-recognition is also a moment of self-alienation, of splitting. The child identifies with an image of itself that is always elsewhere and always also the image of another. We cannot close the gap between the observing self and the observed image, though we constantly seek to do so. Moreover, if this observation of the 'unified self' creates the possibility of subjectivity for the individual, it also creates the possibility of its own objectification.

The second aspect of Lacan's work that I want to consider is his account of the child's entry into language, or the Symbolic, which is his rewriting of Freud's Oedipal process. It is the sense of identity and separation experienced through the mirror stage that creates the *possibility* of our saying 'I', operating as subjects within language. Language itself, however, is a structure which precedes us. The 'I' with which we speak stands in for our identity as subjects, but it is an unstable entity. It can be used by others, and language also places us as 'he' or 'she'; *it* constructs *us* even as we assert ourselves as subjects within it. Language is, moreover, the realm of the Symbolic, substituting linguistic and cultural symbols for the absent real, and meaning for being. It is this linguistic and cultural system which for Lacan constitutes that 'father' which represses the child's desires. The father, in other words, is a 'paternal metaphor' (Lacan terms it also the 'name-of-the-father' or the 'Law of the Father'), and the Oedipal process is the child's entry into the Symbolic, or culture. Nevertheless, the *masculinity* of this 'metaphor' is important. It is the phallus as symbol which signifies sexual difference and which means that, whilst the male child aspires to master language on his entry into the symbolic (to identify himself with the Law of the Father), the female child can have no such aspiration. It is true that *his* hope is illusory, for no one can occupy the place of the Law of the Father; *her* position, however, can only be one of lack. Finally, however, it is important also to note that this sexed identity is always unstable. The continued presence of repressed desires which by definition exceed the boundaries of the Symbolic, the illusory nature of identity, the centrality to human subjectivity of experiences of lack and absence, all mean that the human subject is neither unified nor stable.

It is in Lacan's insistence on language and culture (and, indeed, the unconscious) as *structures* that we can see the meeting ground between Lacanian psychoanalysis and both semiotics and ideological analysis. Like Althusser and Barthes, he insists on the centrality of linguistic and cultural structures, but his work also suggests just what we as individuals have invested in those structures. They are the scene of our search for identity and meaning, our difficulty in finding a place from which to speak, and the construction of our (unstable) sexed identities. Finally, Lacan's theories also

seem to account for the power of *ideology* in positioning us in culture. The images and representations which are the bearers of ideology are also those through which, by processes of identification, we construct our identities as human subjects.

Psychoanalysis and film theory

We can now return to the question posed by Christian Metz: 'What contribution can Freudian psychoanalysis make to the study of the cinematic signifier?' His answer centres on the fact that, whilst linguistics and psychoanalysis are both 'sciences of the symbolic', psychoanalysis shifts the focus of attention from *what* is articulated, in the cinematic text, to the process of articulation itself. Jean-Louis Baudry's account of the operation of the 'cinematic apparatus'[9] compares the situation of cinema spectatorship to that of the dreaming subject, with the 'apparatus' operating upon/within the human subject in much the same way as the dream:

> First of all, ... taking into account the darkness of the movie theater, the relative passivity of the situation, the forced immobility of the cine-subject, and the effects which result from the projection of images, moving images, the cinematic apparatus brings about a state of artificial regression. It artificially leads back to an anterior phase of his development – a phase which is barely hidden, as dream and certain pathological forms of our mental life have shown. (1976: 119)

Like dreams and hallucinations, cinema offers us perceptions (sound, images, movement) which are in fact *representations*, and which allow us access in the same way to desire, keeping at bay the 'reality principle' which would repress desire:

> It is indeed desire as such, i.e. desire of desire, the nostalgia for a state in which desire has been satisfied through the transfer of a perception to a formation resembling hallucination which seems to be activated by the cinematic apparatus. (1976: 121)

Metz makes a similar identification of cinema with (pre-Oedipal) desire and fantasy, this time identifying it with Lacan's mirror phase. The cinema screen is, he writes, 'that *other mirror*' which returns us to the Imaginary (1975: 15). For Metz, however, the film is also a cinematic *text*, albeit one which works to conceal its own processes of construction and present itself as pure perception, like the unfolding of memory or dream. It operates, then, in the realm of the Symbolic, though it activates the desires of the Imaginary, and it will therefore be subject to repressions. It is also unlike Lacan's 'primordial mirror' in one essential point:

although, as in the latter, everything may come to be projected, there
is one thing, and one thing only that is never reflected in it: the specta-
tor's own body. In a certain emplacement, the mirror suddenly
becomes clear glass. (1975: 48)

With what, then, does the spectator identify during the projection of the
film, if his own image is absent? Metz's answer is that we identify with the
camera itself. 'At the cinema, it is always the other who is on the screen; as
for me, I am there to look at him. I take no part in the perceived, on the con-
trary, I am *all-perceiving*' (1975: 51). During the film screening, the camera
itself is absent, but it has a stand-in, the film projector, which operates to
identify the film even more firmly with fantasy, vision and desire:

During the projection [the] camera is absent, but it has a representa-
tive consisting of another apparatus, called precisely a 'projector'. An
apparatus the spectator has behind him, *at the back of his head*, that
is, precisely where fantasy locates the 'focus' of all vision. (1975: 52)

To this account, other contemporary theorists (Heath 1976a; 1976b;
1977/8; Oudart 1977/8) added the concept of 'suture' (literally surgical
stitching or tying in) to explain the process by which we, as viewers, are
'sewn in' to the cinematic narrative. Film narrative, they write, is con-
structed through editing, through the creation of cuts, gaps, 'intermittences'
between shots which it is the function of the narrative to bind together.
Moreover, each new shot creates anxiety as well as pleasure for the specta-
tor. Whose point of view is this? What are we *not* seeing here? Thus:

film is not a static and isolated object but a series of relations with the
spectator it imagines, plays and sets as subject in its movement. ... In
its movement, its framings, its cuts, its intermittences, the film cease-
lessly poses an absence, a lack, which is ceaselessly recaptured for ...
the film, that process binding the spectator as subject in the realization
of the film's space. (Heath 1981: 52)

Cinematic pleasure, then, depends on the articulation of vision and
desire. Its pleasures, argues Metz, are those of Freud's 'perceptual passions',
and particularly 'the desire to see (= scopic drive, scopophilia, voyeurism)'
(1975: 59). 'Freud notes', writes Metz, 'that voyeurism, like sadism in this
respect, always keeps apart the *object* (here the object looked at) and the
source of the drive, i.e. the generative organ (the eye)' (1975: 60). In this
respect, film can be compared to theatre or cabaret (or the strip-show),
which also separate the viewer from the 'show'. In cinema, however, the
object of the gaze is *doubly absent*, since it is represented by the screen
image, even whilst its perceptual 'fullness' makes it seem more 'real'. This
has two consequences. The first is that the element of exhibitionism which
characterizes theatre, cabaret, or the strip-show is absent. The cinematic
gaze is a one-way process, lacking the element of complicity which charac-

terizes other modes of performance, and it is therefore more identified with both unauthorized ('unlawful') seeing and sadism. The second consequence is that cinematic pleasure is also identified with *fetishism*. Just as the fetishist both knows and disavows the fact of the woman's lack of a penis (her 'castration'), so, too, the cinema viewer both recognizes and disavows the 'absence' which characterizes the projected images of the cinema screen. We both 'believe in' the cinematic fiction and know it to be 'just a film'. Finally, just as the film as text turns the Imaginary (desire) into the Symbolic (knowledge), so too, is this process repeated in the operations of the film theorist/critic. He, too, turns his fascination with the (absent) cinematic object into knowledge of that object.

In the last sentence, I called the film theorist 'he', and I want to turn here to a problem that has been implicit throughout this discussion of psychoanalysis, and which is very evident in Metz's work: the problem of sexual difference. Freud's difficulties in dealing with *female* sexual development are well known, and were the source of the attack on his work launched by 'second wave' feminist theorists such as Kate Millett. Lacan's revision of Freud, though it shifts the location of the Oedipal crisis from nature to culture, and concludes that sexual identity is always unstable, since no one can actually 'possess' the phallus, still leaves the woman situated on the side of lack in an apparently unalterable structure. In Metz's work, as Jacqueline Rose points out, the issue is evaded. Although Freud's theories of fetishism and disavowal 'only [have] meaning in relation to the question of sexual difference', they are used by Metz without any reference to sexual difference and 'only in relation to the act of perception itself' (1986: 202). A similar problem occurs in Metz's account of voyeurism. In comparing cinema to the strip-show, the *masculinity* of the spectator is assumed, but not stated, and the object gazed at is by implication female. Even the theorist, since he repeats the process of disavowal, is in Metz's account implicitly male. Where, then, is to be found the source of *women's* fascination with film, cinema's implication in the construction of *female* subjectivity, the *woman's* investment in fantasy, desire or the Imaginary? And from where might the female (feminist?) theorist speak?

Before turning to the ways in which these questions were answered in Laura Mulvey's work, I want to look briefly at the work of another film theorist who was using psychoanalytic theory in the late 1960s and 1970s, Raymond Bellour. Unlike Metz or Baudry, Bellour focused on the individual film text, in particular the work of Alfred Hitchcock, unravelling the film's condensations and displacements as if it were a dream, but he, too, was concerned with the text–spectator relationship and his film analyses demonstrate much of Metz's theory in action. For Bellour, however, sexual difference is crucial to the functioning of cinema spectatorship. It is the *male* spectator who is primarily addressed by film. Although female desire and the woman's desiring look are central to film narrative, in order to set the narrative in motion, the balance between male and female points of view (in

the balance between shots in a sequence, for example, or in the structure of
the narrative) is never symmetrical:

> It seems to me that the classical American cinema is founded on a sys-
> tematicity which operates very precisely at the expense of the woman,
> if one can put it that way, by determining her image, her images, in
> relation to the desire of the masculine subject who thus defines himself
> through this determination. (Bergstrom 1979c: 97)

It is the male spectator for whom the film acts as a mirror. When he looks
at the image of woman, or even when the woman returns the look in a
shot–reverse shot sequence, it his her 'lack' which is emphasized. *Her* image,
or *her* defeat within a narrative which either punishes her or places her as
subordinate to the man, gives *him* the illusion of completeness and power:

> Between man and woman, through woman's look as appropriated by
> the camera, this mirror- or doubling-effect ... serves to structure the
> male subject as the subject of a scopic drive, that is to say, a subject
> who imaginarily attributes to woman the lack he himself has been
> assigned, in response to the anxiety created by the phantasized threat
> of this lack within his own body. (1979: 119)

When asked by Janet Bergstrom in a 1979 interview about the place of
the *woman* spectator and critic, Bellour could only respond:

> If you, as a woman, don't find you have a place in this, I can perfectly
> well understand it. But you ought to ask yourself about what seems to
> attract you so strongly in these films, and also about the attention you
> accord to my work. ... I think that a woman can love, accept and give
> a positive value to these films only from her own masochism.
> (Bergstrom 1979c: 97)

Laura Mulvey

Laura Mulvey's 1975 article, 'Visual Pleasure and Narrative Cinema', has
become the single most anthologized essay in the field of feminist film
theory. As its title indicates, it picks up the concerns of the theorists I have
been discussing, but to them it adds the preoccupation of Johnston and
Cook with the question of woman as signifier in a patriarchal order, and it
places the issue of sexual difference at the centre of its argument. In its con-
cern with the *image* of woman, it can also be seen as reframing the issues
raised by the 'Images of Women' writing on women and film of the early
1970s. 'It takes as its starting point', writes Mulvey, 'the way film reveals
and even plays on the straight, socially established interpretation of sexual

difference which controls images, erotic ways of looking and spectacle'. It therefore employs psychoanalytic theory, but as a 'political weapon, demonstrating the way the unconscious of patriarchal society has structured film form' (Mulvey 1989a: 14). A summary of its argument will, I hope, make clear both the extent of its debt *and* the radical challenge which it presents to the psychoanalytic and semiotic film theory on which it draws.

Like Johnston, Mulvey argues that the sign 'woman', and more importantly the *image* of woman, as 'castrated' Other to man's Imaginary self, underpins the patriarchal order. 'Woman', then, 'stands in patriarchal culture as a signifier for the male other, bound by a symbolic order in which man can live out his fantasies and obsessions through linguistic command by imposing them on the silent image of woman still tied to her place as bearer, not maker, of meaning' (1989a: 15). Cinema, as in Metz's argument, offers the spectator erotic pleasure in looking, the fulfilment of desire through fantasy, and a return to the pleasures of imaginary self-identity which the mirror phase provided. Its 'structures of fascination', as in Heath's argument, play on processes of unity and separation, similarity and difference, allowing the spectator 'temporary loss of ego while simultaneously reinforcing it' (1989a: 18). This spectator, however, is male: 'Unchallenged, mainstream film coded the erotic into the language of the dominant patriarchal order' (1989a: 16). In this 'world ordered by sexual imbalance, pleasure in looking has been split between active/male and passive/female' (1989a: 19). Visual pleasure, therefore, has two aspects. The first is voyeuristic pleasure, active and aggressive, which takes as its object the passive (eroticized) image of the woman. The second is narcissistic pleasure, in which the spectator identifies with his 'ideal ego', that 'more perfect, more complete, more powerful ideal ego conceived in the original moment of recognition in front of the mirror' (1989a: 20), and figured, in Mulvey's argument, in the male movie star. This active/passive division, argues Mulvey, also structures film narrative, so that the image of woman as erotic spectacle interrupts the flow of narrative, whilst the central male figure advances the story and, as the ideal ego of male fantasy, controls events, the woman, and the erotic gaze.

As has already been indicated, however, the image of woman, as 'castrated' other whose 'meaning' is sexual difference, evokes anxiety as well as pleasure in the male spectator. The 'male unconscious has two avenues of escape from this castration anxiety'. The first links voyeurism with sadism, with which, as we have seen, it has close associations in Freudian theory. 'Sadism demands a story' (1989a: 22), and in film narratives this story concerns the investigation of the woman, her 'demystification' and ultimately her punishment. The second avenue is fetishism. Mulvey's account returns fetishism to its primary Freudian meaning of sexual difference. The 'disavowal' which is its central characteristic concerns not the cinematic screen and its projected images, as in Metz's use of the concept, but the figure of woman as 'castrated'. 'Castration' is disavowed by the male spectator

through the 'substitution of a fetish object or [by] turning the represented figure itself into a fetish so that it becomes reassuring rather than dangerous (hence overvaluation, the cult of the female star)' (1989a: 21).

Cinematic codes, then, through their manipulation of not only image but also the dimensions 'of time (editing, narrative) and ... space (changes in distance, editing)', 'create a gaze, a world and an object, thereby producing an illusion cut to the measure of [male] desire'. Their power comes from their alignment of the 'three different looks' of cinema: 'that of the camera as it records the pro-filmic event, that of the audience as it watches the final product, and that of the characters at each other within the screen illusion' (1989a: 25). In the latter, of course, it is the look of the central male character which is privileged, acting as surrogate for the male spectator, 'so that the power of the male protagonist as he controls events coincides with the active power of the erotic look, both giving a satisfying sense of omnipotence' (1989a: 20).

Mulvey, then, offers a powerful reworking of psychoanalytic film theory which places sexual difference, and the privileging of the masculine, as central to the understanding of film pleasure and film meaning. It makes explicit many of the (patriarchal) implications of psychoanalytic film theory as it had been developed by male theorists, and it both restates and reframes the issues raised elsewhere in feminist writing on film. But its very comprehensiveness as an explanatory structure, involving as it does the unconscious processes through which our identities as human subjects are formed, means that its proposals for *changing* those structures must be correspondingly radical. Unlike Claire Johnston, Mulvey cannot see the answer to a male-dominated cinema as lying in the release of 'our collective fantasies' through the mainstream entertainment film. Such fantasies, within our culture, must inevitably be caught up in the patriarchal structures which govern the unconscious, and the mainstream film's very processes reinforce such structures. Instead, she calls for the destruction of cinematic 'pleasure', both within a radical feminist film practice and as the primary aim of feminist film theory/criticism. Such a conclusion seems the inevitable conclusion of a feminist reading of psychoanalytic film theory. Both Metz and Bellour confess to the 'secondary voyeurism' involved in their theoretical explorations of the fascination which cinema holds for them. If such is the position of the male theorist, then the feminist critic can only refuse it.

Conclusion: but where is the woman?

Registering both the fascination which psychoanalysis holds for the feminist theorist and some of the difficulties it presents, Laura Mulvey writes in her 1975 article:

There is an obvious interest in this analysis for feminists, a beauty in its exact rendering of the frustration experienced under the phallocentric order. It gets us nearer to the roots of our oppression, it brings closer an articulation of the problem, it faces us with the ultimate challenge: how to fight the unconscious structured like a language (formed critically at the moment of the arrival of language) while still caught within the language of the patriarchy? (1989a: 15)

She adds that what is needed is for feminist theory to 'conceive a new language of desire' (1989a: 16). Yet it is difficult to see how such a language can be conceived, given the structures of subjectivity which her account proposes. At times she seems to suggest, like Johnston, that patriarchal ideology is a secondary structure, a historically specific ordering of more fundamental psychic processes in the service of a particular social organization (patriarchy). More often, however, in adopting Lacan's account of the formation of subjectivity, she seems to present a closed system in which women are excluded not only from the processes of language construction (bearers, not makers, of meaning), but from desire itself. As Janet Bergstrom points out, whereas Raymond Bellour argues that the woman's *desire* is central to the processes of film narrative, though only 'insofar as the woman's desire is the central *problem* or challenge for the male protagonist' (1979b: 53), for Mulvey it is the woman's *image* which produces this challenge. The division active/male and passive/female seems so complete that the source of a female desire or a woman's discourse seems impossible to determine. In 'The Cinematic Apparatus – Problems in Current Theory' (1980), Jacqueline Rose discusses this problem of 'what a feminine desire might be' and where it might be located (Rose 1986: 211). Two possible answers are suggested. The first is to identify it with a 'primordial', pre-Oedipal or archaic feminine sexuality, repressed within a patriarchal structure but perhaps able to be (re)activated by the regressive processes of cinema. The second is that woman's access to desire in cinema is through a 'masculine identification', in which she is both subject and object of desire. Neither seems satisfactory. The first places woman always *outside* culture and language, reinforcing her position as 'other'. The other simply confirms the binary system which precludes her access to desire *in her own right*.

A second, related problem which Mulvey's account raises, but which she herself does not consider in this essay, concerns the pleasure which the *female* spectator might be assumed to gain from the classical film. According to Bellour, as we have seen, this pleasure can only be masochistic, and Mulvey's account would seem to confirm this – unless, that is, the female spectator can be assumed either to escape the processes of gendered identification on which cinema relies, perhaps through regression to a pre-Oedipal mode, or to find her pleasure through the 'masculine identification' which Rose describes. Writing in 1982, Annette Kuhn argued that this question of 'the place of the female or feminine spectator in the relay of looks set

up within the cinematic apparatus' was one which faced feminist film theory 'with some urgency' (1982: 82). I shall return to this issue in the next chapter.

Looking back on her 1975 essay, Mulvey commented in 1989:

I sometimes feel that the excitement, novelty and sheer difficulty of semiotic and psychoanalytic theory overwhelmed other political concerns and commitments. The priority was to establish the psyche's political reality and its manifestation in image and representation. Looking back from the late 1980s, it seems as though deeply important changes were engulfing society while I was looking elsewhere, at the cinema or at the unconscious. (1989b: xii)

The comment raises the final problem which I wish to discuss here, that of the relationship of the 'spectatorial subject' considered in these accounts to the real women (and men) who comprise the cinema audience, and of the 'cinematic apparatus' of psychoanalytic theory to the historical, cultural and political context in which specific films are produced and watched. Put another way, it is the issue of how a feminist film theory which is founded on an analysis of *unconscious* processes can be related to a feminist politics of change. As Jacqueline Rose asks, 'what would a politics of the unconscious be?' (1986: 213)[10] It is an issue which is raised by Claire Johnston in the final paragraphs of her review of Rosen's *Popcorn Venus* and Haskell's *From Reverence to Rape*. Johnston rejects as 'crude determinism' their assumption that cinema images of women simply reflect social and economic changes produced and lived out elsewhere, insisting on the specificity of the film text and of the process of film analysis. Nevertheless she is anxious that the knowledge so produced 'be related to an analysis of the present conjuncture, its ideological, political and economic determinations. This task of re-inserting the products of the feminist activity of reading/writing into the present conjuncture is vital if we are to make any real headway' (1975: 124). Yet it can be argued that the work produced by Mulvey, Johnston and Cook is equally determinist in its argument that the film text, or the cinematic apparatus, constructs its spectators through processes which can be mapped with alarming neatness onto the unconscious structures through which our gendered identities are produced. It is difficult to see, in such a totalizing system, how spaces for resistance, opposition and change can be found. As Mulvey's rueful 1989 comment seems to suggest, the feminist appropriation of psychoanalytic and semiotic theory massively extends the scope and explanatory power of feminist film theory, but in this process the woman – whether the female spectator or the politically active feminist – seems to have disappeared.

|3|

Female spectators, melodrama and the 'woman's film'

According to Mulvey, the woman is not visible in the audience which is perceived as male; according to Johnston, the woman is not visible on the screen. She is merely a surrogate for the phallus, a signifier for something else, etc. As a woman going into the movie theater, you are faced with a context that is coded wholly for your invisibility, and yet, obviously, you are sitting there and bringing along a certain coding from life outside the theater. ... the cinematic codes have structured our absence to such an extent that the only choice allowed to us is to identify either with Marilyn Monroe or with the man behind me hitting the back of my seat with his knees. How does one formulate an understanding of a structure that insists on our absence even in the face of our presence? What is there in a film with which a woman viewer identifies? (Rich, in Citron *et al.* 1978: 87)

B. Ruby Rich's somewhat exasperated summary articulates here the dilemma produced for feminist film theory by the theoretical framework established by Claire Johnston and Laura Mulvey in the 1970s. Although Mulvey 'does show', she continues, 'that psychoanalysis provides a useful tool primarily for analyzing the status quo, which is patriarchal', the problem is that 'there don't seem to be any women there' (1978: 87). Thus, whilst Laura Mulvey's 1975 'Visual Pleasure and Narrative Cinema', in Janet Bergstrom and Mary Ann Doane's words, 'provided a theoretical framework which feminist film critics henceforth felt compelled to acknowledge' (1989: 7), the main question it provoked is one which in Mulvey's essay, despite its emphasis on sexual difference, is registered only as an absence – even, as Rich suggests, an impossibility – the question, 'But what about the *female* spectator?' This question, and Rich's rather more textually based reformulation of it as, 'What is there in a film with which a woman viewer identifies?', also produced a shift in analytic focus, away from mainstream male-centred narratives, and towards those Hollywood genres

specifically addressed to women. As Bergstrom and Doane argue, 'Since the linguistic/semiotic/psychoanalytic paradigm encouraged a text based analysis, women's genres ... were central to initiating the analysis of the female spectator' (1989: 7–8). The shift, then, was to an analysis of melodrama and the 'woman's film'.

Melodrama

The critical interest of the 1970s in melodrama was not confined to *feminist* film theory, however. Comolli and Narboni's 1969 privileging of the ideologically ruptured or fractured film as one in which an internal criticism of dominant ideology may be perceived led to an interest in those films in which stylistic 'excess' or narrative disjuncture could be seen as exposing ideological contradictions. Prominent in this critical reappraisal were the Hollywood melodramas of Douglas Sirk, which were regarded as employing Brechtian techniques of 'distanciation' in order to critique a 1950s American society which 'appeared to be strong and healthy, but which in fact was exhausted and torn apart by collective neuroses' (Willeman 1972/3: 133). Sirk's techniques included displacements and discontinuities in plot construction, contradictions in characterization, ironic use of camera-positioning and framing, and, following Comolli and Narboni, 'formal negations of ideological notions inherent in the script' (Willeman 1972/3: 131). Through such 'elements of parody and ... the ironic use of cliché', it was argued, 'the few' are enabled to perceive a formal critique, whilst 'the crowd' is kept 'happy' (Willeman, quoting Sirk, 1972/3: 131).

I have already pointed out, however (see Chapter Two), the difficulties in distinguishing the category of the 'internally self-critical' Hollywood film, when it would seem that *all* mainstream films must to some degree betray the evidence of ideological contradictions and repressions. Moreover, the qualities of 'excess', of plot discontinuities, of contradictions in characterization, to which Willeman points in Sirk's work, can be seen as characteristics of all melodrama, whether 'internally self-critical' or not. Thus, as Christine Gledhill points out, 1970s film theory gradually saw 'a slippage of the "subversion" argument from its attachment to Sirk as "author" to melodrama itself' (Gledhill 1987c: 7). If realism is regarded as inevitably complicit with bourgeois ideology, since it works always to 'naturalize' ideologically motivated representations,[1] melodrama, in contrast, can be seen as providing an anti-realist excess which exposes the contradictions which realism works so hard to repress. Thus melodrama itself became the focus of analysis.

Christine Gledhill's account of 'The Melodramatic Field' (1987c), however, draws attention to the difficulty in defining melodrama, particularly

in relation to the cinema. The problem for this new critical enterprise, she writes, 'was precisely what kind of field melodrama offered – genre? style? mode? ideology?' (1987c: 7). Melodrama has its roots in a nineteenth-century aesthetic mode identified not only with specific theatrical conventions – a 'welding of fantasy, spectacle and realism' (1987c: 18) which depended on gesture, *mise-en-scène* and music to convey its emotional effects – but also with a particular way of viewing the world. Whereas realism, she writes, 'by definition ... assume[s] the world is capable of both adequate explanation and representation', melodrama 'attests to forces, desires, fears which ... appear to operate in human life independently of rational explanation'. Its persistent enactment of 'the continuing struggle of good and evil forces running through social, political and psychic life draws into a public arena desires, fears, values and identities which lie beneath the surface of the publicly acknowledged world' (1987c: 31; 33). Given such a definition, the term could clearly be applied to most cinematic genres, or, indeed, to cinema itself. Nevertheless, its persistent identification with pathos, suffering and 'the point of view of the victim' (Elsaesser 1987: 64) also place it in opposition to 'action' genres such as the Western or the gangster movie and, more importantly here, give it a specific designation as a 'feminine' form.

Thomas Elsaesser's account of the characteristics of the melodramatic mode in 'Tales of Sound and Fury: Observations on the Family Melodrama' clarifies the terms of this 'feminine' designation. The melodrama, he writes, is characterized by 'the non-psychological conception of the *dramatis personae*, who figure less as autonomous individuals than to transmit the action and link the various locales within a total constellation'. It is, then, 'the *rhythm* of experience' which is emphasized, rather than 'its value (moral, intellectual)'. The social and political is understood only in 'private contexts and emotional terms'. This emotional truth is expressed, not through its verbal articulation by the individual but through its externalization in an 'orchestration' of visual and musical effects, in music, decor and *mise-en-scène*. '[L]ived time' is foreshortened 'in favour of intensity', and plots, particularly in the domestic melodrama, become circular. A recurrent feature of melodrama is 'that of desire focusing on the unobtainable object' but this desire is represented, as in the mechanisms of dreams, by 'a displaced emphasis, by substitute acts, by parallel situations and metaphoric connections'. Finally, in the claustrophobic setting of melodrama, 'the cathartic violence of a shoot-out or a chase becomes an inner violence', a self-destructive masochism (1987: 44–65).

What is particularly interesting in Elsaesser's account is the linking of qualities culturally labelled as 'feminine' – emotion, 'the *rhythm* of experience', intensity, circularity – with a thwarted desire whose only outlet is masochism. This connection is made even more explicit in Geoffrey Nowell-Smith's (1977) 'Minelli and Melodrama'. Nowell-Smith contrasts the melodrama with the Western:

Broadly speaking, in the American movie the active hero becomes pro-
tagonist of the Western, the passive or impotent hero or heroine
becomes protagonist of what has come to be known as melodrama.
The contrast active/passive is, inevitably, traversed by another con-
trast, that between masculine and feminine. ... The melodrama ...
often features women as protagonists, and where the central figure is
a man there is regularly an impairment of his 'masculinity'. (1987: 72)

Nowell-Smith's analysis is made within a psychoanalytic framework.
The failure of women protagonists to achieve their 'social and sexual
demands', despite their centrality in the melodrama, is seen, following
Lacan, to reflect 'an imbalance already present in the conceptual and sym-
bolic structure. "Masculinity", although rarely attainable, is at least known
as an ideal. "Femininity", within the terms of the argument, is not only
unknown but unknowable' (1987: 72). The 'happy ending' of melodrama is
therefore achieved only at the cost of the repression of (female) desire, but
the need for melodrama to conform to some degree with the demands of
realism, so that we can accept its fictions, means that this repression cannot
be acknowledged on the surface of the film. Instead, it returns as 'excess', as
the heightened emotionality which is expressed through music and *mise-en-
scène*. The melodramatic text functions, then, like the body of the patient
suffering from hysteria: it exhibits as symptoms what has been repressed
from conscious discourse. The 'hysterical' moment of the text can be identi-
fied as the point at which realist conventions break down, and the text's ide-
ological contradictions are revealed. The interest of melodrama therefore
lies in its 'ideological failure' (1987: 73–4).

It should be clear from this account just why, in Christine Gledhill's
words, feminism 'claim[ed] a stake' in the 'critical reappropriation' of melo-
drama (1987b: 1), and particularly in that 'sub-set' of melodrama which
Nowell-Smith identifies as having a female protagonist, the 'woman's film'.
Laura Mulvey's 1977 article, 'Notes on Sirk and Melodrama', also differen-
tiates between two types of melodrama, that which focuses on 'tensions in
the family, and between the sexes and generations', in which the point of
view is masculine, and that 'coloured by a female protagonist's point of
view which provides a focus for identification' (1989c: 40). Mulvey, how-
ever, takes issue with the view, propounded in different ways by both
Willeman and Nowell-Smith, that melodrama exposes *hidden* contradic-
tions. 'Ideological contradiction', she argues, 'is actually the overt main-
spring and specific content of melodrama, not a hidden, unconscious thread
to be picked up only by special critical processes' (1989c: 39). Her view,
then, is more pessimistic than theirs. Melodrama, she writes, acts as a
'safety-valve' for patriarchy, a place where ideological contradictions cen-
tred on sex and the family may be safely aired. Those melodramas which
feature a female point of view, she agrees, 'tell a story of contradiction, not
of reconciliation' since, as Nowell-Smith also argues, 'the fact of having a

female point of view dominating the narrative produces an excess which precludes satisfaction'. Nevertheless, their 'fantasy escape[s]' for women are clearly marked as illusory, and their final message is stark: 'Even if a heroine resists society's overt pressures, its unconscious laws catch up with her in the end' (1989c: 43). But Mulvey's article also raises the question of the *female* spectator of melodrama, and here her comments point in a rather less pessimistic direction – though one difficult to contain within psychoanalytic theory. Sirk's distinction between the ideologically complicit (and stupid) pleasures of 'the crowd' and the critical pleasures of 'the few' had also – since these films are precisely *'women's'* films – been an implicitly gendered distinction. The 'crowd' is female, whereas the critic is male. Mulvey in effect reverses this distinction. It is women who, because of their ideological and social positioning within patriarchy, derive pleasure from the contradictions of melodrama:

> The workings of patriarchy, and the mould of feminine unconscious it produces, have left women largely without a voice, gagged and deprived of outlets (of a kind supplied, for instance, either by male art or popular culture) ... In the absence of a coherent culture of oppression, a simple fact of recognition has aesthetic and political importance. There is a dizzying satisfaction in witnessing the way that sexual difference under patriarchy is fraught, explosive, and erupts dramatically into violence within its own private stamping-ground, the family. (1989c: 39)

A number of issues are raised here. There is the potential for resistance (however unrealized) in women's *social* positioning (the 'pent-up emotion, bitterness and disillusion' which is 'well known to women') and popular culture. There is the capacity of such positioning to produce a *critical* reading (the 'dizzying satisfaction' in witnessing patriarchy's internal collapse). There is also, however, the contrast between this analysis and Mulvey's emphasis on patriarchy's capacity to 'mould' the feminine unconscious and manage female rebellion through its melodramatic 'safety-valves'. Mulvey is caught between her sense of the apparently limitless power of the patriarchal film to determine audience positioning and the feminist need to argue for resistance and change. The question on which this difficulty hinges, that of the relationship between the melodramatic *narrative* and the female *spectator*, was one to which she returned four years later.

The female spectator

In 'Afterthoughts on "Visual Pleasure and Narrative Cinema" ' inspired by King Vidor's *Duel in the Sun*' (1981), Mulvey considered two related issues.

First the question of the female spectator, 'whether the female spectator is carried along, as it were by the scruff of the text, or whether her pleasure can be more deep-rooted and complex'. Second '(the "melodrama" issue), how the text and its attendant identifications are affected by a *female* character occupying the centre of the narrative arena' (1989d: 29). Her answers again turn to psychoanalysis, this time to Freud's account of the female Oedipal journey. In Freud's account of early development, auto-erotic activity in both sexes is 'active', and hence (in an assumption of equivalence which, as Mulvey points out, constantly shifts between the merely 'conventional' and the biological), *masculine*. 'Indeed,' writes Freud, 'if we were able to give a more definite connotation to the concepts of "masculine" and "feminine", it would even be possible to maintain that libido is invariably and necessarily of a masculine nature, whether it occurs in men or in women' (Freud 1977b: 141). Whereas sexual maturity for the boy, therefore, involves a shifting of the *object* of desire, away from the mother and towards another woman, for girls it involves the repression of desire itself:

> Puberty, which brings about so great an accession of libido in boys, is marked in girls by a fresh wave of *repression*, in which it is precisely clitoridal sexuality that is affected. What is thus overtaken by repression is a piece of masculine sexuality. (Freud 1977b: 143)

Hence, sexual maturity in women is signalled by passivity, whose function is to further stimulate the activity of the male libido. This is understandably, however, a difficult project for women to accomplish, so that they are particularly prone to regressions to the pre-Oedipal 'masculine' period.

For Mulvey, Freud's account describes, not a universal development, but an account of the construction of femininity within patriarchy. She points to the identification, in popular narratives of 'folk' and 'mass' culture, of the function of narrative *subject* (the character with whom the narrative places us) with the masculine hero. But she points, too, to the 'age-old cultural tradition' by which the woman reader/spectator accepts this narrative placing with the hero, and is thus able to identify 'with the *active* point of view, allow[ing] a woman spectator to rediscover that lost aspect of her sexual identity, the never fully repressed bedrock of feminine neurosis' (1989d: 31). The female spectator, then, habitually operates a 'trans-sex identification', an oscillating and uneasy 'transvestite' fantasy of masculinization.

It is this feminine Oedipal narrative which Mulvey also sees as being enacted in the female-centred melodrama. Her example, *Duel in the Sun* (1946) is superficially a Western, but, Mulvey argues, in shifting its focus to the journey to maturity of a female protagonist, it becomes a melodrama. Thus the choice to be made by the female protagonist, Pearl, between an active, and regressive 'tomboy' relationship with the outlaw, Lewt, and the acceptance of a passive femininity in marriage to his respectable brother, Jesse, plays out for the female spectator her own uncomfortable Oedipal

journey. Pearl, of course, dies in a shoot-out with her lover, Lewt, thus signalling the impossibility of a female assumption of 'masculine' activity and desire. 'The memory of the "masculine" phase has its own romantic attraction,' writes Mulvey, 'a last-ditch resistance, in which the power of masculinity can be used as postponement against the power of patriarchy' (1989d: 37). But her conclusion is pessimistic: 'Rather than dramatising the success of masculine identification, Pearl brings out its sadness. Her "tomboy" pleasures, her sexuality, are not fully accepted by Lewt, except in death. So, too, is the female spectator's fantasy of masculinization at cross-purposes with itself, restless in its transvestite clothes' (1989d: 37). Within the terms of the psychoanalytic framework which Mulvey adopts, activity can only be *borrowed* by the female protagonist or spectator. With 'maturity' she must relinquish these 'tomboy' pleasures. Such a framework cannot theorise the spaces for resistance which the earlier essay on Sirk tentatively identified with women's different social and cultural positioning under patriarchy. To borrow B. Ruby Rich's terms, then, there *still* 'don't seem to be any women there', since when they *are* present they are dressed in men's clothing.

Desire and the 'woman's film'

The most sustained examination of the implications of the psychoanalytic approach to cinema for a theorisation of the *female* spectator can be found in the work of Mary Ann Doane during the 1980s. The textual focus of Doane's work is most often the 'woman's film' of the 1940s, but what she sees as uniting this group of films, and what interests her in them, is their attempt to address, and so construct a viewing position for, the female spectator:

> Because the woman's film of the 1940s was directed toward a female audience, a psychoanalytically informed analysis of the terms of its address is crucial in ascertaining the place the woman is assigned as spectator within patriarchies. The question then becomes: As a discourse addressed specifically to women, what kind of viewing process does the 'woman's film' attempt to activate? A crucial unresolved issue here is the very possibility of constructing a 'female spectator,' given the cinema's dependence upon voyeurism and fetishism. (1984: 68–9)

As this extract demonstrates, Doane accepts the analysis of the operation of the cinematic apparatus and its relationship to the formative processes of male subjectivity, as outlined by Metz, Bellour and Mulvey. But, she argues, since the 'spectator purportedly anticipated and positioned by the text, defined by the psychical mechanisms of scopophilia or voyeurism, fetishism

and a primary mirror identification, is inevitably male' (1984: 68), these analyses tell us nothing about *female* spectatorship. Since the little girl cannot fear castration, being already 'castrated', she cannot have access to the two mechanisms through which the masculine subject seeks to protect himself from this anxiety: voyeurism and fetishism. Similarly, she cannot share 'the relationship of the man to the mirror' (1987: 15) which is outlined in Lacan's theory. Being less differentiated as a subject, and more bound to the mother, she cannot find, in the mirror or the cinema screen, that confirmation of the subject's identity proposed by both Metz and Mulvey. Thus, the *distance* between spectator and screen which is established through the mechanisms of voyeurism and fetishism, and which is so crucial to Metz's theorisation of the operation of cinema, cannot, within the terms of Metz's own psychoanalytic theory, apply to the female spectator. To the binary opposition in the 'pleasure in looking' suggested by Mulvey, that between 'active/male and passive/female' (Mulvey 1989a: 19), Doane adds a second, that between distance (male) and proximity (female).

This logical extension of psychoanalytic film theory has, in Doane's account, a number of consequences. The first is that films constructed to address the female spectator assume an *overidentification* of the spectator with the cinematic image: 'Proximity rather than distance, passivity, overinvolvement and overidentification (the use of the term "weepies" to indicate women's pictures is symptomatic here) – these are the tropes which enable the woman's assumption of the position of "subject" of the gaze' (1987: 2). Thus the distinction between subject of the gaze and its object is collapsed in these films. What the female spectator is offered is an identification with herself as image, or, more precisely, with 'a certain image of femininity' (1987: 30). It is, moreover, a commodified image. Through the marketing of the female star and the commodities – clothes, makeup, accessories – associated with her star image, the female spectator is invited to consume both discourses and goods. The goods, however, are designed to make her an *object* of desire. Thus, the 'cinematic image for the woman is both shop window and mirror, the one simply a means of access to the other. The mirror/window takes on then the aspect of a trap whereby her subjectivity becomes synonymous with her objectification' (1987: 33).

At the same time, however, since the 'woman's film' centres both our narrative identification and its structures of looking on a female protagonist, it must also offer *resistance* to the objectification of woman as spectacle characteristic of the male-centred narrative. Its narratives claim, at least, to place *female* subjectivity, desire and agency at their centre. The result of the conflict between this aim and the 'apparent "masculinization" of the very process of looking in the cinema' (1984: 69) is an instability and incoherence in the structures of both narrative and 'the gaze'. The inability of the films to sustain the female protagonist's voice-over or the collapse or undercutting of point-of-view shots or flashbacks identified with her is one example of this instability. More significant, however, is the tendency, during the

course of the narrative, to replace her point of view with that of an authoritative masculine discourse. This discourse, most frequently the medical discourse, diagnoses the female protagonist's 'symptoms', by subjecting her to the 'medical gaze', and then proceeds to restore her to normality/passivity by 'curing' her (1984: 74). Thus, argues Doane, the instability in the representation of female subjectivity which characterizes these films is obliquely recognized by them, but as a sign of female illness or psychosis.

A further consequence of this internal conflict is that the gaze of the female protagonist, which must assume centrality in the 'woman's film', is de-eroticized. Instead, it is often 'invested with fear, anxiety, horror' (1984: 70). In many of the films, for example *Gaslight* (1944) and *Rebecca* (1940), the narrative is one of investigation, but what is being investigated is the protagonist's own victimization, its location that most feminine of spaces, the home. 'The woman's exercise of an active, investigating gaze', then, 'can only be simultaneous with her own victimization' (1984: 72). The narratives assume an identification of female fantasy with persecution: 'Addressing itself to a female audience, the "woman's film" raises the crucial question: How can the notion of female fantasy be compatible with that of persecution, illness and death?' (1984: 77) For the female spectator the spectatorial pleasure offered is masochistic: 'in films addressed to women, spectatorial pleasure is often indissociable from pain' (1987: 16).

To explain this masochistic construction of the female spectatorial position in the 'woman's film', Doane turns to Freud's 'A Child is Being Beaten', his account of a clinical case of female masochistic fantasy. During the course of analysis, Freud's patient reveals the progressive stages of the fantasy. These, writes Doane,

> take ... the form of a three-part transformation of a basic sentence:
> (1) My father is beating the child whom I hate; (2) I am being beaten
> (loved) by my father; (3) A child is being beaten. In the construction of
> the male fantasy, Freud can isolate only two sentences: (1) I am being
> beaten (loved) by my father; (2) I am being beaten by my mother.
> (1987: 18)

What interests Doane in the sexual differentiation of the two scenarios is the presence or absence of spectatorship within them. In the development of the male fantasy, the fantasist 'retains his own role and his own gratification in the context of the scenario. The "I" of identity remains'. In the final stage of the female fantasy, however, the fantasist becomes a spectator ('*a child* is being beaten') and the fantasy is desexualized. 'Masochistic fantasy *instead* of sexuality', reflects Doane. 'The phrase would seem to exactly describe the processes in the "woman's film" whereby the look is de-eroticized' (1987: 19). The 'woman's film', therefore, whilst appearing to reverse the distinction between active/male (bearer of the gaze) and passive/female (object of spectacle) which Mulvey describes as characteristic of the male-centred film, in fact offers its female spectator *fewer* options for identification. She cannot

now perform Mulvey's 'transvestite' identification with the active hero; nor can she identify with the object of spectacle. Both her body as erotic spectacle and her eroticized gaze are absent. She has no access to desire – merely to 'the desire to desire' (1987: 9). She can only trace Freud's feminine journey to passivity enacted through masochistic scenarios.

Of the four sub-groups of the 'woman's film' which Doane identifies – the 'Medical Discourse' film, the maternal melodrama, the love story and the 'paranoid' film – only one, the love story, seems to offer potential for subversion. The love story is *premised* on the possibility of female desire. Thus, although it may work to establish the illusory nature of that desire, or its failure in the death of its protagonist, or its domestication through marriage, nevertheless, 'it is precisely because there is so much at stake here that the genre has the potential to interrogate the woman's position – to explode in the face of patriarchal strictures' (1987: 118). The love story therefore remains 'one of the most vulnerable sites in a patriarchal discourse' (1987: 118).

Doane's focus throughout this analysis is on, in Thomas Elsaesser's words (1988: 111), 'how a male cinema *imagines* the functioning of female subjectivity' (my italics). Although the term 'the woman's film' suggests, she argues, that 'the films are in some sense the "possession" of women' (1988: 196), what interests her is not the real woman in the audience but the 'perhaps illusory female spectator' which the films themselves 'anticipate and in some sense construct' (1988: 196). This preoccupation with the terms within which female spectatorship might be imagined is also, she argues, a feature of the films' own narratives which 'play out scenarios of looking in order to outline the terms of their own understanding' (1982: 87). Thus, for example, both *Caught* (1949) and *Rebecca* (1940), which she analyses at length, contain scenes in which the female protagonist is positioned as a film spectator, with her husband in control of the film's projection. Both also contain scenes in which the female body is literally repressed, with the camera standing in for the absent female figure.[2] Nevertheless, whilst Doane's interest is in the *textually inscribed* spectator, this figure is not seen to be, as so often in psychoanalytic theory, somehow outside history. The 'women's films' of the 1940s were produced at a time when women's presence in the labour market created both a need for films to address this new female audience and an ideological crisis around the redefinition of sexual roles which such a shift produced. It is the urgency of their need to conceptualize female subjectivity and the female spectator which makes these films of interest and which produces in them 'an intensity and an aberrant quality' (1987: 4) peculiar to the decade.

Doane's is therefore a complex analysis with two key points of focus: the need to extend psychoanalytic theories of cinema spectatorship to produce an understanding of how the *female* spectator is positioned, and the wider question of how, at specific moments, female *subjectivity* is produced within patriarchy. To bring these two issues together, she employs the theories of

Michel Foucault. Power, argues Foucault, does not simply operate through processes of repression, censorship and denial. It also 'works positively to construct the positions which subjects inhabit' (Doane 1987: 177). According to Foucault, then:

> What gives power its hold, what makes it accepted, is quite simply the fact that it does not simply weigh like a force which says no, but that it runs through, and it produces, things, it induces pleasure, it forms knowledge [*savoir*], it produces discourse; it must be considered as a productive network which runs through the entire social body much more than as a negative instance whose function is repression. (Foucault 1979: 36)

Viewed in this way, the discourses of the 'woman's film' can be seen as one of those operations of power (together with, for example, the discourses of consumerism) which produce and regulate female subjectivity within a patriarchal culture. As Lois McNay argues, such a view is attractive to feminism because it serves to position female subjectivity *within* culture and history rather than as always the *Other* of male-centred culture, as we have seen in theories from de Beauvoir to Mulvey. McNay writes[3] that 'Foucault's idea that sexuality is ... the effect of historically specific power relations has provided feminists with a useful analytical framework to explain how woman's experience is impoverished and controlled within certain culturally determined images of feminine sexuality' (McNay 1992: 3). However, as McNay makes clear, such a view also produces difficulties for feminism. Foucault's account of power does not allow for disruptions, contradictions and resistances, tending to 'posit ... disciplinary power as a monolithic and inexorable force which saturates all social relations' (1992: 43). If female subjectivity is *produced* by discourses like the 'woman's film', what room for resistance and change can be found?

Doane's view of the 'woman's film' itself is uncompromising. 'There is an extremely strong temptation', she writes, 'to find in these films a viable alternative to the unrelenting objectification and oppression of the figure of the woman in mainstream Hollywood cinema'. It is a temptation, however, which must be resisted: 'the woman's film does not provide us with an access to a pure and authentic female subjectivity, much as we might like it to do so. It provides us instead with an image repertoire of poses – classical feminine poses and assumptions about the female appropriation of the gaze' (1987: 4). More than this, however, by identifying the mechanisms through which female *spectatorship* is produced with those which produce female *subjectivity*, Doane seems to offer no way out of the masochistic scenario she describes. Yet her aim, as a feminist, is change – the production of a *different* spectatorship and subjectivity, and the creation of a different cinema. Three questions, then, recur insistently in her work. How might a different reading strategy be theorised for the female spectator, one resistant to the lure of overidentification and lack of distance? How, since '[w]ays of look-

ing are inevitably linked to ways of speculating, of theorizing' (1987: 37), and since we know that women (and feminist theorists) *do* speak, can the position of the feminist theorist be understood? And how can such understanding be used to produce a different cinema?

Her answer to the first question turns to the strategy of 'masquerade'. The concept of masquerade was first theorised in 1929 by psychoanalyst Joan Riviere. Riviere's analysis was of a successful 'intellectual woman' whose way of dealing with the threatening 'masculinity' of her position was to adopt an excessive pose of feminine flirtatiousness in her behaviour with men. 'Womanliness', argues Riviere, was 'assumed and worn as a mask, both to hide the possession of masculinity and to avert the reprisals expected if she was found to possess it' (Riviere 1986: 38). What is interesting about Riviere's account is not only the fact that she sees such masquerade as a common strategy adopted by women, but that she sees it as a quality inherent in femininity itself: 'The reader may now ask how I define womanliness or where I draw the line between genuine womanliness and the "masquerade". My suggestion is not, however, that there is any such difference; whether radical or superficial, they are the same thing' (1986: 38). This wearing of femininity as a mask, argues Doane, can allow the female spectator, or subject, to create a distance between herself and the image on the screen. Rather than overidentifying with it, she can *play* with the identifications offered by the film, manipulating them for her own pleasure and purposes. Whereas Mulvey's 'transvestite' spectator must imagine herself a man in order to obtain cinematic pleasure, Doane's 'feminine' spectator (and feminist critic) plays at being a woman.

A similar strategy of *mimicry* as a means of disrupting patriarchal discourse is also advocated by the French feminist theorist, Luce Irigaray. 'One must assume the feminine role deliberately', argues Irigaray. 'Which means already to convert a form of insubordination into an affirmation, and thus to begin to thwart it' (1985: 76). Irigaray's theories, which offer a critique of psychoanalysis, but from within its own framework, also offer for Doane a means of providing answers to the further questions which she poses. Psychoanalysis, argues Irigaray,[4] is itself governed by unconscious male fantasies. Freud's account of psychic development, like all other defining discourses of Western society, such as philosophy and linguistics, is in fact a single-sex model. Femininity is simply seen in relation to the male model, as lack, absence, negativity. Similarly, Lacan's account of the beginnings of subjectivity in the 'mirror stage' is an exclusively masculine account. The separation effected by the perception of difference, which for Lacan is an essential prerequisite for entry into the symbolic, is an exclusively masculine perception. The separation envisaged is that of the *male* child from the mother. The idealized body image which the mirror reflects is therefore implicitly male. Lacan's account of the 'imaginary' is of a masculine imaginary; his 'symbolic' is a masculine symbolic. Like all forms of Western thought, psychoanalysis, based as it is on an imaginary which has the

morphology (imagined form) of the male body, leaves women with no position from which to speak. Other than the strategy of mimicry, therefore, women's goal must be to create a new and female 'symbolic', based on a morphology of the *female* body. Such a symbolic would stress, not separation and difference, but contiguity and connection. Doane's espousal of such theories in 'Woman's Stake: Filming the Female Body' is tentative. They offer no more than a possible way out of the pessimism to which her adoption of psychoanalytic and Foucauldian theory seems to lead. They can also lead to the charge that the feminist theorist is simply repeating the patriarchal opposition between culture/reason/distance (male) and nature/emotion/proximity (female) – thus placing sexual difference yet again beyond the reach of political change. Nevertheless, she argues, adoption of such theories may be a 'necessary risk' if women are to achieve an 'autonomous symbolic representation' (1981b: 33).

The 'resistant' spectator

'Current film theory', writes Tania Modleski in 1980, tells us that 'all traditional narratives re-enact the male Oedipal crisis. For this crisis to be successfully resolved, the argument runs, feminine sexuality must undergo a complete suppression, feminine desire, an utter silencing, so there is nothing left for the feminist critic to do but outline the process by which this silencing is inscribed into the text' (1980: 34). Modleski, like other critics of the psychoanalytic framework adopted by Mulvey and Doane, prefers another project: that of identifying *resistant* discourses within and about the 'woman's film'. '[T]here must', she writes, 'be other options for the female spectator than the two pithily described by B. Ruby Rich: "to identify either with Marilyn Monroe or with the man behind me hitting the back of my seat with his knees"' (1988: 6). By simply reiterating these choices, the theorist contributes to the repression which s/he is describing.

Films may enact the repression of the feminine voice and viewpoint, argues Modleski, but this repression is not necessarily complete. In films centring on a woman, the 'woman's voice [may] speak, if only in a whisper, articulating her discontent with the patriarchal order' (1980: 34). It is the feminist critic's task to identify and locate that repressed voice, not to participate in its silencing. 'But how', she asks, 'are we to begin attempting to locate a feminine voice in texts which repress it and which ... grant possession of the Word only to men?' (1987: 329). Her answer returns to Thomas Elsaesser's definition of melodrama. Melodrama, writes Elsaesser, emphasizes 'the *rhythm* of experience ... against its value (moral, intellectual)' (Elsaesser 1987: 48). The description, as Modleski points out, bears a striking resemblance to feminist theorist Julia Kristeva's account of the semiotic

chora. Like Luce Irigaray, with whom she is often bracketed, Kristeva is a feminist theorist who challenges the conclusions of Lacanian psychoanalysis from within the terms of psychoanalytic theory. Kristeva, then, displaces Lacan's distinction between the Imaginary (the pre-Oedipal) and the Symbolic (the order of language or culture) into a distinction between the *semiotic* and the symbolic. The use of the term *semiotic* is confusing since Kristeva does not intend it in its usual sense of the study of signs. Instead, she identifies it with Freud's 'primary processes', the pre-Oedipal drives which are felt as a ceaseless flow of rhythms or pulsations across the body of the subject. These rhythmic charges together form the *chora* (from the Greek word for enclosed space or womb). Although the *chora,* as 'rupture and articulations (rhythm) ... vocal or kinetic rhythm' (Kristeva 1986a: 94), *precedes* language, and although there are non-verbal signifying systems such as music which are constructed from it, language itself, she writes, comprises both the symbolic and the semiotic. The semiotic produces the rhythms, the condensations and displacements of language, that which is 'irreducible to its intelligible verbal translation' (1986a: 97). It is felt as a *pressure on* language.

As might already be apparent, the semiotic *chora,* whilst it is the pre-Oedipal realm of both sexes, is identified with the feminine, and in particular with the mother, whereas the symbolic is dominated by the Law of the Father. It is the 'role of the "mother"'[5] (or the 'the repressed element' in our culture. 'Women's Time'[5] (or maternal time), unlike 'Father's time' which is the linear time of history, is cyclical and recurrent: 'As for time, female subjectivity would seem to provide a specific measure that essentially retains *repetition* and *eternity* from among the multiple modalities of time known throughout the history of civilizations' (1986d: 191). It is a time 'indissociable from space, ... a space-time in infinite expansion' (1986d: 192). It is to this mode of time that the hysteric returns when what has been repressed returns to be experienced in the body. Women's relation to the symbolic or social contract is consequently different from that of men, 'a difference ... in the relationship to power, language and meaning' (1986d: 196). What Kristeva advocates, therefore, is that women attempt 'to explore the constitution and functioning of this contract, starting less from the knowledge accumulated about it (anthropology, psychoanalysis, linguistics) than from the very personal affect experienced when facing it as subject and as woman'. This will involve the attempt 'to break the code, to shatter language, to find a specific discourse closer to the body and emotions, to the unnameable repressed by the social contract' (1986d: 200). Unlike Irigaray, however, Kristeva does not suggest the possibility of an autonomous 'woman's language'. There cannot be an *alternative* symbolic system. If the 'truth' of the unconscious 'can be imagined only as a *woman'* (1986b: 153) that is because woman is an exile, a 'dissident' in relation to the social and symbolic contract (1986c: 296). Kristeva's utopian future envisages the disappearance of the concept of sexual identity. In the present, she advocates

the dissident eruption into language of the female exile, and in particular of the mother, who, existing on the margins of society, 'circulates passion between life and death, self and other, culture and nature, singularity and ethics, narcissism and self-denial' (1986c: 298).

For Tania Modleski, as for other feminist film theorists such as E. Ann Kaplan ,[6] Kristeva's theories provide an alternative way of viewing the melodrama and 'woman's film'. The 'hysteria' which both Nowell-Smith and Doane see as characteristic of the melodramatic text becomes, from the viewpoint of the 'women in melodrama' and of the female spectator to whom they 'speak', rather the manifestation of *another* relationship to time and space, desire and memory' (Modleski 1987: 336). Woman's 'placement on the margins of patriarchal culture – at once inside and outside its codes and structures' (1988: 117) means that the position of the female spectator is complex and contradictory. Woman's greater bisexuality, the result of a stronger pre-Oedipal relationship with the mother which is a relationship of both identification and desire, means that female spectatorship cannot be fitted into the straightforward binary oppositions which both Mulvey and Doane propose. But, as Kristeva also argues, bisexuality and a preoccupation with the 'feminine' is a characteristic of men, too, though in a repressed and often hostile form. Thus Modleski can argue that a repressed feminine 'voice' can be found in apparently misogynist texts, a voice which can be identified and 'read' by the female spectator. Her 1988 book *The Women who Knew too Much*, therefore, is a reading of Hitchcock's films which argues that Hitchcock's preoccupation with the feminine produces texts which are 'divided against themselves' (1988: 117). In these films 'men's fascination and identification with the feminine continually undermine their efforts to achieve masculine strength and autonomy' so that 'occasionally the "individuality" of the Other triumphs over the efforts to assimilate and destroy it'. It is the task of the feminist critic to 'identify and celebrate these triumphs' (1988: 8, 117). The feminist critic, like all female spectators, occupies a reading position which is *different* from that of the male critic/spectator. To 'insist on the very different meaning a given text may have for women' (1988: 17) involves a struggle over meaning, a political act of interpretation. Echoing Kristeva, Modleski argues that

> [f]eminist critics must refuse to bow before the camera's 'terrifying power' and, instead, *affirm* the theatrical, 'treacherous' aspects of these 'seductive' texts – those parts which 'know' more than their author, those moments ... when woman resists capitulation to male power and male designs (1988: 119)

Modleski's reading of Hitchcock's *Rebecca* (1940) is consequently very different from that of Doane. Doane's analysis focuses on the film's 'narrativized paranoia', on the fear with which the gaze of the female protagonist is invested, and on the film's narrative preoccupation with the woman as spectator which culminates in the scene where the protagonist watches her-

self as image in a home movie made by her husband, Maxim. In this scene, we see enacted the two positions which are offered to the female spectator, the narcissistic desire to 'become the image which captures the male gaze' and the paranoid 'fear of being looked at' (Doane 1987: 166–8). Towards the end of the film we also see performed the ultimate repression of female subjectivity, as Maxim narrates the story of his dead wife Rebecca, and *the camera* enacts her movements, dictated by his words. Here, argues Doane, '[i]n tracing the absence of the woman, the camera inscribes its own presence in the film as phallic substitute – the pen which writes the feminine body' (1987: 170). Modleski's analysis, however, gives the scene a very different meaning. It is true, she argues, that 'in the film's *narrative*, Rebecca is subjected to a brutal devaluation and punishment', punishment for her sexuality and her 'challenge to patriarchal laws of succession' (1988: 53). Nevertheless, she maintains, Rebecca's very absence in the film makes it 'impossible for any man to gain control over her in the usual classical narrative fashion' (1988: 52). She *cannot* be reduced to the object of the gaze, but instead 'lurks in the blind space of the film, with the result that ... she never becomes "domesticated"' (1988: 53). Like Doane's ideal female spectator, Rebecca wears femininity as a mask, revelling in her multiplicity and duplicity, so that the film manages 'in the course of its unfolding to hint at what feminine desire might be like were it allowed greater scope' (1988: 54).

Elsewhere, Modleski explicitly takes issue with Doane's pessimistic view of the female spectator's available options. In 'Film and the Masquerade – Theorising the Female Spectator' (1982), Doane analyses a 1948 still photograph by Robert Doisneau as an image of the negation of the female gaze in classical Hollywood cinema. The photograph, she writes, performs an elaborate visual joke at the expense of the female spectator. At its centre is a woman gazing intently at a painting whose back is to us. By her side, and on the margins of the frame, a man (presumably her husband) looks past her, to another painting, of a female nude, which we, like the husband, *can* see. Despite her centrality in the frame, therefore, the joke is on the woman. Her gaze is blocked, since we cannot see what she is looking at; his pleasure (and triumph) is shared by the spectator. To 'get' the joke, argues Doane, the female spectator must assume either a masculine or a masochistic reading position. Modleski, however, disagrees. The female spectator, she argues, may 'get' the joke but, because her reading position is *different* from that of the man, may respond with *anger* rather than pleasure. It is this anger which fuels feminist criticism. What is perhaps most attractive about Modleski's position is that, whereas Doane identifies the position of the (ordinary) female spectator with that of the duped woman in the picture, but sites the feminist critic somewhere else ('masquerading' as feminine), Modleski positions the feminist critic *with* the (ordinary) female spectator, united in a common response. Jokes, argues Modleski, take on different meanings and different political inflections according to the community within which they are told. Her example, 'Why do women have vaginas? So

men will talk to them', means something very different when told within an all-women group from its meaning when told in an all-male context.

Modleski's is therefore a position which gives far greater power to the differently positioned female spectator than does Doane's. Despite its attractiveness, however, it does have problems. One is outlined by Doane in her response to Modleski's criticism. 'The pressures', she writes, 'are great – the pressure to find pleasure, the pressure to laugh, the pressure not to feel excluded from the textual field of a dominant mass culture' (1991b: 42). To bow to this pressure, however, is to abandon feminism's critical function. To attempt to recuperate Hitchcock's films for feminism, as Modleski does, is to lose sight of the *dominant* meaning of the text, and its social and symbolic power in a patriarchal culture. The joke, she argues, *is* only funny at the expense of the woman; to argue otherwise is to abandon the search for *different* jokes, and different films.

A second problem can be seen to lie in Modleski's identification of the repressed 'feminine voice' within the male-dominated text with the 'femininity' of the female spectator who may respond to it. Doane emphasizes that the patriarchal text constructs only its own *idea* of femininity, an 'imaginary' female spectator who is the product of the text's organization. Modleski, however, in suggesting that an authentic 'feminine voice' may be heard despite, in Hitchcock's case, the film's own constructions, seems to reach towards an essentialist notion of femininity which is somehow anterior to the text but accessible to the female spectator. It is a tendency which her adoption of Kristeva's theories can seem to support. To identify the feminine always with that which is repressed and/or that which subverts the patriarchal order (the '*rhythm* of experience [which] establishes itself against its value') can, despite efforts to locate this in women's different *positioning* within patriarchy, appear simply to repeat patriarchal dualisms.

The social spectator

Another writer who challenges a pessimistic view of the female spectator is Linda Williams. Williams raises explicitly the difficulty of identifying an 'authentic' female subjectivity, but concludes:

> It is an understandably easier task to reject 'dominant' or 'institutional' modes of representation altogether than to discover within these existing modes glimpses of a more 'authentic' (the term itself is indeed problematic) female subjectivity. And yet I believe that this latter is a more fruitful avenue of approach, not only as a means of identifying what pleasure there is for women spectators within the classical narrative cinema, but also as a means of developing new representational

strategies that will more fully speak to women audiences. For such speech must begin in a language, that, however circumscribed within patriarchal ideology, will be recognised and understood by women. (1987: 304)

Like Modleski and Doane, Williams looks to Irigaray and Kristeva to provide accounts of how an alternative theory of female subjectivity might be developed. Irigaray, then, provides a utopian vision of 'a community of women relating to and speaking to one another outside the constraints of a masculine language that reduces everything to its own need for unity and identity' (1987: 207). Kristeva, however, goes beyond Irigaray in recognizing that 'such speech is never entirely authentic, never entirely free of the phallic influence of symbolic language' (1987: 308). Thus, though Kristeva speaks 'from the mother's position', she does so, according to Williams, in the knowledge that 'there is no unified subject position there'. Maternity 'is characterised by division', and articulated in the dialectic between the semiotic and the symbolic (1987: 308). But Williams also draws on the theories of American sociologist Nancy Chodorow to explain the different positioning of women within patriarchy. Chodorow's (1978) *The Reproduction of Mothering* is an analysis of 'the reproduction of mothering as a central and constituting element in the social organization and reproduction of gender' (Chodorow 1978: 7). For Chodorow, the Oedipal journeys which Freud describes are indeed accurate descriptions, but they are not, as psychoanalysis assumes, the result of universal psychic processes. They are rather the result of a particular social organization which produces a division between the 'private, domestic world of women and the public, social world of men' (1978: 174). Because it is women who mother, the first role identification for children of both genders is with their mothers. For girls, therefore, maturity means a continuity of identification. The girl's identification with her mother is established through the mother's *presence* and is unbroken, which means that 'women's sense of self is continuous with others' (1978: 207). A boy's identity, however, is established through separation and difference, and his identification with the father is based on the father's *absence*. None of this, however, is, according to Chodorow, immutable. It is rather the product of 'social structurally induced psychological processes' (1978: 7).

Williams' view of the 'female positions constructed by the maternal melodrama' has, therefore, a more sociological cast to it than Modleski's. The reading positions structured into such films demand, she argues, a 'female reading competence', one developed through the 'social construction of female identity' (1987: 305). Her analysis of the 1937 maternal melodrama, *Stella Dallas*, articulates her argument. *Stella Dallas* has been generally seen as exemplifying the maternal melodrama of sacrifice. Stella (Barbara Stanwyck) is, in Mary Ann Doane's words, 'the victim of desires which exceed her social status' (1987: 75). Refusing to follow her upper-

class husband to New York, she brings up her daughter Laurel alone, becoming more and more *excessive* (as Molly Haskell pointed out) in her performance of femininity, and so preventing Laurel from achieving the social success to which they both aspire. Realizing this, Stella pretends to Laurel that she wants to be 'something else besides a mother' and gives her up to the care of her father and his new wife. The final scene of a film which foregrounds the female gaze sees Stella, now stripped of all her ruffles, feathers, jewellery and make-up, gazing from the street through the window at her daughter's wedding. She leaves the scene apparently triumphant in her sacrifice. For Mary Ann Doane this final scene demonstrates the position of the female spectator. Stella, at the window, 'cannot be a voyeur despite the policeman's exhortation to move on (and hence the suggestion of the illegality of her vision). Her visual pleasure is not (at least explicitly) a sexual one – it must be mixed with tears and suffering'. Stella loses her own identity in her overidentification with the romantic image of her daughter; as spectators, we are in turn invited to overidentify with Stella in 'a ritualized mourning of the woman's losses in a patriarchal society' (1987: 77–8).

This analysis of the transformation of Stella into 'mother-as-spectator'[7] as a model for the female spectator is one rejected by Williams. The ending, like the rest of the film, she argues, is 'multiply identified'. In the film we are offered a *number* of female subject positions – those of Laurel and her stepmother, Helen Morrison, as well as Stella's – and Stella's own position is full of contradiction. We are also invited to identify with the relationship *between* the women. The female spectator, then, views the film 'from a variety of subject positions'; indeed, she 'tends to identify with contradiction itself – with contradictions located at the heart of the socially constructed roles of daughter, wife *and* mother – rather than with the single person of the mother' (1987: 314). Drawing on Kristeva, Williams argues that the female spectator's position is not unified, but caught in a dialectic between 'maternal and paternal forms of language'. Drawing on Chodorow, she argues that this position is *socially* produced. Her conclusion, therefore, explicitly challenges Doane's pessimism. The distance from the image which Doane argues is possible for the female spectator only through a conscious adoption of 'masquerade' is for Williams a characteristic of the viewing experience of *all* women. Thus the process of disavowal (the balancing of knowledge and belief) which from Metz onwards has been seen as a characteristic of the male spectator's viewing experience is, though in a different form, characteristic of *women's* viewing. The female spectator '*knows* that women can find no genuine form of representation under patriarchal structures of voyeuristic or fetishistic viewing, because she has seen Stella lose herself as a woman and as a mother. But at the same time she *believes* that women exist outside this phallic economy, because she has glimpsed moments of resistance in which two women have been able to represent themselves to themselves through the mediation of their own gazes' (1987: 318).

Williams' shifting of the argument towards a more *socially* constructed concept of the female spectator is carried further in her analysis of *Mildred Pierce* (1945). Here she expresses her concern that 'in reading films in the context of current feminist enlightenment we sometimes ignore the more difficult task of reading the contradictory situation of the historical female spectator' (1988: 13). It is only, she argues, if we return to a consideration of the *historical* female spectator (largely absent in feminist film theory since Rosen and Haskell's work of the early 1970s[8]) that the full complexity of the female spectator's 'multiple and often contradictory identifications' (1988: 27) can be understood. *Mildred Pierce*, she argues, a film which was produced during the Second World War but which omits any reference to the war, *both* represses *and* reflects women's wartime experience. By not representing the war, it can allow women's wartime experience of independence and autonomy to be represented without constant reference to the 'heroic but absent patriarch' (1988: 23). At the same time, however, such an omission also represses the extent of the real and threatening matriarchal power which the war made possible. In the film, patriarchy can be easily restored; the temporarily 'absent' husband can be reinstated without any acknowledgement of the upset in gender relations caused by the war.

'Women's discourse'

The return of the socially and historically positioned female spectator – an answer to the exasperated protest of B. Ruby Rich with which I began this chapter, that in feminist film theory 'there don't seem to be any *women* there' – can be seen even more fully in the work of Maria La Place and Christine Gledhill with which I shall end it. Like Williams, La Place insists that only a consideration of a film's historical positioning can reveal the 'elements of contradiction, discursive struggle and subversive signification which throw up barriers to closure and patriarchal hegemony' (1987: 138). Her analysis of *Now, Voyager* (1942) identifies three discourses privileged by the film and its marketing. The first, that of consumerism, recalls Doane's arguments about the relationship of the female spectator to consumption. La Place, however, sees this appeal to the woman as consumer as more contradictory than Doane allowed. Consumerism may harness female desire to a female market, in the service of patriarchy and capitalism, but to do so it must also 'appeal to female desire itself, to wants and wishes, to (libidinal) pleasure, sexuality and the erotic, and a species of economic decision and choice' (1987: 145). The second discourse, that of the star-system, is equally contradictory. Like Molly Haskell, La Place sees the image of the star, constructed across a range of films as well as through

cinema-related texts (fan magazines, gossip columns, newspaper and magazine articles), as one which may work to modify or subvert the film's narrative. The narrative outcome of *Now, Voyager*, in which Charlotte Vale (Bette Davis) relinquishes sexuality in favour of a quasi-maternal role, is therefore complicated by Davis' image as assertive, independent and powerful. Viewed from this perspective, Charlotte's final placing outside marriage and domesticity can be seen as a (limited) assertion of female autonomy. Finally, the discourse of women's fiction, with its twin themes of self-discovery and romance, serves to pull the film even further into the orbit of a *women's* (resistant) discourse. Like many 'women's films', *Now, Voyager* was based on a best-selling women's novel. Such novels are structured by a specifically female narrative trajectory, in which female desire – for autonomy as well as romance – is powerfully registered, even though it may be reconciled with patriarchy through its confinement to the realm of the personal and domestic. By appealing to this subordinate 'woman's culture', *Now, Voyager* opens itself to a reading from within a 'symbolic system in which women can try to make sense of their lives and even create imaginative spaces for resistance, a system which the film, seeking to address women, drawing on a woman's popular novel and a popular woman's star, enters despite itself' (1987: 165).

A similar argument, that the woman's film is the product of 'cultural negotiation', in which *competing* discourses may be discerned, is also made by Christine Gledhill in her survey of 'The Melodramatic Field' with which this chapter began. Melodrama and the 'woman's film', argues Gledhill, may reduce 'woman' to a symbol through which patriarchal fears and desires centring on the 'feminine' may be played out, but, in order to appeal to a female audience, they must draw on a 'circuit of women's discourse' for their material. Inevitably, then, the 'figure of woman' becomes a contested symbol in a 'struggle between male and female voices' (1987: 37), both within the film and in the readings which male and female spectators might make of it.

For Christine Gledhill, then, the 'woman's film' is both a product and a source of 'cultural negotiation', the site of 'a struggle between male and female voices'. This is an argument – that the 'popular' is *always* 'fraught with tension, struggles and negotiations' (1987: 37) – which is a long way from Laura Mulvey's claim in her 1977 essay on 'Sirk and Melodrama' that women have been 'largely without a voice, gagged and deprived of outlets', including that of 'popular culture' (1989c: 39). To make it, Gledhill, like La Place, has shifted the theoretical terrain – away from what she calls 'cine-psychoanalysis' (1988: 65), and towards what can be termed a 'Cultural Studies' perspective. Such a break offers one way out of the apparent impasse which the powerful and influential work of Mulvey and Doane seemed to produce. Faced with a 'cine-psychoanalysis' which produced so little space for resistance by its female spectators, feminist film theory seemed to have two options. The first, suggested in Doane's concept of

masquerade and spectatorial play, was to wrest from psychoanalysis a view of spectatorship and cinematic pleasure which would be less tied to the Oedipal trajectory. The second was to look elsewhere for theoretical ground from which to argue the possibility and/or reality of women's resistance. Both directions were pursued; discussion of them will form the material of Chapters Four and Five.

4

Negotiating the text: spectator positions and audience readings

We can usefully analyse the 'you' or 'yous' that the text as discourse constructs, but we cannot assume that any individual audience member will necessarily occupy these positions. The relation of the audience to the text will not be determined solely by that text, but also by position-alities in relation to a whole range of other discourses ... elaborated elsewhere, already in circulation and brought to the [text] by the viewer. (Brunsdon 1981: 32–7)

I have never thought of the female spectator as synonymous with the woman sitting in front of the screen, munching her popcorn. ... The female spectator is a concept, not a person ... In *The Desire to Desire*, I view the female spectator as the vanishing point of a textual configu-ration. ... She is a projection of the text ... (Doane 1989: 142–3)

[R]eading through the minefield of critical literature on 'the female spectator,' one thing emerges clearly: '*a* cinematic female spectator' has certainly been constructed within feminist theory but 'she' is very much a construction of that critical discourse, based in psychoanalytic theory, and probably bears only a tenuous relation to the woman who sits silently in the darkened auditorium eating her peanuts. (Creed 1989: 132–3)

In the pages of the special issue of *Camera Obscura* (20/21, 1989) devoted to the concept of the female spectator, the question raised by these three quotations – that of the relationship between the 'cinematic female specta-tor of feminist theory' and the 'female spectator in the theater' (Creed 1989: 133) – recurs as a constant pressure. But Creed's formulation of the issue also prompts another question: where is the feminist theorist positioned in relation to this division? She would seem, after all, to be neither the 'she' constructed by critical discourse nor the figure caught – significantly – in the act of consumption ('munching her popcorn' or 'eating her peanuts') by the feminist's critical gaze. The need to theorize the relationship between these

three positions – those of the feminist, the textually inscribed female specta-
tor, and the woman in the audience – is also the stated imperative behind
Christine Gledhill's 1978 essay, 'Recent Developments in Feminist
Criticism'. Gledhill's own engagement with feminist film theory is the result,
she writes, firstly of her encounter with the new 'neo-Marxist and psycho-
analytic' film theory in the pages of the journal *Screen*, whilst also teaching
film in further and adult education, and secondly of her need, as a socialist-
feminist, to 'interrogate current theoretical work in film for "really useful
knowledge"' in political terms. This need to close the gap between 'current
theories of culture and political practice', and between 'readings of films
that are illuminating to feminist film theorists' and the way these films are
'understood and used by women at large' (Gledhill 1978: 457, 461), leads
Gledhill, as it does Charlotte Brunsdon, to an engagement with the perspec-
tives emerging in the 1970s within British Cultural Studies.

'Cultural Studies and the Centre'[1]

British Cultural Studies locates its institutional 'founding moment' in 1964,
with the establishing at Birmingham University of the Centre for
Contemporary Cultural Studies under the directorship of Richard Hoggart.
Hoggart's *The Uses of Literacy* (1957), along with Raymond Williams'
Culture and Society (1958) and *The Long Revolution* (1961) and E. P.
Thompson's *The Making of the English Working Class* (1963), supplied, in
Stuart Hall's words, 'the original "curriculum" of the field' (Hall 1980a:
16), although this 'curriculum' was to undergo rapid development during
the 1960s and 1970s. Together, these books enabled a reconceptualization
of culture as '*both* ... a way of life – encompassing ideas, attitudes, lan-
guages, practices, institutions, and structures of power – and a whole range
of cultural practices: artistic forms, texts, canons, architecture, mass-
produced commodities, and so forth' (Nelson *et al.* 1992: 5). They also
inaugurated an interdisciplinary methodology which would combine
textual analysis with a focus on historical and social context, and, most
important, they established the central project of cultural studies as both
theoretical and political. In Stuart Hall's words:

> From its inception, ... Cultural Studies was an 'engaged' set of disci-
> plines, addressing awkward but relevant issues about contemporary
> society and culture, often without benefit of that scholarly detachment
> or distance which the passage of time alone sometimes confers on
> other fields of studies. The 'contemporary' ... was, by definition, hot
> to handle. This tension (between what might loosely be called 'politi-
> cal' and intellectual concerns) has shaped Cultural Studies ever since.
> (Hall 1980a: 17)

It was under Stuart Hall's directorship from 1968–79 that the Centre fully established this focus and produced its most important work. Reviewing this history in 1992, Hall writes of this central but 'ever irresolvable' tension between the theoretical and the political within cultural studies as 'the worldliness of cultural studies, ... the dirtiness of the semiotic game'. There is always, he writes, 'something decentred about the medium of culture, about language, textuality, and signification, which always escapes and evades the attempt to link it, directly and immediately, with other structures. And yet, at the same time, the shadow, the imprint, the trace, of those other formations, of the intertextuality of texts in their institutional positions, of texts as sources of power, of textuality as a site of representation and resistance, all of those questions can never be erased from cultural studies'. Culture, then, 'will always work through its textualities', but at the same time, 'textuality is never enough' (Hall 1992: 278, 284).

Like feminist film theory, then, cultural studies embraced the 'structuralist' theories of ideology and subjectivity emerging within the work of Althusser, Barthes, Lévi-Strauss and Lacan in the 1960s and 1970s. What such theories offered was, in Hall's words, a view of culture as 'itself a practice – a *signifying* practice – [with] its own determinate product: meaning' (Hall 1980a: 30). This shift 'from the *what* to the *how* of cultural systems' also offered a way of theorising the ideological *power* of cultural institutions, texts and practices. The work of Althusser, in particular, argues Hall, 'reasserted the conception of ideologies as practices rather than systems of ideas. It defined ideologies as providing the frameworks of understanding through which men interpret, make sense of, experience and "live" the material conditions in which they find themselves' (1980a: 32). It also, as we have seen (Chapter 2), regarded this process as operating through the power of cultural apparatuses like cinema to constitute or 'interpellate' individual human beings as 'subjects' within culture.

The textual focus of cultural studies, however, was considerably broader than that of film theory. In the words of Hoggart's inaugural lecture at the Birmingham Centre, it concerned itself with '"neglected" materials drawn from popular culture and the mass media' (Hall 1980a: 21). As such, it found itself engaging critically not only with contemporary developments in cultural and film theory but with an existing tradition of media research which approached the study of film and television from a very different perspective. This approach, characterized by Hall as '"mass-communications research"... defined largely by American empirical social science practice' (1980b: 117), focused on the effects and influence of the mass media, as measured by large-scale audience surveys and quantitative content analysis. If film theory in the 1970s could be viewed as operating without a concept of the socially and historically positioned spectator, 'mass communications' research operated without a concept of the text. In Hall's words, media texts were regarded as '"transparent" bearers of meaning – as the "message" in some undifferentiated way' (1980b: 117). Cultural studies work on

the mass media set out to position itself against both of these theoretical stances, to produce a model of the text–reader relationship which would account for the whole of the communicative process. Such a model was set out in Hall's 1973 paper, 'Encoding and Decoding in the Television Discourse'.[2]

Hall's model sees the communicative process as 'a structure produced and sustained through the articulation of linked but distinctive moments' (1980c: 128). These moments – of production ('encoding'), text ('programme as "meaningful" discourse') and reception ('decoding') – are 'relatively autonomous' in relation to the whole process. Each is a 'determinate' moment – that is, each has its own structures and processes, whether institutional (in the case of the moment of production) or semiotic (in the case of the text) which will be productive of meaning. Each is the site of struggle – over which meanings about an event or narrative will be 'encoded' by the producers, which meanings will be 'structured in dominance' in the text, and which meanings will be read off ('decoded') by the audience/spectator. Following Barthes, therefore (see Chapter Two), Hall argues that the textual sign, at its connotative level, is a carrier of ideology, but he also argues, following Valentin Volosinov,[3] that the sign is 'multi-accentual'. Texts, that is, are the sites of *struggles* over meaning: terms such as 'the nation' or 'black' or 'woman' will have meanings which are 'preferred' by the dominant ideology, but these meanings will also be contested by subordinate groups within society and often wrenched from their original connotations. Texts, then, are 'polysemic' (open to more than one possible reading), although the dominant cultural order will always tend 'with varying degrees of closure, to impose its classifications of the social and cultural and political world' (1980c: 134).

Audiences, too, will be engaged in the struggle over meaning. As part of the same social formation as the text's producers, the reader/spectator will have access to broadly the same range of discourses and 'maps of meaning'. The reader/spectator's *position* in this social formation may be different – as working class, as a member of an ethnic minority group, as a woman – so that the meanings 'preferred' by the text may be negotiated or even opposed by the reader/spectator. Thus the social subjects who decode a text's meaning are not the same as the text's implied or inscribed readers; they may draw on broadly the same range of discourses for their readings, and the range of readings they are able to produce will be limited by the text, but their readings cannot be *determined* by the text's preferred meanings. Underlying Hall's model was Antonio Gramsci's concept of 'hegemony', first articulated in the 1930s but adopted by the Birmingham Centre in the 1970s as one of its 'organizing ideas' (Hall 1980a: 286 n.92). In Gramsci's use, 'hegemony' refers to the processes whereby a dominant social group maintains this dominance politically and culturally, not through repressive means but by mobilizing the *consent* of subordinate groups to its explanations and definitions of social reality, so that they seem merely 'common

sense'. Like Althusser's concept of 'dominant ideology' (see Chapter 2), hegemony theory sees the sphere of culture as crucial in maintaining social inequalities through ideological means. Far more than Althusser's work, however, it sees the sphere of culture as a site of *struggle*, for in Gramsci's view '"hegemony" is never a permanent state of affairs and never uncontested' (Hall 1980a: 36). Adopting Gramsci's concept, therefore, Hall could see the communicative process as embodying a struggle over meaning both *between* its separate 'moments' and *within* the moments of the text's production, its own signifying structures, and its reception.

From this standpoint, therefore, Hall and his colleague David Morley took issue with '*Screen* film theory' of the early 1970s, which, as we have seen, drew on semiotics, Althusserian Marxism and psychoanalysis for its understanding of the text and the cinematic apparatus. *Screen* theory's mistake, argue Morley and Hall, is that it elides the processes by which the *subject* is inserted into culture and language (Lacan's 'symbolic order') with the processes by which each individual text seeks to position its reader. In so doing, argues Morley, it isolates the text–reader encounter 'from all historical and social structures *and* from other texts':

> To conceptualize the moment of reading/viewing in this way is to ignore the constant intervention of other texts and discourses, which *also* position 'the subject'. At the moment of textual encounter other discourses are always in play besides those of the particular text in focus – discourses which depend on other discursive formations, brought into play through 'the subject's' placing in other practices – cultural, educational, institutional. And these other discourses will set some of the terms in which any particular text is engaged and evaluated. (Morley 1980a: 163)

The entry of the subject into language and culture may, Morley continues, create the mechanisms through which s/he is *available* for positioning by specific texts, but it cannot predetermine what those positionings will be or how the subject, who comes to *that* text bearing the traces of previous textual and social positionings ('interpellations'), will respond. Nor, he argues, does the fact that the individual may take up the spectator position preferred by the text mean that s/he necessarily subscribes to the ideological position inscribed in it: 'The text may be contradicted by the subject's position(s) in relation to other texts, problematics, institutions, discursive formations' (1980a: 167). I may, for example, (at least partially) identify with Julia Roberts when I watch *Pretty Woman*, but that does not mean that when I leave the cinema I will subscribe to the ideology of femininity which the film prefers. Stuart Hall goes further in his critique of *Screen* theory, arguing that its reliance on Lacan's theories of the subject to explain how ideology works produces a monolithic concept of ideology which is always patriarchal and always in place. If, he argues, 'the "Law of Culture" is by definition and always, the "Law of the Father", and this is the condition of

language and the "symbolic", then it is difficult to see why patriarchy is not
– psychoanalytically rather than biologically – a woman's necessary and
irreversible destiny' (Hall 1980d: 162).

Investigating the 'social subject'

Looking back on his encoding/decoding model in 1994, Stuart Hall
reflected: 'It suggests an approach; it opens up new questions. It maps the
terrain. ... It's only once I had written it that I saw that if you were going
to contest an old model of audience research and open up a new one, then
somebody's going to try and put it into effect. And then ... we had the
real problem: How the hell do you actually test this with some actual
folks?' (Cruz and Lewis 1994: 225). David Morley's research on *The
'Nationwide' Audience* (1980) set out to do that. Morley, together with
Charlotte Brunsdon, had already published a textual study of the ideo-
logical address of the BBC's early evening magazine programme,
'Nationwide'. His follow-up study set out to explore the degree to which
actual social subjects accepted or rejected the programme's preferred read-
ing of events and issues. Morley showed two videotaped 'Nationwide' pro-
grammes to 29 groups of between five and ten people drawn from
different social and cultural backgrounds, and from different levels of the
educational system. In each case, the group's 'social identity' was seen to
lie in its members' common position in the occupational (bank managers,
apprentices, shop stewards) or educational (school-children, further or
higher education students) structure. The group interviews and discussions
which followed were tape-recorded and then transcribed. The aim was to
see how far the conceptual frameworks and perspectives of the respon-
dents matched those of the programme's discourse, and how this degree of
conceptual 'fit' corresponded with the groups' social and cultural position-
ing. This research, in the words of Shaun Moores, marked 'an important
turning point at which attention began to be switched from the narrow
investigation of textual forms towards an empirical exploration of audi-
ence engagement with texts' (1993: 22). What Morley found was that
audience groups did indeed produce 'negotiated' readings of the text, but
that these readings could not be matched in any straightforward way with
social or economic class positioning. He concluded that 'the subject's posi-
tion in the social formation structures his or her range of access to various
discourses and ideological codes, and correspondingly different readings of
programmes will be made by subjects "inhabiting" these different dis-
courses' (1980b: 158). What was clear, however, was that in identifying
this 'position in the social formation', social class was not the only, nor
indeed the most important, factor.

Feminism and/in cultural studies

For cultural studies . . . , the intervention of feminism was specific and decisive. It was ruptural. It reorganized the field in quite concrete ways. First, the opening of the question of the personal as political, and its consequences for changing the object of study in cultural studies, was completely revolutionary in a theoretical and practical way. Second, the radical expansion of the notion of power, which had hitherto been very much developed within the framework of the notion of the public, the public domain, with the effect that we could not use the term power – so key to the earlier problematic of hegemony – in the same way. Third, the centrality of questions of gender and sexuality to the understanding of power itself. Fourth, the opening of many of the questions that we thought we had abolished around the dangerous area of the subjective and the subject, which lodged those questions at the center of cultural studies as a theoretical practice. Fifth, the 're-opening' of the closed frontier between social theory and the theory of the unconscious – psychoanalysis.
(Hall 1992: 282)

Stuart Hall's 1992 account of how feminism 'broke, and broke into, cultural studies' (1992: 283) makes it clear that this was no easy relationship. Nevertheless, in the concepts of hegemony and textual negotiation – once freed from their original grounding in class-based analysis and re-framed as an account of the operations of *patriarchal* power – feminists could find an account of the text–reader relationship which might challenge the textual determinism of psychoanalytic accounts. The focus in David Morley's research on the *act of reading*, and on the relationship between that act and the complex positionings of individuals within culture, also offered a methodology through which feminists might explore in their own research the relationship between feminist theory and the textual readings made by actual women. At the same time, *feminist* research based on Hall's encoding/decoding model, in shifting from a class-based concept of power to one focused on gender relationships, would also shift the arena of such research from the public domain of Morley's occupationally organized groups to the private domain of the family. Thus, in the words of Sarah Franklin, Celia Lury and Jackie Stacey, such research could 'engage with the "personal" dimensions of culture in the political context of a feminist analysis' (1991: 6). The personal and the theoretical, 'feminism' and 'women' – the troubling gap between both these pairs of terms might perhaps be closed. Thus the 1970s and 1980s saw a growing feminist interest in research which would move beyond the analysis of the textual positions constructed for the (imagined) female spectator to explore the actual readings which women made of such texts.

Dorothy Hobson's (1982) *'Crossroads': The Drama of a Soap Opera* was one of the first contributions to such study. Like Morley, Hobson was based at the Birmingham Centre, and her study of the Midlands-based soap opera sought to examine both its moment of 'encoding' (its production processes and the views of its producers) and audience 'decodings' of specific episodes. Unlike Morley, Hobson used an 'ethnographic'[4] research methodology: to study the viewing processes of its female audience she watched *with* the viewer, following such observation with a (transcribed) unstructured interview. Thus, she argues, 'I became part of the shared experience of viewing in that situation and I struggled to concentrate against the same odds as [the young mother who was her object of study]. The three year old invited me to help her eat her tea, the five year old to look at drawings from play school and talk about new shoes . . . ' (1982: 112–3). As a result, her view of the text–viewer relationship underwent a considerable shift. She found that her subjects watched the programme in a 'distracted' fashion whilst simultaneously completing household tasks, often relying on the dialogue alone for information since they were not free to watch the screen. She also found that the women refused in their discussions to isolate the individual episode as an object of analysis, but instead ranged backwards and forwards over the serial as a whole, drawing on knowledge and experience both of the serial itself and of their social positioning as women in order to produce their interpretations. Their 'readings' differed according to their own experiences and understandings as women – were made, indeed, through reference to those experiences. The conclusion which she draws is effectively an abandonment of Hall's model of meaning production as articulated 'determinate moments', in favour of an insistence on the moment of *reading* as the site of the construction of the text's meaning: 'To try to say what Crossroads means to its audience is impossible for there is no single Crossroads, there are as many different Crossroads as there are viewers. Tonight twelve million, tomorrow thirteen million; with thirteen million possible understandings of the programme' (1982: 136). Such wholesale abandonment of the effectivity – indeed the very concept – of the text would seem to be an extreme outcome of the effort to align the position of 'feminist theorist' with that of 'female viewer' since its result is in effect to deny the theorist any position other than that of uncritical celebration of whatever readings 'real women' produce.

A rather more complex account of the text–reader relationship from a cultural studies perspective appears in Janice Radway's (1984) study of romantic fiction and its readers, *Reading the Romance*. Radway's academic background, as a scholar in the US working within American studies and literary criticism, would seem to separate her from the theoretical tradition examined so far in this chapter. Indeed, as she makes clear in her introduction to the British edition of the book, the research for *Reading the Romance* was begun in ignorance of the parallel work being undertaken in Britain. Nevertheless, both its methodology – a combination of textual

analysis and ethnographic research – and its conclusions make it an important contributor to feminist cultural studies. Radway studied a 'community' of women romance readers in a Midwestern town which she called Smithton, using a combination of questionnaires, observation, and group and individual interviews to obtain her material. The group was loosely organized around Radway's contact, Dot, who worked in a bookstore selling romantic fiction and who, through her production of a regular review newsletter, had become the focal point for a group of women who relied on her judgement in choosing their romance reading material. Based on the women's characterization of the 'ideal romance', Radway also analysed the genre's structural and ideological features, and the 'unconscious needs that underpin and reinforce the more conscious motives ... that prompt [the women] to seek out the romantic fantasy' (1987: 120).

Like Linda Williams, in her analysis of the maternal melodrama, Radway turns to the work of Nancy Chodorow for her theoretical framework. Drawing on Chodorow's characterization of 'the female personality as self-in-relation' (Radway 1987: 138), the consequence of the early mother–daughter relationship, Radway sees the 'ideal romance' as *both* representing women's felt needs for nurturing and relationship in a patriarchal culture which 'systematically represses' men's capacity to nurture *and* offering the promise that these needs can in fact be fulfilled within the heterosexual relationship. The 'ideal heroine', then, begins in a state of 'emotional isolation and [with a] profound sense of loss', the loss, often explicitly figured, of her relationship with her mother. The romance then charts her 'successful journey from isolation and its threat of annihilation to connection and the promise of a mature, fulfilled, female identity' (1987: 135). This success is achieved through 'the combination of her womanly sensuality and mothering capacities that will magically remake a man incapable of expressing emotions or of admitting dependence. As a result of her effort, he will be transformed into an ideal figure possessing both masculine power and the more "effeminate" ability to discern her needs and to attend to their fulfillment in a tender, solicitous way' (1987: 127–8). Thus, the romance's initial scenario of unfulfilled heroine and independent, emotionally repressed hero provides a represention of the inadequacy for women of gendered relationships as constructed within patriarchy: 'all popular romantic fiction originates in the failure of patriarchal culture to satisfy its female members' (1987: 151). But its 'magical solution', in which, with the aid of the heroine, the hero is revealed to be in fact capable of that nurturance which she needs and desires, produces a reaffirmation of patriarchal culture:

Because the romance finally leaves unchallenged the male right to the public spheres of work, politics, and power, because it refurbishes the institution of marriage by suggesting how it might be viewed continuously as a courtship, because it represents real female needs within the story and then depicts their satisfaction by traditional heterosexual

relations, the romance avoids questioning the institutionalized basis of patriarchal control over women even as it serves as a locus of protest against some of its emotional consequences. (1987: 217).

When Radway turned from the texts themselves to an analysis of the significance of the 'act of reading' for the Smithton readers, however, she was 'surprised into' rather different conclusions. The readers saw the act of romance reading as a 'declaration of independence' (1987: 7), a carving out of 'a solitary space within an arena where their self-interest is usually identified with the interests of others and where they are defined as a public resource to be mined at will by the family' (1987: 211). In indulging their own 'private pleasure', they refused the demands of husband and children and claimed, at least vicariously, that nurturance which the story's heroine discovers in heterosexual romance. They also insisted on the independence and assertiveness of the heroine of the 'ideal romance', arguing that they themselves were strengthened by identification with such qualities. The discrepancy between Radway's textual analysis and the women's own readings leads her to conclude that 'the meaning of their media-use was multiply determined and internally contradictory and that to get at its complexity it would be helpful to distinguish analytically between the significance of the *event* of reading and the meaning of the *text* constructed as its consequence' (1987: 7). It is an interesting distinction, since Radway here seems to add to Hobson's differentiation between the media text as artefact (television programme or romance novel) and as constructed in the act of reading ('there are as many different Crossroads as there are viewers') the further distinction between reading as interpretation and reading as cultural event. 'Meaning' is therefore the product of negotiation and contradiction first within the text itself (between the representations of women's needs and the demands of patriarchy), second within the text–reader relationship (between the reader's needs and desires and the 'preferred meaning' of the text), and third within the *act* of reading (between the reader's compliance with the structures of patriarchal marriage and her resistance to them).

Despite this emphasis on 'multiple determinations' and 'internal contradictions', however, Radway's conclusion does offer its own 'preferred reading' of these competing levels of meaning. Although her introduction (to the British edition) sees her theoretical position as 'quite close' to that of Dorothy Hobson, in its argument that 'there can be as many interpretations of a programme [or text] as the individual viewers bring to it' (1987: 8), in fact her conclusions point in a very different direction. Although an 'oppositional' or 'utopian'⁵ moment can be said to characterize the romance story, in its fantasy vision of an ideal nurturing relationship, both its message and the act of reading which it produces, she argues, function as ideological containment of its women readers. The 'oppositional impulse' which the Smithton women identify in the act of romance reading may embody a very real dissatisfaction with and protest against patriarchal structures, but

'despite the utopian force of the romance's projection, that projection actually leaves unchallenged the very system of social relations whose faults and imperfections give rise to the romance and which the romance is trying to perfect' (1987: 215). The romance thus functions hegemonically, to represent but ultimately contain women's limited protest, and win their consent to the patriarchal order. Rather than aligning the position of 'feminist theorist' with that of 'female reader', as Hobson's study does, Radway's analysis, despite its emphasis on contradiction and negotiation, in fact serves to align the 'female reader' of romance with its 'textually inscribed reader/spectator'. The Smithton women, it seems, cannot do other than occupy the positions which the romance text prefers. The task of the feminist theorist is once again, as it was in the very different work of Mary Ann Doane, to disturb that alignment through critical intervention. Her position is that of critical, and knowledgeable, other. In Ien Ang's words, 'Radway, the researcher, is a feminist and *not* a romance fan, the Smithton women, the researched, are romance readers and *not* feminists' (1988: 183). Unlike Doane's, however, Radway's theoretical position can at least *account for* the feminist theorist. Positioned differently within the social formation from the working-class women whom she studies, the feminist theorist has access to a different and more extensive range of discourses from which she may, following Stuart Hall's model, construct her 'maps of meaning'.

The criticism that Radway's conclusions embody 'a "recruitist"[6] conception of the politics of feminist research' in which the goal is to make 'them' (ordinary women) more like 'us' (feminists) is one made by Ien Ang in her review of *Reading the Romance* (Ang 1988: 184–5). Radway's aim, argues Ang, 'is directed at raising the consciousness of romance reading women, its mode is that of persuasion, conversion even. "Real" social change can only be brought about, Radway seems to believe, if romance readers would stop reading romances and become feminist activists instead' (1988: 184). Ang's own (1985) ethnographic study of Dutch followers of the American 'prime time' soap opera, *Dallas* (*Watching 'Dallas': Soap Opera and the Melodramatic Imagination*), offers a rather different analysis of the text–reader relationship. Unlike Radway, Ang relies for her material not on interviews but on the written responses of her subjects, but like Radway she uses these responses to theorise the troublesome relationship between feminism, women, and the text directed at a female audience.

Ang uses the accounts of melodrama produced within feminist film theory (see Chapter Three) to characterize *Dallas* as 'melodramatic soap opera' (1985: 68). Like film melodrama, she argues, *Dallas* represents 'the eternal contradiction, the insolubility of inner conflicts, the unbridgeability as it were of the antithesis between pleasure principle and reality principle' (1985: 72). The combination of this melodramatic scenario, with its focus on intensity and excess, and soap opera's lack of narrative resolution, its endless deferral and delay, evokes, in Ang's view, 'a tragic structure of feeling' (1985: 78). The continuous narrative of *Dallas* imprisons its characters

in a world of irresolvable contradictions, 'in which the area of the personal is all-prevailing, but in which at the same time all personal lives are perverted. For not a single individual in a soap opera is free to construct his or her own life history' (1985: 76). In the 'claustrophobic sphere of the closed community in which the characters live, ... hysteria can break out any moment, but is also curbed time and again. For in *Dallas* life always goes on normally, whatever happens' (1985: 78). The multiple characters of the soap opera mean that the 'viewer's position towards the individual characters is also ambiguous' (1985: 75). Like the maternal melodrama of Linda Williams' account (see Chapter Three), the soap opera offers its viewers 'multiple identifications'[7] which are, inevitably, contradictory.

The 'tragic structure of feeling' which is 'inscribed in the meaning-system of *Dallas*' will only 'make sense', however, 'if one can and will project oneself into, i.e. recognize, a *melodramatic imagination*', and 'it is mainly women who are susceptible to the melodramatic imagination, a type of imagination which appears to express mainly a rather passive, fatalistic and individualistic reaction to a vague feeling of powerlessness and unease' (1985: 79–82). This identification of the structures of melodrama with femininity is not, however, seen as the product of women's inevitable positioning in relation to culture or the 'symbolic order', as it would be in psychoanalytically based accounts. Instead, it is viewed as a matter of 'cultural competence',[8] the result of women's everyday experiences. Women's pleasure in the 'tragic structure of feeling' of *Dallas* is the pleasure of *recognition*, recognition of an emotional structure which 'is felt as "real" and which makes sense for these viewers' (1985: 87). Unlike the romance fiction which was the object of Radway's study, soap opera has no utopian 'happy ending': 'the problems in *Dallas* can never be solved and are essentially cyclical: the patriarchal status quo is non-viable but remains intact' (1985: 123). The pleasures it offers, therefore, are masochistic scenarios indulging feelings of fatalism and passivity. These pleasures, however, belong, argues Ang, to the realm of *fantasy*, 'a fictional area which is relatively cut off and independent'. Fantasy is 'a dimension of subjectivity which is a source of pleasure *because* it puts "reality" in parentheses, because it constructs imaginary solutions for real contradictions which in their fictional simplicity and their simple fictionality step outside the tedious complexity of the existing social relations of dominance and subordination' (1985: 135). Ang, then, relies on Laura Mulvey's accounts of the melodramatic structure for her textual analysis, but she reverses Mulvey's conclusions. Because she denies the positions offered by the text any direct relationship with the subject's positioning in culture, she can advocate the indulgence, not the destruction, of popular pleasures. Melodramatic fantasy, she argues, is only *one* discourse or subject position available within contemporary culture to the female reader, whose 'identity is the precarious and contradictory result of the specific set of subject positions she inhabits at any moment in history' (1990: 84). Its pleasures, then, are not only not incompatible with a feminist

politics but perhaps even necessary to it, a self-indulgent breathing space before the struggle is resumed.

If Ang accuses Radway of a 'recruitist' conception of the politics of feminist research, her own analysis can be said to fall within the category of what Charlotte Brunsdon terms the 'redemptive reading' of popular culture. Such readings, argues Brunsdon, are the outcome of the attempt to counter 'both the left-pessimist despair over and the high-cultural dismissal of mass and popular cultures'. The 'redemptive reading' is one which seeks to identify the 'progressive' potential of the popular text, although it is not simply celebratory of popular culture since it 'starts with an acceptance of the uncongenial politics of whatever cultural text – for it is primarily a political reading – and then finds, at the least, incoherences and contradiction, and at the most fully articulated subtexts of revolt' (1989: 121). In the case of *feminist* research, such readings are also the outcome of the attempt to bridge the gap between the feminist theorist and the 'ordinary' woman. As Brunsdon's account makes clear, it is the *political* need to align feminist theory more firmly with women's experience which drives such theoretical moves. But, she argues, in work such as Ang's, the film or television text has in fact 'been displaced by the text of the audience – a much more various and diverse text – and the enormous conceptual and methodological problems entailed' (1989: 122). The analyst is offering a 'reading' of her audience no less theoretical or abstract than the 'readings' of the textual critic. This argument, that the 'audience' or 'subculture' of the supposedly concrete ethnographic analysis' is as much an 'abstraction' as the 'female spectator' of psychoanalytically based feminist film theory, is one also made by Mary Ann Doane (1989: 143). In its attempt to bridge the gap between the theorist and the woman in the audience and give weight to the latter, such arguments suggest, ethnographic research risks simply sidestepping the difficult theoretical issues involved. Ang herself provides a response to such criticisms in a later piece, where she accepts the 'partial' (in both senses of the word) nature of cultural studies work on audiences, but argues that this 'partiality' is an aspect of that 'tension between the theoretical and the political' which Stuart Hall argued was central to the project of cultural studies:

> it is in the dialectic between the empirical and the theoretical, between experience and explanation, that forms of knowledge, that is interpretations, are constructed. Here then the thoroughly political nature of any research manifests itself. What is at stake is a *politics of interpretation*: 'to advance an interpretation is to insert it into a network of power relations'. ... audience ethnographies are undertaken because the relation between television and viewers is an empirical *question*. But the empirical is not the privileged domain of the *answers* ... Answers (temporary ones, to be sure) are to be constructed, in the form of interpretations. (Ang 1989: 105–6)

In contrast to Ang's methodological blurring of the categories of text and audience, Charlotte Brunsdon's work continues to insist (following Hall) upon the 'analytic importance' of the different 'moments' in the construction of meaning. '[A]n adequate television aesthetic', she writes, must take a position on 'the relationship(s) between what we might call the institutional and the program components of televisual discourse' as well as addressing 'extremely variable and diverse ways of watching television' (1989: 118). Her (1981) discussion of the soap opera *Crossroads* distinguishes, then, between 'the subject positions that a text constructs, and the social subject who may or may not take these positions up'. Thus it may well be, as Laura Mulvey argues, that 'visual pleasure in narrative cinema is dependent on identification with male characters in their gaze at female characters, but it does not necessarily follow that any individual audience member will unproblematically occupy this masculine position' (1981: 32). Like Ang, however, she argues that 'feminine' genres such as soap opera and the 'woman's film' are so designated because they both call on and practise 'the culturally constructed skills of femininity – sensitivity, perception, intuition and the necessary privileging of the concerns of the personal life' (1981: 36). Although these skills 'are not *natural* attributes of femininity', it is more likely 'under present cultural and political arrangements ... that female viewers will possess this repertoire of both sexual and maternal femininities' (1981: 36).

Brunsdon's later work expresses anxieties about the move 'from the "bad" text to the "good" audience' (1989: 125) in feminist research of the 1980s, of the kind exemplified in the work of Ien Ang. Such work, she argues, in its endorsement of audience pleasures, in effect 'either eliminate[s] the text as a meaningful category, or render[s] all texts the same' (1989: 125). The fact that I may 'construct' the text differently when I watch it in different contexts – in an academic context, say, or at home with my family – does not alter the fact that the text itself remains recognizable through these changing contexts. If, she argues, we go along the route proposed by Dorothy Hobson ('there are as many different Crossroads as there are viewers') and endorsed, though in a rather more complex fashion, by Ien Ang – however motivated by a desire to defend women's pleasures – what is lost is the political pressure for change. The desire to align the position of 'feminist' with that of 'ordinary woman' by insisting on the viewer's capacity to resist the positions offered by the text may result in an endorsement of the texts currently on offer to women: 'The problem of working always with what people are, of necessity, watching, is that we don't really ever address that something else – what people might like to watch'. If feminism ceases to be, in Ang's term, 'recruitist', it may end by simply 'reproduc[ing] and elaborat[ing] the dominant paradigm' (1989: 126). As Ellen Seiter *et al.* point out, 'there is nothing inherently progressive about pleasure' (1989: 5).

Television and film

For Charlotte Brunsdon, writes Annette Kuhn, 'the spectator addressed by soap opera is constructed within culture rather than by representation'. Despite her attempt to bring together notions of the textually constructed spectator and the 'social subject' constructed within culture, Brunsdon's argument, Kuhn feels, remains weighted firmly in favour of the latter. In its view of the text as playing on and appealing to 'cultural competences' constructed as feminine, 'spectator–text relations are apparently regarded virtually as an effect of socio-cultural contexts' (1987: 346). Kuhn's own (1984) essay 'Women's Genres' represents a sustained attempt to think through this difficult relationship, refusing either to 'bracket off' considerations of the social subject in the manner of early feminist film theory or to consider the text only in terms of 'cultural competences' as she feels Brunsdon does. It is an essay which also returns us to the specificity of *film,* considering both its similarities to and differences from the medium of television which has been the focus of much of the work considered so far in this chapter.

'Women's Genres', then, reminds us of the very different theoretical origins of film and television analysis. Film theory, which has 'taken on board a conceptualisation of the spectator derived from psychoanalytic accounts of the formation of human subjectivity', regards the *'spectator ...* [as] a subject constituted in signification, interpellated by the film or TV text' (1987: 341, 343). Its difficulty is that it cannot satisfactorily address issues of the historical specificity of texts, their institutional or social contexts, and their audiences. Theoretical work on televsion, however, existing 'until recently under the sociological rubric of media studies' (1987: 346), has found it difficult, despite the attempt of cultural studies to bring the two together, to theorise the text. This difference is also accounted for, she points out, by the very different structure and status of the film and television text. Unlike the film text, the typical television text is not discrete. It is constructed characteristically in series or serial form, is embedded within the 'flow' of television output, and is composed of 'segments'[9] which intersect both within the individual programme (the different storylines of the soap opera, for example) and with segments of other programmes (advertisements or news bulletins, for example). Neither is it watched in the concentrated fashion of cinematic spectatorship: the housewives in Dorothy Hobson's study who watched in a 'distracted' manner are typical of television's viewing audience. Nevertheless, both the film melodrama and the television soap opera construct 'narratives motivated by female desire and processes of spectator identification governed by female point-of-view' (1987: 339). They are also aimed at a female audience. How then, she asks, since 'spectator and audience are distinct concepts which cannot – as they frequently are – be reduced to one another' (1987: 341), can the relationship between them be theorised?

Her answer is to distinguish analytically between the spectator who is 'constituted in signification, interpellated by the film and TV text' and the 'social audience'; 'Social audiences become spectators in the moment they engage in the processes and pleasures of meaning-making attendant on watching a film or TV programme'. On the other hand, '[i]n taking part in the social act of consuming representations, a group of spectators becomes a social audience' (1987: 343). Thus 'women's genres' *both* address themselves to an already gendered spectator *and* help to construct a feminine subject position. Such a move still contains a dualism, however, in which one term (the social audience) is historically specific but the other (the spectator) is not. 'Is there a way', she asks, 'in which spectator/subjects of film and television texts can be thought in a historically specific manner, or indeed a way for the social audience to be rescued from social/historical determinism' (1987: 346–7). The 'way around this apparent impasse', she feels, is through 'a move into theories of discourse' (1987: 342, 347).

'Discourse', writes Diane Macdonell in *Theories of Discourse* (1986), 'is social. The statement made, the words used and the meanings of the words used, depends on where and against what the statement is made' (1986: 1). This concept of discourse draws, once again, on Volosinov's concept of the 'multi-accentuality' of the sign. '[I]n the alternating lines of a dialogue', argues Volosinov, 'the same word may figure in two mutually clashing contexts. ... Actually, any real utterance, in one way or another or to one degree or another, makes a statement of agreement with or negation of something' (1973: 80). Thus, not only is dialogue the primary condition of discourse, but different social groups produce differently organized discourses. Discourse, then, unlike the linguistic structures of psychoanalytic accounts, is historically and socially specific. The kind of speech used to describe an event will depend on the precise context in which it is used and the social positioning of the speaker. This means that discourses are connected to institutions (medical discourse or legal discourse for example), to ways of understanding or forms of knowledge, and to power. 'In any institution', writes Macdonnell, 'there is a distribution and a hierarchy of discourses' (1986: 2). The medical discourse used by nurses, for example, differs from that of the hospital consultant; both, however, will have more power than the discourse of the patient, who, being excluded from the medical discourse, may well find that her views will scarcely be heard. Discourses, then, produce knowledge(s) and are the product of power relations. In any given society they will be ordered both hierarchically and in opposition, but these power relations may shift, allowing different discourses to acquire dominance. Such a view, which is articulated most clearly in the work of Michel Foucault (see Chapter Three), allows the linking of the textual and the institutional/social (text and context), since both are constituted in discourse. Both David Morley and Ien Ang draw on such work in arguing that each of us is subject to a range of 'contradictory interpellations' (Morley 1980a: 165), through which we are positioned and

repositioned in relation to texts and cultural practices. It can also be used to suggest that the text itself is composed of a hierarchy of (competing) discourses, as Maria La Place argues (see Chapter Three) in relation to the 'woman's film'.

Textual negotiations

Both spectators and social audience, then, may be regarded as positions constructed within discourse, argues Annette Kuhn, the first within the discourse of the text(s) and the second within a range of social groupings and practices. 'Representations, contexts, audiences and spectators would then be seen as a series of interconnected social discourses, certain discourses possessing greater constitutive authority at specific moments than others'. Such a model, argues Kuhn, would permit 'relative autonomy for the operations of texts, readings and contexts, and also allow[] for contradictions, oppositional readings and varying degrees of discursive authority' (1987: 347). For a more detailed account of how this might work in relation to the film text, I shall return to the work of Christine Gledhill. Gledhill, as we have seen (Chapter Three), employs the concept of competing discourses to argue that twentieth-century melodrama is the site of 'a struggle between male and female voices over the meaning of the symbol "woman"' (1987: 37). In her 1988 essay 'Pleasurable Negotiations' she develops this argument, this time within a more explicitly cultural studies framework. 'Meaning', she argues, 'is neither imposed, not passively imbibed, but arises out of a struggle or negotiation between competing frames of reference, motivation and experience. This can be analysed at three different levels: institutions, texts and audiences' (1988: 68).

Gledhill herself, though she gives examples of such work, does not offer an analysis of the process of negotiation at the level of institution or audience. Her focus is on the film text. 'Language and cultural forms', she writes, 'are sites in which different subjectivities struggle to impose or challenge, to confirm, negotiate or displace, definitions and identities. In this respect, the figure of woman, the look of the camera, the gestures and signs of human interaction, are not given over once and for all to a particular ideology – unconscious or otherwise' (1988: 72). But if the text does not offer us a single position from which it must be read, as readers we nevertheless use texts in order to construct and confirm our sense of identity. It is the task of the textual critic, therefore, to ask what readings the text makes available, a task to which the knowledge gained from ethnographic studies can contribute. But such a task, argues Gledhill, is not neutral. The critical act itself 'generates new cycles of meaning production and negotiation' (1988: 74). The text may be appropriated for a new reading, a different politics of

reading, as were for example the melodramas considered in the last chapter. Moreover as politically engaged readers, '[w]e need representations that take account of identities – representations that work with a degree of fluidity and contradiction – and we need to forge different identities – ones that help us to make productive use of the contradictions of our lives'. Identities may not be fixed, and may be constituted in discourse, but we need to assume, at least provisionally, a 'consistent and answerable identity' if we are to act in the world (1988: 72). The feminist critic, therefore, must 'perform a dual operation'. She must 'open up the negotiations of the text' in order to determine the possibilities that exist for a gendered reading, but she also 'enters into the polemics of negotiation, exploiting textual contradiction to put into circulation readings that draw the text into a female and/or feminist orbit' (1988: 75). Gledhill's stance here is neither 'redemptive' nor 'recruitist' – indeed she suggests that such an opposition is over-simplistic. The readings made by the feminist critic, she argues, will be 'animations of possibilities arising from the negotiations into which the text enters' (1988: 87). But they will also themselves participate in the 'social negotiation of meaning, definition, identity' (1988: 74), and hence will be subject to negotiation by the reader in their turn.

Gledhill's concern is the question of how, in the analysis of 'textual negotiations', we can 'distinguish the patriarchal *symbol* of "woman" from those discourses which speak from and to the historical socio-cultural experience of "women"' (1988: 75). Her analysis of the (1977) film *Coma,* then, draws on two levels of discourse. The first is that of melodrama, on which she feels the film, like much of popular culture, draws for its moral framework – the 'struggle between good and evil, personified in the conflicts of villain, heroine and hero' (1988: 76). In the melodramatic structure, the figure of 'woman' functions as a 'powerful and ambivalent patriarchal symbol, heavily over-determined as expression of the male psyche'. In order to solicit the recognition and consent of contemporary audiences for such a framework, however, the popular film must also draw on contemporary social discourses for its scenario. Re-framing its dramas of good and evil through the discourses of contemporary society – 'psychoanalysis, for example, marriage guidance, medical ethics, politics, even feminism' – the popular film can make claims to realism in order to solicit the recognition of its audience (1988: 76). *Coma,* then, makes its investigating hero a woman, a female doctor whose task is to uncover the hospital conspiracy to put selected patients into a coma so that their organs can be auctioned for profit. In so doing, it can draw on the traditional attributes of innocence and moral purity of the melodramatic heroine, but it also references the social discourses surrounding the 'independent woman' which second wave feminism had put into play in the 1970s. As a result, argues Gledhill, 'the film struggles to align woman as melodramatic symbol with the independent heroine's reference to women's struggles in the real world', so that in the figure of the heroine, Susan (Genevieve Bujold), 'the intermeshing of symbolizing

and referential modes contructs the female image as an object of contest, of negotiation, for the characters and for the audience' (1988: 84–5). Such a process of textual negotiation will inevitably produce deeply ambivalent results – and would explain, for example, feminist disagreements about the 'progressiveness' of films like *Thelma and Louise* (1991) or the *Alien* trilogy (1979, 1986, 1992). Such popular films will produce 'a wider address – more serviceable to a capitalist industry – than a more purely feminist text, or counter-text, could'. They can be read as hegemonic projects, which work to 'make safe' disturbing or oppositional discourses. But they also offer readings which can be pulled by the feminist critic into 'frameworks which interpret the psychic, emotional and social forces at work in women's lives' (1988: 87).

Straddling traditions

'Whilst it may be time for feminists looking at television to pause and caution against the abandonment of the text in favour of the audience', writes Jackie Stacey, 'in feminist film criticism the exploration of women as cinema spectators has barely begun' (1994: 47). As we have seen, most cultural studies work on audiences has concentrated on television, and most feminist work on film focuses on the text. Christine Gledhill's work, though it employs a cultural studies perspective, is no exception to this. This focus on the text in feminist film theory, adds Stacey, permits a 'skirting around' of the political and ethical questions around the relationship of feminist researcher to female audience which are raised constantly in feminist ethnographic research. 'It is certainly less controversial', she comments, 'within the politics of feminist research to make critical judgements about film texts than about the female spectators who enjoy them' (1994: 12). The final section of this chapter looks at two studies of film which have attempted in some way to bridge the gap between psychoanalytic studies and audience studies, theories of unconscious processes of identification and theories of cultural negotiation, and which also engage with the issue of the (feminist) researcher's relationship to her subjects.

The first is Valerie Walkerdine's (1986) 'Video Replay: Families, Film and Fantasy'.[10] Walkerdine offers an analysis of the viewing of the video of *Rocky II* (1979) by a working-class family, the Coles, and combines this with a critique of her own role as academic 'spectator' of this process. Like other writers examined in this chapter, Walkerdine opposes models of cinema spectatorship which impose a 'universalism of meaning, reading and interpretation', arguing that the '*position* produced for the reader or spectator is not identical with an actual reader constituted in multiple sites and positions' (1989: 182, 171). But Walkerdine also attempts to bring together

psychoanalytic theory and ethnography, fantasy and lived social practices. Within the Cole family, she focuses on two family members, Mr Cole and his six-year-old daughter, Joanne. In the case of Mr Cole, her focus is on discourses of 'fighting', discourses which are 'fictions, set and worked out in the film itself' but which are also 'lived out in the practices in which Mr Cole is inserted' (1989: 183), since he sees himself *as* a fighter. For Mr Cole *Rocky II* offers fantasies of 'omnipotence, heroism and salvation', but whilst such fantasies are the result of a very specific male working-class experience of 'oppression and powerlessness' (1989: 172), they are not *separate* from Mr Cole's lived existence, as Ien Ang argued the fantasies of her *Dallas* viewers were. They also structure his lived social and domestic experience: 'There is no "real" of these practices which stands outside fantasy, no split between fantasy as a psychic space and a reality which can be known' (1989: 183). The fantasy of masculinity as 'fighting/being a fighter' structures Mr Cole's conscious self-identification, then, and regulates his domestic relations, but it also reaches back into his unconscious, as 'a defence against powerlessness, a defence against femininity' (1989: 182); like all fantasies, it has a manifest and a latent content.

Walkerdine's account of Mr Cole's daughter Joanne ('Dodo') draws also on her own childhood experiences. Mr Cole's infantilization of his daughter as 'Dodo' confirms his identification as a 'fighter' on her behalf, but it also creates a fantasy identification for her, one which is, however, 'fractured', since Joanne is seen by Mr Cole as *both* the fragile and feminine 'Dodo' *and* a working-class 'fighter' like her father. Joanne, like Walkerdine before her, must somehow inhabit this fractured identity. Thus the 'fantasy-structure' of *Rocky II* not only intersects with the domestic dynamics of the Cole family in complex ways, it is also a part of the power relations within the family. Fantasy, then, 'is invested in domestic relations just as much as it is in films', and to understand this we need not only to examine the 'regimes of meaning' constructed within discursive practices but also to 'go beyond the present use of psychoanalysis' (1989: 192, 189). Walkerdine's final point is that the researcher/observer, too, occupies a 'fantasy space in which certain fictions are produced', fictions of 'knowledge' and 'truth' which themselves have a latent content, the fear of the unruly 'masses' (1989: 194).

Walkerdine's combination of ethnography with psychoanalytic theory, argues Jackie Stacey, 'marks an important break with the existing dichotomies of psychic versus social readers, and a departure for audience studies which have totally ignored questions of the unconscious' (1994: 42). It is problematic on a number of counts, however. Its account of the text of *Rocky II* remains undeveloped, as does its account of exactly how fantasy, power relations and gendered subjectivity intersect within the family and its members. Finally, its account of the research process as a regulatory activity which masks 'the terror of a lack of control', mitigated in Walkerdine's case by her 'attempt to speak also of my own identification with the film I watched with this family' (1989: 196–7, 167), whilst it points to the

problems inherent in ethnographic research, offers the researcher no position, other than the autobiographical, from which to speak.

Jackie Stacey's (1994) *Star Gazing* is a much more ambitious and developed attempt to bring together what she sees as the antagonistic traditions of feminist film theory and cultural studies audience research. Her study of female spectators'[11] memories of Hollywood stars in 1940s and 1950s Britain investigates 'how historical and national location affects the meanings of Hollywood stars for female spectators', but it also examines 'how the processes of cinematic spectatorship produce and re/form feminine identities', identities which are seen as always 'in process', 'continually being transformed' (1994: 73):

> What the project aims to offer is an investigation of the ways in which psychic investments are grounded within specific sets of historical and cultural relations which in turn shape the formation of identities on conscious and unconscious levels. How, for example, are spectators' fantasies and desires formed differently within specific contexts? In short, my investigation analyses the relationship between psychic and social formations, challenging the ways in which the latter have been so often ignored at the expense of the former within feminist film criticism. (1994: 79)

Her argument begins, then, from a concept of the 'impossibility of femininity' within patriarchal culture, which defines it as 'an unattainable visual image of desirability' (1994: 65–6). Like Mary Ann Doane, she argues that the 'work of femininity' requires consumption, of both commodities and images (1994: 9), so that women are both subjects and objects of exchange, their sense of identity bound up with a sense of 'woman as image', forever unattainable, always invoking a sense of loss. Unlike Doane, however, she adds that this 'work' also involves the 'active negotiation and transformation of identities which are not simply reducible to objectification' (1994: 208). Thus she insists *both* that '"identity", be it gender, nationality or ethnicity, should be seen as partial, provisional and constantly "in process"' *and* that 'identities *are* fixed by particular discourses, however unsuccessfully, temporarily or contradictorily' (1994: 226). The ideal images of Hollywood female stars function as one such discourse, and her examination of spectators' memories of such stars suggests the way in which this 'relationship between stars and spectators involves the complex negotiation of self and other, image and ideal, and subject and object. Screen image and self image are connected through a dialectical interplay of multiple feminine identities' (1994: 227).

The material for Stacey's ethnographic investigation comes from responses to an advertisement placed in two women's magazines, and a follow-up questionnaire compiled according to the themes emerging from the letters. Her respondents came from a fairly narrow class background (C1, C2 and D) and were all white, so that her study is of 'white fantasy and the

relationships between white female spectators and their ideals on the Hollywood screen' (1994: 62). Such a study raises a number of theoretical and methodological problems, of which Stacey is acutely aware. The spectators' responses are not only shaped by discursive factors, as in all audience responses, but, as memories, they are 'retrospective constructions of a past in the light of the present' formed through another set of negotiations, between 'public' discourses and 'private' narratives of the past (1994: 63). They can therefore be seen to function doubly as 'texts'. As texts, they raise two further problems. One is the role of the (feminist) researcher as interpreter (of women's discourses). Stacey argues that an interpretive framework is inevitable, but that it must be made explicit and open to contestation, including contestation by the material itself. The second, related problem arises from Stacey's desire to address issues of feminine identity generated by psychoanalytic film theory. Given that such issues are usually presented in terms of unconscious processes, how might these be read from audience responses, and what status might such a reading have? Her answer is that the boundary between empirical audience research and psychoanalytic textual analysis is not as clear-cut as it might appear: 'my material demanded a consideration of cultural processes such as those of memory, identity formations, fantasy and daydreaming which involve unconscious processes, but also need to be analysed in terms of the conscious everyday meanings they have for cinema spectators' (1994: 78).

Stacey's ethnographic analysis explores three 'discourses of spectatorship' (1994: 80) which emerge from the material she received: escapism, identification and consumption. All are analysed in terms of the specific construction and organization of femininity during the 1940s and 1950s but all are also seen in terms of the negotiation and construction of feminine identity by her respondents. The utopian ideals of 'abundance, community and transcendence', then, which structure the women's fantasies of 'escape' are the product of wartime experience, but they also involve a fantasized escape *into* a Hollywood ideal which both liberates and constrains. Discourses of consumption, too, though they fix women in the feminine role of consumer-consumed, also 'addressed women as subjects and encouraged their participation in the "public sphere" which could be seen to have offered new forms of feminine identity in contrast to their roles as wives and mothers' (1994: 223). In the context of wartime austerity the promise of self-transformation which such discourses offer can provide a means of negotiating the present; in post-war Britain they could be used to contest the ideological push towards domesticity.

It is the section on identification/identity which is central to *Star Gazing*, since its themes run throughout the book and its analysis most closely unites psychoanalytic theory and ethnographic analysis. Like Walkerdine, Stacey considers both '*identificatory fantasies* and *identificatory practices*' (1994: 171). 'Identificatory practices' might consist of the imitation of a star's hairstyle or clothing or the adoption of a manner of speech or behaviour; each

involves 'an intersection of self and other, subject and object', in order to effect the transformation of the spectator's own identity (1994: 167). The concept of identification is therefore expanded from its use within psycho-analytic theory, to become a more active process of negotiation. It is also further expanded by the distinction between 'identification based on differ-ence and identification based on similarity' (1994: 171). Such a concept involves the recognition of both 'differences between femininities' and the fact that 'identification' is not the opposite of 'desire' but rather may involve 'some forms of homoerotic pleasure' (1994: 171, 173). Identification, then, does not simply confirm existing gendered identities, but can involve the 'transformation and production of new identities' (1994: 172). Such identi-ties may, in specific historical circumstances, function as spaces of resistance and negotiation as well as conformity, but they will also be contingent, par-tial and fragmented.

Stacey's concluding theoretical chapter seeks to combine psychoanalytic theory and historical specificity. The psychoanalytic theory it employs, how-ever, is not that of Freud or Lacan but the 'object relations theory' associ-ated with Melanie Klein. Klein's theory of 'projection' and 'introjection' describes mechanisms whereby the infant learns to deal with the world. 'Projection', according to Klein, 'is a process whereby states of feeling and unconscious wishes are expelled from the self and attributed to another per-son or thing. Introjection is a process whereby qualities that belong to an external object are absorbed and unconsciously regarded as belonging to the self' (quoted in Stacey 1994: 229). Such an account, argues Stacey, is sug-gestive in providing a model for the star–spectator relationship, but it remains universalistic and ahistorical. It must be combined with an analysis of how cinematic 'relations of looking are historically produced within spe-cific spatial locations' to produce changes in 'the relationship between the subject and the object, the self and the other, and between image and iden-tity in different historical periods' (1994: 233).

Conclusion: criticism as retrieval?

Commenting in 1989 on Christine Gledhill's 'Pleasurable Negotiations', Laura Mulvey writes:

> The negotiations she suggests have a reconciliatory function on a crit-ical level and produce a terrain in which the female image and the female spectator can both be positive. In spite of its complex argu-ment, the backlash against the negative aspects of psychoanalytic crit-icism is not questioned. Now criticism works more as a retrieval, a saving of objects and a search for positive identifications, broadening

the concept of a despised form of female entertainment, such as the melodrama, into the soap-operas and sit-coms of contemporary television. (1989e: 78)

The charge, then, is that in the turn towards a cultural studies analytical framework in feminist film theory, what has been lost is not only a sense of the specificity of the film text but also that engagement between 'high' theory and radical politics which characterized feminist film theory in the 1970s. A similar charge of a loss of specificity is also made by Yvonne Tasker, writing in 1991. The move to view popular culture as 'a site of negotiation/contestation', she argues, means that for feminists it is 'not only acceptable to engage with it, but politically correct. And, for feminism, this engagement was also deeply rooted in the desire to reclaim a women's culture' (1991: 86). But in the process, categories – of the text, the feminine subject, the audience, the text of the audience – become confused. The result, she argues, is 'the conflation of categories which can prove almost impossible to differentiate: women, women watching soap opera, the feminine. In the consideration of a textual address to or construction of a feminine subject position, do we end up with a discourse of femininity which speaks women? One feminine text reading another? The possibilities and problems of such a slippage pervade recent work on gendered form' (1991: 89). The outcome of this destabilization of meaning, in which meaning 'slips out of the control of the text and into the hands of the reader', is that 'popular forms are textually rewritten as radical within the parameters of cultural criticism' (1991: 96). Thus the feminist critic, in Tania Modleski's terms (Modleski 1986: xii), colludes with consumer society to justify the status quo.

That a loss of theoretical and political specificity can be one outcome of what Charlotte Brunsdon calls the move 'from the "bad" text to the "good" audience' (1989: 125) is evident in Dorothy Hobson's celebration of the audience and also, I think, in Ien Ang's rather simplistic separation between fantasy and social and material practice. The loss of a concept of the text – or alternatively, in Janice Radway's work, the difficulty of holding together textual and audience readings – has also been evident in a number of the studies examined. It remains the case, too, that despite the re-emergence – indeed, the constant reference to – 'real women' in these studies, the relationship of the feminist researcher to these women remains problematic. And, as the category of 'real women' itself becomes less certain – crossed by differences of class, location, race, ethnicity, sexual orientation – the 'female spectator' as social subject becomes as theoretically problematic as her textual counterpart. Nevertheless, despite these difficulties and the methodological issues raised by much of this work, the attempt to bring together issues generated within psychoanalytic film theory and the discourses and practices generated within culture has been extremely fruitful. In such work the text ceases to exercise a determining power and identities, though

constructed within representation, are the result of processes of negotiation and contestation, constantly in flux. If the critic's own negotiations – between the textual and the social, between psychoanalytic and cultural theory, between a 'recruitist' and a 'redemptive' view of her subject(s) – constitute, in Stuart Hall's words, 'a set of unstable formations' (1992: 278), the questions remain constantly engaged and in play.

|5|

Fantasy, horror and the body

'A Child Is Being Beaten'

A systematic application of [analysis] shows that beating-phantasies have a historical development which is by no means simple, and in the course of which they are changed in most respects more than once – as regards their relation to the author of the phantasy, and as regards their object, their content and their significance. . . .

The first phase of beating-phantasies among girls . . . must belong to a very early period of childhood. . . . The child being beaten is never the one producing the phantasy, but is invariably another child, most often a brother or a sister if there is any. Since this other child may be a boy or a girl, there is no constant relation between the sex of the child producing the phantasy and that of the child being beaten. The phantasy, then, is certainly not masochistic. . . . The actual identity of the person who does the beating remains obscure at first. Only this much can be established: it is not a child but an adult. Later on this indeterminate grown-up person becomes recognizable clearly and unambiguously as the (girl's) *father*.

The first phase of the beating-phantasy is therefore completely represented by the phrase: '*My father is beating the child*'. . . .

Profound transformations have taken place between this first phase and the next. It is true that the person beating remains the same (that is, the father); but the child who is beaten has been changed into another one and is now invariably the child producing the phantasy. . . . Now, therefore, the wording runs: '*I am being beaten by my father*'. It is of an unmistakably masochistic character. . . .

The third phase once more resembles the first. It has the wording which is familiar to us from the patient's statement. The person beating is never the father, but is either left undetermined just as in the first phase, or turns in a characteristic way into a representative of the

father, such as a teacher. The figure of the child who is producing the beating-phantasy no longer itself appears in it. In reply to pressing enquiries the patients only declare: 'I am probably looking on'. Instead of the one child that is being beaten, there are now a number of children present as a rule. Most frequently it is boys who are being beaten (in girls' phantasies) ... the phantasy now has strong and unambiguous sexual excitement attached to it ...

[I]n the male phantasy ... the being beaten also stands in for being loved (in a genital sense), though this has been debased to a lower level owing to regression. So the original form of the unconscious male phantasy was not ...: 'I am being beaten by my father', but rather: *I am loved by my father*. The phantasy has been transformed by the processes with which we are familiar into the conscious phantasy: *I am being beaten by my mother*. The boy's beating-phantasy is therefore passive from the very beginning, and is derived from a feminine attitude towards his father. (Freud 1979: 169–86)

[I]n my own thinking I have been drawn most toward work demonstrating that *there is no female spectator*, at least at the level of unconscious identification. ... While there are 'masculine' and 'feminine' positions in fantasy, men and women, respectively, do not have to assume these positions according to their assigned genders. (Penley 1989a: 256)

Re-opening the case: feminism and psychoanalysis[1]

We have already (Chapter Three) come across reference to Freud's 1919 essay, 'A Child Is Being Beaten', in the work of Mary Ann Doane on the 'woman's film' and the female spectator. For Doane, it is the difference between the male and female versions of the fantasy[2] which is important. Whereas the male fantasist retains his own role and his own gratification in the shifting versions of the fantasy, in the female fantasy the fantasist becomes simply a spectator ('I am probably looking on'), so that the fantasy, like the 'woman's film', substitutes masochistic fantasy *for* sexuality. Doane quotes Freud's conclusion in this respect: by means of the fantasy, 'the girl escapes from the demands of the erotic side of her life altogether. She turns herself in phantasy into a man, without herself becoming active in a masculine way, and is no longer anything but a spectator of the event which takes the place of a sexual act' (Freud 1979: 187). Increasingly in film theory of the 1980s, however, the essay acquired a different significance. Its account of multiple and shifting subject positions in fantasy and its description of the mobile nature of fantasy's gender identifications seemed to offer a way out of what James Donald has called the 'uninviting Catch-22'

represented by Laura Mulvey's position in her 1975 'Visual Pleasure and Narrative Cinema' (see Chapter Two), 'with its emphasis on cinema's power to fix or "position" both the female characters within a narrative and also the female spectator in the cinema' (Donald 1989: 137). If fantasy can be seen to offer shifting and multiple positions for the fantasizing subject, then so, too, might the 'dream factory' of cinema. Since it serves as an underpinning for much of the work discussed in this chapter, Freud's essay is quoted here at length.

The implications of Freud's account of fantasy in 'A Child Is Being Beaten' and elsewhere are explored in a second essay which was to be crucial in the attempt of psychoanalytic feminist film theory to find a model of the film text and film spectatorship which would retain, in Constance Penley's words, the psychoanalytic insistence on *'taking the unconscious seriously'* (Penley 1989b: xvi) whilst also offering a more flexible account of spectatorship. This is the (1964) essay, 'Fantasy and the Origins of Sexuality' by Jean Laplanche and Jean-Bertrand Pontalis. Fantasy, in Laplanche and Pontalis' account, has a number of characteristics which are suggestive for such a reworking of psychoanalytic film theory. The first is that suggested above, its existence for the subject across a number of subject positions. 'A father seduces a daughter', then, is 'the summarized version of the seduction fantasy', but the actual structure of the fantasy offers 'a scenario with multiple entries, in which nothing shows whether the subject will be immediately located as *daughter*; it can as well be fixed as *father*, or even in the term *seduces*' (1986: 22–3). Identification in fantasy, then, is shifting, unconfined by boundaries of biological sex, cultural gender or sexual preference.

The second important characteristic is the connection between fantasy and desire. Sexuality *begins* for the individual, argue Laplanche and Pontalis, at the moment when, 'disengaged from any natural object, [it] moves into the field of fantasy and by that very fact becomes sexuality' (1986: 25). It is therefore inseparable from desire. But fantasy, they argue, is 'not the object of desire, but its setting. In fantasy the subject does not pursue the object or its sign: he appears caught up himself in the sequence of images'. Fantasy, then, is the *staging* of desire, its *mise-en-scène*, in which the subject, whilst always present, 'cannot be assigned any fixed place' (1986: 26).

The third important characteristic of fantasy, in the formulation of Laplanche and Pontalis, is its 'mixed nature'. Fantasy crosses the boundaries between conscious and unconscious; there is a 'profound continuity between the various fantasy scenarios – the stage-setting of desire – ranging from the daydream to the fantasies recovered or reconstructed by analytic investigation' (1986: 28). The *structure* of fantasy is formed from three 'original' fantasies – that is, fantasies relating to the origins of the individual – 'the primal scene [which] pictures the origin of the individual; fantasies of seduction, [which picture] the origin and upsurge of sexuality; fantasies of

castration, [which picture] the origin of the difference between the sexes'
(1986: 19). However, 'secondary' fantasies – unconscious or conscious,
dream, daydream or narrative fiction – rework these original fantasies,
using the 'kaleidoscopic material' drawn from the subject's own present
existence. As Elizabeth Cowie explains, the fantasy

> hovers between three times: the present provides a context, the mater-
> ial elements of the fantasy; the past provides the wish, deriving from
> the earliest experiences; the dreamer then imagines a new situation, in
> the future, which represents a fufilment of the wish. ... Fantasy then
> as a privileged terrain on which social reality and the unconscious are
> engaged in a figuring which intertwines them both. (Cowie 1984: 84)

Thus, in Laplanche and Pontalis' account any simple opposition between
'fantasy' and 'reality' disappears. First, since sexuality only comes into exis-
tence through fantasy, fantasy is fundamental in the organization and rep-
resentation of sexuality and desire. Second, fantasies address social reality
(Lacan's symbolic) as well as 'original fantasies' in their reworking of the
'kaleidoscopic material' of the subject's social existence.

Elizabeth Cowie's (1984) essay, 'Fantasia', elaborates the implications
for feminist film theory of this reformulation of the role and importance of
fantasy in psychoanalysis. Fantasy, she points out, has long been a problem
for feminist theory, seeming – for example in romance fiction or the mater-
nal melodrama – to tie women into masochistic identificatory structures at
the level of the (by definition inaccessible) unconscious. It has been assumed
that women's point of identification in such structures must be with the pas-
sive and suffering fictional heroine. Laplanche and Pontalis' account, how-
ever, suggests 'another way to considering the fixity, or not, of the sexual
positions of cinema-subjects' (1984: 72). The importance of their emphasis
on fantasy as a *scene*, the setting rather than the object of desire, she argues,
'cannot be overemphasised, for it enables the consideration of film as fan-
tasy in the most fundamental sense of this term in psychoanalysis' (1984:
77). Like those of the daydream, cinematic fantasies do not fix the spectator
in a specific gendered position; instead they 'join with the "original" fan-
tasies in visualising the subject in the scene, and in presenting a varying of
subject position so that the subject takes up more than one position and thus
is not fixed' (1984: 80). Like the daydream, too, cinematic fantasies not only
involve 'original' fantasies but also draw on contemporary material for their
scenarios, so that just as we draw on events of the day to produce our own
fantasies, so as spectators 'we can adopt and adapt the ready-made scenar-
ios of fiction, as if their contingent material had been our own' (1984: 85).
The *realism* of cinema thus acts both as a defence against admitting the cen-
trality of fantasy in cinematic fiction, and as a 'hook', drawing us into the
fantasy structure 'unawares'. Conventions – of realism, of narrative, of
genre – provide the means through which the structuring of desire is repre-
sented in public forms.

Two questions, argues Cowie, arise from such an account: 'first, if fantasy is the *mise-en-scène* of desire, whose desire is figured in the film, who is the subject for and of the scenario? No longer just, if ever, the so-called "author". But how does the spectator come into place as desiring subject of the film? Second, what is the relation of the contingent, everyday material drawn from real life, i.e. from the *social,* to the primal or original fantasies? Is the contingent 'dressing' of the fantasy irrelevant?' (1984: 87). To answer these questions, Cowie considers two 1940s 'women's films'. One of these is *The Reckless Moment* (Ophuls, 1949), a maternal melodrama which concerns the unacknowledged desire of a white, middle-class mother, Lucia Harper, for her blackmailer, Donnelly. It is a film considered also by Mary Ann Doane, for whom its 'pathos is generated by a situation in which maternal love becomes a sign of the impossibility of female desire' (Doane 1987: 94). Not only, argues Doane, does Mrs Harper fail to realize that she is involved in a love story until it is too late, and Donnelly is dead; Donnelly himself falls in love with her *as* a mother. Thus the film is both 'a fantasy about the power of mothers' and a delineation of motherhood as 'the repression of desire ... and the body' (1987: 92–3). In this analysis, Doane's assumption is that the female spectator's identification is with the figure of Lucia Harper. Cowie, however, argues that the film 'clearly presents a series of positions which are presented through pairings and equivalences, the terms of which are successively taken up by Lucia and Donnelly, the two main protagonists' (1984: 99). It is a 'sliding of positions' (Lucia as mother, as lover, but also Donnelly as father, as lover, as son, and as 'mother') which the film tries to contain by the death of Donnelly and the restoration of the family unit at its close, but which is in fact 'unstoppable', involving 'the diverse positions father, mother, child, lover, wife, husband, each of which are never finally contained by any one character. ... The film thus illustrates the way in which at its most radical, that is in the original fantasies, the staging of desire has multiple entries, where the subject is both present *in* the scene and interchangeable with any other character' (1984: 101). As spectators, we are caught up in this play of positions: *we* are 'the only place in which all the terms of the fantasy come to rest' (1984: 91).

Cowie's answer to her second question – one of central importance to a feminist politics – that of the relation of the *social* to the psychic material of fantasy, seems to suggest the subversive potential of fantasy's slippage between subject positions. Whilst the film's *narrative,* she argues, seeks to fix the meaning of sexual difference within the family structure, its 'unstoppable sliding of positions' undermines this attempt, with an implication 'which is an attack on the family as imprisoning' (1984: 101). Nevertheless, it is difficult to see the extent to which this disjuncture can function as *political* critique, for, as Cowie makes clear, 'while subject-positions are variable the terms of sexual difference are fixed' (1984: 102). Mother, father, son, daughter – we may oscillate between these positions but, in psychoanalytic theory, they cannot be evaded. Elsewhere, Cowie develops further this

analysis of the relation between fixity and play, the construction and the subversion of sexual difference in cinematic fantasy. In her (1989) contribution to the special issue of *Camera Obscura* devoted to 'The Spectatrix', she argues that, whilst the viewing subject may take up multiple identificatory positions within the film fantasy, 'all these positions are not alternatives in the sense of being a set of choices for the spectator'. The narrative structures of the text produce positions for the spectator, 'for, insofar as one identifies with the narrative and the narration, one must, willy-nilly, follow the positions of identification these set up' (1989: 129). These positions 'are not fixed by or dependent upon the gender of either characters or the spectator'; nevertheless, the text itself is always engaged in the construction of sexual difference 'for its narrative and characters, and, through the narration, for the spectator'. At the same time, cinema 'presumes sexual difference, it presumes the very field of of difference which it so relentlessly re-makes and it presumes sexual difference in its audiences as a condition of its readability, its ability to work for and on its spectators' (1989: 129). Such a formulation seems to imply an ideological level of textual organization beyond that of conscious or unconscious fantasy, one which works through processes of narrative and narration to reaffirm sexual difference for the spectator. Cowie's (1979–80) reading of the 1978 film, *Coma*, supports such a view. Whilst *Coma*'s protagonist, Susa Wheeler, is constructed as a 'strong woman', causing the film to be seen by many as feminist, in fact, argues Cowie, its narrative strategies work to position her as 'victim to the events she seeks to engage with – the film becomes about how little she knows rather than how much' (1988: 125). Through the shifting identificatory structures of the film a concept of sexual difference is produced which is 'inadequate and unacceptable to the feminist political project' (1988: 125). In Cowie's account, then, whilst the psychoanalytic account of fantasy contributes to an understanding of the multiple and contradictory levels at which the film text operates, its *political* usefulness seems limited, since narrative structures still function to position the spectator within the accepted terms of sexual difference, and the question of the precise relation between textually produced identificatory positions and socially contructed gendered identities remains unresolved.

The end of the 'bachelor machines'?

A rather larger claim for the usefulness of the psychoanalytic concept of fantasy in rethinking cinematic processes of identification is made by Constance Penley. Penley's proposal is that the concept of fantasy as *'the staging and imaging of the subject and its desire'* (1989c: 78) offers an alternative conceptual model of cinema to the apparatus theories of Metz and

Baudry. As Mary Ann Doane points out (see Chapter Three), a model of the cinematic apparatus which is based on the mechanisms of voyeurism, fetishism and a primary mirror identification 'is inevitably male' (1984: 68). It cannot *but* produce, in Penley's words, an apparatus which is 'a bachelor machine', with consequences that Doane describes for conceptualizations of the female spectator and her textual counterpart. But, argues Penley, a turn to 'alternative theories of the feminine' such as those of Irigaray or Kristeva simply works to essentialize the identification of gendered sexuality with the female body: 'what is in danger of disappearing is the sense of sexuality as an arbitrary identity that is imposed on the subject, as a law' (1989c: 76). A turn to Chodorow's sociologically biased psychoanalysis, in for example the work of Radway or Williams (see Chapter Four), similarly works to eliminate a sense of 'the *difficulty* of femininity as a sexual position or category in relation to the symbolic as well as social order' (1989c: 77), a difficulty caused by the 'ill-fit' between conscious and unconscious processes.

The psychoanalytic model of fantasy, argues Penley, has a number of further advantages over these alternatives. First, it 'presents a more accurate description of the spectator's shifting and multiple identifications and a more comprehensive account of these same movements within the film' (1989c: 80). Second, it 'would allow us to retain the apparatus theory's important stress on cinema as an *institution*: in this light, all films, and not just the products of Hollywood, would be seen and studied in their fully historical and social variety as *dream-factories*' (1989c: 80). Finally, in its identification of fantasy with the origins of desire and sexuality, and therefore of *lack* – the moment when the real object which is the object of our *need* becomes the fantasy object of our *desire* – such a model produces an account of the essential conditions for cinema – distance, vision and desire – which is not tied to sexual difference. Thus women, too, as both filmmakers and film spectators, can 'accomplish[] something that psychoanalytic film theory claims that women cannot do': they can produce and represent 'the lack that is the precondition of all symbolic activity' (1988: 21). This is a point made forcefully by Elisabeth Lyon, in her reading of Marguerite Duras' film, *India Song* (1975), where she argues that the film enacts a fantasy of loss and distance which is also a fantasy of desire, 'an impossible desire – the desire for that to which the subject can have no access' (1988: 269).

Penley's more recent work takes these issues of desire, fantasy, pleasure and identification into a new area: the study of 'a female fandom that is devoted to reading, writing and publishing sexually explicit poems, stories and novels depicting *Star Trek*'s Captain James T. Kirk and his First Officer, Mr. Spock, as passionate lovers' (1989a: 258). The result: a 'hybrid genre of romance, pornography, and science fiction' (1992: 480). This study, which is both textual and ethnographic, brings Penley in some ways close to the work of Jackie Stacey, which was considered in the last chapter. Like Stacey, she argues that the reader's investment in the fiction and its central

characters is a combination of identification and desire, and that our con-
cept of identification must be expanded to account for this. Like Stacey, too,
she sees this 'female appropriation[] of a popular culture product' as
demonstrating 'how women, and people, resist, negotiate, and adapt to
their own desires this overwhelming media environment that we all inhabit'
(1992: 484). Penley's theoretical framework, however, is very different from
Stacey's. Using fantasy theory, she emphasizes the fluid identifications of
'slash' fantasy, identifications across gender boundaries – or with 'the entire
scene, or the narrative itself' (1992: 490). Such fantasies also, in their repre-
sentation of Kirk and Spock as lovers but as somehow *not* homosexual, per-
mit a combination of identification and desire in their women readers. Such
a construction, she argues, 'allows a much greater range of identification
and desire for the women: in the fantasy one can *be* Kirk or Spock (a possi-
ble phallic identification) and also still *have* (as sexual objects) either or both
of them since, as heterosexuals, they are not *un*available to women. If, in the
psychoanalytic description of fantasy, its two poles are being and having, in
the slash universe this binary opposition remains but is not held to be
divided along gender lines' (1992: 488).

 This concept of gender identifications as *not* tied to the gender of the
spectator/reader, however, whilst it offers a more complex account of the
processes of identification, raises problems at the level of the cultural and
social which are particularly apparent in Penley's account of 'slash' fandom.
Answering the question as to why 'slash' fans choose to 'write their sexual
and social fantasies across male bodies', Penley responds that it 'has to do
with the fans' rejection of the female body'. The fans, she writes, 'reject the
female body as a terrain of fantasy or utopian thinking, but the female body
they are rejecting is the body of woman as it has been constituted in this cul-
ture: a body that is a legal, moral and religious battleground' (1992: 498).
There is an admission here – in the fans' very refusal to fantasize a female
body – that the gendered body within representation is rather less open to
the fluid identifications of fantasy, and rather more determined by the gen-
der of the spectator, than fantasy theory suggests. The cross-gender identifi-
cations of 'slash' fantasy seem in fact to be operating within – indeed, to be
determined by – the constraints of a patriarchal culture, in what Penley calls
'a kind of politics of inner protest' at a world in which it is 'still not possi-
ble to imagine two women passionately in love with one another who go out
and save the galaxy once a week' (1992: 490, 500). Cross-gender identifica-
tion *instead of* political protest, then – and it is perhaps significant that
'slash' fans also reject feminism. Jacqueline Rose, in a criticism of positions
such as Penley's, argues that fantasy theory has been used as a 'saving
device' through which questions of the *politics* of representation can be
evaded through the offering of 'something for everyone both in the uncon-
scious and on the screen' (1989: 275). The kind of political evasion of which
Rose writes is perhaps best illustrated by the use of fantasy theory by certain
male critics – for if fantasy theory 'frees' the female spectator from her

gender positioning, it equally 'frees' the male spectator from the uncomfortable implications of the masculine viewing position. Thus, Donald Greig, for example, closes his study of 'The Sexual Differentiation of the Hitchcock Text' with the (perhaps comforting) conclusion that '[i]n the same way that the subject is found in a sort of infinite play of fantasy, at rest in a dynamic structuration, so the film text might be seen as a continuous interaction of fantasies and enunciations – and any resultant structure is dependent upon the individual position taken up in relation to the text' (1989: 192).

Fantasy and the body

If we return now to Freud's essay, 'A Child Is Being Beaten', with which this chapter began, two further points about it can be made. The first is that this analysis of the shifting gender identifications in the structuring of fantasy is also, and is seen primarily by Freud as, a study of *masochism* and its complex and shifting relationship to both sadism and spectatorship. The second, and related point is that in this fantasy, desire, in its distorted/perverted form (of beating) is, to borrow Penley's phrase, 'written across the body'. This 'special fascination with the body that characterises the fantastic' is noted by Steve Neale, who adds that this fascination comprises 'an ambivalent and highly erotic compound of attraction and repulsion' (1989: 222). Neale adds that we should not conflate the psychoanalytic concept of fantasy with the genre of 'the fantastic' with which his essay is concerned. Nevertheless, a relation between 'gender, genre, fantasy and structures of perversion' (Williams 1991: 12) is suggested, one which is carried further in Linda Williams' (1991) study of 'body genres', 'Film Bodies: Gender, Genre and Excess'.

The 'body genres' which Williams discusses are pornography, horror and melodrama, genres marked respectively by 'gratuitous sex, gratuitous violence and terror, [and] gratuitous emotion' (1991: 3). All have in common a quality of excess which marks them as 'low genres', an excess which is 'written across the body'. Visually, then, 'each of these ecstatic excesses could be said to share a quality of the body "beside itself" with sexual pleasure, fear and terror, or overpowering sadness. Aurally, excess is marked by recourse not to the coded articulations of language but to inarticulate cries of pleasure in porn, screams of fear in horror, sobs of anguish in melodrama' (1991: 4). All measure their success by the extent to which the spectator, too, is 'caught up in an almost involuntary mimicry of the emotion or sensation of the body on the screen'. More important, in all three it is the bodies of *women* which have 'functioned traditionally as the primary *embodiments* of pleasure, fear, and pain' (1991: 4). All, too, are genres 'in which fantasy predominates' (1991: 6), fantasy which is marked not only by an oscillation of

identificatory subject positions but by an oscillation which is, as in Freud's 'A Child Is Being Beaten', between the poles of sadism and masochism.

In Williams' work on the maternal melodrama we have already seen (Chapter Three) her insistence on the 'multiple subject positions' with which the viewer is invited to identify. Here she goes further, in arguing that this oscillation is 'between powerlessness and power'. Even in the predominantly masochistic melodramatic woman's film, then, there is a 'strong mixture of passivity and activity, and a bisexual oscillation between the poles of each'. Despite the genres' apparently gendered address, Williams argues – following Laplanche and Pontalis – that 'the subject positions that appear to be contructed by each of the genres are not as gender-linked and as gender-fixed as has often been supposed' (1991: 8). Her explanation of this 'fluidity and oscillation', however, is tied to the culturally specific as well as the psychically persistent. 'Like all popular genres', she argues, 'body genres' address 'persistent problems in our culture, in our sexualities, in our very identities'. These 'genres of gender fantasy' specifically explore 'basic problems related to sexual identity' (1991: 10), hence their play with gendered identifications and their preoccupation (that 'highly erotic compound of attraction and repulsion') with the gendered body. Each of the genres, she argues, can be seen to correspond with one of the three 'original fantasies' described by Laplanche and Pontalis: pornography with the fantasy of primal seduction, horror with the castration fantasy, and melodrama with the fantasy of the primal scene. But whilst each constantly (and repetitively) reworks its 'original fantasy' of sexual identity, each is also historically specific, recasting its story and its pattern of identifications in response to cultural shifts. As 'cultural problem-solving', these genres' 'very existence and popularity hinges upon rapid changes taking place in relations between the "sexes" and by rapidly changing notions of gender – of what it means to be a man or a woman' (1991: 12). This does not mean, of course, that they 'solve' the problems they are addressing – all offer 'solutions' which remain bound within the terms of the problem (more, different or better sex as the solution to the problem of sex, more violence related to sexual difference as the answer to the problem of violence related to sexual difference, more loss as the answer to the pathos of loss). Nevertheless, the problems which they address are constantly recast in response to the changing nature of gendered power relations.

Williams' use of fantasy theory, then, relates it back to perversion (though with the understanding that, in terms of sexuality, 'we are all perverts') and to the body. In its insistence that it is *women's* bodies which have persistently embodied bodily excess, across different genres and despite generic shifts, it also seeks to articulate fantasy theory with an investigation of the relations between gendered power and sexual identity. Arguing that it is 'through what Foucault called the sexual saturation of the female body that audiences of all sorts have received some of their most powerful sensations' (1991: 4), Williams asks how this can be read in terms of historical

power as well as identificatory structures. This rather different 're-opening of the case' between feminism and psychoanalysis through the use of fantasy theory, its insights and its difficulties, can be seen in the work of a number of writers on what Williams calls 'body genres' or 'genres of gender fantasy'. The remainder of this chapter will consider three: the work of Barbara Creed and Carol Clover on the contemporary horror film, and the work of Williams herself on hard-core film pornography.

Identification and/with the abject

Barbara Creed also cites the work of Laplanche and Pontalis to explain the horror film. The horror film, she writes, 'provides a rich source for constructing the settings upon which phantasy is attendant. It continually draws upon the three primal phantasies ... – birth, seduction, castration – in order to construct its scenarios of horror. Like the primal phantasies, horror narratives are particularly concerned with origins: origin of the subject; origin of desire; origin of sexual difference' (1993a: 153). Horror films also offer a 'fluidity of identificatory positions, across gender and between the poles of sadism and masochism: 'The subject positions with which the horror film most frequently encourages the spectator to identify oscillate between those of victim and monster but with greater emphasis on the former. In this respect, the horror film sets out to explore the perverse, masochistic aspects of the gaze'[3] (1993a: 154). However, the horror film represents its fantasies of 'birth, seduction and castration' in a *mise-en-scène* which is marked by the *abject:* 'In these texts, the setting or sequence of images in which the subject is caught up, denotes a desire to encounter the unthinkable, the abject, the other. It is a *mise-en-scène* of desire – in which desire is for the abject' (1993a: 154). And in this expression of a perverse desire, the abject, the other, is typically represented by 'the monstrous-feminine in one of her guises – witch, vampire, creature, abject mother, castrator, psychotic' (1993a: 154–5).

Creed's concept of 'the abject' is drawn from the work of Julia Kristeva, whose *Powers of Horror* (1982), Creed argues, 'provides us with a preliminary hypothesis for an analysis of the representation of woman as monstrous in the horror film' (1993a: 8). The abject, defined by Kristeva as that which does not 'respect borders, positions, rules', that which 'disturbs identity, system, order' (Kristeva 1982: 4), is linked with Kristeva's distinction between a maternal semiotic and a paternal symbolic. In order for the child to gain access to the symbolic, and become a speaking subject, Kristeva claims, it must first delimit its own 'clean and proper' body, separating its bounded, unified self from 'the improper, the unclean and the disorderly' (Grosz 1989: 71). Yet, argues Kristeva, what is excluded 'can never be fully

obliterated but hovers at the borders of our existence, threatening the apparently settled unity of the subject with disruption and possible dissolution' (Grosz 1989: 71). Abjection, then, disturbs identity, system and order, 'respecting no definite positions, rules, boundaries or limits. It is the body's acknowledgement that its boundaries and limits are the effects of desire not nature. It demonstrates the precariousness of the subject's grasp of its own identity.' It is 'the place where meaning collapses' (Grosz 1989: 74; Kristeva 1982: 2). Kristeva distinguishes three broad forms of abjection: abjection in relation to food, to waste and to sexual difference. Though all are represented in the horror film, it is the last of these which particularly concerns Creed. In marking 'the place of the genesis *and* the obliteration of the subject' (Grosz 1989: 73), abjection is identified not only with the feminine (menstrual blood as an index of sexual difference) but more specifically with the *maternal*. Like the semiotic and the maternal *chora*, the abject is placed on the side of the feminine and the maternal, in opposition to the paternal symbolic, and as such is the focus of both repulsion and desire. This concept of the abject, argues Creed, 'provides us with an important theoretical framework for analysing, in the horror film, the representation of the monstrous-feminine, in relation to woman's reproductive and mothering functions'. It is the ideological project of the horror film 'to bring about a confrontation with the abject (the corpse, bodily wastes, the monstrous-feminine) in order finally to eject the abject and redraw the boundaries between the human and non-human' (1993a: 14).

Rather than signifying 'a sort of infinite play of fantasy' (Greig 1989: 192), then, the shifting subject positions and blurring of gender boundaries of the horror film enact the mixture of fascination and repulsion with the maternal and the female body which characterizes the male subject. In her (1987) essay, 'From Here to Modernity: Feminism and Postmodernism', Creed carries this argument further. In the contemporary horror film, she argues, not only has 'the body, particularly woman's body, ... come to signify the spaces of the unknown, the terrifying, the monstrous'; in addition, there is an 'increasing preoccupation with the theme of "becoming woman"– literally' (1987: 58–9). For the male subject, becoming woman is 'the ultimate scenario of powerlessness' (1987: 60). In films like *Alien* (1979) and *Aliens* (1986), then, 'virtually all aspects of the *mise-en-scène* are designed to signify the female: womb-like interiors, fallopian-tube corridors, small claustrophobic spaces', and the central point of horror is concerned with processes of birth, particularly, in the first of these two films, with the process by which a man (Kane) is impregnated and gives birth to a monster/alien. If such narratives embody masochistic scenarios, however, and the emergence of a female hero (Ripley) signifies a further blurring of gender boundaries and identifications, this response to cultural shifts and uncertainties is one which enlists Ripley, the 'woman-hero', to destroy the 'monstrous', generative (abject) aspects of the maternal body – herself. Such a move is, Creed suggests, of dubious benefit to women.

For Creed, then, 'the very nature of horror [is] an encounter with the feminine' (1993b: 121). The prototype of the abject body is the maternal body 'because of its link with the natural world signified in its lack of "corporeal integrity": it secretes (blood, milk); it changes size, grows and swells; it gives birth in "a violent act of expulsion through which the nascent body tears itself away from the matter of maternal insides"' (Creed 1993b: 122, quoting Kristeva 1982: 101). All monsters, whether superficially male or female, are 'feminized', and the male spectator, in identifying with this figure, is also 'feminized via the body; he bleeds, gives birth, is penetrated and generally undergoes abject bodily changes associated with the feminine' (1993a: 156). The 'monstrous-feminine' described here is a long way from the female figure of conventional Freudian theory who provokes anxiety in the male spectator because she is 'castrated', thus producing the protective mechanisms of voyeurism and fetishism. Creed in fact suggests that Freud's concept of the 'castrated' woman represses his own recognition of her *alter ego*, the *castrating* woman. This figure, whether witch, vampire, protagonist of the rape-revenge film, or castrating mother, is, she argues, a central figure of the horror film, and her presence further complicates the issue of spectator identifications. 'The *femme castratrice*', argues Creed, 'controls the sadistic gaze: the male victim is her object' (1993a: 153).

Through both its male victim and its 'feminized' monster, then, the horror film, like the fantasy 'A Child Is Being Beaten', 'makes a feminine position available to the male spectator', appealing to 'the spectator's masochistic desires', and it also 'challenges the view that femininity, by definition, constitutes passivity' (1993b: 131; 1993a: 151). Its identificatory processes must therefore be extremely fluid and allow the spectator to switch identification across gender and between victim and monster 'depending on the degree to which the spectator wishes to be terrified and/or to terrify' (1993a: 155). Creed therefore contests a number of psychoanalytic assumptions which have underpinned film theory. If the female figure represents the threat of the powerful *castrating* woman/mother, she argues, then the model of cinema spectatorship based on the mechanisms of voyeurism and fetishism is inadequate, since both mechanisms are assumed to function as protection against the anxiety-producing 'castrated' woman who symbolizes lack and mirrors the male spectator's own possible castration. The 'castrating' woman is not herself 'castrated'; her power derives from her completeness. Equally, there is in these films no male hero who can function as the male spectator's 'ideal ego' and so reinforce his sense of identity. Like Penley, then, she replaces this model of the viewing process with one based on psychoanalytic fantasy theory, with its fluid identificatory processes. Further, her argument that the male subject fears woman as powerful and castrating, and that these fears are expressed in the horror film where man himself becomes the 'site of lack' (1993a: 163), also challenges the proposition that it is the *paternal* figure (the possessor of the phallus) who threatens the child with castration and who thus represents law and the

symbolic order (1993a: 163). Indeed, she argues, this idea – that the symbolic order, the order of culture and language, *must* be patriarchal because of the importance of the father/phallus in representing difference for both men and women – represents a comforting male illusion based on the repression of man's *fear* of woman. This repressed fear returns in the figure of the monstrous-feminine in the horror film, in which the maternal body is constructed as 'abject' in order that the rational, coherent, unified subject may be seen as masculine. But, insofar as the horror film also expresses the perverse *desire* for this collapse of gendered boundaries, it attests to the instability of gendered identity and 'the perversity of masculine desire and of the male imagination' (1993b: 132).

Creed's argument that the figure of the monstrous-feminine 'speaks to us more about male fears than about female desire or feminine subjectivity' (1993a: 7) returns us to issues of gendered power in the consideration of fantasy. This is an issue which she also takes up in her (1988) study of David Lynch's film, *Blue Velvet* (1986). There, Creed argues that fantasy theory suggests that 'many (all?) possible roles can be taken up by the subject in the narrative, which in turn allows multiple identifications for the spectator'. Moreover, she argues, Freud's three primal fantasies would seem to involve *different* forms of looking: the fantasy of castration a voyeuristic/sadistic look; the fantasy of the primal scene a masochistic look; and the seduction fantasy an oscillation between the two (1988: 114). If this is the case, then Laura Mulvey's theory of the 'male' gaze is an accurate description of *one* of the primal fantasies. Nevertheless, she argues, the castration fantasy is *culturally* dominant, and in relation to this fantasy – which concerns having and not having a penis – the female and male spectator *must* identify differently. Moreover, both the organization of the *mise-en-scène* and the 'modes of looking' in film are gendered, with the latter most often 'closely linked with the point of view of a male character' (1988: 115). Thus, whilst the female spectator is free to occupy a multiplicity of subject positions in the filmic fantasy, the fantasy itself remains 'someone else's fantasy', the product of *male* desire (1988: 115).

Creed, however, is less concerned to explore the historical specificity of the 'genres of gender fantasy' which she discusses than to trace their psychoanalytic origins and mythical archetypes. As a result, the monstrous female figures she describes remain relatively unsituated in relation to the *social* changes that in Williams' view have generated the specific anxieties about sexual difference which are embodied in, for example, the figures of Ripley and the alien mother in *Aliens*. Thus, despite her dismantling of the psychoanalytic supports for the inevitability of the patriarchal symbolic, her argument centres less on cultural change than on psychic continuities. In this study of male fears and desires, too, there is little consideration of the position of the *female* spectator – so important in earlier feminist film theory. 'What is the appeal of the horror film to the female spectator?' she asks, but her answers are both tentative and brief. She might, answers

Creed, 'feel empowerment from identifying with the castrating heroine of the slasher film ... or the rape-revenge film', but many of these figures 'do not encourage spectator identification', being insane, psychotic or otherwise monstrous (1993b: 155) and Creed does not pursue the question. The horror film, she argues, speaks to the unconscious fears and desires of both the human subject and the gendered subject, but its 'pleasures/terrors ... are male-defined' (1993a: 156). Her concern is with the exploration of these 'pleasures/terrors' and their functioning for the male spectator and patriarchal ideology rather than with, in Lizzie Francke's words, 'just how furtive and useful the notion of the monstrous-feminine might be' to the female spectator (Francke 1995: 78).

'Her body, himself'[4]

Carol J. Clover's investigation of the contemporary horror film also concludes that 'male viewers are quite prepared to identify not just with screen females, but with screen females in the horror-film world, screen females in fear and pain' (1992: 5). Like Creed, therefore, she too raises questions about 'film theory's conventional assumption that the cinematic apparatus is organized around the experience of a mastering, voyeuristic gaze' (1992: 8–9), and she employs fantasy theory derived from 'A Child Is Being Beaten' to explain the importance in the horror film of both 'cross-gender identification of the most extreme, corporeal sort' (1992: 154) and the *masochistic* gaze. In this analysis, she draws on the work of Kaja Silverman on masochism and (male) subjectivity.

Silverman takes issue with the psychoanalytic assumption underlying much film theory, that the (male) subject's *first* experience of loss or lack is the Oedipal moment, when sexual difference is recognized. In fact, she argues, as Lacan's account of the pre-linguistic mirror stage makes clear, the pre-Oedipal subject is *already* structured by absence and loss at the moment of sexual differentiation. The act of birth, the loss of the mother's breast, the loss of the child's faeces: all these acts of separation, as well as the splitting of the self which comes with the child's identification with its idealized image in the mirror stage, precede the recognition of sexual difference. All apply to both the male and the female child. 'The Oedipal moment', then, 'parades as the moment of primal loss, but actually it screens that loss from us' (1980: 7). Two important consequences follow from this. The first concerns the importance of masochism in the construction of subjectivity. If the subject is constituted through 'splittings', then it follows that *'instinctual unpleasure'* (the experience of splitting and loss) produces *'cultural pleasure'* (the integration into culture and the assumption of a coherent subjectivity) (1980: 3). Moreover, since the integration into culture is the integration into a struc-

ture which *masters us*, rather than one which we master, such a process involves 'the pleasure of passivity, of subject-ion', not that of mastery (1980: 3). This is a pleasure which texts endlessly repeat, at the level of content and also, in the case of film, at the level of cinematic construction. In the filmic structure, the editing cut serves both to sever the 'imaginary plenitude' of the individual shot (unpleasure and loss) *and* to integrate it into the broader structure of narrative (cultural pleasure) (1980: 4).

The second consequence of Silverman's argument is that Freud's insistence on the primacy of the moment of 'discovery' of sexual difference in the construction of subjectivity functions as a displacement. In order to 'place a maximum distance between the male subject and the notion of lack' (1985: 22), Freud – himself of course a male subject – ignores earlier experiences of loss and lack, and instead places the whole burden of this 'discovery' onto the 'recognition' of woman's lack. This too is a scenario which is constantly replayed in the cultural text, so that the process which Laura Mulvey describes – in which the pleasure of the male spectator is constituted by the identification of the female character with lack and her consequent punishment and subjugation – is in fact a scenario of displacement: 'The story belongs as much to the male as to the female subject, but for a variety of cultural reasons it is generally represented in literary and cinematic texts as a female paradigm' (1980: 4). Silverman, then, employs Freud's 'A Child Is Being Beaten', with its oscillation between male and female figures, sadism and masochism, to argue that the position of the spectator/fantasist in this scenario 'is less the site of a controlling gaze than a vantage point from which to see and identify with the whipping boys' (1988b: 50). Although voyeurism has been coded within western culture as a male activity, and associated with aggression and sadism, in fact, she argues, 'it is always the victim – the figure who occupies the passive position – who is really the focus of attention, and whose subjugation the subject (whether male or female) experiences as a pleasurable repetition of his/her own history. Indeed, I would go so far as to say that the fascination of the sadistic point of view is merely that it provides the best vantage point from which to watch the masochistic story unfold' (1980: 5). Freud's concept of 'feminine masochism' is, in fact, a condition which has much more 'to do with male than with female masochism' (1988b: 62). Its construction as 'feminine' enables the male subject to both transgress the 'masculine'/phallic position and yet still keep intact the poles of the existing cultural order (male = active/sadistic/voyeuristic; female = passive/masochistic/to-be-looked-at) – and so preserve the 'cultural secret' (1980: 8) of male masochism and lack.

Clover's analysis of the contemporary horror film draws on Silverman's work to argue that

> the masochistic aesthetic is and always has been the dominant one in horror cinema and is in fact one of that genre's defining characteristics; that the experience horror moviegoers seek is likewise rooted in a

pain/pleasure sensibility; that the fantasies in which horror cinema trades are particularly (though not exclusively) tailored to male forms of masochistic experience (accounting for the disproportionate maleness of the audience); and that the willingness of horror moviegoers to return for sequel on sequel, imitation on imitation, and remake on remake bespeaks a degree of *Wiederholungszwang* [repetition compulsion] that in turn stands as proof of the pudding (1992: 222).

The three genres which she analyses – the slasher film, the possession film and the rape-revenge film – can all be explained in terms of Freud's 'feminine masochism' – that is, a masochism which is *coded* as feminine by the male subject. Each corresponds with a specific aspect of such masochistic fantasies as described by Freud. The possession film 'seems organized around the thought of being "copulated with" and impregnated; the slasher around thoughts of being beaten, castrated, and penetrated (the proportions varying with the film); and the rape-revenge film, obviously, around thoughts of being or having been humiliatingly and violently penetrated' (1992: 216–7). Each functions for its predominantly young *male* audience by enacting such fantasies upon a specifically *female* body: 'in narrative and cinematic imagery, it is the female body that structures the male drama, and to which he assimilates, in his imagination, his own corporeal experience' (1992: 218).

Like Creed, therefore, Clover employs fantasy theory and 'A Child Is Being Beaten' to explain the cross-gender identifications of the horror film. Despite her use of Silverman's work, however, she is less exclusively dependent than Creed on psychoanalytic theory. Many horror scenarios, she argues, exhibit a quality of 'slidingness' about their male and female characters which suggests a pre-Freudian model of sexual difference (the 'one-sex model') in which the sexes are seen as simply inverted models of each other (the external genitals of the male being matched exactly by their 'inverted' internal counterparts in the female). In the premodern world of horror, the *sex* of the individual character is determined by the cultural *gendering* of his or her role (helplessness is gendered female; aggression is gendered male). But because horror is supremely a 'body genre', such gendered roles must be *performed* upon/by male and female bodies within the film. Yet, argues Clover, in the contemporary slasher film, for example, the two central characters – the male killer and the female 'Final Girl' who survives and/or defeats the killer – both exhibit gender confusion. The former is a 'feminized' male, ranging 'from the virginal or sexually inert to the transvestite or transsexual' (1992: 47); the latter a 'masculine female', her gender 'compromised from the outset by her masculine interests, her inevitable sexual reluctance, her apartness from other girls, sometimes her name' (1992: 48). Slasher films are texts, then, 'in which the categories masculine and feminine, traditionally embodied in male and female, are collapsed into one and the same character – a character who is anatomically female and one whose point of view the [male] spectator is unambiguously invited, by

the usual set of literary-structural and cinematic conventions, to share' (1992: 61). The reason for this category confusion, argues Clover, is the contemporary shift in gender roles in which the boundaries between 'masculine' and 'feminine' are being redrawn.

In the example of the slasher film, then, we find 'the rezoning of the feminine into territories traditionally occupied by the masculine' (1992: 107), and the rape-revenge film, too, envisages its female (for the most part) protagonist as not only the victim of rape – 'the limit case of powerlessness and degradation' (1992: 154) – but also as the perpetrator of violent (often literally castrating) revenge. 'The women's movement', comments Clover, 'has given many things to popular culture, some more savory than others. One of its main donations to horror, I think, is the image of an angry woman – a woman so angry that she can be imagined as a credible perpetrator ... of the kind of violence on which, in the low-mythic universe, the status of full protagonist rests' (1992: 17). The possession film demonstrates this 'territorial displacement in the world of gender' in a different way, evincing a preoccupation 'with a shift in the opposite direction: rezoning the masculine into territories traditionally occupied by the feminine' (1992: 104, 107). In the 'dual focus narratives' of this genre, argues Clover, although the literal possession is enacted upon the female body, the 'male story' which usually runs alongside this 'female story' is one of *psychological* opening up and letting in of emotions. In horror's 'concretizing' world, however, 'being impressionable or emotionally open is gendered feminine'; thus, it 'is only by referring to her body that his story can be told' (1992: 101).

However, if all three of Clover's contemporary horror genres exhibit gender confusion and cross-gender identifications, to the extent that in them 'gender is less a wall than a permeable membrane' (1992: 46), this 'vision is hardly an egalitarian one' (1992: 113). The cultural boundary shifts which these genres so graphically illustrate all function for the *male* spectator (like Creed, Clover tends to sidestep the issue of the female spectator), speaking 'deeply and obsessively to male anxieties and desires' (1992: 61). As with Williams' definition of genres as 'cultural problem solving', Clover argues *both* that these 'body genres' return us to primal fantasies which play out the relationship between sadism and masochism, *and* that they are a product of gendered power relations in which anxieties about shifts in these relations are reworked from the dominant male perspective. Thus the androgynous Final Girl of the slasher film is '(apparently) female not despite the maleness of the audience but precisely because of it' (1992: 53). She is a vehicle for the sado-masochistic fantasies of the male spectator, feminine enough 'to act out in a gratifying way, a way unapproved for adult males, the terrors and masochistic pleasures of the underlying fantasy', but 'masculine' enough to permit cross-gender identification (1992: 51). Similarly, the rape-revenge film plays on 'two powerful moments of the male oedipal drama: the fantasy of being "beaten" (sexually penetrated) by the father (a fantasy well accommodated and at the same time well distanced by its

enactment in female form) and the fantasy of killing the father' (1992: 164).
That the masochistic fantasy can be joined to a revenge plot 'coded as an
action film' (1992: 153) is a circumstance made possible – like the figure of
the Final Girl – by the social changes which have allowed the 'victim-hero'
to be re-gendered female. In the case of the possession film, the gender shift
is in the opposite direction. In order to expand the definition of masculinity
to include characteristics like emotional openness, femininity too must be
'relocated' – otherwise the binary division which sustains masculine power
and privilege will collapse. Hence, 'for a space to be created in which men
can weep without being labeled feminine, women must be relocated to a
space where they will be made to wail uncontrollably; for men to be able to
relinquish emotional rigidity, control, women must be relocated to a space
in which they will undergo a flamboyant psychotic break; and so on' (1992:
105). All three genres, then, exhibit the 'feminine masochism' of which
Silverman writes, in which male spectators can both experience 'the
pain/pleasure of (say) a rape fantasy by identifying with the victim' whilst
simultaneously disavowing 'their personal stake on the grounds that the vis-
ible victim was, after all, a woman' (1992: 228). At the same time, all con-
stitute a visible, though ambiguous, 'adjustment in the terms of gender
representations' (1992: 64).

Like Creed's, Clover's analysis of the fluid and perverse identificatory
structures of the horror film challenges some fundamental assumptions of
(feminist) film theory. The 'feminine masochism' so corporeally present in
these genres points, she argues, to the inadequacy of theories of cinematic
spectatorship such as Laura Mulvey's which, in emphasizing the *sadism* of
male spectatorship, in effect help to preserve the 'cultural secret'
(Silverman) which is male masochism and cross-gender identification.[5]
Whilst Mulvey's emphasis on the sadism of the male gaze may have had
political importance for feminism, it also had the effect, argues Clover, of
naturalizing male sadism and with it the binary opposition (male =
sadism; female = masochism) which underpins the existing structure of
gendered power relations. Like Creed's 'monstrous-feminine', her concept
of a 'one-sex model' of gender difference which, she argues, underlies
many horror scenarios, denies the centrality of the castration complex in
the construction of cinema's female figures. In the horror film, she writes,
woman 'represents many bad things, but lack and castration are not
among them' (1992: 108). Clover's account, however, places more
emphasis than Creed's upon the importance of cultural factors in deter-
mining the structures of the contemporary horror film. The shifts in 'the
surface male–female configurations of a traditional story-complex' which
such films exhibit are indications, she writes, of 'a deeper change in the
culture' (1992: 16). Her use of the 'one-sex model' emphasizes not only
the 'slippage and fungibility' (1992: 14) of sexual identity in the universe
of horror, but also the importance of cultural assumptions about gender
in assigning the sex of a character. If 'the sex of a character proceeds from

the gender of the function he or she represents' (1992: 16), then the contemporary confusion over such attributions attests to a period of cultural change even as the violence they enact upon the female body affirms male anxieties and fears about such change.

Finally: what of the female spectator in all this? Clover's primary concern, she writes, is with 'the male viewer's stake in horror spectatorship', and she admits to consigning 'to virtual invisibility all other members of the audience' (1992: 7). As a result, her discussion of the female spectator, like Creed's, is brief and tentative: female spectators, she writes, may 'engage at some level' with horror's masochistic scenarios, and perhaps also gain a certain sadistic satisfaction from the 'surface stories' of genres like the rape-revenge film (1992: 223). Given that she confesses her own conversion to the role of 'fan', such an omission is disappointing, but it attests, as Linda Williams points out (1991: 7), to the difficulty which the concept of *female* masochism ('too much the normal yet intolerable condition of women') poses for feminist critics – an issue to which I shall return.

Fantasy, power and pleasure

In Linda Williams' 'Film Bodies: Gender, Genre and Excess' (1991), hardcore pornography, like the horror film, is described as a 'system of excess' centring on 'the gross display of the human body' (1991: 3). Like the horror film, it is characterized both by the importance of fantasy and by the functioning of the *female* body as the primary embodiment of 'pleasure, fear and pain' (1991: 4). Williams' (1990) study *Hard Core* re-emphasizes this point. 'The animating male fantasy of hard-core cinema', she writes, 'might ... be described as the (impossible) attempt to capture visually [the] frenzy of the visible in a female body whose orgasmic excitement can never be objectively measured' (1990: 50). Like Clover, then, Williams identifies this 'body genre' with both primal fantasy (in this case the seduction fantasy) and 'cultural problem solving'. Citing Beverley Brown's (1981) definition of pornography as 'a coincidence of sexual phantasy, genre and culture in an erotic organization of visibility' (1990: 30), her analysis combines the use of psychoanalytic theory ('an unavoidable partial explanation of the desires that drive sexual fantasy and pornography' [1990: 270]) with a historical analysis which draws on the work of Michel Foucault to argue that 'pleasures of the body' are the product of historically specific 'discourses of sexuality' which are themselves produced 'within configurations of power that put pleasures to particular use' (1990: 3). Pornography, like other forms of sexual 'knowledge', is, argues Foucault, the product of an institutionalised machinery of power through which an 'implantation of perversions' (Foucault 1981) takes place.

The specific 'institutionalised machinery of power' in which Williams is interested is, of course, the institution of cinema. The specific 'perversions' with which Laura Mulvey identifies cinema – voyeurism and fetishism – are, she argues, not 'eternal', already 'inscribed in the subject', as Mulvey, like Metz and Baudry, assumes (1990: 43–4). Rather, they are the specific products of the regime of representation which is cinema. At the origin of cinema, then, 'we have not only a psychic apparatus with a "passion for perceiving" and a technological apparatus that makes perception possible; we have ... a social apparatus as well. And this social apparatus is ultimately what constructs women as the objects rather than the subjects of vision' (1990: 45). Psychoanalysis, in this view, is both an explanatory system which sheds light on this regime and itself a 'discourse of sexuality' produced at the same moment and by the same structures as cinema itself – hence an 'unavoidable partial explanation'. Hard-core film pornography, as the (impossible) attempt to render visible the 'involuntary confession' of feminine pleasure through its representation of 'the female body in the grips of an out-of-control ecstasy' (1991: 4), can be seen as simply an extreme manifestation of the cinematic apparatus.

The specific cultural problem with which hard-core pornography has historically – and increasingly – struggled is the problem of sex itself. 'Pornography as a genre', writes Williams, 'wants to be about sex. On close inspection, however, it always proves to be about gender.' Sex, 'in the sense of a natural, biological, and visible "doing what comes naturally", is the supreme fiction of hard-core pornography; and gender, the social construction of the relations between "the sexes", is what helps constitute that fiction' (1990: 267). Thus, hard-core constructs its 'pornotopias' (pornographic utopian fantasies) as utopian 'numbers' (like the song and dance 'numbers' of the musical) which attempt to resolve through body performance the narrative problems of the text. From this viewpoint, the 'money shot' (visible penile ejaculation) – the characteristic representation of the ultimate climax – must be seen as 'the hard-core fetish par excellence' (1990: 271). Whilst it asserts the penis as 'the unity symbol of plenitude' and phallic power (1990: 268), its very presence – as *external* ejaculation – signals the *absence* of what it seeks to represent: heterosexual pleasure and specifically *woman's* pleasure. 'While undeniably spectacular', writes Williams, 'the money shot is also hopelessly specular; it can only reflect back to the male gaze that purports to want knowledge of the woman's pleasure the man's own climax' (1990: 94). Increasingly, she argues, the genre has manifested a desire 'to see and know the woman's pleasure' (1990: 270), a desire which has been intensified by the changes in gendered relations between the sexes which have resulted from the women's movement. Whilst pornographic films simply assert 'the performance of more, different or better sex' as the solution to the 'problem' of sex (1991: 9), their narratives nevertheless betray a recognition of the crisis in phallic discourse which has occurred since the early 1970s.

In Williams' discussion of sado-masochistic pornography, she turns more

specifically to the issue of fantasy, its multiple and oscillating subject positions, and the relationship between sadism and masochism. Williams draws on the work of Clover and Silverman to argue that 'there is often a more complex "play" of gender roles in films and fantasies than can be accounted for by appealing to a sadistic "male gaze" or to a preoedipal masochistic merger' (1990: 207). Like Clover's female 'victim-hero' of the slasher film, she argues, it is the 'victim-hero' of sado-masochistic pornography who is the male viewer's primary point of identification. Masochism, however, is, she argues, 'a perversion whose absolute passivity has been overestimated' (1990: 216). The 'search for recognition through apparent passivity' which characterizes it is in fact a 'ruse intended to disavow what the masochist actually knows to exist but plays the game of denying: his (or her) very real sexual agency and pleasure' (1990: 212). There can be no pleasure without some power, she insists; the female masquerade which Mary Ann Doane, in her analysis of the female spectator of the 'woman's film', saw as an *avoidance* of the masochistic position of suffering is in fact, argues Williams, actually an oscillation which is *typical* of masochism. The masochistic victim has *arranged* to play the role of suffering victim, the better to enjoy pleasure, so that identification with her/him 'is not *simply* identification with pain, humiliation and suffering' (1990: 214). Moreover, argues Williams, *sado*-masochism is a better term to describe the oscillating subject positions – between active and passive and male and female – which are characteristic of this type of pornography.

The shifting subject positions of 'A Child Is Being Beaten', then, inform Williams' discussion of pornography, as they do Creed's and Clover's discussions of the horror film. But Williams also tackles the issue of *women's* spectatorial investments in such fantasies, an issue which both Creed and Clover side-step. Her redefinition of masochism enables her to argue that the woman viewer of sado-masochistic pornography 'may be in closer "contact" with the suffering of the female victim-hero, but she is not condemned ... to lose herself in pure abandonment, pain, or pre-oedipal merger' (1990: 216). Not only is masochism not identical to an absolute passivity, but the female spectator too will find power and pleasure in the oscillating subject positions which such fantasies offer. Nevertheless, women's greater investment in masochism must be viewed also from a political and social perspective. The cultural dominance of the phallus is, she argues, an important factor in female masochism, 'for masochism, as a way of achieving pleasure without also taking on the appearance of power, eschews the control and agency associated with phallic mastery that is so foreign to the construction of "normal" female subjectivity'. If masochism is not wholly identified with passivity, then, it is still 'an alienated and devious way of becoming a hero-subject' (1990: 258) and one which does not allow us to forget that 'the father is still the one with ultimate power' (1990: 216). Sado-masochistic film pornography 'is not a form that, even at its most aesthetic and playful, challenges male dominance' (1990: 225).

Williams therefore takes issue with what she calls the 'subversive emphasis' of Clover's account of the slasher film. Whilst Clover's emphasis on the fluid movement between masculine/feminine, active/passive, sadistic/masochistic, Oedipal/pre-Oedipal poles is useful, she argues, Clover ignores the fact that at the moment when the 'female victim-hero' confronts the monster-killer, she too becomes monstrous, 'not so much both male and female as *neither* male *nor* female' (1990: 208). The power invested in the 'normal' hierarchy of male dominance and female submission is not so easily subverted. Williams also points out the tendency of feminist critics like Clover, Creed and Silverman to concentrate on the subversive potential of *male* masochism in undermining conventional assumptions about gendered hierarchies – whether in film or film theory (1991: 7). Such a focus avoids the far more difficult problem (for feminism) of *female* masochism. If male masochism (or an oscillation between sadistic and masochistic poles) can be seen, at least to some extent, as a subversion of patriarchal law, no equivalent subversion is available to the female masochist for whom 'masochism is ... a "norm" for female behaviour under patriarchy' (1990: 217). The masochistic female spectator, like her screen counterpart, 'gets pleasure, but she must pay obeisance to a value system that condemns her for her pleasure; the rules of the game are not her own' (1990: 209). To ignore this, in a celebration of fluid identificatory positions and oscillating gender roles, can be to forget 'where ultimate power lies' (1990: 217).

Conclusion: *'there is no female spectator'*

The escape from Laura Mulvey's 'uninviting Catch-22' (Donald) offered by fantasy theory has proved, it would seem, both fruitful and problematic for feminist film theory and criticism. Its assertion, in Penley's words, that *'there is no female spectator*, at least at the level of unconscious identification', suggests that identificatory processes are both multiple and shifting, not tied to gender identities as Mulvey's division between the sadistic male gaze and the female object of spectacle would suggest. But this is to beg the questions of where, in that case, gendered identity/identification *is* to be located, and what relationship the fluid subject positions of fantasy have to the social configurations of gendered power which organize identity at the level of the social. If we can move between sadistic and masochistic identifications, 'masculine' and 'feminine' positions, how is this fluidity to be related to the power of the (sadistic) masculine position in the social world? And should fantasy, with its shifting identifications, be regarded as a subversive force, or is it always subject to overdetermination at the level of textual organization and discursive structure – no more than 'escapist fantasy' in the pejorative sense? Finally, at what level should feminist theory

and criticism make its intervention: as the celebration of the fluid identifica-
tions of fantasy or the critical analysis of the operation of gendered power
at the level of the (social) symbolic? Mary Ann Doane makes the case force-
fully for the latter. Fantasy theory's desire, she writes,

> is to annihilate an identity which has been oppressive – but to annihi-
> late it by fiat, simply declaring it non-operational at the level of an
> indisputable psychical reality of slippage, splitting and failure.
> However, if this is indeed the case, and texts do operate in this man-
> ner *vis-à-vis* their spectators, there is no need for feminist criticism.
> For feminist criticism must of necessity deal with the constraints and
> restraints of reading with respect to sexual identity – in effect, with the
> question of power and its textual manifestation. It may be true that at
> the level of the psychical, identity is always ultimately subject to fail-
> ure, but at the level of the social, and with respect to configurations of
> power, this is clearly not the case. (Doane 1989: 145)

All of the work discussed in this chapter grapples in some way with these
questions, finding different ways of articulating an analysis of the psyche
with a consideration of the social. Linda Williams' account of pornography
as 'a coincidence of sexual fantasy, genre and culture' states one view of the
usefulness, and the limitations, of psychoanalytic fantasy theory in the
analysis of 'genres of gender fantasy'. Psychoanalysis, she writes, is 'an
unavoidable partial explanation for the desires that drive sexual fantasy and
pornography', but just as 'fantasy, coming from the deepest regions of the
psyche, is most resistant to change [whilst] genre and culture are most capa-
ble of change', so too psychoanalysis functions as 'a theoretical limit to
change in the human psyche' (1990: 270). Psychoanalytic fantasy theory, in
this view, cannot by itself serve a feminist project.

Such a point is made even more clearly when we consider the difficulty of
such theory in considering the question of the female spectator. As Penley
makes clear, such a figure loses all meaning at the level of the unconscious.
Yet as Doane responds, she is central in any feminist political analysis of
texts and their readers – and, in the person of the *feminist critic*, she is the
point from which critical resistance must be articulated. It is one thing to
destabilize *masculine* identity, but quite another political enterprise to strip
the identity 'woman' of any meaning. As Linda Williams argues, such a
'decentering' could cause women to 'lose the gender identification that most
effectively recognizes our experience of oppression and provides the most
dramatic impetus to resist' (1990: 56). Most studies which employ fantasy
theory, as she points out, simply avoid the problem, and with it the problem
of their own speaking position. Her own solution looks itself like a version
of the Freudian concept of 'disavowal'. Women's resistance, she writes,
must 'continue to rely on the *fiction* of the unity "woman" insofar as
oppression continues to make that unity felt' (my emphasis). Like all forms
of disavowal, it is a difficult balance to hold.

|6|

Rereading difference(s) 1: conceiving lesbian desire

Some feminists might wonder why I have said nothing about black or lesbian (or black-lesbian) feminist criticism in America. ... The answer is simple: this book purports to deal with the theoretical aspects of feminist criticism. ... This is not to say that black and lesbian criticism have no political importance; on the contrary, ... [t]hese 'marginal feminisms' ought to prevent white middle-class First-World feminists from defining their own preoccupations as universal female (or feminist) problems. (Moi 1985: 86)

[R]adical change requires that [difference] not be limited to 'sexual difference', that is to say, a difference of women from men, female from male, or Woman from Man. Radical change requires a delineation and a better understanding of the difference of women from Woman, and that is to say as well, *the differences among women*. For there are, after all, different histories of women. There are women who masquerade and women who wear the veil; women invisible to men, in their society, but also women who are invisible to other women, in our society. (de Lauretis 1987: 136)

Reading Toril Moi's dismissal of black and lesbian feminist criticism in the light of Teresa de Lauretis' very different account of the moment of feminist theory from which they both speak[1] (de Lauretis' account was also first published in 1985), a number of points become apparent. First, Moi's account seems less a *description* of the state of feminist theorising in 1985 (which is what she claims) than an act of exclusion, of actively rendering 'invisible', in de Lauretis' terms. Not only is politics (simple-minded activism?) to be separated from theory, in contrast to de Lauretis' insistence that radical change *requires* a shift in theoretical understanding. The political importance of black and lesbian feminisms is also seen in terms of their usefulness *to us*, who are assumed to be neither of these things. If these feminisms are 'marginal', then 'white middle-class' *heterosexual* (Moi does not even have to

name *this* norm) 'First-World feminism' is by definition central. Put another way, its centrality as subject can be seen to *depend on* the relegation to the margins (as other) of those paradigms which might insist on seeing (it) differently. In the ten years since Moi wrote, the centrality which she assumes so easily has been increasingly challenged. The following two chapters will attempt to trace these challenges and their theoretical implications.

Challenging heterobinarism

In feminist film theory, one of the most basic working assumptions has been that in the classical cinema, at least, there is a fit between the hierarchies of masculinity and femininity on the one hand, and activity and passivity on the other. If disrupting and disturbing that fit is a major task for filmmakers and theorists, then lesbianism would seem to have a strategically important function. For one of the 'problems' that lesbianism poses, insofar as representation is concerned, is precisely the fit between the paradigms of sex and agency, the alignment of masculinity with activity and femininity with passivity. (Mayne 1990: 117–8)

How to conceive lesbian desire given that it is the preeminent and most unambiguous exemplar of *women's* desire (for other women)? ... How can a notion like desire, which has been almost exclusively understood in male (and commonly heterocentric) terms, be transformed so that it is capable of accommodating the very category on whose exclusion it has been made possible? (Grosz 1995: 175)

'Desire' and 'activity': these, together with 'identification', are the terms in which Laura Mulvey's groundbreaking 'Visual Pleasure and Narrative Cinema' (1975) described the pleasures of mainstream cinema for the male spectator. As Mayne and Grosz point out, this theorisation of the sexual hierarchy in cinema simply cannot account for lesbian desire either as representation or as spectator position. Later challenges to Mulvey's account, from Mulvey's own (1981) description of the female spectator's 'trans-sex identification' shifting 'restlessly in its *borrowed* transvestite clothes' (1989d: 33, my italics) to fantasy theory's insistence on fluid identifications across gender boundaries,[2] still tend, as Judith Mayne points out, not only to affirm heterosexual norms but to assume a 'heterosexual division of the universe' as the basic condition for cinematic identification (1990: 118). The reason for this theoretical blind spot, as de Lauretis, Grosz and Mayne all suggest, is the reliance of feminist film theory on psychoanalysis. Yet paradoxically, de Lauretis insists, it was this reliance which also produced the position from which lesbian desire/spectatorship/identification *could* be

theorised. Feminism's insistence – using psychoanalysis – on sexual differ-ence, she writes, 'open[ed] up a critical space – a conceptual, representa-tional, and erotic space – in which women could address themselves to women. And in the very act of assuming and speaking from the position of subject, a woman could concurrently recognize women as subjects *and* as objects of female desire' (1994: 5). Nevertheless, she adds, lesbian desire is 'simply incomprehensible' within the psychoanalytic framework. Thus, the implications of rendering such desire theoretically and cinematically *visible* (to return to de Lauretis' 1987 formulation) are not simply that feminism's theoretical scope must be extended. Rather, it must be radically re-thought.

Psychoanalysis and female homosexuality

In Freud's account of female sexual development, lesbian desire is both a troublingly persistent theme and a phenomenon inexplicable in other than masculine terms. For the girl as well as for the boy, the first erotic object is the mother and 'her sexual aims in regard to her mother are active as well as passive' (Freud 1977e: 383). The path to 'normal' adult femininity is there-fore, as Freud confesses, a 'very circuitous' one. The girl must accept her own 'castration', and in so doing transfer her desire from the mother (who is also 'castrated') to the father (who possesses the penis she envies). She must also abandon the (phallic) clitoris for the vagina as her 'leading genital zone', and accept her feminine passivity. It is an account of female develop-ment in which the girl's active, pre-Oedipal desire for her mother is promi-nent. Because, argues Freud, 'the phase of exclusive attachment to the mother, which may be called the *pre-Oedipus* phase, possesses a far greater importance in women than it can have in men' (1977e: 377), girls are much more disposed towards bisexuality than boys. Moreover, 'we had to reckon with the possibility that a number of women remain arrested in their origi-nal attachment to their mother and never achieve a true change-over towards men' (1977e: 372). If we add to this two further difficulties, first that 'a girl may refuse to accept the fact of being castrated' (1977c: 337) and insist on 'a defiant over-emphasis of her masculinity' (1977e: 379), and sec-ond that 'if a girl is not happy in her love for a man, the [homosexual] cur-rent is often set flowing again by the libido in later years and is increased up to a greater or lesser degree of intensity' (1977b: 95), we can see that the path towards adult heterosexuality is problematic indeed for women. The terms which Freud finds to discuss these rebellious desires, however, remain rooted in the heterosexual assumptions which his account renders problem-atic. The woman who disavows her own castration and retains a female love-object exhibits a 'masculinity complex' ('She had thus not only chosen a feminine love-object, but had also developed a masculine attitude towards

this object' [Freud 1963: 141]). The female homosexual who does *not* exhibit a masculinity complex has chosen as her love-object a 'phallic woman', a substitute man (Grosz 1995: 153).

If we turn to Lacan's rewriting of Freud in terms of language and culture, the concept of lesbian desire becomes, paradoxically, even more of an impossibility. Lacan argues that sexual difference is constituted in language, or the symbolic, in which the marker of difference is the phallus. Put simply, one either *has* (masculine) or *is* (feminine) the phallus:

> simply by keeping to the function of the phallus, we can pinpoint the structures which will govern the relations between the sexes.
>
> Let us say that these relations will revolve around a being and a having which, because they refer to a signifier, the phallus, have the contradictory effect of on the one hand lending reality to the subject in that signifier, and on the other making unreal the relations to be signified. (Lacan 1982: 83–4)

What this rather difficult formulation means is that, although the phallus is only a linguistic signifier (and not the anatomical penis), it is through this all-powerful signifier that we are given our cultural positions as subjects. The woman's position, then, is the one accorded to her in Laura Mulvey's account of cinematic representation – a symbol of and for masculine desire: 'images and symbols *for* the woman cannot be isolated from images and symbols *of* the woman' (1982: 90). This position is 'insoluble': 'the symbolic order literally submits [the woman], it transcends her' (Lacan in Rose 1986: 69). Woman is 'symptom' for the man, the place onto which lack is projected, nothing other than a 'fantasmatic place' for him (Rose 1986: 72). For, of course, she cannot *be* the phallus other than through masquerade, or appearance, and that very masquerade reveals her 'deficiency':

> Paradoxical as this formulation might seem, I would say that it is in order to be the phallus, that is to say, the signifier of the desire of the Other, that the woman will reject an essential part of her femininity, notably all its attributes through masquerade. (Lacan 1982: 84)

When Lacan writes of lesbian desire, therefore, it is as a product of 'disappointment' in the failure of the heterosexual masquerade. Whilst masculine homosexuality, he writes, is constituted on the axis of the 'phallic mark which constitutes desire' (Lacan 1982: 85), 'feminine homosexuality' is 'set off by a demand for love thwarted in the real'. Taking his cue from Freud's description of the 'devoted admiration' with which his lesbian patient had pursued her 'lady' (Freud 1963), Lacan models his account of lesbian desire on courtly love (the mediaeval code in which it was the lady's inaccessibility which made her an object of desire):

> In that such a love prides itself more than any other on being the love which gives what it does not have, so it is precisely in this that the homosexual woman excels in relation to what is lacking to her. (Lacan 1982: 96)

But not only does the lesbian have to imagine herself a man in order to desire, the object of her desire is also in some sense herself (evidenced by 'the care which the subject shows for the enjoyment of her partner'), and the whole performance is accompanied by 'the fantasy of the man as invisible witness' (1982: 97). Quite apart from the fact that this sounds like a scenario from male pornography (and hence reveals itself as *Lacan's* fantasy), there seems little difference in Lacan's formulation between lesbian and heterosexual female sexuality, since for the heterosexual woman, too, the only access to desire is through an identification with the man's desire of her. It is perhaps not surprising, then, that it is his discussion of 'feminine homosexuality' which leads Lacan to his *general* formulation of the relationship between female sexuality and desire:

> Far from being the case that the passivity of the act corresponds to this desire, feminine sexuality appears as the effort of a *jouissance* [ecstatic or orgasmic enjoyment] wrapped in its own contiguity ... to be *realised in the envy* of desire. (1982: 97)

It is this view of the woman's relation to desire as no more than the 'envy of desire' – the 'desire to desire' – which serves as Mary Ann Doane's guiding premise in her study of the woman's film of the 1940s (Doane 1987: 12).

Feminist film theorists who have sought a more useful (to feminism) psychoanalytic model of female sexuality have, as we have seen (Chapter Three) turned to the work of Nancy Chodorow and Julia Kristeva. Both writers emphasize the pre-Oedipal connection to the mother in their accounts of female development. Chodorow, following Freud, argues that the pre-Oedipal phase is more important in female development than in male development, and, as a connection which is never broken, accounts for women's sense of self as relational rather than separate. Yet, as Judith Mayne argues, whilst in Chodorow's *The Reproduction of Mothering* 'the possibility of strong erotic bonds between women is posed constantly at the edge of the text', it is a spectre which is simultaneously evoked and dismissed (Mayne 1990: 150–1). For most women, concludes Chodorow, 'deep affective relationships are hard to come by on a routine, daily, ongoing basis. ... Lesbian relationships do tend to recreate mother–daughter emotions and connections, but most women are heterosexual' (Chodorow 1978: 200). This is a curious statement which seems to place a double prohibition on lesbian desire. Not only is it de-eroticized as 'mother–daughter emotions and connections', but it is dismissed as out of reach for most women – when one might have supposed that women's pre-Oedipal connections to the mother would make 'deep affective relationships' between women *more* rather than less likely.

Kristeva's semiotic *chora*, like Chodorow's pre-Oedipal realm, is a feminine space, the realm of the mother. More firmly bound to a Lacanian psychoanalytic perspective than Chodorow, however, Kristeva conceives the *chora* as always *anterior* to the realm of language and culture, the symbolic,

or, alternatively, as *disruptive* of the symbolic. In this view, female homo-
sexuality can only be seen as a relation between a woman and her (fanta-
sized) mother (Grosz 1989: 93), and as such as inevitably regressive. It is a
retreat from the maturity of the symbolic order, an order in which a woman
finds herself always more vulnerable than a man (Kristeva 1986d: 204).
Thus, Kristeva's imagined 'erotics of the purely feminine' is in fact *de*-eroti-
cized:

> Lesbian loves comprise the delightful arena of a neutralised, filtered
> libido, devoid of the erotic cutting edge of masculine sexuality. ... It
> evokes the loving dialogue of the pregnant mother with the fruit,
> barely distinct from her, that she shelters in her womb. Or the light
> rumble of soft skins that are iridescent not from desire but from that
> opening–closing, blossoming–wilting, an in-between hardly estab-
> lished that suddenly collapses in the same warmth, that slumbers or
> wakens within the embrace of the baby and its nourishing mother.
> (Kristeva 1987: 81)

As we might expect, this 'fundamental female "homosexuality"'
(Kristeva 1986b: 149) is for Kristeva most properly realized in motherhood,
or pregnancy. When, however, 'such a paradise is not a sidelight of phallic
eroticism, ... when it aspires to set itself up as absolute of a mutual rela-
tionship', a very different picture emerges. This version of the lesbian is psy-
chotic (as well as feminist):

> Obliteration of the pre-Oedipal stage, identification with the father,
> and then: 'I'm looking, as a man would, for a woman'; or else, 'I sub-
> mit myself, as if I were a man who thought he was a woman, to a
> woman who thinks she is a man'. Such are the double or triple twists
> of what is commonly called female homosexuality, or lesbianism. ...
> Thus the lesbian never discovers the vagina, but creates from this resti-
> tution of pre-Oedipal drives (oral/anal, absorption/rejection) a power-
> ful mechanism of symbolization. Intellectual or artist, she wages a
> vigilant war against her pre-Oedipal dependence on her mother, which
> keeps her from discovering her own body as other, different, possess-
> ing a vagina. (Kristeva 1986b: 149)

The lesbian continuum?

Psychoanalytic theory, concludes Elizabeth Grosz, which 'has problems in
its accounts of (heterosexual) women and ("normal") femininity', finds
these problems amplified to 'a point of constitutive incoherence and confu-
sion when it addresses lesbianism'. She therefore asks:

Can theoretical frameworks that have been instrumental in the development of present-day feminist theory be presumed to be similar to those of lesbian theory? ... What is at stake in trying to include what was previously excluded, to place at the centre what was marginalized, to explain and analyze what was inexplicable and unanalyzable? (Grosz 1995: 157–8)

If we apply these questions within the context of feminist film theory, we might ask further: is what is needed a theorising of a *specific* lesbian desire and its relationship to representation, fantasy and cinema – a set of processes radically *other* than those used to theorise the relationship of heterosexual women to cinema and representation? Or is it rather a more *general* rethinking of the issues of female desire, identification and fantasy, one which would *not* relegate lesbian desire either to the realm of the (immature) pre-Oedipal or to the status of the merely imitative ('I'm looking, as a man would, for a woman') – but one which would not constitute it as radically other? The first, we might argue, risks leaving the structures of heterosexuality (and perhaps heterosexism) untouched. The second, however, risks recuperating the *difference* of lesbianism for a more general, and de-eroticised, theory of what Teresa de Lauretis calls female 'homo*sociality*' (1994: 116–20).

These questions in turn raise the issue of what we *mean* by 'lesbian desire' and 'lesbian identity'. Is there, in Adrienne Rich's formulation, a 'lesbian continuum' to which all women have access and which is defined as 'the erotic in female terms: as that which is unconfined to any single part of the body or solely to the body itself' (Rich 1996: 136)? For such a continuum, the pre-Oedipal attachment to the mother might serve as a theoretical basis, once shorn of its relegation to the pre-discursive and rethought in terms of the symbolic. Or does such a concept, as Teresa de Lauretis claims, simply offer a seductive fantasy for heterosexual feminism which would like to envisage the possibility of access to an autonomous sexuality? Does it, as she claims, obscure the understanding of lesbianism 'as a specific form of female sexuality, but also as a sociosymbolic form; that is to say, a form of psychosocial subjectivity that entails a different production of reference and meaning' (1994: xvii)? Depending on our answers to these questions, we might frame an account of lesbian desire and identity in terms of fantasy and the unconscious, or in terms of social and cultural positioning. And we might adopt as our methodology a rethought psychoanalytic film theory or a cultural studies framework.

Rethinking psychoanalysis: Kaja Silverman

Film theory, observes Silverman, has since its inception been haunted by the spectre of loss or absence. It is a loss, however, which has proved 'surpris-

ingly mobile' (1988a: 10). But whether it is the loss of the real, the absence
of the site of cinematic production or the lack which is inscribed in the
female body which is being theorised, the real preoccupation is always, as it
is in mainstream cinema itself, with male subjectivity: 'If crisis surrounds the
discovery that filmic construction is organized around absence, that is
because the spectating subject is organized around the same absence'
(1988a: 6). This preoccupation, she argues, accounts for the reliance on psy-
choanalysis by theorists such as Metz and Baudry,[3] for the loss which is at
the centre of male subjectivity is also the focus of psychoanalysis. And psy-
choanalysis, like cinema, is concerned to displace a lack which is funda-
mental to the *male* subject on to the body of the woman. Reinterpreting
Freud, then, what Silverman argues is that the child who enters the Oedipus
complex is *already* marked by loss or lack – the loss that begins, as Freud
himself admits, with 'the act of birth itself (consisting as it does in the sepa-
ration of the child from his mother, with whom he has hitherto been
united)' a loss which is 'the prototype of all castration' (Freud 1977f: 172).
Indeed, were the child not already to have experienced lack or loss, she
argues, the idea that sexual *difference* could be perceived as an image of *loss*
would be inexplicable. Freud, like Hollywood cinema and its male theorists,
is *projecting* a loss/lack at the heart of all subjectivity on to the body of
woman, and hence constructing a position for her within the symbolic order
which ensures his own identity as a subject at the expense of hers. In cinema
this projection, though it is anatomically naturalized, is in fact 'an exclusion
from symbolic power and privilege'. The woman, relentlessly exposed to the
male gaze, finds her own gaze 'depicted as partial, flawed, unreliable, and
self-entrapping. She sees things that aren't there, bumps into walls, or loses
control at the sight of the color red'. Her speech, too, is externally manipu-
lated, self-disparaging, an 'acoustic mirror' for the male: 'Even when she
speaks without apparent coercion, she is always spoken from the place of
the sexual other' (1988a: 31).

But if all this is familiar ground for feminist film theory, Silverman's
alternative account of psychic development takes us into new theoretical
areas. She notes that at several points Freud, following psychoanalyst
Jeanne Lampl-de Groot, referred to the girl's early attachment to the mother
not as 'pre-Oedipal' but as the 'negative Oedipus complex'.[4] In this alterna-
tive formulation, 'the subject is generally obliged to negotiate his or her way
between two versions of the Oedipus complex, one of which is culturally
promoted and works to align the subject smoothly with heterosexuality and
the dominant values of the symbolic order, and the other of which is cultur-
ally disavowed and organizes subjectivity in fundamentally "perverse" and
homosexual ways' (1988a: 120). Thus the girl's desire for the mother occurs
after her entry into language and culture. It is indeed, like all desire, a prod-
uct of that entry. It cannot therefore be consigned, as Julia Kristeva consigns
it, to the realm of the pre-discursive and the pre-erotic – at best a disruptive
force within the symbolic. Such a reconceptualization, argues Silverman,

'makes it possible to speak for the first time about a genuinely oppositional desire – to speak about a desire which challenges dominance from within representation and meaning, rather than from the place of a mutely resistant biology or sexual "essence"' (1988a: 124). It is a desire which is simultaneously an *identification* with the mother: 'desire and identification may be strung along a single thread in the female version of the Oedipus complex' (1988a: 150). And it persists, in the split female subject, 'long after the Oedipus complex has ostensibly run its course' (1988a: 123).

As Judith Mayne points out,[5] Silverman's rereading of psychoanalysis could be said to restate in psychoanalytic terms Adrienne Rich's concept of a lesbian continuum. It provides theoretical space for an alternative primal 'fantasmatic scene' for women, one which Silverman terms the 'homosexual-maternal fantasmatic' (1988a: 125). It is this founding fantasy which grounds feminism and makes it possible for the feminist subject to speak and to articulate an oppositional 'libidinal politics', and which enables a feminist film-maker to articulate an alternative model of desire. In the concept of 'cultural disavowal', too, we can find a suggestive reworking of earlier theories of cinematic spectatorship. It was *disavowal* which for Christian-Metz characterized the processes of cinematic 'belief' (the viewer both recognizes and disavows the absence which characterizes the projected images of the cinema screen, just as the fetishist both affirms and denies the female phallus). And it was the identification of this process with *male* subjectivity which for feminist theorists from Laura Mulvey onwards posed such a problem for the conceptualization of a *female* viewing position.[6] To disavow is to simultaneously affirm and deny. If the female subject has no recourse to this mechanism (being already 'castrated', she has no reason to fear castration), she cannot maintain her distance from the cinematic image. The 'homosexual maternal fantasmatic' which is culturally disavowed by the dominant order might, then, provide the basis for an ironic distance for the female spectator. As split subject, she can simultaneously recognize herself in and refuse to be contained by the positionings offered by mainstream cinema, attracted always to alternative scenarios of desire.

Perverse desire: Teresa de Lauretis

If Silverman's reconceptualization of female desire is suggestive for feminism, however, it says little about the *specificity* of lesbian desire or the marginality of lesbianism within the current symbolic order and structures of representation. Criticizing this lack of specificity, Teresa de Lauretis argues that Silverman's project is to 'provide a *revised* account of female subjectivity, and one that would be *inclusive of all women*'; it is not to account for lesbian subjectivity (1994: 183). Silverman's 'homosexual-maternal fantas-

matic', she argues, is a *heterosexual* feminist fantasy, one which '*projects onto female sexuality certain features of an idealized feminist sociality* – sisterly or woman-identified mutual support, anti-hierarchical and egalitarian relationships, an ethic of compassion and connection, an ease with intra-gender affectionate behavior and emotional sharing, and a propensity for mutual identification' (1994: 185–6). It is a fantasy necessary to feminism but it is one which must be resisted by the lesbian theorist.

De Lauretis' work in the 1980s was concerned with the relationship of sexual difference to the cinematic apparatus. In *Alice Doesn't* (1984) she argues that the 'present task of theoretical feminism and of feminist film practice alike is to articulate the relations of the female subject to representation, meaning, and vision, and in so doing to construct the terms of another frame of reference, another measure of desire' (1984: 68). The questions to be asked are: 'by what processes do images on the screen produce imaging on and off screen, articulate meaning and desire, for the spectators? How are images perceived? How do we *see*? How do we attribute meaning to what we see?' (1984: 39). In 1994 her focus is a much more specific and personal concern with *lesbian* subjectivity and what she terms 'perverse desire'. The pronoun which articulates her questions is no longer 'we' but 'I': 'How do I look at the film? How do I appear in its fantasy? Am I looking on? Can I be seen? Do I see myself in it? Is this my fantasy?' (1994: 98). De Lauretis, then, refuses the concept of a 'lesbian continuum', however theorised, and argues for a radically *other* structure of lesbian desire and fantasy.

In one sense, as she argues, *all* sexuality may from a Freudian perspective be regarded as perverse. The infant (and particularly the female infant) is, as we have seen, bisexual. Moreover, in the *Three Essays on the Theory of Sexuality* (1905) Freud concludes that 'a disposition to perversions is an original and universal disposition of the human sexual instinct' (1977b: 155). As Elizabeth Grosz summarizes:

> If perversion is, as Freud suggests, a deviation from an instinctual activity, the insinuation of a gap between a drive and its aims and objects, then *all* sexuality is a deviation, all desire perverse, all pleasure an amalgam of heterogeneous component drives that refuse any simple subordination to genital and reproductive functions. Heterosexual genital and reproductive sexuality are only the tenuous results of the repression and reordering of the heterogeneity of drive impulses. (Grosz 1995: 160)

Such a formulation, however, whilst it accounts for 'perverse desire', does not necessarily accord it access to the symbolic order, the order of language and culture. And it does not accord it the status of a mature ordering of sexuality. For de Lauretis, such access implies some theory of castration, of a fantasy of loss which gives access not only to desire but to representation. In the lesbian subject, she argues, what is castrated, lost and disavowed

is a lovable or desirable *female body* – the subject's own (imaginary) body-image. As with the male subject, therefore, this fantasized castration is a 'narcissistic wound' (1994: 231), threatening the subject's sense of being, and not an actual loss – of the mother's body or breast. Like the male fetishist, the lesbian subject disavows this loss, displacing the libido attached to it onto a fetishistic substitute. Whatever the nature of this fetish – two examples are the mannish clothing of the butch lesbian or the exaggerated femininity of the femme – its function is to act as a signifier of desire. Lesbian desire is thus not constructed along the axis of *identification,* as Silverman's formulation would suggest, but is the *desire* for the other's desire 'as signified in the fetish and the fantasy scenario it evokes'. The fetish does not stand in for a missing penis or even for the body of the other woman. It is simply a signifier of her desire. 'What one desires is her lover's perverse desire; her fetish, in which her castration or lack of being is both acknowledged and denied, also mediates the other's fantasmatic access to her originally lost body' (1994: 251).

Fantasy and disavowal: these are the terms on which film theory is grounded. What de Lauretis seeks to construct is a radically *other* fantasy scenario and a different form of disavowal. Like the theorists examined in Chapter Five, she sees fantasy as central to the construction of sexuality and desire, but there is a fundamental difference, she argues, between private and public forms of fantasy, between the subject's conscious or unconscious scenarios of desire and the specific social technology which is cinema. Thus we cannot all occupy any position in any film repesentation/fantasy, as writers such as Penley[7] have suggested. The public forms of fantasy which constitute cinematic representation are particular orderings of desire, in which we, as social as well as psychic subjects, may or may not be able to locate ourselves. But, as public orderings of fantasy and desire, cinematic representations also help to *construct* our identities as social subjects, and produce what de Lauretis calls a discursive 'consent to activity' (1994: 73). The public representation of the scenarios of desire which are specific to lesbian fantasy may serve then as an 'authorizing social force' (1994: 76) for lesbian perverse desire.

The move from de Lauretis' position in the mid-1980s to her 1994 *The Practice of Love* marks a move to a greater specificity, but it involves losses as well as gains. We can perhaps see these best in the discussions of the two films through which she articulates her views, Lizzie Borden's (1983) *Born in Flames* (discussed in 1985) and Sheila McLaughlin's (1987) *She Must Be Seeing Things* (discussed in 1994). *Born in Flames*, argues de Lauretis, succeeds in 'address[ing] its spectator as female' (1987: 132) because it represents not only the difference of (real, historical) *women* from (the patriarchal concept) Woman, but also '*the differences among women*'. And our engagement with these women is 'erotic' yet at the same time 'a recognition, unmistakable and unprecedented'. Finally, this multiple and eroticized engagement with difference brings also a recognition of the

'differences *within* women' – of our fractured and multiple positionings (across 'class, race, language, and social relations') within the social order (1987: 136–9). This is an account which seems to string recognition and difference, identification and desire, in Kaja Silverman's words, 'along a single thread'.

What marks *She Must Be Seeing Things* as 'guerrilla cinema' (1990: 25), however, is its rewriting of primal fantasy in lesbian terms: 'McLaughlin's film does not merely portray a lesbian fantasy ... but effectively constructs a scenario of lesbian *spectatorial* desire and enables the visualization – it would be appropriate to say the invention – of a *lesbian* subject of viewing' (1994: 99–100). In its self-conscious performance of masculine and feminine gender positions in a masquerade which is not addressed to men but which instead fetishizes lesbian desire, this film acts as an authorizing representation for lesbian fantasy. Two things, however, seem to be lost in this account. One is the concept of *multiple* differences, between and within women: indeed, de Lauretis' account, like the film itself, can be accused of ignoring – or reducing to a 'fetish' – the racial difference between the two central characters (see Rich 1993). The second is an 'erotic charge' which is available to *all* female spectators. Put differently, what de Lauretis denies in her 1994 formulation is the *mobility* of desire. For the difference between heterosexual and lesbian women is not absolute or fixed: women 'become' lesbians. As Elizabeth Grosz puts it: 'Unless there is a common structure of desire – or at least a very broad continuum on which both lesbian and heterosexual women's desires can be located – the openendedness of desire in its aims, objects, and practices cannot be adequately explained' (Grosz 1995: 170). To specify a *lesbian* perverse desire risks losing the insight that *all* desire may be characterized as perverse and thus both mobile and excessive. If this account privileges the lesbian spectator (the process of disavowal is available to her but apparently *not* to the heterosexual female spectator), it leaves the boundary heterosexual (normal)/homosexual (perverse) intact.

Identification and desire in the social subject

'To read much lesbian film theory is to understand lesbian spectatorship as a constant struggle to insist on and locate "lesbian" as a reading/viewing position', writes Tamsin Wilton (1995: 157). Her own solution is to abandon psychoanalysis in favour of the concept of a 'cinematic contract' whereby 'the spectator agrees to draw upon the personal emotional/political/social narratives which she brings with her into the cinema in order to devise engagement strategies which she puts at the service of the film'. Such narratives 'derive less from the unconscious and more from the social location of the spectator' (1995: 16). Similar to Christine Gledhill's concept of

'negotiation',[8] this formulation places 'lesbian identity' firmly within the social. Lesbian oppression is material, and '"women" who identify as "lesbian" inhabit a particular set of interstices among social notions of gender, desire, deviance, criminality, sin, naturalness, etc' (1995: 158–9). They make use of these positionings in order to negotiate a space of (perhaps limited) identification with the meanings proposed by the film. Or, alternatively, they may *set aside entirely* their 'lesbian reading position' in a temporary escapism into the 'joys, sorrows and fantasies of the wider culture' which the darkened cinema affords (1995: 156–9).

Despite its attractiveness (no more difficult theory!) and its welcome insistence on the materiality of our social positioning, such a wholesale abandonment of the concept of a spectator positioned within the structure of desire *as well as*, though not wholly separately from, within the social formation, risks making cinema spectatorship as free-floating as does its opposite, fantasy theory. If we can step in and out of our identities at the cinema door, then identity becomes wholly a matter of political choice, and fantasy something quite separate from identity. Perhaps this formulation owes something to the methodology of 'auto-ethnography' which Wilton employs: it is always tempting to see our own identity as a matter of choice.

A more complex reading of the relationship between the psychic subject and the social subject in lesbian spectatorship is offered by Andrea Weiss in her study of Hollywood stars and lesbian spectatorship in the 1930s.[9] Pointing out that Mary Ann Doane's model (see Chapter Three) of the female spectator's overidentification with the screen image of femininity 'cannot account for the different cultural positioning of lesbians at once outside of and negotiating within the dominant patriarchal modes of identification', she nevertheless argues that identification involves 'both conscious and unconscious processes' (1991a: 290–1). Whilst identification cannot be *reduced* to 'a psychoanalytic model that sees sexual desire only in terms of the binary opposition of heterosexual masculinity and femininity', nor does it *exclude* 'psychosexual positioning'. Rather, it involves 'varying degrees of subjectivity and distance depending on race, class and sexual differences' (1991a: 291). Lesbian spectatorship, then, will involve a complex process of negotiation between the individual's private fantasies, the textual ambiguity of particular cinematic images or moments, and extra-cinematic discourses ('rumour and gossip') which might 'authorize' lesbian readings of specific stars (in particular, in the 1930s, Garbo and Dietrich). If Hollywood itself marketed hints of lesbianism in order to address male voyeuristic interest, and mainstream narratives recuperated their moments of sexual ambiguity in narrative closures which confirmed the patriarchal social order, it was nevertheless possible for differently positioned spectators – particularly with the aid of a star's rumoured lesbianism – to produce more subversive readings. What de Lauretis calls 'consent to activity' is here provided, then, not by an overtly lesbian narrative but by extra-cinematic gossip about stars such as Garbo and Dietrich which could serve as an enabling fantasy in the

tor and his screen surrogate – the homosexual/hommosexual relation of
which Luce Irigaray writes: 'all economic organization is homosexual. That
of desire as well, even the desire for women. Woman exists only as an occa-
sion for mediation, transaction, transition, transference, between man and
his fellow man, between man and himself' (quoted in Mayne 1990: 45). The
other set of relations is that between women, masked in the constant reduc-
tion of women to (the image of) Woman but nevertheless always threaten-
ing to disrupt the sexual hierarchy of subject/object of the gaze and offering
a different economy of desire.

What happens, then, 'when the *female* subject – whether as film-maker,
protagonist or spectator – engages with the ambivalence of the screen?'
(1990: 46). In Mayne's discussion of women film-makers it is again ambiva-
lence, the tensions of 'both/and' which she stresses. The lesbian/feminist
film-maker cannot simply be *outside* patriarchal relations. Just as relation-
ships between women are 'at once contained by the (false) symmetries of
male/female, paternal/maternal, heterosexual/homosexual identities, and
suggestive of other formulations of identity, relationships and representa-
tion' (1990: 84), so the lesbian film-maker both draws on existing cinematic
codes and seeks to open up other possibilities for cinematic meaning, plea-
sure and identification. To return to the argument between de Lauretis and
Silverman outlined above, then, Mayne's answer is that lesbianism is *both*
identification *and* desire, both 'the most intense form of female and feminist
bonding' and 'distinctly opposed to heterosexuality', both the 'projection of
patriarchal – and feminist – fantasies' and 'another register of desire alto-
gether' (1990: 115, 154). It cannot be fully outside the structures of patriar-
chal cultural relations, but nor can it be contained by them. For the
mainstream film-maker what is masked by the screen – relations between
women – threatens to disrupt the seamless flow of narrative and the struc-
ture of the gaze. In the lesbian/feminist films which Mayne discusses, the
screen retains its ambivalent status – but now as that which 'both resists and
gives support to the representation of female agency and desire' (1990: 51).
If lesbian scenarios of desire cannot be figured outside the structures of rep-
resentation which constitute the cinematic apparatus, then nor can they be
fully represented *by* it. The lesbian author is 'both complicit in and resistant
to the sexual fictions of patriarchal culture' (1995: 204). The films which
she produces have a similarly ambivalent or ironic relationship to the cine-
matic apparatus: 'both complicit with and radically other than the laws of
narrative and visual pleasure' (1990: 123, 154).

For the lesbian spectator, too, the screen is a site of tension. As both
apparatus for the reproduction of patriarchal structures and site of disrup-
tion of them, the cinematic screen regulates, excludes but also provides the
site for different relationships of desire. If for the female spectator 'the plea-
sures of the cinema draw upon lesbian eroticism' (1990: 149), nevertheless
we are all also 'complicit with the fictions of patriarchy'. When she turns to
the question of the lesbian spectator as *social* subject, therefore, Mayne's

position is similar to that of de Lauretis. As mediation between individual fantasy and public ritual, the cinema and the 'cinematic public sphere' (which includes extra-cinematic information and gossip about its stars) is important in the construction of lesbian and gay identities, and hence in the consolidation of lesbian and gay communities (1993: 166). Film spectatorship itself, however, remains 'an activity wherein distinctions between center and margin dissolve' and desire may be mobilized in contradictory ways (1993: 166).

Queering desire

Lesbians have, at least since the so-called 'second wave' of women's liberation in the 1960s, been suspended, theoretically and politically, somewhere between the women's movement and gay liberation, between feminism and queer, between a position that privileges gender as paradigmatic site of oppression ... and resistance and a position that privileges sexuality as that site. (Wilton 1995: 2)

The recent rise in prominence of 'queer theory', in which queer is defined as whatever is '"other" outside of the heterosexual norm (be it as dyke, bi, transgender, transracial sex, as well as any number of other compositions)' (Grosz and Probyn 1995: xiv), provides a potential framework for the discussion of lesbian film spectatorship/production which is different from/ other than that of feminism. In her most recent work Elizabeth Grosz, for example, whilst still insisting that 'it *does* make a difference which kind of sexed body enacts the various modes of performance of sexual roles and positions' (1995: 250), has been concerned to find models for understanding desire which are radically other than those proposed so far in this chapter. Current feminist theory, she writes, is simply inadequate: 'In the terms we have most readily available, it seems impossible to think lesbian desire' (1995: 179). Indeed the attempt should be abandoned. Sexuality and desire 'are not fantasies, wishes, hopes, aspirations (although no doubt these are some of its components), but are energies, excitations, impulses, actions, movements, practices, moments, pulses of feeling'. Sexuality is a 'truly nomad desire unfettered by anything external, for anything can form part of its circuit, can be absorbed into its operations' (1995: 182–3). Lesbianism, then, 'attests to the fundamental plasticity of women's (and presumably men's) desire, its inherent openness not only to changes in its sexual object (male to female or vice-versa), but also its malleability in the forms and types of practices and pleasures available to it'. Queer desire undermines heterosexuality because it reveals heterosexuality's own 'contingency, and openendedness, its own tenuous hold over the multiplicity of sexual impulses and impulses characterizing all human sexuality'. Sexual identity is

no more than 'a consolidated nucleus of habits and expectations', a pattern of repetitions which can be undone at any moment (1995: 226–7).[11]

A similar concept of sexual identity as performance (in Grosz' words, 'a body is what a body does' [1995: 214]) can be found in the work of Judith Butler. For Butler, gender is 'a kind of impersonation and approximation ... but ... *a kind of imitation for which there is no original*'. The appearance of 'naturalness' which accompanies heterosexual gender identity is simply the effect of a repeated imitative performance. What is being imitated, however, is 'a phantasmatic ideal of heterosexual identity'. There is no essence of heterosexual masculinity or femininity which precedes our performance of these roles; we construct the ideal of that essence *through* our performances (1991: 21). Moreover, as a copy of a fantasized ideal, heterosexuality always *fails* to approximate its ideal. It is thus doomed to compulsive repetition, with risk and excess – that which is *not* contained by the performance – constantly threatening its disruption. Homosexuality, then, becomes not the copy of heterosexuality (the 'mannish' lesbian or the 'effeminate' gay man), though heterosexuality presents it that way since 'if it were not for the notion of the homosexual *as* copy, there would be no construct of heterosexuality *as* origin' (1991: 22). It is, rather, a self-conscious parody, a masquerade which subverts because it draws attention to the non-identity of gender and sexuality, to the *multiple* sexualities which can be written on our bodies.

Butler's formulation, though she herself does not elaborate these connections, is suggestive for film theory in a number of ways. Mainstream film, it can be argued, can be seen to 'compulsively' repeat its performance of heterosexual gender in 'a kind of imitation that produces the very notion of the original as an *effect* and consequence of the imitation itself' – but one which never contains the disruptive 'excess' which 'contests every performance' (1991: 21, 28). A film which 'repeats in order to remake', however, may foreground the ambiguities of performance.[12] The theory also suggests the possibility of a mode of spectatorship which is truly a subversive masquerade, marked by the ironic distance which produces the possibility of alternative identities.

The work of Grosz and Butler can be situated at the point of intersection of feminist and queer theory. As Tamsin Wilton points out, however, on the whole queer theory, like queer cinema, has not been so accommodating to lesbians. 'One of the problems for lesbians looking to queer for a new direction', she writes, 'is that queer, that "no-man's land beyond the heterosexual norm", is in fact more like a no-woman's land'. In queer cinema the desire which is celebrated 'is not only "exclusively male", it is profoundly phallocentric' (1995: 6–7). Echoing Grosz' comment that 'it *does* make a difference which kind of sexed body enacts the various modes of performance of sexual roles and positions', she goes on to argue that '[o]n a more fundamental level, the relationship between "lesbian" and femaleness is radically different to the relationship between "gay" and maleness. ... For

men to regard other men as sexually desirable and sexually available to them represents a threat of a very different, and less radical, order than for women to do so' (1995: 8). Lesbian theory, therefore, must produce its own conceptual tools. If lesbian film theory, then, rests uneasily within *feminist* film theory, it risks suffering, in Elizabeth Grosz's words, 'a certain loss of specificity, and the capacity for cooption and depoliticization' (1995: 249) – in fact, a renewed *invisibility* – within queer theory. It may be that it is in the space of 'both/and' – which Judith Mayne characterizes as not only the position of women in patriarchal culture (both complicit with and resistant to patriarchal fictions) but also the position of the lesbian within feminism (both complicit with and resistant to *feminist* fictions) – that lesbian film theory can most productively develop.

|7|

Rereading difference(s) 2: race, representation and feminist theory

We know less about about the sexual life of little girls than of boys. But we need not feel ashamed of this distinction; after all, the sexual life of adult women is a 'dark continent' for psychology. (Freud 1953: 212)

one aspect of the dominant form of white feminism which is important in regard to black women's absence from cinematic representation is the continued use of the 'dark continent' trope . . . there has been white feminist overinvestment in the gender component of the 'dark continent', which has resulted in the virtual elimination of the racial and colonial implications. Thus this most racialized of sexual metaphors has become synonymous with the concerns of white women. (Young 1996: 177)

Feminist film theory rooted in an ahistorical psychoanalytic framework that privileges sexual difference actively suppresses recognition of race, reenacting and mirroring the erasure of black womanhood that occurs in films, silencing any discussion of racial difference – of racialized sexual difference. Despite feminist critical interventions aimed at deconstructing the category 'woman' which highlight the significance of race, many feminist film critics continue to structure their discourse as though it speaks about 'women' when in actuality it speaks only about white women. (hooks 1992: 123)

of white feminists we must ask, what exactly do you mean when you say 'WE'?? (Carby 1982: 233)

Writing in 1971 about the recently released Newsreel film, *The Woman's Film*, Siew Hwa Beh celebrated its 'raising of consciousness about women's real position in life', a position which can be characterized as: 'The parallel: "women as niggers", the private property of one man to another, from father to husband' (Beh 1976: 202). The film, she writes, presents the multiple

oppression of 'black, Chicano, and white working-class women' with a 'flowing ease' which is possible because 'the film-makers were all women whose level of consciousness complemented that of their subjects'. It demonstrates that 'working-class women bring an advanced consciousness to the common struggle, that the struggle against oppression is basically and naturally intrinsic to these women's lives' (Beh 1976: 203–4). There are a number of crucial assumptions in this account: that the oppression of women (all women) functions *in the same way as* that of blacks (all blacks); that the different sources of oppression (being female, being working-class, being black) act in an *additive* way, so that some women are simply *more* oppressed than others; but that the struggle against this oppression can nevertheless be guaranteed because such struggle is an *instrinsic* and *natural* product of women's *experience*. These assumptions also underpin the (1972–76) journal *Women and Film*, of which Beh was a founding editor, with its manifesto to 'transform the derogatory and immoral attitudes the ruling class and their male lackys have towards women and other oppressed peoples' (1972: 5).

But Beh's attempt to assert a political solidarity between all women and between women and 'other oppressed peoples' through a claiming of common experience also produces a theoretical elision. Mary Ann Doane describes it thus:

> What is lost in the process is the situation of the black woman. Her position becomes quite peculiar and oppressively unique: in terms of oppression, she is both black and a woman; in terms of theory, she is neither. In effect, she occupies a position which is difficult to think within current paradigms. (Doane 1991c: 231)

In the equation, 'woman = black', what disappears is the specificity of both, and hence the possibility of theorising the relationship between sexual and racial difference and their articulation in the subjectivity – and representations – of black women. It is this theoretical elision which could make possible Toril Moi's summary dismissal of black feminist thought as being, like lesbian feminist thought, of no *theoretical* significance ('So far, lesbian and/or black feminist criticism have presented exactly the same *methodological* and *theoretical* problems as the rest of Anglo-American feminist criticism'), whatever its *political* importance (Moi 1985: 86, my emphases, and see Chapter Six). This chapter is concerned with attempts to address the theoretical issues which Moi's dismissal denies.

Rendering visible

Faced with the problem of this theoretical invisibility, an invisibility compounded by the claims of white feminism to speak on behalf of all women,

much 1970s black feminist theory concentrated on rendering visible, on reclaiming a tradition of black – feminist thought seen as founded, as in Beh's account, on a distinctive black – specifically black American – experience. Thus Barbara Smith begins her 1977 manifesto for a black feminist literary criticism, 'Towards a Black Feminist Criticism', with 'I do not know where to begin. . . . This invisibility, which goes beyond anything that either Black men or white women experience and tell about in their writing, is one reason it is so difficult for me to know where to start' (1986: 168). But she goes on to argue that there is nevertheless an identifiable literary and historical tradition of black women's writing to be uncovered, since 'thematically, stylistically, aesthetically, and conceptually Black women writers manifest common approaches to the act of creating literature as a direct result of the specific political, social, and economic experience they have been obliged to share' (1986: 174). It is the task of the black feminist critic, she writes, to recover this tradition with its common language and cultural experience, and, writing out of her own identity within such a tradition, to make explicit the ideas and political implications expressed within its writings.

Writing a decade later, in 1987, Barbara Christian argues that this tradition constitutes also a distinctive black feminist *theoretical* tradition:

> people of color have always theorized – but in forms quite different from the Western form of abstract logic. . . . our theorizing . . . is often in narrative forms, in the stories we create, in riddles and proverbs, in the play with language, because dynamic rather than fixed ideas seem more to our liking. . . . My folk, in other words, have always been a race for theory. (Christian 1988: 68)

She is suspicious of what she terms 'the new emphasis on literary critical theory' and of the eagerness with which (white) feminist theorists, 'eager to enter the halls of power', have embraced it, since:

> seldom do feminist theorists take into account the complexity of life – that women are of many races and ethnic backgrounds with different histories and cultures and that as a result women belong to different classes and have different concerns. Seldom do they note these distinctions, because if they did they could not articulate a theory. Often as a way of clearing themselves they do acknowledge that women of color, for example, do exist, then go on to do what they were going to do anyway, which is to invent a theory that has little relevance for us. (1988: 75)

White feminist theorists, then, exclude black women, and black women's theorising, in much the same way as did black *male* theorists of the 1960s, who, when they 'said black . . . meant *black male*'.

Four years later, Jacqueline Bobo and Ellen Seiter could argue that, because of the work of Christian and other black feminist critics, the groundwork for a theoretically informed black feminist *literary* criticism had been

laid. 'No longer', they write, 'can a text constructed by a black woman be considered in isolation from the context of its creation, from its connection with other works within the tradition of black women's creativity, and from its impact not just on cultural critics but on cultural consumers' (1991: 286). Turning their attention to film and television adaptations of the work of black women novelists, they suggest that the work of black feminist literary critics, sociologists and historians be applied to such texts and their audiences (1991: 302). 'Within the narrow range employed by the media in showing black women', they argue, 'three features are familiar: the black woman tends to be defined by a "natural" connection to sexuality, by her relationship to white people as domestic servant, and by her role in the nuclear family as a domineering or restraining force'. Television adaptations of novels by black women, such as the 1989 adaptation of Gloria Naylor's *The Women of Brewster Place*, challenge these representations by insisting both on the social and economic sources of black women's oppression and on the relationships between black women which sustain their resistance to oppression (1991: 300–1). Since such adaptations are also a reworking of the form of the soap opera or maternal melodrama, they also offer a challenge to white feminist readings of those genres. For *The Women of Brewster Place* insists that it is the public rather than the private sphere which is the site of black women's oppression, and thus demands a reading grounded in an understanding of the social, rather than in the psychoanalytic theory which has underpinned much feminist film theory. Finally, studies of the *audiences* for such adaptations not only challenge the limited range of responses charted by white ethnographic studies but also call into question the identification of gender difference with the public/private distinction frequently made by such studies. Research by black women ethnographers can uncover the importance of a black women's community in the consumption as well as the content of such texts.

A black women's standpoint

Bobo and Seiter's analysis draws explicitly on the work of Patricia Hill Collins, whose work in the 1980s developed what she terms a black women's or Afrocentric feminist epistemology. 'Like other subordinate groups', argues Collins, 'African American women not only have developed distinctive interpretations of black women's oppression, but have done so by using alternative ways of producing and validating knowledge itself' (1995: 338). The specific forms of black women's economic and political oppression and the nature of their collective resistance to this oppression mean, she argues, that 'African American women, as a group, experience a different world than those who are not black and female' (1995: 339). This

distinctive experience in turn produces a distinctive black feminist *consciousness* about that experience. There exists, therefore, a specific black feminist intellectual tradition, a tradition often expressed in 'alternative institutional locations and among women who are not commonly perceived as intellectuals' (1990: 14), and it is this tradition which Collins, like Barbara Christian, sets out to reclaim.

Shared experience is the keynote – indeed the 'necessary prerequisite' – of this tradition of 'connected knowing' (1995: 347, 349). Such experience is not only of a distinctive black women's community but also of a 'curious outsider-within stance, a peculiar marginality' within the dominant white culture (1990: 11). This is produced by the black woman's traditional position as domestic worker within the white family, in which she occupies the contradictory position of both economically exploited worker and surrogate family member, and is thus located simultaneously within the public and the private spheres. This 'peculiar marginality' is in turn inherited by the black feminist intellectual, who also occupies the position of 'outsider-within', this time in relation to the academy, envisaged as both concrete institution and ideological terrain. It is she who emerges as the crucial figure in the *articulation* of black women's knowledge, for it is her conscious merging of thought and action which provides the leadership necessary for black women's empowerment (1990: 34). It is the 'peculiar marginality' of the position of black women intellectuals, caught between 'our discipline of training and our experiences as Black women' (1990: 18), argues Collins, which makes possible the challenge which black feminist thought makes to hegemonic structures of knowledge and power.

If black women's resistance is rooted in distinctive material histories, however, the oppression of black women has functioned not only through economic and social structures but also by means of key 'controlling images' through which the threatening figure of the black woman is constructed as objectified Other to the dominant white culture. Collins identifies four such images: the *mammy* – the faithful, obedient, desexualized domestic servant; the *black matriarch* – the aggressive, unfeminine head of the dysfunctional black family: the *welfare mother* – the overfertile, idle drain on public resources; and the *'Jezebel, whore, or sexually aggressive woman'* (1990: 77) – the figure which underpins them all. It is her uncontrolled sexuality which produces both the black matriarch and the welfare mother and which is 'properly' contained in the figure of the asexual mammy. These images, argues Collins, have functioned not only as ideological justification for racial and sexual oppression of black women; they have served also as ideological Other to 'controlling images' of white femininity. Mammy, matriarch, welfare mother and whore: all are images of a female corporeality from which an idealized white femininity might be distinguished and against which it might be defined. Perhaps most important, however, is Collins' account of the way in which these 'controlling images' function within the lives of black women. In her descriptions of the ideological power of such

representations in forming the self-images of black women, she presents a
more complex account of the relationship between experience and con-
sciousness than elsewhere in her writing. Here, the relationship between col-
lective experience and resistant consciousness, which can at times in her
work be presented as a simple linear movement (*this* set of experiences
inevitably produces *that* mode of consciousness), becomes instead a more
complex *struggle* 'to form positive self-definitions in the face of denigrated
images of Black womanhood' (1990: 83).

It is this rather contradictory element within Collins' thought to which
Patricia Ticineto Clough draws attention in her analysis of Collins' work.
For Clough, Collins' figure of the 'outsider-within' domestic worker, the
woman who is envisaged as 'the mother, the grandmother, the aunt or the
sister of the African-American feminist', in fact serves less as a historical
antecedent than as an enabling 'figure of hope and desire', a 'productive fic-
tion to frame a tradition of survival which enables the struggle against oppres-
sion' (1994: 89). Indeed, this figure could be said to function in the same way
that, in Teresa de Lauretis' view (1994: 185–6), the fantasy of an idealized
feminist community functions for white heterosexual feminism: as a 'found-
ing fantasy' necessary to the articulation of a resistant politics. As such, argues
Clough, it also bears witness to the centrality of 'the difference of *desire*'
within feminist politics, however determined Collins may be to ground her
'politics of empowerment' in a difference of *experience* (Clough 1994: 89–90).

The critical gaze

If Collins draws on a concept of 'externally defined controlling images' to
explain the persistence of black women's oppression, bell hooks goes fur-
ther. 'There is a direct and abiding connection', she argues, 'between the
maintenance of white supremacist patriarchy in this society and the institu-
tionalization via mass media of specific images, representations of race, of
blackness that support and maintain the oppression, exploitation, and over-
all domination of all black people' (1992: 2). Positioning herself within a
cultural studies framework, hooks argues that 'the field of representation
remains a place of struggle (1992: 3), and urges black feminists to make
active interventions into feminist film theory and criticism. Feminist film
criticism, she argues, has 'most claimed the terrain of woman's identity, rep-
resentation, and subjectivity as its field of analysis', yet has remained
'aggressively silent on the subject of blackness and specifically representa-
tions of black womanhood'. The cause, she argues, is its reliance on psy-
choanalysis, which places sexual difference as 'the primary and/or exclusive
signifier of difference' (1992: 124–5) and constructs a monolithic category
'woman', effacing the specific socio-historic differences between women.

hooks' critique echoes that of other feminist theorists within a cultural studies tradition (see Chapter Four), but differs in its emphasis on blackness as primary visual signifier of difference. If, argues hooks, processes of identification depend on the imaginary closing of the gap between self and other, then the gap between *black* female spectator and idealized *white* image of femininity is one which can be imaginatively closed only through 'the masochistic look of victimization' (1992: 121). In fact, she argues, the black female spectator more often resists that process, placing herself *outside* the structures of cinematic visual pleasure proposed by Laura Mulvey or Mary Ann Doane (see Chapter Two), and developing instead a critical or oppositional gaze. Such a gaze is born, like Collins' black women's standpoint epistemology, from an experience of racist and sexist domination which leads to a resistant consciousness. It is also fuelled by a cinematic context that either erases black women altogether, denying 'the "body" of the black female so as to perpetuate white supremacy' (1992: 118), or constructs stereotypical images of the black woman as 'foil, backdrop' – as non-feminine Other to an idealized white image.

For hooks, then, the power of the gaze is *materially* as well as psychoanalytically constructed. The politics of slavery functioned to deny the slave the right to gaze; black men were lynched for looking at white women.[1] Hence, a space of black agency can be opened up by 'a rebellious desire, an oppositional gaze' (1992: 116). For black men, in the darkened space of the movie theatre, this might simply mean entry into 'an imaginative space of phallocentric power' denied them in a racist society (1992: 118). Black *female* spectators, however, refusing to identify with 'the phallocentric gaze of desire and possession', can create a 'critical space where the binary opposition Mulvey posits of "woman as image, man as bearer of the look" [is] continually deconstructed' (1992: 122–3). For them visual pleasure can be the distanced, interrogative pleasure – the 'passionate detachment' – that is Mulvey's goal for all female spectators. Yet, hooks insists, 'the field of representation remains a place of struggle'. The critical gaze may be a product of experience but it is not guaranteed by it; black women may instead have a 'colonized' gaze, 'shaped by dominant ways of knowing' (1992: 128). But she insists on the power of individual agency in the construction of resistant identities and oppositional gazes: 'Those black women whose identities were constructed in resistance, by practices that oppose the dominant order, were more inclined to develop an oppositional gaze' (1992: 127).

Black women as audiences

Also positioning herself within a cultural studies framework is Jaqueline Bobo, whose ethnographic study of black women viewers of the 1985 adap-

tation of Alice Walker's novel, *The Color Purple*, employs the concept of 'negotiation' outlined by Christine Gledhill (see Chapter Four). But Bobo also links her work explicitly to that of Barbara Christian and Patricia Hill Collins. Like Christian, she argues that the task of the black feminist critic is to operate within an interpretive community 'to give voice to those who are usually never considered in any analysis of cultural works' (1995: 51). Drawing on Collins, she argues that such a process will clarify and make conscious for black women the distinctive 'black women's standpoint' which is a product of their shared experience, which expresses their resistance to oppression, but of whose full contours they may not be fully aware.

Like Collins and hooks, then, Bobo argues that '[r]epresentations of black women in mainstream media constitute a venerable tradition of distorted and limited imagery' (1995: 33). Black women film-makers like Julie Dash,[2] on the other hand, 'recode' these false, stereotypical representations to produce a more 'accurate' story of black women's lives. These texts, like the literary texts discussed by Barbara Smith, exist in a 'symbiotic relationship' with the community of readers for and on behalf of whom they speak, and who are crucial in 'interpreting the works appropriately' (1995: 6). Like Smith, therefore, Bobo assumes an unproblematic experiential relationship between the black female cultural producer and the 'interpretive community' of which she is part. Texts reflect (or distort) reality; readers interpret appropriately (or inappropriately). The role of the critic – also a participant in this community – is to articulate this relationship and so foster 'an activism that works toward the goal of substantially changing black women's lives' (1995: 51).

In the case of a film like *The Color Purple*, however, a mainstream film adapted from a novel by a black woman writer, the critic's role is somewhat different. In this case, though Bobo herself demonstrates convincingly the ways in which Spielberg's film consistently undercuts the radicalism of Walker's novel, this is not the way in which its black women viewers judged it. Their much more positive reading of the film is analysed by Bobo as an example of 'cultural consumers' subversive capacity' (1995: 5). Utilizing interpretive strategies arising from their own social and cultural histories, black women, she argues, will 'negotiate' a reading of the film which reclaims its oppositional potential. Thus their defiantly 'oppositional' reading of the film (oppositional, that is, in relation to the negative reading which was the dominant critical reaction) is born of the 'same spirit manifested by black women during enslavement'. It is a product of the 'oppositional impulse that has fueled black women's history' (1995: 92, 94). In this situation, the role of the black feminist critic is to represent these voices, in order to ensure that they are heard: 'In this way feminist critics can intervene strategically in the politics of interpretation' (1995: 54).

Although in some ways, therefore, Bobo's ethnographic study can be linked to those of Janice Radway (1984) and Ien Ang (1985) – indeed the phrase 'the politics of interpretation' is drawn from Ang – her theoretical

position is in fact rather different. There is no concept of internal contradic-
tion within the film spectator in her analysis – whether a contradiction pro-
duced from the complexity of unconscious desires or one produced from
contradictory subject positionings. Nor are there tensions or complexities in
the relationship between ethnographic researcher and her interviewees. As
'cultural producers, as critics, and as audience members', black women are
part ('components' or 'segments') of a single 'dynamic entity' locked in an
activist cycle. Black women as cultural producers create interpretations of
black women's experience, critics explicate them and readers provide an
interpretive community. The whole constitutes a 'progressive and effective
coalition' in which is assumed a commonality of both experience and con-
sciousness.

Psychoanalysis and race

Analysing Collins' 'black women's standpoint epistemology', Patricia
Ticineto Clough comments that 'Collins emphasizes consciousness as a
sphere of freedom but leaves underdeveloped the relationship of conscious-
ness, the erotic and unconscious desire' (1994: 103). Black feminist theorists
have, as we have seen, been critical of the privileging of sexual difference
within psychoanalytic theory and of the way in which feminist film theory
has perpetuated the racist assumptions behind Freud's use of the 'dark con-
tinent' as a metaphor for female sexuality. Yet, as Clough suggests, the
appeal to a commonality of experience in the work of black American fem-
inist theorists elides both differences *between* and differences *within* black
women. Collins' work, for example, persistently assumes that all black
women are *American*, insisting that '[l]iving life as an African American
woman is a necessary prerequisite for producing black feminist thought'
(1995: 349) – an assertion which clearly demonstrates the *imaginary* nature
of the all-inclusive black women's community to which she appeals. And
Bobo's insistence on the primacy of an interpretive community denies the
complexities of individual response as well as those of the 'community'
itself. A black American (or British or African or Afro-Caribbean) woman
will be positioned as a textual reader by structures other than simply the
'black women's community' – by nationality, by economic and social posi-
tion, by sexual preference, as mother/non-mother, in relation to the white
community. These gaps and elisions, argues Clough, point to the need for
black feminist theory to engage with psychoanalytic theory – or at least 'a
feminist counterpsychoanalysis' – if only 'as objects for critical revision'
(1994: 103).

Freud's own psychoanalytic project, however, presents problems which
are both theoretical and historical. As Freud's use of the 'dark continent'

metaphor clearly signals, it is linked with a white colonialist imagination through its identification of sexuality with the 'primitive' landscape of Africa, to be 'penetrated' and exposed to the 'light' of consciousness. As Ella Shohat argues:

> Freud speaks of female sexuality in metaphors of darkness and obscurity often drawn from the realms of archaeology and exploration – the metaphor of the 'dark continent', for example, deriving from a book by the Victorian explorer, Stanley. Seeing himself as explorer and discoverer of new worlds, Freud ... compared the role of the psychoanalyst to that of the archaeologist 'clearing away the pathogenic psychical material layer by layer' which is analogous 'with the technique of excavating a buried city.' The analogy ... calls attention to the role of the therapist in locating obscure trains of thought followed by penetration, as Freud puts it in the first person: 'I would penetrate into deeper layers of her memories at these points.' (Shohat 1991: 57)

Moreover, as Mary Ann Doane reminds us, a psychoanalytically informed *feminist* theory can be accused of 'hierarchizing sexual difference over racial difference and of being ill-equipped to deal with issues of racial oppression' (1991c: 216). Yet bell hooks, as we have seen, produces a historicized account of 'the gaze' which still draws on psychoanalytic theory for its explanatory framework. The question thus remains as to whether the insights of psychoanalysis might still – despite their unpromising origins – be appropriated for black feminist theory.

Frantz Fanon

The work of Frantz Fanon (especially *Black Skin, White Masks* 1952) represents an early application of psychoanalytic theory to racism – specifically to the relationship between colonizer and colonized and to the way in which black people internalize racial oppression. Fanon returns us to Lacan's concept of the 'mirror phase' but, like bell hooks, insists on *blackness* as primary visual signifier of difference. For Lacan, the significance of the mirror phase is that it provides an image of the bodily self as whole and unified which serves as 'ideal ego' for the child who then internalizes it. The visual difference of the black body – the way in which it, in Mary Ann Doane's words, 'poses the possibility of *another* body' (1991c: 225) – presents a threat to this represented wholeness. In Fanon's words, this perception of the black body as Other 'impedes the closing of the postural schema of the white man'. For the white man 'The Other is perceived on the level of the body image, absolutely as the not-self – that is, the unidentifiable, the unassimilable' (1989: 160, 161). Thus, as Doane argues, the position of the

black man as different, Other, 'would appear analogous to that of the woman in psychoanalysis, who embodies castration' (1991c: 225). The difference, however, as she points out, is that whereas the woman's threat to the idealized white male image is identified with loss or absence, the threat of the black man is in contrast that of a perceived *overpresence*, a 'hypervisibility associated with skin color'. It is this perceived overpresence which is linked to white fears of the hypersexuality of black men.

For the black man, however, argues Fanon, although there is a similar shock of difference in his first perception of the white man, 'historical and economic realities come into the picture' (1986: 161), so that the process is in fact very different. What the black man perceives in his first encounter with a white man is the fact of his own blackness. The idealized image with which he is presented is a white image. 'As long as the black man is among his own', writes Fanon, 'he will have no occasion, except in minor internal conflicts, to experience his being through others. ... In the white world the man of color encounters difficulties in the development of his bodily schema. Consciousness of the body is solely a negating activity. It is third-person consciousness' (1986: 109–10). Fanon's concern, then, is with two issues. The first is the process through which the black man internalizes feelings of inferiority which are actually constructions of a racist white society. The second is 'Negrophobia', not only in the white *man*, for whom this irrational fear and hatred is a result of his projection on to the black man of his own repressed desires, but also in the *white* woman. For her, in an echo of Freud's 'A Child Is Being Beaten' essay (see Chapter Five), Fanon proposes a core fantasy, 'A Negro is raping me'. The fear of rape expressed in this fantasy, Fanon feels, in reality masks an underlying desire ('Basically, does this *fear* of rape not itself cry out for rape?' [1986: 156]). Following Freud, he argues that on her journey to adult (passive) femininity the female child must relinquish 'masculine' activity and thus must project on to others her own aggressive impulses. The figure of the black man serves as repository for these impulses since his image is already invested with a hypersexualized aggression.

Stereotypes of sexuality

Fanon's work is valuable in its linking of racism, sexuality and representation, but, as the above analysis makes clear, it is less than useful in its account of black – and white – female sexuality. As Mary Ann Doane writes, 'because this analysis circulates around questions of vision, visibility, and representability, there is a sense in which it is strongly applicable to black women, who are the objects of a double surveillance linked to race and gender. Yet Fanon ... transforms the problematic of racial vision into

an affair between men' (1991c: 223). Sander L. Gilman's work on 'Stereotypes of Sexuality, Race and Madness' in his (1985) study, *Difference and Pathology*, provides a far more useful psychoanalytic explanation of stereotypes of black *female* sexuality.

'Everyone creates stereotypes', argues Gilman (1985: 16). The process is a product of the child's struggle to control its environment, in which are split into 'good' and 'bad' versions both the self ('good' self in control of the world, and 'bad' self unable to control its environment) and the world ('good' regulated/controllable world, and 'bad' hostile/uncontrollable world). Since a confrontation with the contradictions produced by any attempt to integrate the 'good' and 'bad' selves would be painful and difficult to deal with, the child projects outwards the 'bad' self:

> With the split of both the self and the world into 'good' and 'bad' objects, the 'bad' self is distanced and identified with the mental representation of the 'bad' object. ... The deep structure of our own sense of self and the world is built upon the illusory image of the world divided into two camps, 'us' and 'them'. (1985: 17)

Stereotypes, then, 'perpetuate a needed sense of difference between the "self" and the "object", which becomes the "Other"', but, whilst they seem to refer outwards, to 'the world of the object, of the Other', they in fact draw on 'repressed mental representations for [their] structure'. They arise as a defense 'when self-integration is threatened' (1985: 18).

But the categories into which stereotypes can be divided are not arbitrary. They are based on relations of seeing, in which objects are perceived as reflections or distortions of the (idealized) image of the self:

> Because the Other is the antithesis of the self, the definition of the Other must incorporate the basic categories by which the self is defined. I believe that three basic categories of this kind are generated by our sense of our own mutability, the central role of sexuality in our nature, and our necessary relationship to some greater group. To use a rather crude shorthand, I will speak of illness, sexuality, and race. (1985: 23)

Gilman's category of 'illness' here, defined as the human organism's 'susceptibility to disease, pollution, corruption, and alteration' has clear similarities to Julia Kristeva's concept of 'the abject' (see Chapter Five). Like 'the abject', its function is to preserve the boundaries of the self and distinguish it from that which threatens to invade and corrupt it. Like 'the abject', too, it is linked to sexuality, specifically to 'perverse' and to female sexuality, the two often being equated. For nineteenth-century Europe, argues Gilman, the 'prostitute is the essential sexualized female. ... She is perceived as the embodiment of sexuality and all that is associated with sexuality, disease as well as passion'. For Freud then, very much the product of his century, 'in every female the act of seduction may bring forth the disguised tendency

toward perversion ..., for most women "have an aptitude for prostitution"' (1985: 94, 54).

'Race' is Gilman's third category of Otherness. Like sexual difference, it is constructed around visual signifiers of difference:

> In 'seeing' (constructing a representational system for) the Other, we search for anatomical signs of difference such as physiognomy and skin color. The Other's physical features, from skin color to sexual structures such as the shape of the genitalia, are always the antitheses of the idealized self's. (1985: 25)

Like Gilman's other two categories, however, 'race' is not an autonomous category of Otherness; the categories of 'pathology', 'sexuality' and 'race' are constantly intertwined:

> sexual anatomy is so important a part of self-image that 'sexually different' is tantamount to 'pathological' – the Other is 'impaired', 'sick', 'diseased'. Similarly, physiognomy or skin color that is perceived as different is immediately associated with 'pathology' and 'sexuality'. (1985: 25)

Thus Gilman cites the persistent identification in nineteenth-century discourses – medical and scientific as well as literary and artistic – of the black woman with a perverse and pathologized sexuality, and of the (white) prostitute with both. For nineteenth-century Europe, argues Gilman, '[t]he primitive is the black, and the qualities of blackness, or at least of the black female, are those of the prostitute' (1985: 99).

It is in 'structured systems of representation' – texts – that stereotypes can best be studied in both their reductiveness and their fluidity, argues Gilman. Applying Gilman's work to her (1996) study of British cinema, Lola Young summarizes the argument:

> Scientific racist ideologies, racial myths, and stereotypical characterizations in theatrical, literary and visual culture are enactments which materialize from the cycle of repression and projection, as are individual, institutional and state racisms. Embedded in this psychic process are distortion, ambivalence and contradiction and it is underpinned by guilt and denial. These processes interact in a complex manner with economic and other imperatives. (1996: 32)

Thus Young demonstates the way in which British films such as *Sapphire* (1959) and *Flame in the Streets* (1961) not only respond to the specific social and economic circumstances of 1950s Britain but also exhibit the processes which Gilman outlines. In these films, she argues, fear of a 'perverse' sexuality identified with miscegenation and the 'primitive, wild and excessive' sexuality of the 'mixed race' female is linked to a threatened loss of identity not only in the self but also in the nation. The threatened dissolution of the 'bounded' self through 'fusion with the Other' which would be

the outcome of an interracial *sexual* relationship, argues Young, is persistently identified in the films with threats to the 'boundedness' of the *nation* from 'invasion through "swamping", "flooding" and "inundating" by "waves", "tides" and "floods" of immigrants' (1996: 92). Thus a perverse and excessive (female) sexuality is linked both to a racialized Other and to the threat of bodily infection/invasion in a powerful complex of images which interact with social anxieties fuelled by economic factors.[3]

Colonial stereotypes

Homi K. Bhabha's essay, 'The Other Question – the Stereotype and Colonial Discourse' (1983), also deals with the issue of the stereotype in representations of the racialized Other. Bhabha's concern, however, is specifically with the operation of *colonial* stereotypes, and to explain these he draws upon Michel Foucault's concept of discourse as well as on psychoanalytic theory. For Foucault (see Chapter Four), discourse is a socially constructed mode of speaking, writing or representation which is supported by institutional power and tied to particular historical moments. Analysis of discourse reveals the ways in which specific forms of 'knowledge' are produced within language and representation by the operations of power. For it is power, not 'fact' which produces 'knowledge' or 'truth':

> We should admit that power produces knowledge ... that power and knowledge directly imply one another; that there is no power relation without the correlative constitution of a field of knowledge, nor any knowledge that does not presuppose and constitute ... power relations. (Foucault 1977: 27)

Thus colonial discourse, argues Bhabha, is an apparatus of power: one which

> turns on the recognition and disavowal of racial/cultural/historical differences. Its predominant strategic function is the creation of a space for a 'subject peoples' through the production of knowledges in terms of which surveillance is exercised and a complex form of pleasure/unpleasure is incited. It seeks authorisation for its strategies by the production of knowledges of coloniser and colonised which are stereotypical but antithetically evaluated. The objective of colonial discourse is to construe the colonised as a population of degenerate types on the basis of racial origin, in order to justify conquest and to establish systems of administration and instruction. (1983: 23)

It is the stereotype, he argues, which is the major 'discursive strategy' of colonial discourse. Like Gilman, then, he argues that the Otherness which is

constructed through the stereotype links racial and sexual forms of difference. But far more than Gilman he presents the stereotype as an *ambivalent* construction. For the stereotype both affirms fixity (the stereotyped Other is always, has always been, like this) and betrays anxiety in its compulsive repetitions. In its representation of the *Other* (the unknowable) always in terms of that which is both *knowable* (the stereotype is always the same) and *visible* (the stereotype is obvious), it simultaneously affirms and denies racial and cultural difference.

The stereotype, then, is both phobia and fetish. As phobia, it is evident in 'those terrifying stereotypes of savagery, cannibalism, lust and anarchy which are the signal points of identification and alienation, scenes of fear and desire, in colonial texts' (1983: 25). As fetish, it functions like the Freudian sexual fetish, simultaneously acknowledging and disavowing (racial) difference. As fetish, too, it is bound up with fantasy, defined, as Laplanche and Pontalis define it (see Chapter Five), as the setting rather than the object of desire. For the stereotype both dramatizes the impossible desire for a 'pure' undifferentiated origin (in its idealized white self-image) and simultaneously recognizes difference. Like other forms of fantasy, too, it depends on relations of seeing. If colonial power functions, argues Bhabha, through disciplinary mechanisms of *surveillance*, these mechanisms are also related to *voyeurism*, that is to the regime of Freud's *scopic* drive. This, as we have seen, is 'the drive that represents the pleasure in "seeing", which has the look as its object of desire, is related both to the myth of origins, the primal scene, and the problematic of fetishism and locates the surveyed object within the "imaginary" relation' (1983: 28–9). Thus Bhabha insists both on the historical nature of the colonial stereotype, as part of a power structure operating through specific discursive regimes, and on its character as 'scenario of colonial fantasy' (1983: 34). Like Fanon, he also argues that this process operates for both colonizer and colonized alike, for both are implicated in the colonial discourse, just as both are presented with the image of 'an ideal ego that is white and whole' (1983: 28).

'Race', gender and sexuality

Bhabha's formulation makes possible an analysis of the operation of colonialist cinematic discourses which brings together the historical and the psychoanalytic, mechanisms of surveillance and visual and narrative pleasure. But, like Fanon, in constructing his psychoanalytic account of the construction of *racial* difference on the model of Freud's account of the construction of *sexual* difference, Bhabha elides the question of sexual difference altogether.[4] Lola Young, in her study of 'race', gender and sexuality in British cinema, *Fear of the Dark* (1996), criticizes Bhabha's account on these

grounds, but she also follows Bhabha in her bringing together of approaches drawn from psychoanalysis and from discourse theory. Commenting implicitly on work such as that of Barbara Smith or Patricia Hill Collins, she argues that 'the attempt to represent the reality of "the black experience" needs to be interrogated. ... such a stance implies that the answer to negative, stereotypical images is to produce "truthful" or "realistic" representations. The assumption here is that somehow it is possible to claim unmediated access to an essential black subjectivity, to speak with an "authentic voice" of "the black experience".' Such subjectivities, she argues, 'only exist in the realms of mythology' (1996: 36).

Young, then, analyses British colonialist films such as *Sanders of the River* (1935) in both historical and psychoanalytic terms. In such films, she argues:

> The central character of the white male is represented as whole, unified and coherent, a perception constantly in danger of disruption through the mirror image of the black Other. Embedded in the psyche is the 'knowledge' that difference – specifically racial and sexual difference – subverts and disrupts the notion of cohesion and order and this anxiety needs to be constantly mollified. These films served as comforting narratives for a nation which, used to assuming spiritual, cultural and political superiority, was traumatised by the Indian 'mutiny' and the subsequent fear of further destabilizing uprisings and acts of resistance. (1996: 82)

If racial difference acts as disturbing 'mirror-image' for white men, then the black woman, argues Young, constitutes a 'double problem' for them, 'double negation of the white, male self which underlines the notions of sexual and racial difference' (1996: 20). Similarly, since black women 'have been frequently described as hypersexual and are phenotypically marked as inherently and immutably different' (1996: 64), then the fear of female sexual difference finds its ultimate embodiment for the colonial imagination in the figure of the black woman. On to her can be projected a (perverse and excessive) sexuality which can then be denied in the contrasted figure of the (middle-class) white woman.

Like Bhabha and Gilman, Young links this sexualized gaze with the surveillant and investigative colonialist eye. 'Structured into this assumption of the right to look', she argues, 'is the power to define and categorize and this is crucial in determining who may or may not initiate or return the look' (1996: 48). In nineteenth-century scientific and medical discourses about the black female body and its supposed sexual 'overdevelopment', the sexualized and the investigative gazes merge. Hence Young returns to Laura Mulvey's account of the 'male gaze' to argue that the 'first strategy of the male unconscious to which Mulvey refers, that of cinematically investigating the woman in order to demystify her, is analogous to nineteenth-century medical approaches to racial and sexual difference' (1996: 16). The photo-

graphic and then the film camera, used as 'an extension of the imperial/anthropological eye' (1996: 50), thus become instruments of power and control of the Other – as doubly figured in the image of the black woman.

Young's use of psychoanalytic theory also leads her to a view of identity – and *identification* – as mobile rather than fixed. Drawing on Fanon's description of internalized racial self-hatred, she argues that it is possible 'for black people to adopt what might ... be termed "white" positions and *vice versa*' (1996: 144). Thus she rejects the equation of experience and consciousness often found in the work of black American feminists. Questioning bell hooks' concept of the resistant gaze which is the direct outcome of a different *experience*, she insists rather on the importance of fantasy and desire in relations of looking, and asks: 'Does returning the look in itself constitute an act of resistance or does this imply an essentialist notion of black subjectivity based on the presumption of a counter-hegemonic gaze which may not be there?' (1996: 144). Black subjects, too, she argues, are positioned 'within the matrix of desire and fascination, anxiety and repulsion that constitutes colonial relations'. But black subjects are positioned *unequally* within this matrix, and this leads Young to raise issues of strategy as well as of theory, when she turns to the analysis of the work of black British *film-makers*. She insists, then, that *all* cinematic texts must be analysed 'as part of a complex web of interrelated experiences, ideas, fantasies and unconscious expressions of desire, anxiety and fear that need to be located in their historical, political and social contexts' (1996: 175). But if this means that the frequent reliance by black film-makers on realism as a means of countering 'negative' images of black people presumes an oversimplistic view of how the cinematic text operates, such a move may nonetheless be justified as a *strategy*. For the adoption and assertion of a discrete black identity has served the important political purpose of countering the processes of subordination and inferiorization which are the products of colonialist and racist ideologies. Counter-myths, as we have seen, may be important as 'productive fictions' in enabling the struggle against oppression, and may be produced – and read – to serve such a function.

Hyphenated identities and hybrid realities

Arguing the need for what she terms a 'materialist' black feminist analysis, Patricia Ticineto Clough suggests that such an analysis

> not only argues that Black women's experiences differ; it also suggests that their experiences are profoundly related to the dominant fiction constituting and reconstituting hegemony. Indeed, it is in relationship to hegemony that Black women's experiences may appear more simi-

lar than they are; certainly subjugated knowledges owe at least some of their shape to their repression in the construction of hegemony, that is, to the force with which they are opposed. (1994: 93)

If such an analysis is evident in Young's work but only intermittently acknowledged in much African-American feminist thought, it finds its most challenging expression in post-colonial feminist theory. Thus the work of Trinh T. Minh-ha, who is both a theorist and a film-maker, places as central the question of fragmented, or hybrid, subject-identities which seems so uncomfortable a concept for black American theorists.

For Trinh, as for Homi Bhabha and other post-colonial critics, colonial power is discursive power, and identity as a colonial or post-colonial subject is constructed within discourse. Gayatri Chakravorty Spivak describes the relationship between the imperialist project and textual constructions thus:

As far as I understand it, the notion of textuality should be related to the notion of the worlding of a world on a supposedly uninscribed territory. When I say this, I am thinking basically about the imperialist project which had to assume that the earth that it territorialized was in fact previously uninscribed. So then a world, on a simple level of cartography, inscribed what was assumed to be uninscribed. Now this worlding is also a texting, textualising, a making into art, a making into the object to be understood. (Spivak 1990: 1)

From such a perspective, it becomes impossible to look to a concept of 'authentic' experience on which to ground a politics of resistance, for one can never be *outside* the discourse which maps that experience. Our very denunciations of oppression and hegemony are spoken within the terms of that oppression and hegemony. Like Bhabha, then, Trinh argues that representations of the Other involve both power/knowledge and desire, so that to seek to understand such representations is to 'reopen endlessly the fundamental issue of science and art; documentary and fiction; universal and personal; objectivity and subjectivity; masculine and feminine; outsider and insider' (1989a: 133). The ethnographic gaze of *surveillance* is also the gaze of fantasy and desire.

Trinh's specific concern, as theorist and film-maker, is with documentary film-making, but the terms in which she discusses it draw on the language of psychoanalytic film theory as well as on theories of hegemony:

Factual authenticity relies heavily on the Other's words and testimony. To authenticate a work, it becomes therefore most important to prove or make evident how this Other has participated in the making of his/her own image; hence, for example, the prominence of the string-of-interviews style and the talking heads, oral-witnessing strategy in documentary film practices. This is often called 'giving voice', even though these 'given' voices never truly form the Voice of the film, being mostly used as devices of legitimation whose random, con-

veniently given-as and taken-for-granted authority often serves as compensation for a filmic Lack . . . (1989a: 134)

In the anthropological/ethnographic discourse, no less than in that of the fiction film, what 'a man always looks for . . . is fortunately what he always/never finds: a perfect reflection of himself' (1989b: 58). How, then, is the feminist post-colonial film-maker to intervene in this process? Trinh is acutely aware of the difficulties. Distinguishing between 'I (the all-knowing subject)', 'I/i (the plural, non-unitary subject)' and 'i (the personal race-and-gender-specific subject)', she writes:

Every path I/i take is edged with thorns. On the one hand, i play into the Savior's hands by concentrating on authenticity, for my attention is numbed by it and diverted from other, important issues; on the other hand, i do feel the necessity to return to my so-called roots, since they are the fount of my strength, the guiding arrow to which i constantly refer before heading for a new direction. (1989b: 89)

These difficulties, however, become 'perhaps less insurmountable' if 'I/i succeed in making a distinction between difference reduced to identity-authenticity and difference understood also as critical difference from myself'.

This 'critical difference from myself' means recognizing the multiple character of the self, the differences *within* as well as between: 'Not One, not two either. "I" is, therefore, not a unified subject, a fixed entity, or that solid mass covered with layers of superficialities one has gradually to peel off before one can see its true face. "I" is, itself, *infinite layers*' (1989b: 94). For Trinh, then, it is inadequate to propose a 'female/ethnic identity/difference' which can be expressed through black women's writing, film-making or theory. Instead, difference is *'that which undermines the very idea of identity'* (1989b: 96). The position of the post-colonial feminist film-maker is no more (or less) *authentic* than any other: 'This is not to say that the historical "I" can be obscured or ignored, and that differentiation cannot be made; but that "I" is not unitary, culture has never been monolithic, and more or less is always more or less in relation to a judging subject. Differences do not only exist between outsider and insider – two entities – they are also at work within the outsider or insider – a single entity' (1989a: 146–7). As 'impure, both-in-one insider/outsider', as 'Inappropriate Other', she must rather employ strategies of dislocation and displacement, juxtaposing techniques of fiction and documentary, history and storytelling, and refusing viewers a singular viewpoint. Interviewed about her (1989) film, *Surname Viet Given Name Nam*, for example, she describes her strategies:

The interviews are made to look gradually less and less 'natural' as the film advances. Only halfway through it does the staged quality of the visualized speech become more manifest: when a woman is seen pacing back and forth while she delivers her thoughts; when another woman is also seen speaking with her back to the camera in a denuded

setting; or when the reflexive voice-over is heard with the synchronous voice, thinking aloud the politics of interviews. Thus, interviews which occupy a dominant role in documentary practices – in terms of authenticating information; validating the voices recruited for the sake of the argument the film advances (claiming however to 'give voice' to the people); and legitimizing an exclusionary system of representation based on the dominant ideology of presence and authenticity – are actually sophisticated devices of fiction. (1995: 43)

Rethinking white femininity

In her (1991) essay, 'Dark Continents: Epistemologies of Racial and Sexual Difference in Psychoanalysis and the Cinema', Mary Ann Doane considers the implications for a psychoanalytically informed feminist film theory of the work considered in this chapter. She points out the 'impossibility of any valid parallel between the position of the white woman and that of blacks' in any account of the visual politics of the cinema. It is a parallel which it is tempting to draw: both, after all 'take on the role of Other in relation to the white man'; both function to represent corporeality, bodily difference, hypersexuality. But it is a temptation which must be resisted 'precisely because of what it relegates to the realm of the invisible. . . . What is lost in this process is the situation of the black woman' (1991c: 231). In repeating this process of erasure, white feminist theory has been complicit with the representational strategies of both Hollywood cinema and psychoanalysis. Both employ a 'representational topography' which situates the black woman in relation to the white woman in a positioning 'which activates the registers of foreground and background, presence and absence' (1991c: 215). The white woman can embody femininity only in uneasy relationship to her racial other, the black woman, who is relegated to a realm outside of femininity. The black woman becomes the white woman's *mise-en-scène*; only when she 'aspires to whiteness' does she become representable within a Hollywood problematic which is 'so heavily dependent upon structures of voyeurism and fetishism' (1991c: 237–8). Thus Doane returns to her earlier work on the 'woman's film' (see Chapter Two) but now labels it 'more accurately, the "white woman's film"' (1991c: 232).

But Doane also considers within this essay the difficulties she feels in her own position as a white feminist theorist writing about issues of race. Thus, whilst it can be accepted that 'race is an arbitrary signifier' and whiteness and blackness 'the most artificial of racial categories', covering and concealing 'a host of ethnicities, of cultural backgrounds', it is nevertheless true that at the level of experience they have been 'historically *real* categories . . . in their lengthy and problematic collision with each other in the context of

systems of colonialism and slavery' (1991c: 246). At this level of experience, the white feminist theorist feels unqualified to speak. Yet, argues Doane, for the white theorist to maintain that she has no 'right' to speak about issues of race assumes a relationship between experience, identity and discourse which is extremely problematic. What is required, she proposes, in an argument which echoes that of Trinh, is 'a reexamination and reevaluation of the concept of experience in feminist theory'. It is a concept which, she argues, 'seems to adhere persistently to the vicissitudes of the first person singular. What "I" know best is what "I" experience. The emphases of feminism must be shifted toward that which, precisely, exists at the limits of (or better, beyond) the regime of the "I" (1991c: 247).

Nevertheless, Doane recognizes dangers in this argument. In responding to the demands from black feminists that white feminists examine their own racial identity, her analysis of the pivotal role which representations of white women have played in a racist cinema risks foregrounding yet again the position of the white woman – thus reducing the black woman once more to invisibility. The dangers of such a hegemonic move highlight once again the difficulties for feminism of an anti-essentialism which seeks to deconstruct the category of identity completely. Criticizing Julia Kristeva's attempt to 'dissolve identity', Trinh argues that, despite her own insistence on the multiple character of identity, difference 'does not annul identity. It is beyond and alongside identity' (1989b: 104). It is, however, a precarious balance to maintain, and Doane's unease about her own hegemonic position as a white feminist theorist signals perhaps the dangers in a post-colonialist theory which, in seeking to move away from an unproblematized concept of the relationship between experience and identity, risks losing sight of the material realities of colonialist and racist power structures.

|8|

Postmodern scepticisms

[F]eminist theory . . . properly belongs in the terrain of postmodern philosophy. (Flax 1990: 42)

The eighties became a period in which film theory, and particularly feminist film theory, lost its specific momentum under a broadening out of debates into other aesthetic and cultural areas which were also concerned with the question of female spectatorship, including television, photography, the fine arts and art history. . . . In the meantime, the female spectator has tended to become the empirical consumer of television, advertising, shopping malls and so on. (Mulvey 1989e: 77)

[H]ow does feminism define itself in an intellectual world now characterized by shifting borders, boundaries and identities? (McRobbie 1994: 61)

In the (1989) special issue of the journal *Camera Obscura*, devoted to the concept of the female spectator, Laura Mulvey's review of twenty years of British feminist film theory identifies four areas of loss in feminist film theory's engagement with what she terms 'the fashionable self-referentiality and self-serving intertextuality of a new post-modern ethos' (1989e: 77). The first is a sense of the specificity of film as a medium and cinema as an apparatus. The second is a concept of cinema *spectatorship* – as distinct from concepts of (empirical) *consumption* or *use*. Underpinning both of these is the loss, or abandonment, of psychoanalytic theory as feminist film theory's primary analytic tool. Finally, in this loss of specificity there is also a divorce of feminist film theory from feminist film-making, and hence the loss of 'a politics of vision' which would bind feminist theory to an activist feminist politics.

 Mulvey's narrative is thus constructed almost exclusively as one of loss. And, if we are going to present the narrative in these terms, we might add another loss, one identified by Charlotte Brunsdon in her (1993) survey of

fifteen years of feminist television criticism, the loss of an assumed identity (or possibility of identity) between the category 'feminist' and the category 'woman'. 'Woman', as Brunsdon argues, has become a profoundly problematic category (1993: 314), and the relationship of the theorising 'feminist' to this increasingly fragmented category an extremely troubled one. What this final chapter will attempt to do, therefore, is to explore the terms of Mulvey's narrative, though not necessarily to chart it, as she does, as a narrative of loss.

Decentred screens

> One of the as yet unresolved issues . . . is that of the degree to which theories devised for the classical Hollywood cinema are pertinent to the very different televisual apparatus. (Kaplan 1987b: 3)

> [In the 1970s] the emerging discipline of film studies was constantly impelled to justify the status of its own object, the value of analyzing the cinema. Struggling to establish its own legitimacy, film studies was confronted with relentless oppositions between high art and mass culture, single-authored works and collective industrial productions, art and mechanical reproduction. . . . It was crucial to define film as autonomous and hence necessitating its own modes of analysis. (Doane 1991a: 4)

Mary Ann Doane's account of the development of her own thinking offers a rather different perspective on the emergence of 1970s feminist film theory from that of Laura Mulvey. Doane's account privileges two factors, the institutional pressure to define a clear disciplinary space (one which was *not* feminist literary studies or art history or the study of 'mass communication'), and the need to produce a critical theory adequate to the specificity of a popular medium. But Doane acknowledges that the theoretical frameworks which resulted were 'abstractions'. Theoretically and historically necessary, they nevertheless ignored both the empirical processes of actual spectatorship and their own historical origins. The film theory which developed thus rested on what Lawrence Grossberg terms 'the assumed privileging, not only of a particular apparatus, but also of a particular form of engaged subjectivity' (1987: 32). Cinema spectators, argues Grossberg, perhaps never viewed popular films in the absorbed way which is assumed by film theory, and the pleasures and meanings which they took from cinema were always mediated intertextually: by film magazines, by star images and by other forms of popular culture. In the 1990s world of mass media apparatuses, however, this abstraction – and its bracketing out of the empirical, historically situated spectator – becomes far more difficult to maintain. I may watch

a film in the cinema; I may watch (or re-watch) it on video; I may watch it on large-screen TV. I may watch it in all three contexts in a concentrated fashion; alternatively, I may accord it only what Grossberg calls 'TV's delegated look and distracted glance' (1987: 34). I may segment it, replay it, interrupt it with other segments from different media, overlay it with other media texts, use it as primer for dance routines, clothing, body image, 'permitted' behaviours and identities, and so on. The film itself may have been produced for screening on television (or video) as well as, or instead of, in the cinema. Even if I wish to maintain that throughout these processes the film text *as text* remains the same, the *apparatus* (the whole context of production, consumption and technological appropriations) through which meaning is being produced will in each case be radically different.

The loss of 'specific momentum' within feminist film theory of which Laura Mulvey writes, and the 'broadening out' of its concerns in the writing of critics like E. Ann Kaplan and Tania Modleski, would seem, then, to be inevitable. Kaplan's question, quoted at the head of this section, is raised in the context of her study of MTV (Music Television), which she sees as embodying television's 'decentered address, its flattening out of things into a network or system, the parts of which all rely on each other, and which is endless, unbounded, unframed' (1987b: 44). For Kaplan, MTV is a manifestation of Jean Baudrillard's vision of a postmodern universe. In Baudrillard's account, film as 'scene and mirror' has given way to television as 'screen and network' (Baudrillard 1985: 126). Whereas in the first, the screen functioned as representation of the real and site of the projection of our fantasies and identifications, in the second there is no representation, only a network of communication controls. In this universe, 'people no longer project themselves into their objects, with their affects and their representations, their fantasies of projection, loss, mourning, jealousy' (1985: 127). Instead, 'the entire universe comes to unfold arbitrarily on your domestic screen' (1985: 130). Everything is visible, but the welter of images, networks and circuits with which the screen presents us is a surface without depth, and the illusion of democratic control which it offers is in fact its opposite: the individual 'is now only a pure screen, a switching center for all the networks of influence' (1985: 133).

Integrated circuits

Kaplan's conclusion is that television as a 'postmodernist apparatus' *can* be read through the insights and frameworks provided by (a more historicized) feminist film theory, indeed that such analysis is crucial if we are to resist the power of the televisual apparatus to 'construct subjects unable any more to distinguish an "inside" from an "outside," "fiction" from "reality"'

(1987b: 153). But Kaplan's analysis of *one* television context, MTV, does not engage with the wider aspects of Baudrillard's account of the postmodern 'universe of communication'. This vision of a postmodern communications network or circuit in which new communications technologies function to produce not representations but an 'informatics of domination' is one which is, however, explored by Donna Haraway. Much of this new technology is optical, making visible what has hitherto been invisible or unrepresentable. In Haraway's vision of the 'integrated circuit' which is contemporary social and cultural reality, therefore, the boundaries between the material and the symbolic, social reality and the cultural text, dissolve. New technologies, driven by microelectronics, reduce all to 'a problem of coding, a search for a common language in which all resistance to instrumental control disappears and all heterogeneity can be submitted to disassembly, reassembly, investment and exchange' (1990a: 206). The same technologies underpin both the communications networks of multinational corporations and new techniques of film and video production. Microelectronics 'is the technical basis of simulacra, that is, of copies without originals' (1990a: 207), but such productions have material effects:

> Technologies like video games and highly miniaturized television seem crucial to production of modern forms of 'private life'. The culture of video games is heavily oriented to individual competition and extraterrestrial warfare. High-tech, gendered imaginations are produced here, imaginations that can contemplate destruction of the planet and a sci-fi escape from its consequences. (1990a: 210–11)

These same 'technologies of visualization' also make women's bodies 'newly permeable to both "visualization" and "intervention"' – from predatory male gaze and medical reproductive technology alike (1990a: 211). If, then, as Haraway suggests, feminists *are* still engaged in 'struggles over how to see', in a 'politics of vision' (1990b: 149), the arena of struggle is hugely extended. When she, like Laura Mulvey twenty years before, calls for 'passionate detachment' on the part of the feminist critic, it is no longer as a counter to the seductive power of cinematic pleasures, but a call for 'situated knowledges' and 'partial perspectives' which might counter the dominance of the global communications circuit.

Haraway's own response is to offer the liberatory myth of the 'cyborg'. She argues that we must abandon the 'feminist dream of a common language' because it operated as a 'totalizing and imperialist' force, appropriating, marginalizing, or excluding those (black women, lesbian women, 'third world' women) whose identities could not be constructed within it (1990a: 215). We cannot, however, do without 'foundational myths', shared stories which define the possibilities and limits of an oppositional politics. Haraway's mythic 'cyborg' aims to serve such a function. The cyborg is a hybrid of body and machine, blurring the categories of human and machine, and with it those other Western dualisms: self/other, mind/body, nature/culture, male/female,

civilized/primitive, reality/appearance, whole/part, agent/resource, maker/ made, active/passive, right/wrong, truth/illusion, total/partial, God/man (1990a: 219). It is embodied but not unified, and being a figure of blurred boundaries and regeneration rather than (re)birth, it cannot be explained by reference to Oedipal stories or psychoanalytic narratives of identity. It is locally specific but globally connected: Haraway reminds us that 'networking' is a feminist practice as well as a multinational corporate strategy, a way of surviving 'in diaspora' (1990a: 212).

Haraway's cyborg myth, then, is a way of extending the insights of post-colonial feminism, such as that of Trinh T. Minh-ha (see Chapter Seven), to embrace the position of all women in the 'integrated circuit'. Her example of a contemporary cyborg identity is thus the 'fusion of outsider identities' called 'women of color', but the target of her oppositional politics goes beyond structures of representation to include what she sees as a 'world system of production/reproduction and communication called the informatics of domination' (1990a: 205). In such a system it is the body as 'etched surface', rather than the screen, which becomes the point of both oppression and resistance.

Identity-in-culture

We cannot simultaneously claim (1) that the mind, the self, and knowledge are socially constituted and that what we can know depends upon our social practices and contexts and (2) that feminist theory can uncover the truth of the whole once and for all. (Flax 1990: 48)

for me [the female spectator] is already a historical concept. . . . television confronts us with the fact that 'spectatorship' is perhaps no longer the most appropriate or productive way of conceptualizing reception or the relationship between viewers and texts. (Doane 1989: 142, 146)

The integrated technologies of a 'world system of . . . communication' make it difficult, then, to hold on to a concept of the specificity of the film text and the cinematic apparatus. But they also serve to render problematic Mulvey's concept of the 'female spectator', who might be clearly distinguished from her more 'fashionable' counterpart, the 'empirical consumer'. Mary Ann Doane argues that the 'female spectator' of the 1970s and 1980s was always an 'empty' concept, an abstraction from the text, 'the vanishing point of a textual configuration' (1989: 143), but one which 'has acted as a powerful impetus to re-examine the supposed neutrality of reading processes', doing its part in 'chipping away at the solid and powerful generic "he" (white, male, heterosexual) of Western culture' (1989: 146). But it is a

concept, she suggests, which is in danger of forgetting its own origins and acquiring 'a certain orthodoxy and institutionalization' (1991a: 6). Thus it may no longer serve our needs. Indeed, if we go further to argue, as both Haraway and Flax do, that feminism must stand opposed to all totalizing theory, grounded as such theory must be on hierarchy, exclusion and domination, then it must accept its status as partial knowledge and seek to base its readings in the historically specific rather than the conceptually abstract. If we add to this view the argument that our contemporary social reality offers – indeed, cannot be separated from – a ceaseless flow of interacting images and texts, all providing the raw material through which our identities may be constructed, and all bound up with processes of consumption, it becomes even more difficult to maintain a clear conceptual boundary between the textually constructed 'female spectator' and her social counterpart, the 'empirical consumer'. Thus Angela McRobbie, for example, argues that we must move away from the binary opposition between 'text and lived experience, between media and reality, between culture and society'. What is now required, she argues, is 'a methodology, a new paradigm for conceptualizing identity-in-culture' (1994: 59).

McRobbie argues that such a methodology is to be found in 'an ethnographic approach which takes as its starting-point the relational interactive quality of everyday life' (1994: 59). Thus ethnographic studies, always localized and specific, acquire a new theoretical importance in the drive to construct a 'postmodernist' feminist theory and politics. But these are ethnographic studies no longer focused on audience readings of specific texts, or even specifically on audiences. Celia Lury's (1996) study of consumer culture, for example, employs concepts such as 'the male gaze', masquerade and narcissistic identification, drawn from feminist film theory, in her broader analysis of women's relationship to consumer culture. Concepts such as masquerade and narcissism, she argues, 'provide the basis for identifying a distinctively feminine relation to contemporary consumer culture', with masquerade being seen as 'a strategy of resistance in situations in which women do not have the power directly to refuse the terms of their address by the male gaze, but may sidestep its force by turning it to their own ends' (1996: 148–9). Such an analysis may include the study of film audiences (Lury cites Angela Partington's study of the pleasures British working-class women found in watching film melodrama of the 1950s), but may equally well apply to the consumption of magazines, advertising images, fashion, or shopping.

Gender scepticism

Lury's concept of the 'male gaze', however, looks for its theoretical justification not to the psychoanalytic explanation of theorists like Laura Mulvey

but to the more materialist explanation of John Berger (1972). Berger, writes Lury, suggests that the unequal relationship between man as subject and woman as object or possession of his gaze 'is so deeply embedded in our culture – from high art to pornography to popular culture, advertising and everyday life – that it is possible to talk of a *male gaze*' (1996: 140). Like Haraway's cyborg myth and McRobbie's concept of 'identity-in-culture', her analysis of consumer culture is one which seeks to displace the centrality of psychoanalytic theory in explanations of the construction of gendered identities. A distrust of psychoanalysis is, as we have seen, characteristic of a number of strands of recent feminist thought. The centrality of *sexual* difference within psychoanalysis, and its difficulty in dealing with other differences – of class, sexual preference or race, for example – have seemed to fix psychoanalytic feminist theory within the very dualism it seeks to explain. Such a dualism, it can be argued, inevitably privileges the masculine subject, with the feminine figured always as the Other, lack, or the maternal body. It is a dualism, moreover, which cannot accommodate ambiguity and multiplicity. Haraway's cyborg identity is one attempt to find a way out of what she calls this 'maze of dualisms in which we have explained our bodies . . . to ourselves' (1990a: 223), and recognize the multiplicity of discourses, positions and meanings across which the female subject is constructed. But like other attempts to construct a 'postmodern feminism', it risks displacing sexual difference as a central organizing principle altogether. If sexual difference is only *one* term of difference, and one which is not, by virtue of being written in the unconscious, *fundamentally* constitutive of our identity, then it cannot be privileged. Indeed, to privilege it becomes, in Christine Di Stefano's words, 'just another . . . totalizing fiction which should be deconstructed and opposed in the name of a difference that serves no theoretically unifying master' (1990: 65–6).

Such a move towards 'a profound sense of gender scepticism' can be seen in some recent feminist work on media consumption. In the view of Ien Ang and Joke Hermes, for example, 'media consumption should be conceptualized as an ever proliferating set of heterogeneous and dispersed, intersecting and contradicting cultural practices, involving an indefinite number of multiply-positioned subjects' (1991: 322). According to this argument, gender is only one axis along which, in the viewing process, identifications may be constructed. On any one viewing occasion, gender positioning may or may not be central, or may not operate at all. Women, write Ang and Hermes, 'do not always live in the prison house of gender' (1991: 320); sexual difference is not always in play. The task of ethnography – which Ang and Hermes, like McRobbie, see as the central methodology for a postmodern feminism – is to carry out local, contextualized studies, in order to produce 'situated knowledges' which will 'make these historically specific continuities and discontinuities explicit' (1991: 324, 322).

The incredible shrinking woman

In such a context, the category 'woman' becomes extremely unstable, and the position of the feminist theorist a curiously disembodied one. Charlotte Brunsdon discusses this development in her (1993) review of fifteen years of feminist television criticism, 'Identity in Feminist Television Criticism'. At this point, she writes, '[e]veryone . . . is an other – and there are no pronouns beyond the "I"' (1993: 316). Interestingly, she concludes that such a position is a relatively *comfortable* one for the feminist intellectual to occupy. After all, if the figure of 'woman' is now a fragmented one – women constituting, in Ang and Hermes' words, 'an indefinite number of multiply-positioned subjects' – then the question of the relationship between *feminism* and *women* is no longer pressing. The need to theorise the troubling triangular relationship between the feminist, the textually inscribed female spectator, and the woman in the audience – a need which has been so important in feminist film theory – dissolves into 'gender scepticism' and multiple differences. It does not *matter* whether I claim to speak *for* women, *as a* woman, or *about* women; my speech, too, is partial, multiple, fragmented. I am absolved from responsibility. Hence, comments Brunsdon, it is no accident that, whilst there may be 'no pronouns beyond the "I"', there are, relatively, 'lots of women teaching and writing books about these ideas' (1993: 316).

Other writers have gone further in arguing that postmodernism, with its urging of a 'radical and decentered attention to multiple differences, none of which merit theoretical privileging over others' (Di Stefano 1990: 75), is inherently inimical to feminism. It would seem to be no accident, as Nancy Hartsock points out, that 'just at the moment when so many of us who have been silenced begin to demand the right to name ourselves, to act as subjects rather than objects of history, that just then the concept of subjecthood becomes problematic' (1990: 163). To this Susan Bordo adds that, whilst in theory all 'totalizing' narratives – including those of feminism – may be equal, and must be equally opposed, 'in the context of Western history and the actual relations of power characteristic of that history', there are crucial differences between the narratives of feminist theory and those 'arising out of the propertied, white, male, Western intellectual tradition'. Contemporary feminism, she reminds us, has always been 'an "outsider" discourse, that is, a movement born out of the experience of marginality'. Whilst, then, it must embrace differences other than that of gender, it has in fact been 'unusually attuned to issues of exclusion and invisibility' (1990: 141). It is less in danger from 'totalizing' tendencies than from a paralysing anxiety about them.

What is problematic about positions such as Haraway's, argues Bordo, is that the figure of the embodied woman disappears within them. 'Certainly, the duality of male/female is a discursive formation, a social construction',

she writes. 'So, too, is the racial duality of black/white. But as such, each of these dualities has had profound consequences for the construction of experience of those who live them . . . [L]ike it or not, in our present culture, our activities *are* coded as "male" or "female" and will function as such within the prevailing system of gender-power relations. . . . One cannot be "gender neutral" in this culture' (1990: 149, 152). The fantasy of '*becoming* multiplicity – the dream of limitless multiple embodiments, allowing one to dance from place to place and self to self' (1990: 145), which is enacted in images such as Haraway's cyborg, denies the realities of our material existences *as women*. Being everywhere is much the same as being nowhere. Postmodernist 'gender scepticism', with its accompanying figure of the shrinking woman (Di Stefano 1990: 78), simply plays into the interests of existing power structures, 'operating in the service of the reproduction of white, male knowledge/power' (1990: 151).

Theory and history

Part of the impulse of the theoretical approaches of the 1970s . . . was to counter the effects of tendencies in contemporary society toward increasing fragmentation, specialization, individualism, and positivism. This could only be done by establishing a framework or frameworks within which interconnections between seemingly isolated components of society – i.e. art and politics, sexuality and representation, language and ideology – could become visible and analyzable. The fear of abstraction, the fear of 'Theory', threatens to transform the analysis of culture into another aspect of that culture's relentless drive toward compartmentalization. (Doane 1991a: 10)

If, then, this chapter returns to a narrative of (threatened) loss – though not quite in the terms with which it began – what pointers towards resolution (a happy ending?) can be found? It seems to me that the terms in which Linda Williams (see Chapter Five) describes her own view of the usefulness of psychoanalytic theory – 'an unavoidable partial explanation' (1990: 270) – provide a starting point. Neither Williams nor Jackie Stacey (Chapter Four) abandon the use of psychoanalytically informed feminist film theory (or 'Theory', as Doane terms it), but both, though in different ways, subject it to a radical historicization. In Stacey's study of a specific group of spectators, the concept of identification is expanded from its use within psychoanalytic theory to become a more active, historically based process of negotiation, one which involves the recognition of both 'differences between femininities' and the fact that 'identification' and 'desire', far from being opposites, are complexly interwoven (1994: 171, 173). Thus placed on the border of the psychic and the social, the unconscious and the historically

specific, the concept of identification functions neither simply to confirm existing gendered identities, as in some forms of psychoanalytic film theory, nor to offer the free play of fantasy, as suggested by others. In specific circumstances, it may rather involve the 'transformation and production of new identities' (1994: 172), identities which – however contingent, partial and fragmented – may have a role as spaces of resistance and negotiation for the individual, historically positioned spectator.

Linda Williams' description of film texts as 'cultural problem-solving', whose generic structures both address 'persistent problems in our culture, in our sexualities, in our very identities' (1991: 10), *and* are constantly recast in response to the changing nature of gendered power relations, also provides a reading of film texts in terms of historical relations of gendered power as well as (unconscious) identificatory structures. In her study of hard-core pornography she thus combines the use of psychoanalytic theory ('an unavoidable partial explanation of the desires that drive sexual fantasy and pornography' [1990: 270]) with a historical analysis which draws on the work of Michel Foucault to argue that 'pleasures of the body' are the product of historically specific 'discourses of sexuality' which are themselves produced 'within configurations of power that put pleasures to particular use' (1990: 3). Cinema, as one such 'institutionalised machinery of power', has at its origin 'not only a psychic apparatus with a "passion for perceiving" and a technological apparatus that makes perception possible', but also 'a social apparatus as well. And this social apparatus is ultimately what constructs women as the objects rather than the subjects of vision' (1990: 45). Psychoanalytically informed feminist film theory, then, must be subjected to interrogation from a historically based analysis of circumstances of production and consumption. But its stubborn insistence on sexual difference as, in Christine Di Stefano's words, 'a difference that makes a difference' (1990: 78) in turn functions as a theoretical limit point to the fantasies of multiple identities beyond gender offered by some forms of postmodern feminism.

Theory and politics

What, then, of the final argument in Laura Mulvey's narrative of loss: that in its diffuseness of focus and loss of contact with its 'utopian other' – feminist film-making – recent feminist film theory has lost that 'politics of vision' which is essential to any feminist politics? I have suggested already in this chapter that a politics of vision has, on the contrary, remained central to feminist theory. Rosi Braidotti, for example, writing in 1994, argues that 'feminists have been fast and effective in their critiques and actions against the perverse effects induced by the new technologies', precisely through their work on 'the question of the power of the visible and of visibility'. The

starting point, she argues, is the recognition that 'the visual metaphor' ('seeing' as synonym for 'understanding') is central to Western epistemologies – to 'everything our culture has constructed in the ways of knowledge' (1994: 70). If, then, new technology now makes it possible to 'make visible the invisible, to visualize the secrets of nature' (1994: 64), such shifts move us into 'a new culture of visualization' in which 'the fantasy that visibility and truth work together' becomes also a 'fantasy of absolute domination' (1994: 68–9). Braidotti, then, like Mulvey, insists that 'today the essence of the political struggle is a struggle over meaning and the value of representation' (1994: 69, 70), but the arena of struggle which she identifies encompasses biomedical science as well as film and popular culture. When Braidotti draws her own line of development through feminist theories of 'the power of vision, the visible, and the visual', therefore, it is one which runs from Laura Mulvey's own work in the 1970s, through that of Teresa de Lauretis in the 1980s, and to Donna Haraway's (1990) attempt to 'rescue the faculty of seeing, of vision, and to re-possess it for feminist discourse' (1994: 73).

It is nevertheless true that, faced with what Braidotti calls contemporary feminism's 'double-edged project' – it must both organize around a politics of identity (in feminist theory 'one *speaks as* a woman') *and* subject the concept 'woman' to constant critical analysis – utopian visions may be neither so clear nor so firmly situated in a distinctively feminist film-making as before. Yet this development, too, should not be seen unambiguously as loss. Michelle Citron, reviewing in 1988 her own work as a feminist film-maker in the 1970s, argues that whilst the more recent move of women film-makers 'into the mainstream' may partly reflect the loss of a politicized viewing 'community' for 'alternative' feminist films, it is also a move from an overly 'didactic' approach into an engagement with the 'contradictions, paradoxes, uncertainties' of narrative film (1988: 62). The 'shift from film-maker to director', she argues, 'can be seen as trading control for power', and although power brings its own seductive temptations towards compromise, it also means 'the opportunity to reach a larger audience, the potential of using mainstream culture to critique or subvert it, the freedom to define and test one's own personal boundaries as film-maker' (1988: 57). Above all, the use of narrative film allows for the exploration of 'myth and ambiguity', an exploration which has become possible 'only at the present historical and personal moment' (1988: 62).

Citron's reference to a changed 'historical moment' is echoed by other writers. Angela McRobbie's study of youth culture and femininity in the 1990s, for example, argues that 1970s feminism has crucially inflected contemporary mainstream cultural forms and expressions. 'Femininity is no longer the "other" of feminism', she writes. Instead it now 'incorporates many of those "structures of feeling" which emerged from the political discourse of feminism in the 1970s' (1994: 173). It is therefore no longer possible to oppose a utopian *feminist* vision to mainstream constructions of *femininity*. Similarly – though with more reservations – Pam Cook's

introduction to the (1993) *Sight and Sound* reader, *Women and Film*, argues that the 'feminisation of popular genres and return of the "women's picture" during [the 1980s and 1990s] is as much a recognition of the cultural power of feminism . . . as it is an attempt to capitalise on and control it' (1993: xiii). Moreover, women directors like Sally Potter (herself an avant-garde film-maker in the 1970s and 1980s) and Jane Campion have been able to explore issues fundamental to feminist theory through mainstream film. Thus, for example, *Orlando* and *The Piano* (both 1993), she writes,

> transgress boundaries – between national and international, home and abroad, art and entertainment, masculine and feminine – finding their identities in the very act of transgression. . . . In their ambivalence towards 'home', the place where women are traditionally meant to find themselves, they echo longstanding feminist concerns; but in their engagement with post-imperial and post-colonial histories, their embracing of spectacle and masquerade, and their forging of new forms of cinematic expression, they are very much of the 90s. (1993: xiii–xiv)

Not a utopian vision, perhaps, but one which very much echoes the theoretical struggles and concerns of contemporary feminist film theory.

Conclusion: story lines

The 'documents' are separate and discrete but when placed in sequence, certain themes and strands begin to form patterns or even story lines. They chart the early development of a debate that was generated in the first place by politics, that broadened out into aesthetics and that has finally come to influence some spheres of academic thought. (Mulvey 1989b: vii)

There is a feeling among many . . . that feminist film and media theory has been cut off from its original sense of bold innovation and political purpose. . . .We must be careful, however, not to seem to participate in what is, in effect, a generalized cultural backlash against feminism. We inhabit a time in which social contradictions allow for an institutionalization of feminism which is simultaneous with a continuing refusal to give to women an adequate number of secure positions in teaching, writing, filmmaking and, yes, even administration. Postmodernism and postfeminism threaten to remove women's concerns from the intellectual arena altogether. (Bergstrom and Doane 1989: 16)

One of the most basic connections between women's experience in this culture and women's experience in film is precisely the relationship of spectator and spectacle. Since women are spectacles in their everyday lives, there's something about coming to terms with film from the perspective of what it means to be a an object of spectacle and what it means to be a spectator that is really a coming to terms with how that relationship exists both up on the screen and in everyday life. (Mayne, in Citron *et al.* 1978: 86)

Judith Mayne's 1978 statement captures something of the sense of why, for the past twenty years, cinema has been, in Laura Mulvey's words, 'the crucial terrain' on which feminist debates about culture, representation and identity have been fought through (1989e: 77). Through the exploration of the complex triangular relationship between 'Woman' as cinematic representation, *women* as historically and culturally positioned subjects, and the feminist theorist who – in however problematic a way – *speaks as* a woman, feminist writers on film have been central in the development of feminist theory. Faced today with the twin dangers of on the one hand 'orthodoxy and institutionalization' (Doane 1991a: 6), and on the other a loss of specificity and direction arising from the encounter with postmodernism, it is tempting, perhaps, to conclude that this is no longer the case. Yet, as I hope the particular arrangement of 'patterns or even story lines' traced in this book has made clear, the currents of contestation and debate arising from contemporary theoretical developments still find a central analytical focus in feminist film theory. If, as writers from Laura Mulvey to Rosi Braidotti have insisted, a 'politics of vision' is essential to any feminist politics, this will continue to be the case.

Notes

Introduction: Passionate detachments

1 See Haraway, 'A Cyborg Manifesto' and 'Situated Knowledges', in *Simians, Cyborgs, and Women* (1991). For a discussion of Haraway's position, see also Rosi Braidotti, *Nomadic Subjects* (1994), Chapters Two and Three.
2 The term is Charlotte Brunsdon's, who, in her (1993) survey of feminist television criticism since the mid-1970s, identifies three 'phases' in the shifting sense of relationship between *feminism* and *women*. The first is the *transparent*, in which an unproblematic identification of the two is assumed. The second is the *hegemonic* or 'recruitist', in which the feminist writer manifests 'the impulse to transform the feminine identifications of women to feminist ones' (1993: 313). The third is the *fragmented*, in which no necessary correspondence between the two is assumed.

Forerunners and beginnings

1 See, for example, Imelda Whelehan, *Modern Feminist Thought: From the Second Wave to 'Post-Feminism'* (Edinburgh: Edinburgh University Press, 1995).
2 See Laura Mulvey's account of this demonstration in 'The Spectacle is Vulnerable: Miss World, 1970', in Mulvey, *Visual and Other Pleasures* (Basingstoke and London: Macmillan, 1989).
3 Spender, *Mothers of the Novel: 100 Good Women Writers before Jane Austen* (London: Pandora, 1986).

4 See Judith Okely, *Simone de Beauvoir* (London: Virago, 1986) p. 57.
5 For example the work of Barbara Creed. See Chapter Five of this book.
6 Although 'second wave' feminism is usually dated from 1968–70, Friedan's book was important in its inception both because it 'tackled many of the issues that were to characterize second wave politics in the latter part of the '60s' (Whelehan 1995: 9) and because it led to the formation in the USA in 1966 of NOW (National Organization for Women).
7 Maslow felt it was possible to distinguish five levels of human need:
 (a) Physiological needs
 (b) Security
 (c) Social needs
 (d) Esteem
 (e) Self-actualization
 These needs form a hierarchy, so that if the first level of need has not been met, the individual is unlikely to meet the pressure of 'higher' needs. See Maslow (1970).
8 Though, as bell hooks points out, Friedan's account of the condition of women in 1960s America 'actually referred to the plight of a select group of college-educated, middle and upper class, married white women' and ignored 'the existence of all non-white women and poor white women' (hooks 1984: 1–2).
9 See, for example, Toril Moi's critique in *Sexual/Textual Politics* (London: Methuen, 1985).
10 Spender, *For the Record: the Making and Meaning of Feminist Knowledge* (London: The Women's Press, 1985) p. 39.
11 'The Literary Reflection' is the title of Part Three of *Sexual Politics* (London: Virago, 1977), in which Millett discusses the work of Lawrence, Miller, Mailer and Jean Genet.
12 See, for example, Mary Ellen Brown, *Soap Opera and Women's Talk: The Pleasure of Resistance* (London: Sage, 1994).
13 See also Annette Kuhn, *The Power of the Image* (London: Routledge & Kegan Paul, 1985) p. 6, for a consideration of some of these questions.
14 For a discussion of this issue, see Rosalind Delmar, 'What Is Feminism?' in Juliet Mitchell and Ann Oakley (eds), *What Is Feminism?* (Oxford: Blackwell, 1986) pp. 8–33.
15 From the description on the back cover of the 1974 paperback edition (New York: Avon Books).
16 'Bad faith' is a term used by Jean-Paul Sartre to describe that state 'akin to self-deception, false consciousness, or delusion' (Tong 1989: 197) in which the human being refuses the responsibility of freedom of action by denying that any such freedom is possible for him. De Beauvoir extends this concept, arguing that man's construction of himself as 'the sole essential' and woman as Other and object of myth is also an example of 'bad faith' since it denies to woman that freedom which is funda-

mental to humanity. But it is a 'bad faith' which rebounds on man since woman's failure to conform to his idealised images forces him to construct compensatory but terrifying myths of woman as man-eating monster. As one example of this monstrous image, de Beauvoir cites the 'bad woman of the Hollywood films' (de Beauvoir 1988: 222–3).

17 Linda Williams' 1984 article, 'Something Else Besides a Mother', reprinted in Christine Gledhill (ed.), *Home Is Where the Heart Is: Studies in Melodrama and the Woman's Film* (London: BFI, 1987) pp. 299–325, takes up this argument with much greater theoretical complexity. See Chapter Three of this book for a discussion of Williams' article.

18 See Chapter Five of this book.

19 See *The Second Sex* Part V, Chapter 4, 'Prostitutes and Hetairas' (London: Pan Books, 1988) pp. 568–87.

20 The phrase is from Laura Mulvey's 'Feminism, Film and the *Avant-garde*' in Mary Jacobus (ed.), *Women Writing and Writing About Women* (London: Croom Helm, 1979).

Structures of fascination: ideology, representation and the unconscious

1 Johnston, 'Feminist Politics and Film History', *Screen* 16, 3 pp. 115–25. The review also includes a discussion of Joan Mellen's *Women and Their Sexuality in the New Film* (New York: Dell, 1974).

2 *Women and Film* ceased publication in 1975. The later issues had manifested internal differences in theoretical approach.

3 The political events of May–June 1968 in France led the editors of *Cahiers du Cinema*, along with other French intellectuals, to redefine their position from a Marxist-structuralist-psychoanalytic perspective.

4 Reprinted in E. Ann Kaplan (ed.), *Psychoanalysis and Cinema* (London: Routledge, 1990).

5 See, for example, Sandy Flitterman-Lewis, 'Psychoanalysis, Film, and Television' in Robert C. Allen (ed.), *Channels of Discourse, Reassembled* (London: Routledge, 1992); Elizabeth Wright, *Psychoanalytic Criticism: Theory in Practice* (London: Methuen, 1984); Kaja Silverman, *The Subject of Semiotics* (Oxford: Oxford University Press, 1983). See also Madan Sarup, *Jacques Lacan* (Hemel Hempstead: Harvester Wheatsheaf, 1992) and Elizabeth Grosz, *Jacques Lacan: A Feminist Introduction* (London: Routledge, 1990).

6 Both desires are seen as normal components of the sexual instinct but become perversions when, instead of being 'preparatory to' or a component of the 'normal sexual aim', they 'supplant' it (Freud 1977b: 70).

7 The girl's reaction to sexual difference, writes Freud, is very different: 'She makes her judgement and her decision in a flash. She has seen it and knows that she is without it and wants to have it' (1977c: 336).

8 Elizabeth Grosz, for example, does just this:

The dream must rely on visual images/perceptions through which it can express various logical or causal relations. (In this sense the dream's problem is analogous to that of the film: how to represent negation, or contradictory and conditional relations, i.e., logical, grammatical, or causal relations, without resorting to verbal means?) (1990: 88)

9 The 'cinematic apparatus', in Annette Kuhn's definition, is the 'entire context, structure and system of meaning production in cinema' (Kuhn 1982: 56).

10 Rose is quoting from Mulvey and Wollen's film, *Riddles of the Sphinx* (1977).

Female spectators, melodrama and the 'woman's film'

1 For a widely influential statement of this position, see Colin MacCabe, 'Realism and the Cinema: Notes on Some Brechtian Theses' in *Screen*, 15, 2 pp. 7–27.

2 See Chapter Six of *The Desire to Desire* (Basingstoke and London: Macmillan, 1987) or '*Caught* and *Rebecca*: The Inscription of Femininity as Absence' in Constance Penley (ed.), *Feminism and Film Theory* (London: Routledge, 1988) for the full elaboration of this argument.

3 See Lois McNay, *Foucault: A Critical Introduction* (Oxford: Polity, 1994) and *Foucault and Feminism* (Oxford: Polity, 1992). See also in particular Foucault, *The History of Sexuality* Volume 1 (Harmondsworth: Penguin, 1981).

4 For a much fuller account of Irigaray's theories see Margaret Whitford, *Luce Irigaray: Philosophy in the Feminine* (London: Routledge, 1991). See also Whitford (ed.), *The Irigaray Reader* (Oxford: Blackwell, 1991).

5 The title of a 1979 essay by Kristeva. See Toril Moi (ed.), *The Kristeva Reader* (Oxford: Blackwell, 1986) pp. 187–213. All quotations from Kristeva here are taken from this *Reader*. For a more detailed account of Kristeva's work, see also Toril Moi, 'Marginality and Subversion: Julia Kristeva' in *Sexual/Textual Politics* pp. 150–73 (London: Methuen, 1985).

6 Kaplan argues that patriarchy represses the 'subversive' elements of the mother–daughter bond, those elements which constitute the pre-Oedipal relationship of both identification and desire. See Kaplan, *Women and Film: Both Sides of the Camera* (New York and London: Methuen, 1983), particularly Chapter 15, 'Conclusion: Motherhood and patriarchal discourse' pp. 200–206. See also her discussion in 'The Psychoanalytic Sphere and Motherhood Discourse' in *Motherhood and Representation* (London and New York: Routledge, 1992) pp. 27–56.

7 The phrase is from E. Ann Kaplan, 'The Case of the Missing Mother: Maternal Issues in Vidor's *Stella Dallas*', in Patricia Erens (ed.), *Issues in Feminist Film Criticism* (Bloomington and Indianapolis: Indiana University Press, 1990) pp. 126–36. In this article, originally written in 1983, Kaplan like Doane sees the film as exemplifying the *impossibility* of the position of the female (maternal) spectator.

8 A notable exception is Andrea Walsh's *Women's Film and Female Experience 1940–1950* (New York and London: Praeger, 1984). Walsh's work was partly responsible for Williams' reconsideration of the question of the historical spectator, as she makes clear in a footnote to '*Mildred Pierce* and the Second World War'.

Negotiating the text: spectator positions and audience readings

1 The title of this section is taken from Stuart Hall's 'Cultural Studies and the Centre: some problematics and problems' in Stuart Hall, Dorothy Hobson, Andrew Lowe and Paul Willis (eds), *Culture, Media, Language* (London: Hutchinson, 1980) pp. 15–47.

2 The paper was revised for publication in 1980. I shall quote from the 1980 version. See Stuart Hall, Dorothy Hobson, Andrew Lowe and Paul Willis (eds), *Culture, Media, Language* (London: Hutchinson, 1980) pp. 128–38.

3 In *Marxism and the Philosophy of Language*, first published in 1929, the Soviet semiotician Volosinov argued that there are no fixed meanings in language because the sign is continually the site of a class struggle in which, although the leading social class will always try to impose certain meanings, there will always in fact be a clash of 'social accents'.

4 The term 'ethnography' is used loosely here to refer to a form of audience analysis which uses sources such as interviews, letters and observation to analyse audience viewing processes. The term is 'borrowed' from its source in anthropological research where it refers much more precisely to participant observation conducted over a substantial period of time.

5 Radway is drawing here on Fredric Jameson's argument that every form of mass culture has a dimension 'which remains implicitly, and no matter how faintly, negative and critical of the social order from which, as a product and a commodity, it springs' (Jameson, 'Reification and Utopia in Mass Culture', *Social Text* 1 [Winter 1979] p. 144). See also Radway's 'The Utopian Impulse in Popular Literature: Gothic Romances and "Feminist" Protest', *American Quarterly* 33 (Summer 1981) pp. 140–62.

6 The term is Angela McRobbie's. See McRobbie, 'The Politics of Feminist Research: Between Talk, Text and Action', *Feminist Review* 12 (October 1982) pp. 46–57.

7 Ang is drawing here on Tania Modleski's account of soap opera. See 'The Search for Tomorrow in Today's Soap Operas' in Modleski, *Loving with a Vengeance: Mass-Produced Fantasies for Women* (New York and London: Methuen, 1984) pp. 85–109.

8 Ang is drawing on Pierre Bourdieu's work on patterns of taste and sources of pleasure in consumption practices of contemporary culture. See Bourdieu, 'The Aristocracy of Culture', *Media, Culture and Society* 2, 3 (1980) pp. 225–54.

9 'Flow' is Raymond Williams' term. See 'Programming: distribution and flow' in Williams, *Television: Technology and Cultural Form* (London: Routledge, 1990) pp. 78–118. Segmentation is John Ellis' way of characterizing television programming. See 'Broadcast TV as Cultural Form' in Ellis, *Visible Fictions* (London, Boston and Henley: Routledge & Kegan Paul, 1982) pp. 111–26.

10 Although this viewing is of the *video* of *Rocky II*, and its context is therefore significantly different from that of cinema viewing, I am discussing it here because it draws on psychoanalytic film theory for its conceptual framework whilst also undertaking an ethnographic analysis.

11 Stacey uses the term 'female spectator' not to refer to the viewing position constructed in the text, as in, for example, Annette Kuhn's distinction between the 'spectator' and the 'social audience' (Kuhn 1987: 343), but 'to refer to the woman in the cinema audience' (1994: 73).

Fantasy, horror and the body

1 The title of this section is taken from that of the series of workshops held in London in July 1982, at which an early version of Elizabeth Cowie's article 'Fantasia' was presented.

2 The spelling 'phantasy', used in the English translation of Freud's works, is sometimes adopted by film critics, for example Barbara Creed,

as cited in this chapter. More usually, however, the spelling 'fantasy' is adopted, and this is the usage I shall follow.

3 Linda Williams, in 'When the Woman Looks' (1984), also draws attention to the fact that the horror film is one genre in which the woman does 'return the gaze', but only in order to 'see' 'the mutilation of her own body displaced onto that of the monster': 'in the rare instance when the cinema permits the woman's look, she not only sees a monster, she sees a monster that offers a distorted reflection of her own image' (1984: 88). The monster, then, in its 'difference' from the male subject, functions as a distorted reflection of the woman's 'difference'. As a result, the exchange of looks between the two represents a threat to the male subject ('a recognition of their similar status as potent threats to a vulnerable male power') as well as a punishment for the woman (1984: 90). Williams does not deal in this essay, however, with the issue of cross-gender or oscillating spectator positions.

4 The title of this section is taken from Carol J. Clover's essay, 'Her Body, Himself: Gender in the Slasher Film' (1987).

5 D.N. Rodowick, in 'The Difficulty of Difference' (1982), also argues that Mulvey's concern to construct a sadistic male subject leads her to underestimate the importance of masochism in film spectatorship, for both the male and female spectator. Rodowick, too, draws on 'A Child Is Being Beaten' to support his argument.

Rereading difference(s) 1: Conceiving lesbian desire

1 Though Moi's is a survey of feminist *literary* theory. For a comment on Moi's exclusions see Judith Mayne 1995: 197.

2 See Chapter Five of this book.

3 See Chapter Two of this book.

4 See Freud 1977e: 389–90.

5 See Mayne 1990: 154.

6 See Chapter Three of this book.

7 See Chapter Five of this book.

8 See Chapter Four of this book.

9 Weiss, 'A Queer Feeling When I Look at You', in Christine Gledhill (ed.), *Stardom: Industry of Desire* (London and New York: Routledge, 1991). See also Weiss' longer study, *Vampires and Violets: Lesbians in the Cinema* (London: Unwin Hyman, 1991).

10 Weiss also emphasizes the attraction which the *difference* of the Hollywood star held for female spectators, in her examples working-class and black lesbian spectators. See Weiss 1991a: 291, 299n.

11 The dangers in this concept of desire as energy can be seen in Elspeth

Probyn's application of Grosz's concept to the analysis of images (though she is very imprecise in her definition of 'image'). Probyn concludes: 'through desire I queer images by rendering their relation strange ... The image is lesbian because of the way it moves me to desire and of the way in which my desire moves it. The image is queer because I queer its relation to other images and bodies' (1995: 9, 12). In this formulation everything can be 'queered', and utopia is at hand.
12 For a discussion of such a film see Butler 1993: 124–37.

Rereading difference(s) 2: Race, representation and feminist theory

1 A similar point is made by Jane Gaines, in her analysis of the 1975 film, *Mahogany*. Gaines argues that 'one of the central tenets of contemporary feminist film theory – that the (male) spectator possesses the female indirectly through the eyes of the male protagonist (his screen surrogate) – is problematized here by the less privileged black gaze' (1988: 21). Gaines' central argument is that a psychoanalytically based feminist film theory is inadequate to deal with a film which concerns racial difference and sexuality. What is needed, she suggests, is a historical and materialist analysis.

2 Bobo is discussing Dash's 1992 film, *Daughters of the Dust*, the first film created by a black woman to be released for commercial distribution.

3 John Hill, in his study of British cinema 1953–63, *Sex, Class and Realism* (1986), gives a detailed account of the social and economic factors at work in the Britain of this period. Amongst these were the crisis in national confidence produced by the Suez invasion of 1956, and racial fears produced by the steady rise in immigration from Commonwealth countries following the 1948 British Nationality Act, which granted to all members of the Commonwealth the right to enter and settle in Britain. The Act was revoked in 1962 with the passing of the Commonwealth Immigrants Act. See Hill 1986: 5–34.

4 In an introductory footnote to the essay, Bhabha does point out that a major problem in it is that, 'despite the subject's problematic accession to sexual difference which is crucial to my argument, the body in this text is male', but justifies this on the grounds that because 'the question of woman's relation to castration and access to the symbolic requires a very specific form of attention and articulation, I chose to be cautious till I had worked out its implications for colonial discourse' (1983: 18).

Bibliography

Adams, Parveen 1988: Per os(cillation). *Camera Obscura* 17, 6–29.

Ang, Ien 1985: *Watching Dallas: soap opera and the melodramatic imagination.* London: Methuen.

Ang, Ien 1988: Feminist desire and female pleasure: On Janice Radway's *Reading the romance. Camera Obscura* 16, 178–91.

Ang, Ien 1989: Wanted: audiences. On the politics of empirical audience studies. In Seiter, E., Borchers, H., Kreutzner, G. and Warth, E.-M. (eds) *Remote control: television, audiences and cultural power.* London and New York: Routledge, 96–115.

Ang, Ien 1990: Melodramatic imaginations: television fiction and women's fantasy. In Brown, M.E. (eds), *Television and women's culture.* London: Sage, 75–88.

Ang, Ien and Hermes, Joke 1991: Gender and/in media consumption. In Curran, J. and Gurevitch, M. (eds), *Mass media and society.* London: Edward Arnold, 307–28.

Barthes, Roland 1973: *Mythologies.* London: Granada Publishing.

Barthes, Roland 1977: Introduction to the structural analysis of narratives. In *Image–music–text.* London: Fontana.

Baudrillard, Jean 1985 (1983): The ecstasy of communication. In Foster, H. (ed.), *Postmodern culture.* London: Pluto Press, 126–34.

Baudry, Jean-Louis 1976: The apparatus. *Camera Obscura* 1, 104–26.

Beh, Siew Hwa 1976 (1971): *The woman's film.* In Nichols, B. (ed.), *Movies and methods.* Berkeley, Los Angeles and London: University of California Press, 201–4.

Bellour, Raymond 1972: *The birds:* analysis of a sequence. London: British Film Institute.

Bellour, Raymond 1977: Hitchcock, the enunciator. *Camera Obscura* 2, 72–8.

Bellour, Raymond 1979: Psychosis, neurosis, perversion. *Camera Obscura* 3/4, 105–32.

Berger, John 1972: *Ways of seeing*. London: BBC Books.

Bergstrom, Janet 1979a: Rereading the work of Claire Johnston. *Camera Obscura* 3/4, 21–31.

Bergstrom, Janet 1979b: Enunciation and Sexual Difference (Part 1). *Camera Obscura* 3/4, 33–65.

Bergstrom, Janet 1979c: Alternation, segmentation, hypnosis: Interview with Raymond Bellour. *Camera Obscura* 3/4, 71–103.

Bergstrom, Janet and Doane, Mary Ann 1989: The female spectator: contexts and directions. *Camera Obscura* 20–21, 5–27.

Bhabha, Homi K. 1983: The other question – the stereotype and colonial discourse. *Screen* 24, 6, 18–36.

Bobo, Jacqueline 1995: *Black women as cultural readers*. New York: Columbia University Press.

Bobo, Jacqueline and Seiter, Ellen 1991: Black feminism and media criticism. *Screen* 32, 3, 286–302.

Bordo, Susan 1990: Feminism, postmodernism, and gender-scepticism. In Nicholson, L.J. (ed.), *Feminism/postmodernism*. New York and London: Routledge, 133–56.

Bourdieu, Pierre 1980: The aristocracy of culture. *Media, Culture and Society* 2, 3, 225–54.

Braidotti, Rosi 1994: *Nomadic subjects: embodiment and sexual difference in contemporary feminist theory*. New York: Columbia University Press.

Brown, Beverley 1981: A feminist interest in pornography: some modest proposals. *m/f* 5/6, 5–18.

Brown, Mary Ellen 1994: *Soap opera and women's talk*. London: Sage.

Brunsdon, Charlotte 1981: 'Crossroads': notes on soap opera. *Screen* 22, 4, 32–7.

Brunsdon, Charlotte 1989: Text and audience. In Seiter, E., Borchers, H., Kreutzner, G. and Warth, E.-M. (eds), *Remote control: television, audiences and cultural power*. London and New York: Routledge, 116–29.

Brunsdon, Charlotte 1993: Identity in feminist television criticism. *Media, Culture and Society* 15, 2, 309–20.

Burgin, Victor, Donald, James and Kaplan, Cora (eds) 1989: *Formations of fantasy*. London and New York: Routledge.

Butler, Judith 1990: *Gender trouble: feminism and the subversion of identity*. New York and London: Routledge.

Butler, Judith 1991: Imitation and gender insubordination. In Fuss, D. (ed.), *Inside/out: lesbian theories, gay theories*. New York and London: Routledge, 13–31.

Butler, Judith 1993: *Bodies that matter: on the discursive limits of 'sex'*. New York and London: Routledge.

Cahiers du Cinema 1976 (1970): John Ford's *Young Mr. Lincoln*. In Nichols, B. (ed.), *Movies and methods*. Berkeley and Los Angeles: University of California Press, 493–529.

Camera Obscura 1976: Feminism and film: critical approaches. *Camera Obscura* 1, 3–10.

Carby, Hazel 1982: White woman listen! Black feminism and the boundaries of sisterhood. In Centre for Contemporary Cultural Studies, *The empire strikes back: race and racism in 70s Britain.* London: Hutchinson, 212–35.

Chodorow, Nancy 1978: *The reproduction of mothering: psychoanalysis and the sociology of gender.* Berkeley, Los Angeles, London: University of California Press.

Christian, Barbara 1988: The race for theory. *Feminist Studies* 14, 1, 67–79.

Citron, Michelle 1988: Women's film production: going mainstream. In Pribram, E. D. (ed.), *Female spectators: looking at film and television.* London: Verso.

Citron, Michelle, Le Sage, Julia, Mayne, Judith, Rich, B. Ruby, Taylor, Anna Marie, and the editors of *New German Critique* 1978: Women and film: a discussion of feminist aesthetics. *New German Critique* 13, 83–107.

Clough, Patricia Ticineto 1994: *Feminist thought: desire, power and academic discourse.* Oxford: Blackwell.

Clover, Carol J. 1989 (1987): Her body, himself: gender in the slasher film. In Donald, J. (ed.), *Fantasy and the cinema.* London: BFI, 91–133.

Clover, Carol J. 1992: *Men, women and chainsaws: gender in the modern horror film.* London: BFI.

Collins, Patricia Hill 1990: *Black feminist thought.* New York and London: Routledge.

Collins, Patricia Hill 1995 (1989): The social construction of black feminist thought. In Guy-Sheftall, B. (ed.), *Words of fire: an anthology of African-American thought.* New York: The New Press, 338–57.

Comolli, Jean-Louis and Narboni, Jean 1976 (1969): Cinema/ideology/criticism. In Nichols, B. (ed.), *Movies and methods.* Berkeley and Los Angeles: University of California Press, 22–30.

Cook, Pam 1988 (1975): Approaching the work of Dorothy Arzner. In Penley, C. (ed.), *Feminism and film theory.* London: Routledge, 46–56.

Cook, Pam 1993: Border crossings: women and film in context. In Cook, P. and Dodd, P. (eds), *Women and film: a Sight and Sound reader.* London: Scarlett Press, ix–xxiii.

Cook, Pam and Johnston, Claire 1988 (1974): The place of woman in the cinema of Raoul Walsh. In Penley, C. (ed.), *Feminism and film theory.* London: Routledge, 25–35.

Cowie, Elizabeth 1984: Fantasia. *m/f* 9, 71–104.

Cowie, Elizabeth 1988 (1979–80): The popular film as a progressive text – a discussion of *Coma.* In Penley, C. (ed.), *Feminism and film theory.* New York and London: Routledge/BFI, 104–40.

Cowie, Elizabeth 1989: Untitled entry, *Camera Obscura* 20/21, 127–32.

Creed, Barbara 1987: From here to modernity – feminism and postmodernism. *Screen* 28, 2, 47–67.

Creed, Barbara 1988: A journey through *Blue Velvet*. *New Formations* Vol. 6, 97–117.

Creed, Barbara 1989: Untitled entry, *Camera Obscura* 20/21, 132–7.

Creed, Barbara 1993a: *The monstrous feminine: film, feminism, psychoanalysis*. London: Routledge.

Creed, Barbara 1993b: Dark desires: male masochism in the horror film. In Cohan, S. and Hark, I.R. (eds), *Screening the male: exploring masculinities in Hollywood cinema*. London and New York: Routledge, 118–33.

Cruz, Jon and Lewis, Justin 1994: Reflections upon the encoding/decoding model: an interview with Stuart Hall. In Cruz, J. and Lewis, J. (eds), *Viewing, reading, listening: audiences and cultural reception*. Boulder: Westview Press, 253–74.

de Beauvoir, Simone 1988 (1949): *The second sex*. London: Pan Books.

de Lauretis, Teresa 1984: *Alice doesn't: feminism, semiotics, cinema*. Basingstoke and London: Macmillan.

de Lauretis, Teresa 1987: *Technologies of gender: essays on theory, film, and fiction*. Basingstoke and London: Macmillan.

de Lauretis, Teresa 1990: Guerrilla in the midst: women's cinema in the 80s. *Screen* 31, 1, 6–25.

de Lauretis, Teresa 1994: *The practice of love: lesbian sexuality and perverse desire*. Bloomington and Indianapolis: Indiana University Press.

de Lauretis, Teresa 1995: On the subject of fantasy. In Pietropaolo, L. and Testaferri, A. (eds), *Feminisms in the cinema*. Bloomington and Indianapolis: Indiana University Press, 63–85.

Delmar, Rosalind 1986: What is feminism? In Mitchell, J. and Oakley, A. (eds), *What is feminism?* Oxford: Blackwell.

di Stefano, Christine 1990 (1988): Dilemmas of difference: feminism, modernity, and postmodernism. In Nicholson, L. J. (ed.), *Feminism/postmodernism*. New York and London: Routledge, 63–82.

Doane, Mary Ann 1981a: *Caught* and *Rebecca*: The inscription of femininity as absence. *Enclitic* 5, 2, 75–89.

Doane, Mary Ann 1981b: Woman's stake: filming the female body. *October* 17, 23–36.

Doane, Mary Ann 1982: Film and the masquerade – theorising the female spectator. *Screen* 23, 3–4, 74–87.

Doane, Mary Ann 1984: The 'woman's film': possession and address. In Doane, M.A., Mellencamp, P., and Williams, L. (eds), *Re-vision: Essays in film criticism*. Los Angeles: American Film Institute, 67–82.

Doane, Mary Ann 1987: *The desire to desire: the woman's film of the 1940s*. Basingstoke and London: Macmillan.

Doane, Mary Ann 1989: Untitled entry, *Camera Obscura* 20/21, 142–7.

Doane, Mary Ann 1991a: *Femmes fatales: feminism, film theory, psychoanalysis*. New York and London: Routledge.

Doane, Mary Ann 1991b (1988–89): Masquerade reconsidered: further thoughts on the female spectator. In *Femmes fatales: feminism, film theory, psychoanalysis.* New York and London: Routledge, 33–43.

Doane, Mary Ann 1991c: Dark continents: epistemologies of racial and sexual difference in psychoanalysis and the cinema. In *Femmes fatales: feminism, film theory, psychoanalysis.* New York and London: Routledge, 209–48.

Doane, Mary Ann, Mellencamp, Patricia and Williams, Linda 1984: Feminist film criticism: an introduction. In Doane, M.A., Mellencamp, P., and Williams, L. (eds), *Re-vision: essays in film criticism.* Los Angeles: American Film Institute, 1–17.

Donald, James 1989: Introduction, the *mise en scène* of desire. In Donald, J. (ed.), *Fantasy and the cinema.* London: BFI, 136–45.

Ellis, John 1982: *Visible fictions.* London: Routledge & Kegan Paul.

Elsaesser, Thomas 1987 (1972): Tales of sound and fury: observations on the family melodrama. In Gledhill, C. (ed.) *Home is where the heart is: studies in melodrama and the woman's film.* London: BFI, 43–69.

Elsaesser, Thomas 1988: Desire denied, deferred or squared? *Screen* 29, 3, 106–15.

Erens, Patricia (ed.) 1990: *Issues in feminist film criticism.* Bloomington and Indianapolis: Indiana University Press.

Faludi, Susan 1992 (1991): *Backlash: the undeclared war against women.* London: Chatto & Windus.

Fanon, Frantz 1986 (1952): *Black skin, white masks.* London: Pluto.

Figes, Eva 1970: *Patriarchal attitudes.* Greenwich, Conn.: Fawcett Publications.

Firestone, Shulamith 1979 (1970): *The dialectic of sex: the case for feminist revolution.* London: The Women's Press.

Flax, Jane 1990: Postmodernism and gender relations in feminist theory. In Nicholson, L.J. (ed.), *Feminism/postmodernism.* New York and London: Routledge, 39–62.

Flitterman-Lewis, Sandy 1992: Psychoanalysis, film, and television. In Allen, R. C. (ed.), *Channels of discourse, reassembled.* London: Routledge, 203–47.

Foucault, Michel 1977: *Discipline and punish: the birth of the prison.* London: Penguin.

Foucault, Michel 1979: *Power, truth, strategy* (ed. Meaghan Morris and Paul Patton). Sydney: Feral Publications.

Foucault, Michel 1981: *The history of sexuality* Volume 1. London: Penguin.

Francke, Lizzie 1995: Review: Clover, *Men, women and chainsaws* and Creed, *The monstrous-feminine. Screen* 36, 1, 75–8.

Franklin, Sarah, Lury, Celia and Stacey, Jackie 1991: Feminism and cultural studies: pasts, presents, futures. In Franklin, S., Lury, C. and Stacey, J. (eds), *Off centre: feminism and cultural studies.* London and New York: HarperCollins, 1–19.

Freud, Sigmund 1953 (1925–26): The question of lay analysis: conversations with an impartial person. In Strachey, J. (ed.), *The standard edition of the complete psychological works of Sigmund Freud* Vol. 20. London: Hogarth.

Freud, Sigmund 1963 (1920): The psychogenesis of a case of homosexuality in a woman. In Rieff, P. (ed.), *Sexuality and the psychology of love.* New York: Collier Books.

Freud, Sigmund 1976 (1900): *The interpretation of dreams.* Pelican Freud Library Vol. 4. London: Penguin.

Freud, Sigmund 1977a (1924): The dissolution of the Oedipus complex. In Freud, S., *On sexuality.* Pelican Freud Library Vol. 7. London: Penguin, 313–22.

Freud, Sigmund 1977b (1905): Three essays on the theory of sexuality. In Freud, S., *On sexuality.* Pelican Freud Library Vol. 7. London: Penguin, 45–169.

Freud, Sigmund 1977c (1925): Some psychical consequences of the anatomical distinction between the sexes. In Freud, S., *On sexuality.* Pelican Freud Library Vol. 7. London: Penguin, 323–43.

Freud, Sigmund 1977d (1927): Fetishism. In Freud, S., *On sexuality.* Pelican Freud Library Vol. 7. London: Penguin, 345–57.

Freud, Sigmund 1977e (1931): Female sexuality. In Freud, S., *On sexuality.* Pelican Freud Library Vol. 7. London: Penguin, 367–92.

Freud, Sigmund 1977f (1909): Analysis of a phobia in a five-year-old boy. In Freud, S., *Case histories 1: 'Dora' and 'Little Hans'.* Pelican Freud Library Vol. 8. London: Penguin, 165–305.

Freud, Sigmund 1979 (1919): A child is being beaten. In Freud, S., *On psychopathology.* Pelican Freud Library Vol. 10. London: Penguin, 159–93.

Friedan, Betty 1965 (1963): *The feminine mystique.* London: Penguin.

Gaines, Jane 1988: White privilege and looking relations: race and gender in feminist film theory. *Screen* 29, 4, 12–27.

Gilman, Sander L. 1985: *Difference and pathology: stereotypes of sexuality, race, and madness.* Ithaca and London: Cornell University Press.

Gledhill, Christine 1978: Recent developments in feminist criticism. *Quarterly review of film studies* 3, 4, 457–93.

Gledhill, Christine 1984: Developments in feminist film criticism. In Doane, M.A., Mellencamp, P., and Williams, L. (eds), *Re-vision: essays in film criticism.* Los Angeles: American Film Institute, 18–48.

Gledhill, Christine (ed.) 1987a: *Home is where the heart is: studies in melodrama and the woman's film.* London: BFI.

Gledhill, Christine 1987b: Introduction. *Home is where the heart is: studies in melodrama and the woman's film.* London: BFI, 1–4.

Gledhill, Christine 1987c: The melodramatic field: an investigation. In Gledhill, *Home is where the heart is: studies in melodrama and the woman's film.* London: BFI, 5–39.

Gledhill, Christine 1988: Pleasurable negotiations. In Pribram, E.D. (ed.),

Female spectators: looking at film and television. London and New York: Verso, 64–89.

Greer, Germaine 1971 (1970): *The female eunuch.* St. Albans: Granada Publishing.

Greig, Donald 1989: The sexual differentiation of the Hitchcock text. In Donald, J. (ed.), *Fantasy and the cinema.* London: BFI, 175–95.

Grossberg, Lawrence 1987: The in-difference of television. *Screen* **28**, 2, 28–45.

Grossberg, Lawrence, Nelson, Cary and Treichler, Paula (ed.) 1992: *Cultural studies.* New York & London: Routledge.

Grosz, Elizabeth 1989: *Sexual subversions.* Sydney: Allen & Unwin.

Grosz, Elizabeth 1990: *Jacques Lacan: a feminist introduction.* London: Routledge.

Grosz, Elizabeth 1994: *Volatile bodies: toward a corporeal feminism.* Bloomington and Indianapolis: Indiana University Press.

Grosz, Elizabeth 1995: *Space, time, and perversion.* New York & London: Routledge.

Grosz, Elizabeth and Probyn, Elspeth (eds) 1995: *Sexy bodies: the strange carnalities of feminism.* London & New York: Routledge.

Hall, Stuart 1980a: Cultural studies and the centre: some problematics and problems. In Hall, S., Hobson, D., Lowe, A. and Willis, P. (eds), *Culture, media, language.* London: Hutchinson, 15–47.

Hall, Stuart 1980b: Introduction to media studies at the centre. In Hall, S., Hobson, D., Lowe, A. and Willis, P. (eds), *Culture, media, language.* London: Hutchinson, 117–21.

Hall, Stuart 1980c: Encoding/decoding. In Hall, S., Hobson, D., Lowe, A. and Willis, P. (eds), *Culture, media, language.* London: Hutchinson, 128–38.

Hall, Stuart 1980d: Recent developments in theories of language and ideology: a critical note. In Hall, S., Hobson, D., Lowe, A. and Willis, P. (eds), *Culture, media, language.* London: Hutchinson, 157–62.

Hall, Stuart 1992: Cultural studies and its theoretical legacies. In Grossberg, L., Nelson, C. and Treichler, P. (eds), *Cultural studies.* New York & London: Routledge, 1992, 277–94.

Hall, Stuart 1994: Reflections upon the encoding/decoding model: an interview with Stuart Hall. In Cruz, J. and Lewis, J. (eds), *Viewing, reading, listening: audiences and cultural studies.* Boulder, Col.: Westview Press.

Hall, Stuart, Hobson, Dorothy, Lowe, Andrew and Willis, Paul (eds) 1980: *Culture, media, language.* London: Hutchinson.

Haraway, Donna 1990 (1985): A manifesto for cyborgs: science, technology, and socialist feminism in the 1980s. In Nicholson, L.J. (ed.), *Feminism/postmodernism.* New York and London: Routledge, 190–233.

Haraway, Donna 1991: *Simians, cyborgs, and women.* London: Free Association Books.

Hartsock, Nancy 1990 (1987): Foucault on power: a theory for women. In Nicholson, L.J. (ed.), *Feminism/postmodernism*. New York and London: Routledge, 157–75.

Haskell, Molly 1987: *From reverence to rape: the treatment of women in the movies* (second edition). Chicago & London: University of Chicago Press.

Heath, Stephen 1973: Film/cinetext/text. *Screen* 14, 1/2, 102–27.

Heath, Stephen 1975a: Film and system: terms of analysis, Part 1. *Screen* 16, 1, 7–77.

Heath, Stephen 1975b: Film and system: terms of analysis, Part 2. *Screen* 16, 2, 91–113.

Heath, Stephen 1976a: Narrative space. *Screen* 17, 3, 68–112.

Heath, Stephen 1976b: On screen, in frame: film and ideology. *Quarterly Review of Film Studies* 1, 3, 251–65.

Heath, Stephen 1977/78: Notes on suture. *Screen* 18, 4, 48–76.

Heath, Stephen 1981: *Questions of cinema*. Basingstoke and London: Macmillan.

Hill, John 1986: *Sex, class and realism: British cinema 1956–1963*. London: BFI.

Hobson, Dorothy 1982: *'Crossroads': the drama of a soap opera*. London: Methuen.

hooks, bell 1984: *Feminist theory: from margin to centre*. Boston, Ma.: South End Press.

hooks, bell 1992: *Black looks: race and representation*. London: Turnaround.

Humm, Maggie 1992: *Feminisms: a reader*. Hemel Hempstead: Harvester Wheatsheaf.

Irigaray, Luce 1985: *This sex which is not one*, trans. Catherine Porter. Ithaca: Cornell University Press.

Jameson, Fredric 1979: Reification and utopia in mass culture. *Social Text* 1 (Winter 1979), 130–48.

Johnston, Claire (ed.) 1973a: *Notes on women's cinema*. Screen Pamphlet 2. London: Society for Education in Film and Television.

Johnston, Claire 1973b: Women's cinema as counter-cinema. In Johnston, C. (ed.), *Notes on women's cinema*. Society for Education in Film and Television, 24–31.

Johnston, Claire 1975: Feminist politics and film history. *Screen* 16, 3, 115–25.

Johnston, Claire 1988 (1975): Dorothy Arzner: critical strategies. In Penley, C. (ed.), *Feminism and film theory*. London: Routledge, 36–45.

Johnston, Claire 1990 (1975): Femininity and the masquerade: *Anne of the Indies*. In E. Ann Kaplan (ed.), *Psychoanalysis and cinema*. London: Routledge, 64–72.

Kaplan, E. Ann 1983: *Women and film: both sides of the camera*. New York and London: Methuen.

Kaplan, E. Ann 1987a: Mothering, feminism and representation: the mater-

nal in melodrama and the woman's film 1910–40. In Gledhill, C. (ed.) *Home is where the heart is: studies in melodrama and the woman's film.* London: BFI, 113–37.

Kaplan, E. Ann 1987b: *Rocking around the clock: music television, post-modernism, and consumer culture.* New York and London: Methuen.

Kaplan, E. Ann (ed.) 1990a: *Psychoanalysis and cinema.* London: Routledge.

Kaplan, E. Ann (ed.) 1990b (1983): The case of the missing mother: maternal issues in Vidor's *Stella Dallas.* In Erens, P. (ed.), *Issues in feminist film criticism.* Bloomington and Indianapolis: Indiana University Press, 126–36.

Kaplan, E. Ann (ed.) 1992: *Motherhood and representation.* London and New York: Routledge.

Kristeva, Julia 1982: *Powers of horror: an essay on abjection.* New York: Columbia University Press.

Kristeva, Julia 1986a (1974): Revolution in poetic language. In Moi, T. (ed.), *The Kristeva reader.* Oxford: Blackwell, 89–136.

Kristeva, Julia 1986b (1974): About Chinese women. In Moi, T. (ed.), *The Kristeva reader.* Oxford: Blackwell, 138–59.

Kristeva, Julia 1986c (1977): A new type of intellectual: the dissident. In Moi, T. (ed.), *The Kristeva reader.* Oxford: Blackwell, 292–300.

Kristeva, Julia 1986d (1979): Women's time. In Moi, T. (ed.), *The Kristeva reader.* Oxford: Blackwell, 187–213.

Kristeva, Julia 1987: *Tales of love.* Trans. Leon S. Roudiez. New York: Columbia University Press.

Kuhn, Annette 1982: *Women's pictures: feminism and cinema.* London: Routledge & Kegan Paul.

Kuhn, Annette 1985: *The power of the image: essays on representation and sexuality.* London: Routledge & Kegan Paul.

Kuhn, Annette 1987 (1984): Women's genres: melodrama, soap opera and theory. In Gledhill, C., *Home is where the heart is: studies in melodrama and the woman's film.* London: BFI, 339–49.

Kuhn, Annette (ed.) 1990: *Alien zone: cultural theory and contemporary science fiction cinema.* London: Verso.

Lacan, Jacques 1982: *Feminine sexuality* (ed. Mitchell, J. and Rose, J., trans. Rose). New York and London: W.W. Norton.

La Place, Maria 1987: Producing and consuming the woman's film: discursive struggle in *Now, voyager.* In Gledhill, C. (ed.), *Home is where the heart is: studies in melodrama and the woman's film.* London: BFI, 138–66.

Laplanche, Jean and Pontalis, Jean-Bertrand 1986 (1964): Fantasy and the origins of sexuality. In Burgin,V., Donald, J. and Kaplan, C. (eds), *Formations of fantasy.* London and New York: Routledge, 5–34.

Lury, Celia 1996: *Consumer culture.* Oxford: Polity Press.

Lyon, Elisabeth 1988 (1980): The cinema of Lol V. Stein. In Penley, C. (ed.), *Feminism and film theory.* New York and London: Routledge/BFI, 244–71.

Macdonald, Myra 1995: *Representing women: myths of femininity in the popular media*. London: Arnold.

Macdonell, Diane 1986: *Theories of discourse: an introduction*. Oxford: Blackwell.

McNay, Lois 1992: *Foucault and feminism*. Oxford: Polity.

McNay, Lois 1994: *Foucault: a critical introduction*. Oxford: Polity.

McRobbie, Angela 1982: The politics of feminist research: between talk, text and action. *Feminist review* 12, 46–57.

McRobbie, Angela 1994: *Postmodernism and popular culture*. London and New York: Routledge.

Maslow, A.H. 1970: *Motivation and personality*. London: Harper and Row.

Mayne, Judith 1990: *Woman at the keyhole: feminism and women's cinema*. Bloomington and Indianapolis: Indiana University Press.

Mayne, Judith 1993: *Cinema and spectatorship*. London & New York: Routledge.

Mayne, Judith 1995: A parallax view of lesbian authorship. In Pietropaolo, L. and Testaferri, A. (eds), *Feminisms in the cinema*. Bloomington and Indianapolis: Indiana University Press, 195–205.

Metz, Christian 1975: The imaginary signifier. *Screen* 16, 2, 14–76.

Metz, Christian 1976 (1971): On the notion of cinematographic language. In Nichols, B. (ed.), *Movies and methods*. Berkeley and Los Angeles: University of California Press, 582–89.

Millett, Kate 1977 (1970): *Sexual politics*. London: Virago.

Minh-ha, Trinh T. 1989a: Outside in inside out. In Pines, J. and Willemen, P. (eds), *Questions of third cinema*. London: BFI, 133–49.

Minh-ha, Trinh T. 1989b: *Woman, native, other*. Bloomington and Indianapolis: Indiana University Press.

Minh-ha, Trinh T. 1995: 'Who is speaking?' Of nation, community, and first-person interviews. In Pietropaolo, L. and Testaferri, A. (eds), *Feminisms in the cinema*. Bloomington and Indianapolis: Indiana University Press, 41–59.

Modleski, Tania 1980: 'Never to be thirty-six years old': *Rebecca* as female oedipal drama. *Wide angle* 4, 2, 34–41.

Modleski, Tania 1984: The search for tomorrow in today's soap operas. In Modleski, *Loving with a vengeance: mass produced fantasies for women*. New York and London: Methuen, 85–109.

Modleski, Tania 1986: Introduction. In Modleski (ed.), *Studies in entertainment: critical approaches to mass culture*. Bloomington and Indianapolis: Indiana University Press, ix-xix.

Modleski, Tania 1987: Time and desire in the woman's film. In Gledhill, C. (ed.), *Home is where the heart is: studies in melodrama and the woman's film*. London: BFI, 326–38.

Modleski, Tania 1988: *The women who knew too much: Hitchcock and feminist theory*. New York and London: Methuen.

Moi, Toril 1985: *Sexual/textual politics*. London: Methuen.

Moi, Toril (ed.) 1986: *The Kristeva reader*. Oxford: Blackwell.

Moores, Shaun 1993: *Interpreting audiences: the ethnography of media consumption*. London: Sage.

Morley, David 1980a: Texts, readers, subjects. In Hall, S., Hobson, D., Lowe, A. and Willis, P. (eds), *Culture, media, language*. London: Hutchinson, 163–73.

Morley, David 1980b: *The 'Nationwide' audience*. London: BFI.

Mulvey, Laura 1979: Feminism, film and the *avant-garde*. In Jacobus, M. (ed.) *Women writing and writing about women*. Beckenham: Croom Helm, 177–95.

Mulvey, Laura 1989a (1975): Visual pleasure and narrative cinema. In *Visual and other pleasures*. Basingstoke and London: Macmillan, 14–26.

Mulvey, Laura 1989b: *Visual and other pleasures*. Basingstoke and London: Macmillan.

Mulvey, Laura 1989c (1977): Notes on Sirk and melodrama. In *Visual and other pleasures*. Basingstoke and London: Macmillan, 39–44.

Mulvey, Laura 1989d (1981): Afterthoughts on 'Visual pleasure and narrative cinema' inspired by King Vidor's *Duel in the Sun* (1946). In *Visual and other pleasures*. Basingstoke and London: Macmillan, 29–38.

Mulvey, Laura 1989e: British feminist film theory's female spectators: presence and absence. *Camera Obscura* **20/21**, 68–81.

Neale, Stephen 1989: Issues of difference: *Alien* and *Blade Runner*. In Donald, J. (ed.), *Fantasy and the cinema*. London: BFI, 213–23.

Nelson, Cary, Treichler, Paula A. and Grossberg, Lawrence 1992: Cultural studies: an introduction. In Grossberg, L., Nelson, C. and Treichler, P. (eds), *Cultural studies*. New York & London: Routledge, 1–16.

Nowell-Smith, Geoffrey 1987 (1977): Minelli and melodrama. In Gledhill, C. (ed.), *Home is where the heart is: studies in melodrama and the woman's film*. London: BFI, 70–4.

Oudart, Jean-Pierre 1977/78: Cinema and suture. *Screen* **18**, 4, 35–47.

Okely, Judith 1986: *Simone de Beauvoir*. London: Virago.

Partington, Angela 1991: Melodrama's gendered audience. In Franklin, S., Lury, C. and Stacey, J. (eds), *Off centre: feminism and cultural studies*. London and New York: HarperCollins, 49–68.

Penley, Constance 1988: Introduction – the lady doesn't vanish: feminism and film theory. In Penley, C. (ed.), *Feminism and film theory*. New York and London: Routledge/BFI, 1–24.

Penley, Constance 1989a: Untitled entry, *Camera Obscura* **20/21**, 256–60.

Penley, Constance 1989b: Preface. *The future of an illusion: film, feminism and psychoanalysis*. London: Routledge.

Penley, Constance 1989c (1985): Feminism, film theory and the bachelor machines. In *The future of an illusion: film, feminism and psychoanalysis*. London: Routledge, 57–80.

Penley, Constance 1992: Feminism, psychoanalysis, and the study of popu-

lar culture. In Grossberg, L., Nelson, C. and Treichler, P. (eds), *Cultural studies*. New York and London: Routledge, 479–500.

Pribram, E. Deidre (ed.) 1988: *Female spectators: looking at film and television*. London and New York: Verso.

Probyn, Elspeth 1995: Queer belongings: the politics of departure. In Grosz, E. and Probyn, E. (eds), *Sexy bodies: the strange carnalities of feminism*. London and New York: Routledge, 1–18.

Radway, Janice 1981: The utopian impulse in popular literature: Gothic romances and 'feminist' protest. *American Quarterly* 33, 140–62.

Radway, Janice 1986: Identifying ideological seams: mass culture, analytical method, and political practice. *Communication* Vol. 9, 93–123.

Radway, Janice 1987: *Reading the romance*. London: Verso.

Rich, Adrienne 1996 (1978): Compulsory heterosexuality and lesbian existence. In Jackson, S. and Scott, S. (eds), *Feminism and sexuality: a reader*. Edinburgh: Edinburgh University Press, 130–43.

Rich, B. Ruby 1993: When difference is (more than) skin deep. In Gever, M., Parmar, P. and Greyson, J. (eds), *Queer looks: perspectives on lesbian and gay film and video*. New York and London: Routledge, 318–39.

Riviere, Joan 1986 (1929): Womanliness as a masquerade. In Burgin, V., Donald, J. and Kaplan, C. (eds), *Formations of fantasy*. London and New York: Routledge, 35–44.

Rodowick, D. N. 1982: The difficulty of difference. *Wide Angle* 5, 1, 4–15.

Rose, Jacqueline 1986: *Sexuality in the field of vision*. London: Verso.

Rose, Jacqueline 1989: Untitled entry, *Camera Obscura* 20/21, 274–79.

Rosen, Marjorie 1974 (1973): *Popcorn Venus*. New York: Avon Books.

Sarup, Madan 1992: *Jacques Lacan*. Hemel Hempstead: Harvester Wheatsheaf.

Seiter, Ellen, Borchers, Hans, Kreutzner, Gabriele and Warth, Eva-Maria 1989: Introduction. *Remote control: television, audiences and cultural power*. London and New York: Routledge, 1–15.

Shohat, Ella 1991: Gender and the culture of empire: toward a feminist ethnography of the cinema. *Quarterly Review of Film and Video* 13, 1–3, 45–84.

Silverman, Kaja 1980: Masochism and subjectivity. *Framework* 12, 2–9.

Silverman, Kaja 1983: *The subject of semiotics*. Oxford: Oxford University Press.

Silverman, Kaja 1985: Lost objects and mistaken subjects: film theory's structuring lack. *Wide Angle* 7, 1–2, 14–29.

Silverman, Kaja 1988a: *The acoustic mirror: the female voice in psychoanalysis and cinema*. Bloomington and Indianapolis: Indiana University Press.

Silverman, Kaja 1988b: Masochism and male subjectivity. *Camera Obscura* 17, 31–67.

Smith, Barbara 1986 (1977): Toward a black feminist criticism. In

Showalter, E. (ed.), *The new feminist criticism: essays on women, literature, and theory*. London: Virago, 168–85.

Spender, Dale 1985: *For the record: the making and meaning of feminist knowledge*. London: The Women's Press.

Spender, Dale 1986: *Mothers of the novel: 100 good women writers before Jane Austen*. London: Pandora.

Spivak, Gayatri Chakravorty 1990: *The post-colonial critic: interviews, strategies, dialogues* (ed. Sarah Harasym). New York and London: Routledge.

Stacey, Jackie 1992 (1987): Desperately seeking difference. In *The sexual subject: a 'Screen' reader in sexuality*. London and New York: Routledge, 244–57.

Stacey, Jackie 1994: *Star gazing: Hollywood cinema and female spectatorship*. London and New York: Routledge.

Studlar, Gaylyn 1985 (1984): Masochism and the perverse pleasures of the cinema. In Nichols, B. (ed.), *Movies and methods* Vol. II. London: University of California Press, 602–21.

Tasker, Yvonne 1991: Having it all: feminism and the pleasures of the popular. In Franklin, S., Lury, C. and Stacey, J. (eds), *Off centre: feminism and cultural studies*. London and New York: HarperCollins, 85–96.

Todd, Janet (ed.) 1989: *A Wollstonecraft anthology*. Cambridge: Polity Press.

Tong, Rosemarie 1989: *Feminist thought: a comprehensive introduction*. London: Unwin Hyman.

Trinh, *see* Minh-ha, Trinh T.

Volosinov, Valentin 1973 (1929): *Marxism and the philosophy of language*. New York: Seminar Press.

Walkerdine, Valerie 1989 (1986): Video replay: families, films and fantasy. In Burgin, V., Donald, J. and Kaplan, C. (eds), *Formations of fantasy*. London and New York: Routledge, 167–99.

Walsh, Andrea S. 1984: *Women's film and female experience 1940–1950*. New York and London: Praeger.

Weedon, Chris 1987: *Feminist practice and poststructuralist theory*. Oxford: Blackwell.

Weiss, Andrea 1991a: 'A queer feeling when I look at you': Hollywood stars and lesbian spectatorship in the 1930s. In Gledhill, C. (ed.), *Stardom: industry of desire*. London and New York: Routledge.

Weiss, Andrea 1991b: *Vampires and violets: lesbians in the cinema*. London: Unwin Hyman.

Whelehan, Imelda 1995: *Modern feminist thought: from the second wave to 'post-feminism'*. Edinburgh: Edinburgh University Press.

Whitford, Margaret (ed.) 1991a: *The Irigaray reader*. Oxford: Blackwell.

Whitford, Margaret 1991b: *Luce Irigaray: philosophy in the feminine*. London: Routledge.

Willeman, Paul 1972/73: Towards an analysis of the Sirkian system. *Screen* 13, 4, 128–34.

Williams, Linda 1984: When the woman looks. In Doane, M.A., Mellencamp, P., and Williams, L. (eds), *Re-vision: essays in film criticism*. Los Angeles: American Film Institute, 83–99.

Williams, Linda 1987 (1984): 'Something else besides a mother': *Stella Dallas* and the maternal melodrama. In Gledhill, C. (ed.) *Home is where the heart is: studies in melodrama and the woman's film*. London: BFI, 299–325.

Williams, Linda 1988: Feminist film theory: *Mildred Pierce* and the Second World War. In Pribram, E.D. (ed.), *Female spectators: looking at film and television*. London and New York: Verso, 12–30.

Williams, Linda 1990: *Hard core*. London: Pandora.

Williams, Linda 1991: Film bodies: gender, genre and excess. *Film Quarterly* 44, 4, 2–13.

Williams, Raymond 1990: *Television, technology and cultural form*. London: Routledge.

Women and Film 1972: Overview. *Women and Film* 1, 3–6.

Wilton, Tamsin (ed.) 1995: Introduction: on invisibility and immortality. In Wilton, T. (ed.), *Immortal, invisible: lesbians and the moving image*. London and New York: Routledge, 1–19.

Wilton, Tamsin 1995: On not being Lady Macbeth: some (troubled) thoughts on lesbian spectatorship. In Wilton, T. (ed.), *Immortal, invisible: lesbians and the moving image*. London and New York: Routledge, 143–62.

Woolf, Virginia 1957 (1929): *A room of one's own*. New York: Harcourt Brace Jovanovich.

Wright, Elizabeth 1984: *Psychoanalytic criticism: theory in practice*. London: Methuen.

Young, Lola 1996: *Fear of the dark: 'race', gender and sexuality in the cinema*. London and New York: Routledge.

Index



Unconscious 5, 19, 44
 and conscious response 88
 and film readings 16–7, 18
 and psychoanalysis 4, 34
Utopia 168, 170

Video 160, 162
Video games 162
Villette 9
Visual pleasure 41, 80
'Visual Pleasure and Narrative Cinema'
 40, 45, 95, 118
Voice
 female 6, 29
Volosinov, Valentin 70, 82
Voyeurism 38, 41
 and look 106, 113

Walkerdine, Valerie 85–7, 88
'White fantasy' 87
Whiteness
 as defined against blackness 141–2
 and femininity 141
 as ideal 147
Willeman, Paul 46, 48
Williams, Linda 61, 62–4, 75, 78, 99,
 101, 102, 103, 106, 112, 113–5,
 116, 167, 168
 and Doane, Mary Ann and
 Mellencamp, P. 12, 13, 21
Williams, Raymond 68
Wilton, Tamsin 128, 129, 133, 134
Wollstonecraft, Mary 2

Woman
 and feminist theorist 166–7
 as image ix
 as monster 103, 105, 115
 as real ix
 as sign 28, 30–1, 32, 40
 as symbol of male desire 120
Women('s)
 culture
 reclaiming of 90
 as culturally constructed 5
 lack 107
 as polarized 7, 14
 as 'real' 90
 and women's readings 90
 voice search for 57
Women's film, the xii, 46, 51–5, 63–5
 and desire 51–7
 and overidentification 52
 resistance to 52
 and stars, female 64
 as woman's discourse 65
Women & Film x, xi, 12, 23, 94, 97, 170
Women of Brewster Place, The 140
Women who Knew too Much, The 59
Women's movement x, 13
 and theory 31
 and filmmaking 31
Women's activism xiii
Woolf Virginia 6, 16

Young, Lola 137, 149, 151–3, 154
Young Mr Lincoln 27